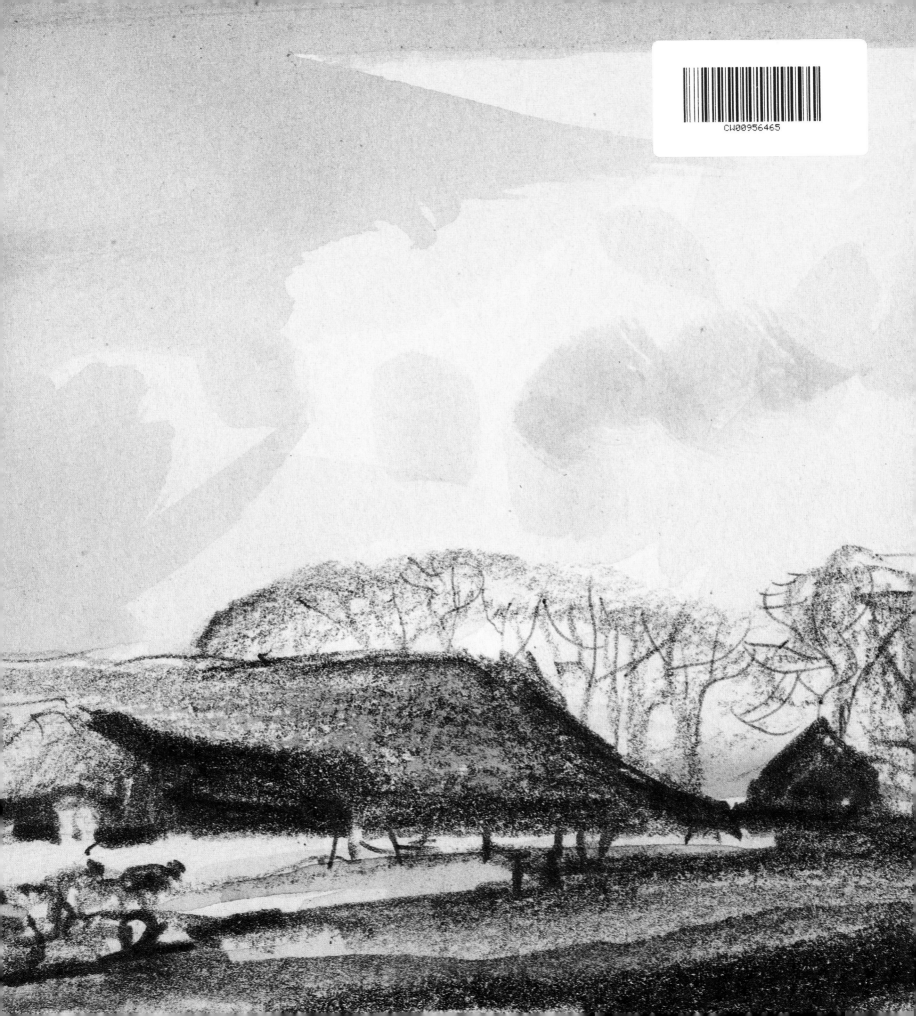

ROWLAND HILDER
Sketching Country

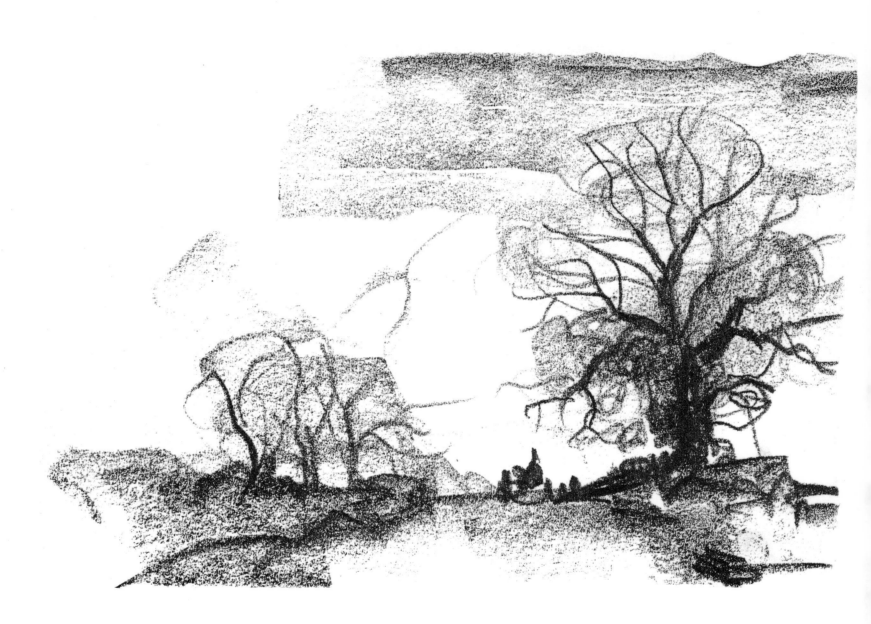

ROWLAND HILDER
Sketching Country

Edited and introduced
by Denis Thomas

THE HERBERT PRESS

Copyright © Rowland Hilder and Denis Thomas 1991
Copyright under the Berne Convention

First published in Great Britain 1991 by
The Herbert Press Ltd, 46 Northchurch Road, London N1 4EJ

House Editor: Sian Parkhouse
Designed by Pauline Harrison

Set in Sabon by
Nene Phototypesetters Ltd, Northampton
Printed and bound in Hong Kong by
South China Printing Co. (1988) Ltd

A CIP catalogue record for this book is available
from the British Library.

ISBN 1 871569 35 4

Contents

Introduction by Denis Thomas 7

Beginnings and Bygones 17

London's River 28

Seas, Sails and Skies 38

A Painter's Country 68

A View from the Studio 112

Acknowledgement 128

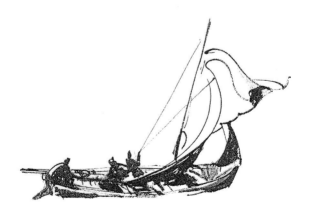

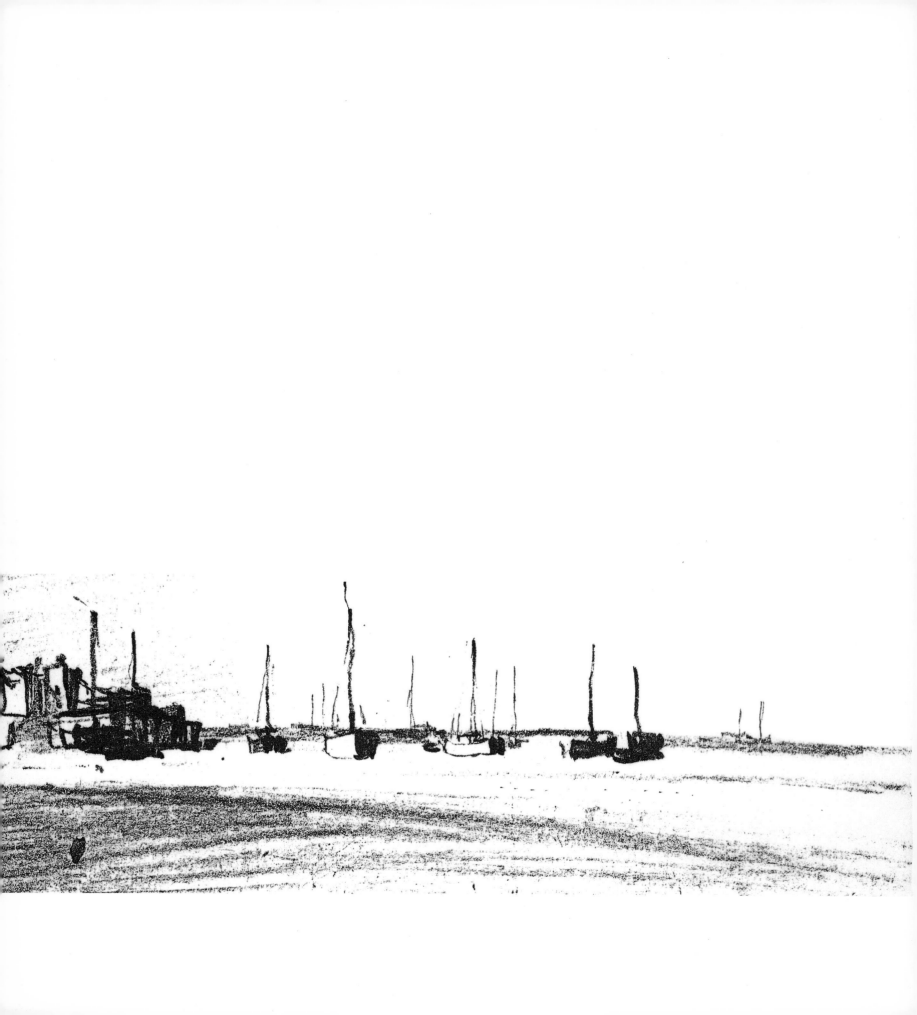

Introduction

THE WELCOME given to *Rowland Hilder's England* and to its successor, *Rowland Hilder Country*, is a testimony to the place the artist holds in people's affections – not just in his beloved England but everywhere in the world where 'the Englishness of English art' strikes a reminiscent chord. It is hard to think of any landscape painter of his generation whose work is so widely accessible, through a myriad of reproductions, or so instantly recognizable. He shares with John Constable the distinction of having seen, in his own lifetime, an entire region of England identified with his name and art. The description 'Rowland Hilder country' evokes a landscape as distinctive and personal as 'Constable's country' along the Suffolk Stour.

As an artist he has had two lifelong loves: the Thames, which he explored as a boy, and which prompted his early ambition to become a marine painter; and the Shoreham Valley, that corner of Kent immortalized by Samuel Palmer as his own Valley of Vision. Both have nourished his career – now in his eighties, he has been earning his living as an artist since he was eighteen years old – and both remain at the centre of his art to this day. His drawings of moored sailing barges, his earliest exercises in documentary draughtsmanship, gave him a feeling for the great waterway that in those days was an artery of the Empire. He immersed himself in the skills and crafts of the seamen, taught himself to sail, and worked happily amid the clatter and clamour of London's dockland, sketching scenes that few of his present-day admirers ever set eyes on. All this gives his marine subjects the smack of authentic observation, as his exhibits at the Royal Society of Marine Artists have testified over the years.

So also with his landscapes: his 'Shoreham' experience, on which his fame as a landscape painter came to be based, dates from his student days at Goldsmiths' College. As it happened, the Shoreham Valley was the first stretch of untouched countryside in those days – a rich farming and hop-growing area – that Hilder and his friends could easily get to, by train or bicycle. Hilder was to return to it over and again, walking its lanes, re-visiting its farmsteads, studying its moods and the pastoral dramas of the seasons along the North Downs. It has remained a fixed point in his imaginative universe, the epicentre of his achievement as a landscape painter.

More generally, Rowland Hilder has found all he needs in the familiar middle-ground of English art, a territory identified a few years ago by Ian Jeffrey in the hugely popular exhibition at London's Hayward Gallery, 'The British Landscape, 1920–1950', as 'a constant negotiation between pastoral and modernising tendencies, with the pastoral usually in the ascendant'. That certainly holds for Hilder, even if 'modernising tendencies' are seldom apparent. He sticks to the instinctively natural image of his painting country: horses, not tractors; corn

stooks, not cylindrical bales; hay wains, not six-wheeled trucks. John and Paul Nash, Eric Ravilious, Edward Bawden and Graham Sutherland were among contemporaries of Hilder who shared and promoted this distinctively English mood between the two World Wars. Geoffrey Grigson, who supplied the text for Rowland and Edith Hilder's illustrations for Shell's 'Flowers of the Countryside' series in the 1950s, wrote of the latent emotion, for the English, in words like 'hill' and 'tree' and 'green', sensing in them origins almost beyond recall.

Hilder's art has remained close to that ideal. His images seem to stay in the mind, as places half-remembered yet still, somehow, within our ken. The typical 'Hilderscape' is a land of plenty in an untroubled heartland, most often stripped of its summer graces and clad in the naked decency of winter. Such art critics as have noticed, have dubbed this style as 'romantic realism'. Rowland Hilder, not a man for 'isms', goes along with that. Both elements are present in his most characteristic work, though the 'realism' is commonly one of mood rather than of mere fact.

Distinguished as he is in oils, he is at his most eloquent in watercolour – 'the most wonderful medium of expression yet invented', as he has called it. He knows the mysteries of the medium inside out. But he marvels still that he and his generation, when they started out to be artists, were totally unaware of the long line of creative achievement that stretches back to Cozens, Girtin, Turner, Cotman and the Norwich School. Such names were never, he says, on their teachers' lips, nor was watercolour painting taught anywhere that mattered. Finding how to do it for himself has been a continuous process, both technical and artistic. One of his satisfactions has been noticing how often his great predecessors in the English School broke away from orthodoxy, mixing media and methods whenever it suited their purpose, as Hilder himself likes to do in his own on-the-spot studies, whether impromptu notes or first thoughts towards more considered work to come.

As an artist who enjoys close relations with the professional world outside his studio, he has always kept up with the latest printing methods, materials, demands of the media, and those market changes which, he says, help to keep the art world on its toes. He is a master of technique, while relying on his first impulse (he does not use the word 'inspiration') to achieve what he sets out to do. Often – as this book helps to show – that impulse comes from the merest jotting on a sketchpad. In a typical Hilder, what changes a location into a subject for a painter is an awareness of mood and place, an abstraction from the general to the personal.

Finding out for himself has always been more productive than textbooks and lectures. It has left him with a profound fellow-feeling for the men who showed him the way, members of the 'beautiful profession', as Peter De Wint called it, that Rowland Hilder has followed for so much of his life. In the past few years his work has taken on a breadth and freedom typical of the forebears he most admires. He still favours his earliest subjects: English landscape in its English light; and in his marine studies, water throwing back the light from travelling skies. In this, the third book on which we have worked together, the theme is Hilder's instinct as a sketcher. Instead of formality or finish he invites us to share his pleasure in the 'rightness' of that first passage of a loaded brush; of tones that stand for form; or a twinkling wash that is a statement in itself. Such moments bring us close to the springs of man's imagination, and of art itself.

DENIS THOMAS

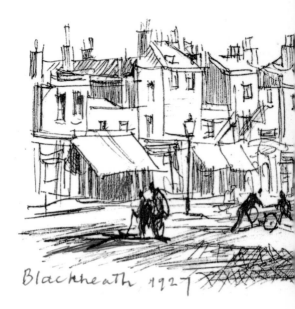

Blackheath 1927

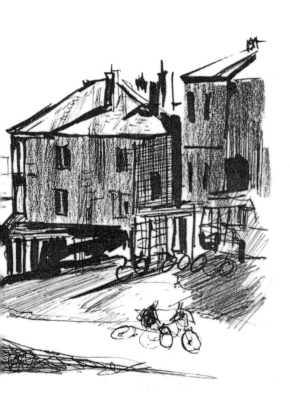

I could not help thinking, as I began to put ideas together for this new book about my work, with the emphasis on sketching, how much I owe to the example of the old masters – and some not so old – who in their day broke the classical mould. I thought of Rubens, the proto-Romantic, and of Rembrandt, whose humanity spills out into his drawings, and of Claude Lorrain, whose free, loose sketches are as lovely as his arcadian oils. As for my predecessors among English landscape painters, I have always been conscious of their example in taking Nature as she is, confronting the artist on the spot. I think of Constable, sticking to his belief that there was room, as he put it, for 'a natural painter'; and of Turner, whose last works are all that we aspire to in the sketch, the happy resolution of spontaneity and form.

The traditional approach has been based on the conception that art rests on three-dimensional form and its sculptural values. Students used to be schooled in anatomy and the structural movements of the body, with lines in a drawing following round the form to emphasize its solidity and contour. We deceive ourselves if we think that the great liberating art movements of the past century and a half, from Corot and Constable to Turner and the Impressionists, have taken the 'hard work' out of painting. What they have done, though, is establish what has been called 'the primacy of the eye' both in making pictures and the way we look at them. In doing so, these artistic heroes of mine have helped to transform the idea of a sketch as just a humble by-product of painting into an art form in its own right.

The techniques of sketching do not change. We are at one with the landscape sketchers of old, responding with the same simple means – and, probably, the same not-so-simple problems of being in the right place, in the right mood, at the right time. I still tend to have two or three sketches on the go at once, so that the sky, say, in one sketch can be drying while I am busy with another subject nearby, laying on broad strokes that help to catch the essence of the time and place. In the same tradition, I carry a good assortment of papers, from white to blue-grey, which are a short cut to establishing the appropriate tone. I work fast, getting through a fair amount of paper in any one session. And I indulge in various devices of technique, such as drawing in pencil over still-damp washes and adding occasional smudges with a forefinger. It is a happy occupation, and I never tire of recommending it.

The great majority of my work begins in this way. I have learned from the past how essential it is to get the tone right, from one's first quick sight of a possible subject to a finished work based on that first perception, but carrying it forward in the total process of making a finished picture. I have found it is possible to work up a satisfactory painting from Nature simply by plotting various areas of tone, creating an image that carries conviction by getting the tone values right, even if the line is not impeccable. One's first sight of a subject, in a painter's terms, is of its form and tones rather than its outlines. So in my case, at least, my initial attempts have been conceived and carried out in monotone. Worrying about colour comes later.

I am not the first painter to work this way. Sickert, for one, used to teach this method. He began with a monotone underpainting (which he claimed should be the colour of a good cigar) best suited to his figure work, and went on from there. Rubens and Turner used grey, a better background colour for an out-of-doors subject. Turner in the 1830s carried notebooks made up of folded blue paper, and made colour notes on them in gouache, which gives a grainy look when it dries. As

a base, blue gives you a workable background to build on. It also suggests atmosphere, in which you can suggest forms in bold, uninhibited strokes. I have always admired the Petworth sketches, which Turner seems to have done for sheer pleasure rather than (with a few exceptions) as starting points for paintings. You might think he puts the figures in rather crudely, but they are certainly dynamic. How else could he have caught those chattering women, for example, in a few seconds of what looks like scribble but lives on as imagery in action? They appeal to us because they appear liberated from art-class conventions, not to mention the high-minded seriousness to be expected of such an august figure as Joseph Mallord William Turner RA.

This, at any rate, seems to have been the view of John Ruskin, Turner's champion and hero-worshipper. When he was going through the Turner Bequest pictures after the great man's death he scribbled on the backs of some of the Petworth sketches 'Rubbish' or 'Inferior' or 'Worse'. It has taken some time for taste to change, to a point where a spontaneous colour note can sometimes take precedence over a 'finished' picture. There are close on a thousand more of these Turner sketches on coarse blue paper (the kind used in those days for wrapping up people's groceries). Turner also used tinted paper for some of his sunset studies and mysterious 'colour beginnings' – an impossible feat for lesser mortals. But as usual he pulled it off.

Those of us who are inveterate sketchers have a lot to thank Turner for – though most of us have a long way to go before we dare lay a sketch of ours alongside any one of his. In my time I have borrowed a Turner theme from one or other of his many sketchbooks, for my own englightenment; and I have dared to include one of them in the pages ahead. You have to think of him not only as the equal of his revered predecessor, Claude Lorrain, with his ventures into the sublime, but also as an innovator who made painting a physical act – a century before the term 'Action

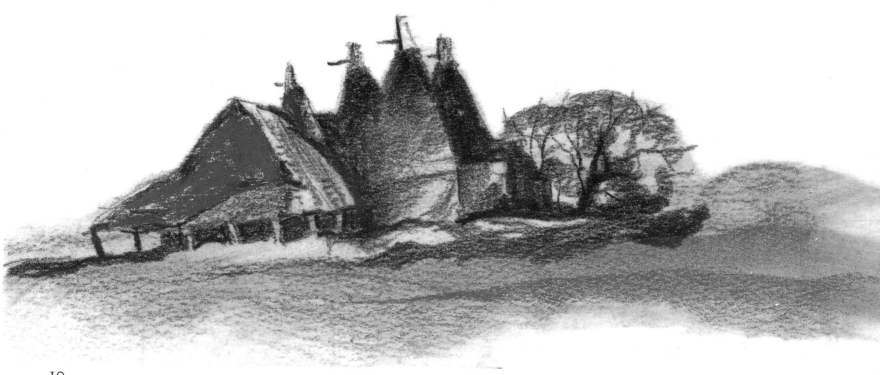

painting' was invented in the United States. He would scratch at the surface with a claw-like fingernail which (it was said) he kept untrimmed for the purpose, or splodge in a face with his thumb-print. Everywhere he went he scribbled ceaselessly with his pencil. There is a letter from a contemporary, John Soane the architect, who wrote home from Naples that Turner's torrent of rough pencil sketches, done on the spot during his visit there, made the fashionable fraternity ask him what he was up to. 'Turner grunted that it took too much time to colour in the open air – he could make fifteen or sixteen pencil sketches to one coloured – then grunted his way home.'

I find it interesting that the young Turner, when still in his twenties and already an established Royal Academician, opened his own gallery for showing his oil sketches and the sepia drawings for his *Liber Studiorum* prints – works that would have been deemed unfit, at that time, for public exhibition.

As a landscape sketcher myself I also have a soft spot for Gainsborough, who was obliged by what are now known as 'market forces' to paint portraits of the rich and fashionable. In an age when trips into the country could be difficult, uncomfortable or dangerous, or all three, he liked to assemble miniature landscapes on the sitting-room table, made out of moss, twigs and broccoli. In the end he would throw most of them away, except the few that pleased him, which he later used for backgrounds. I suppose this is why, in a Gainsborough, we cannot be sure what kind of trees and shrubs we are looking at: his little glades and dells belong in Never-Never Land. I feel closer to him in his readiness to mix his media, turning out sketches in a mixture of oil, gouache and chalks. For life studies, figures and animals he used black, white or red chalks, often on grey or buff paper. He would send sketches of this kind to potential clients in hope of a commission to work them up into landscapes. Joshua Reynolds, referring to Gainsborough, drew attention to 'those odd scratches and marks' that 'by a kind of magic, at a certain distance . . . seem to drop into their proper places', meaning (we may assume) Gainsborough's habit of building up forms by 'hatching'. And it is rather touching to read of what he called his 'fondness for my little Dutch Landskips, that I can't keep from working on an hour or two a day'.

In any discussion of sketching, I find, it is not long before John Constable turns up. Today, the little panels which he painted on the spot as preparations for his big 'six-footers' are preferred by many gallery-goers to the finished pictures with which he tried – not too successfully – to make a living. As a young man, unheard of outside East Bergholt, he made black-chalk sketches in homage to Gainsborough. When he turned his attention to skies and the fleeting effects of weather, he abandoned chalk for pencil, and gradually introduced colour washes. His tiny pencil sketches in the notebooks he always carried are the seeds of his subsequent masterpieces. His breakthrough in oil painting was barely acknowledged in his lifetime; and it has taken a full century for us to realize that those fervent, poetic panels of his, sketched on his knee in the corner of a Suffolk field, contain – as Graham Reynolds has put it – both the energy of Nature and the essence of his imagination. It is worth remembering, perhaps, that Constable refuted any idea that his sketches and drawings were a match for his paintings. To him they were a means to an end, *aides mémoires*, private notes. His friend and biographer, C. R. Leslie RA, tells of an occasion when William Blake singled out one of Constable's pencil drawings of some trees on Hampstead Heath, which he exclaimed were 'not

drawing, but inspiration'. Constable's chilly reply was that he never knew that before, adding 'I meant it for drawing'.

The appeal of Constable's landscapes – at any rate to his fellow countrymen – has always been the 'endearing associations', as he himself called them, that we find in them. He has a lyrical passage in his introduction to his *English Landscape*, the set of mezzotint engravings which he hoped would popularize his work among the public at large, not just those who visited art galleries and salerooms. He makes claims for the English landscape that quite carry him away: he says it 'abounds in grandeur and in Pastoral Beauty'. He tells of the 'vernal freshness' of the English climate, in whose summer skies and rich autumn clouds may be seen 'endless varieties of effect', which the sketcher can seize in 'one brief moment caught from fleeting time'. These were serious matters to Constable, as we know from the sketchbooks now in the Victoria and Albert Museum, London. He did his best to put these ideas across to students. He would not admit that the French masters were better at drawing than the English ('life and motion are the essence of drawing', he told them; which would have pleased my old teacher, Edmund Sullivan). And at the end of his last address, the night before he died, the audience rose to their feet and cheered him.

It is Constable I first think of when people refer to the English landscape tradition. But he himself looked back to what he called the 'Old Men', the early masters such as Claude Lorrain and Poussin, whose Classical landscapes sometimes included mythical creatures by way of decoration. Constable scoffed at this weakness for 'the shaggy posteriors of satyrs', as he called them. On the other hand, if you look at Claude's broad and expressive landscape sketches – his private records of rough, unsophisticated corners of his native land, with no nymph or satyr in sight – you seem to be at his elbow, sharing his pleasure in the unspoiled nobility of 'natural' landscape, drawn with the simplest materials. They catch that first moment of pleasure we feel when we sit down in any patch of countryside which is unvisited by the human horde, a patch which, for an hour or so, is all ours.

These sketches of Claude's have been as influential in their way as his Classical landscapes, by working on the imagination as well as our senses. I feel the same sensations in drawings by Rubens. At an exhibition of early landscape paintings held at the Tate Gallery, London, some twenty years ago, there was a sketch by him, in chalk, pen and ink and a touch of watercolour, of a dead tree trunk entwined with weeds. Rubens had scribbled in the corner: 'Fallen leaves and in some places green grasses showing through.' That is just the kind of note an outdoor sketcher might think to make in our own time. I have felt the same contact in the few drawings that Dürer made from Nature. In one of these, of a large piece of turf, he turns an apparently humdrum subject into a masterpiece of watercolour, touched here and there with gouache. To him, the most important function of art was to reach the truth that lies behind reality. Here, he was showing how this can be achieved in something as modest as a wayside sketch. It reminds me of Constable's famous words, that a painter should walk the fields with a humble mind.

Above all, perhaps, the sketcher whose senses are alert is aware of the sky as the source of all that goes into a picture – light, shade, fleeting variations of form, the brightening and fading of tones – even as his pencil or brush is poised to swoop on the paper. In such a situation I console myself with the knowledge that this has

A rough, on-the-spot charcoal drawing for a familiar architectural subject.

always been the critical moment for an artist who faces Nature free of affectation. We are back with the forefather of all of us landscape artists, Claude Lorrain. He was the first, more than three centuries ago, to use his own eyes, to find unity in the bewildering variety of Nature, its various modulations – as one critic has observed – guiding the eye towards its journey's end: the horizon, the threshold of the sky, and the source of light. Ever since Claude, the true landscape sketcher has allowed the light to work its mysterious way, infusing Nature with the spirit of the place.

When I began painting in watercolour I followed the textbook instructions – beginning by setting up my easel, paints and equipment. My aim was to paint watercolours on location, but I soon realized that this was not as straightforward as it seemed. The best view, from a particular spot, would turn out to be impracticable for setting up all my gear. I was also prone to such hazards as pinching my fingers in my stool or easel, and spilling my waterbottle. By the time I was ready to start I had lost my initial enthusiasm, or the weather had changed, or some enormous vehicle had drawn up and obscured my view. More often still, having got all in order, the lovely light effect or cloud arrangement had gone. I gave up, and returned to my custom of making quick, direct sketches. I found I could get down three or four notes of changing light effects in the time it would have taken me just to assemble my apparatus. Often, I would supplement my notes by taking photographs as further reference.

My sketches tend to be small, made on easily portable pads or on paper clipped to a piece of hardboard. The virtue of small sketches, as I learned from a fellow member of the Royal Institute of Painters in Water Colours, Norman Wilkinson, is that if you start with a large sheet you tend to put in too much. As for how long it takes to produce a finished painting, different works demand a different approach. I often experiment by making small watercolours from sketches, which means composing ideas based on a group of notes. Several of the works illustrated in this book were done this way.

After making a suitable composition I used to try to draw an enlargement freehand, only to find that I was rarely able to make an exact copy or even a satisfactory freehand enlargement. So I adopted the process of 'squaring up', using a numbered grid system; but this proved laborious and tedious for such a lyrical medium as watercolour. Later, by accident, I found a more responsive method. After taking a colour transparency of one of my sketches in order to make a point in a lecture, and projecting the greatly enlarged image on the screen, I was surprised when the audience did me the honour of clapping. This gave me the idea of photocopying sketches that seemed to offer some hope of development, and contemplating them in an enlarged form. I now find this procedure – which, obviously, was not available to my predecessors – increasingly stimulating, helpful and enjoyable.

For architectural subjects, which likewise need to be stylishly composed, I normally make a full-size rough drawing in charcoal, aiming at giving some idea of the overall tone and composition. I make alterations simply by wiping out areas that need correcting, and re-drawing over the faint residual image. Then I lightly fix the drawing with an aerosol spray and overlay a flimsy sheet of paper from a layout pad. This enables me to confirm the necessary perspective and architectural features. The sheet is then ready for tracing on to the virgin watercolour paper by simply inserting a piece of duplicating paper and impressing the lines with a

ballpoint pen. The whole process, from first sketch to finished result, involves a mixture of means and media: ballpoint and pencil, differing shades of blue or grey for the paper, with perhaps a touch of pastel; and watercolour with sometimes a little gouache for the finished picture.

Not being much of a one for ready-made solutions, I hesitate to offer more than a minimal 'must' to anyone who might be tempted to follow my methods. But I am a believer in banishing from a watercolour the kind of detail which I have heard visitors to mixed exhibitions applauding as being 'true to life'. Truth, in all art, is not the same as literal description. You have to be a Birket Foster or a Stanley Badmin to turn an accumulation of detail into a truly successful watercolour. In my own case, I like to see in a 'finished' watercolour the influence of the sketch that gave it life. In all probability, that sketch began with a sky, the light-source that determines tone and form. 'Paint a sky a day!' urged that splendid colourist, Sir Alfred East, some ninety years ago. It sounds a tall order; but it is the best way of coming to terms with the shifting values, tones and colours of outdoor subjects. None of us can expect to make a confident start on a watercolour landscape without making that effort. A sky, as I have found, is a wonderful playground for learning to control a wash and getting to know the drying properties of pigment and paper. There are few satisfactions for a watercolour artist that surpass the achievement of laying a truly flat wash. 'A flat wash,' the great John Varley used to tell his pupils, 'is like a silence in which you can hear the faintest whisper'. It was his generation, including such masters as Cox and De Wint, who caught the essence of the English landscape that is lodged so deeply in our affections. The way I first saw it, and the men and women who worked in it, has remained with me over the years. That is how I paint it still. I could never let it go.

I have found my sketchbook invaluable in helping to catch the elusive play of light, passing shade, and movement in an all-enveloping space. My earliest efforts were more concerned with accurate detail than with sensations. That began to change when I took to sketching the calm reaches of the creeks and inlets where the Thames pours down to the sea. My urge to paint and draw marine subjects led me to a study of the subject, and to such masters as Peter Monamy and Jan van de Cappelle – the Dutch influence, that is. It also, inevitably, took me back to Turner, who began with formal studies of boats at anchor on the Thames and broadened into action studies of sailing ships under full sail.

Another influence on me, as a youth bobbing about in a dinghy, was Whistler. His Thames etchings seemed to me marvels of the sketcher's art, and still do. They are also, by any standard, marvellous drawings. He etched his subjects directly on portable copper plates, ready prepared, which he carried around with him on his excursions along the seamier shores of London's then-smelly river. I joined the ranks of admirers whom Whistler had introduced to these oddly beautiful images. I saw the Thames through his eyes, all 'pitchy and tarry and corny and coaly' as a *Punch* reviewer remarked. My sketchbooks of the time are full of such subjects as cableships at Greenwich; grain elevators in Surrey docks; coal barges at Rotherhithe; barges tied-up with thick ropes; deck scenes of schooners on the Medway.

I took my sketchbooks everywhere, scribbling ashore and afloat, concentrating on observation, which is harder work than mere looking. Sorting through material for this book, I was struck by the number of marine subjects I have tackled over the

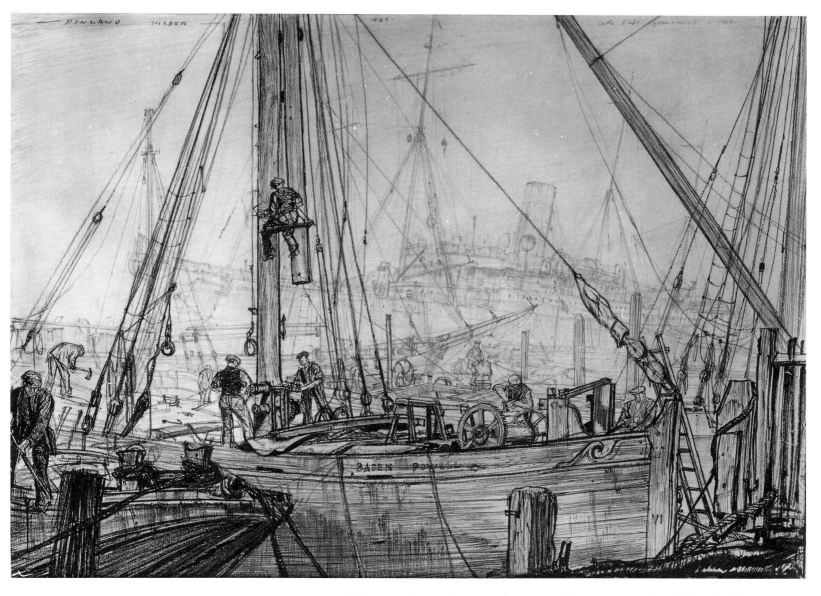

years, and the way in which water keeps getting in even when I thought I was sketching a landscape. Water, and after water, skies – these seem to sweep everything before them.

Nowhere have I sketched more busily or more happily than in the Shoreham Valley. The river Darent winds between ancient farmlands in which the caps of oast houses show white against the green-clad hills, and looping banks mark the river's meandering way. This is Samuel Palmer country, which a few of us, as students at Goldsmiths' College in the mid 1920s, discovered for ourselves at a time when his work was emerging from relative obscurity – a place where, in his own words, 'you might forget the wretched moderns and their spiders' webs'. Those were good times to be an aspiring artist at Goldsmiths': my fellow students there included a number of bright spirits, notably Graham Sutherland, Paul Drury, Robin Tanner and Stanley Badmin. We all, to an extent, responded to the pastoral romanticism of

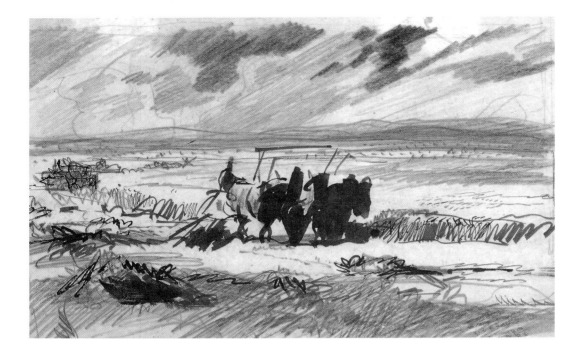

The early painting opposite, like many others of mine over the years, started as a rapid sketch made in a Kentish field.

Palmer's work during his Shoreham period. Sutherland absorbed it into his own strain of romantic imagination. Drury held on to it in his finely-wrought little landscapes. Tanner, in particular, infused his etchings with it all his life.

It is not always obvious to a student just where his talents are leading him, and I was no exception. After a disappointing start in the etching class I switched to illustration, a far happier medium for me. My little drawings done on the spot were starting points for more ambitious compositions, a process that has kept me busy ever since.

My 'discovery' of England's winter landscape, while working on sketches for an illustrated edition of Mary Webb's classic, *Precious Bane*, has been told before. It led me into the countryside and to compositions that aimed at the age-old dignity of working on the land: stocky horses driven across hills and plains; harvesters at work, handling God's plenty. They may look a bit dated now. But they too began as sketches, and I remain fond of them. Land, sea and the open air – these were my beginnings in those bygone days. People talk about the 'nostalgic' element in my work. But much of it was done when the scenes I set down were not nostalgic at all: they were of contemporary life on the land, the farms, along the river banks, and on the rolling Thames. My sketchbooks are an artist's diary of his life and times; and I use them still.

ROWLAND HILDER

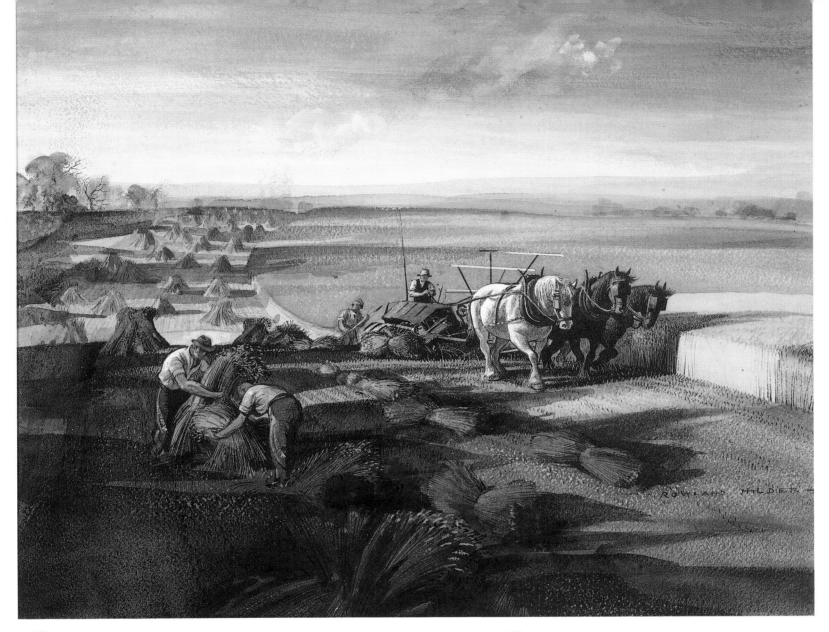

Beginnings and Bygones

THOUGH I have spent the greater part of my life painting, it was as a draughtsman that I was first encouraged to take up art as a career. I was told that to be able to draw is a gift that should be nurtured, as lying at the heart of all the fine arts. My earliest drawing efforts as a schoolboy persuaded my teachers that I ought to move over to an art school; which is how I ended up at Goldsmiths' College, not far from where the family lived at New Cross. The etching class, which I initially joined, seemed a bit of a dead end, for all its high quality and reputation. So I switched to illustration, a field in which my busy pencil led me into various ventures by which I began to get paid for what, up till then, I was perfectly happy to do for love. Through illustrating books and working to tight deadlines for various magazines and newspapers, I acquired the professional knack of working to a brief, and getting my work in on time. Some themes that I returned to in later years were born in those days, when my eye and hand learned to work in partnership. It was sketching, but with a purpose. Those early sketchbooks contain some images that have persisted for sixty years.

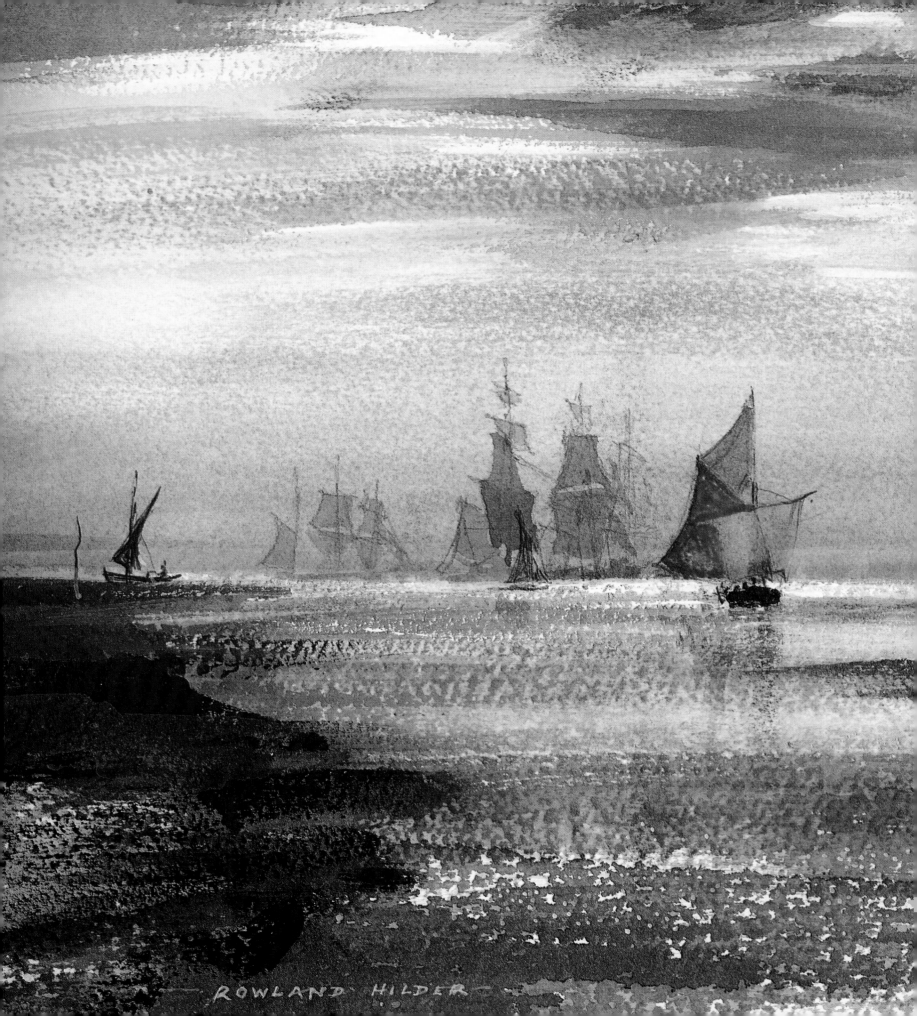

ROWLAND HILDER

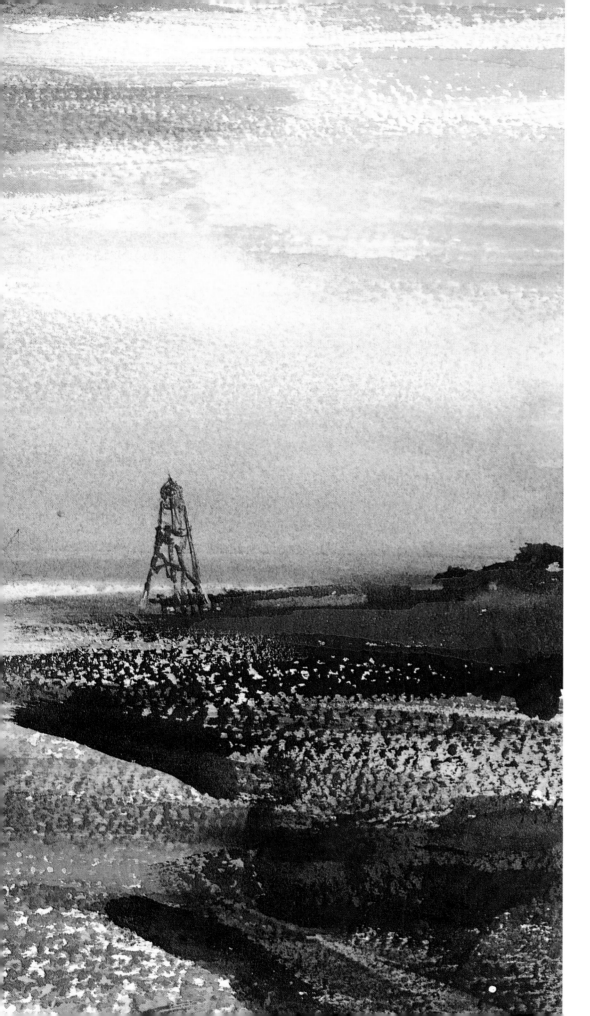

One of my earliest subjects was the sight of sailing craft along the Medway. My first sketchbooks show them like this, in full sail at low water – a typical spectacle in the waterways close to home, where I first learned to sail.

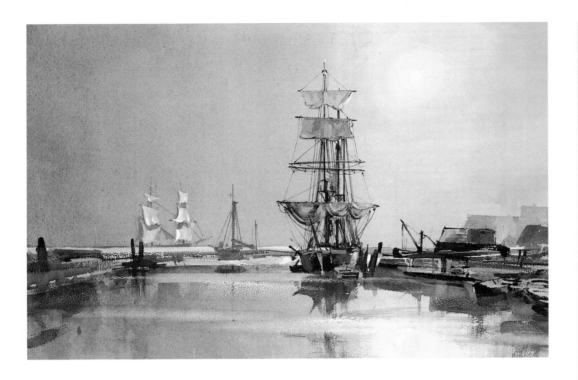

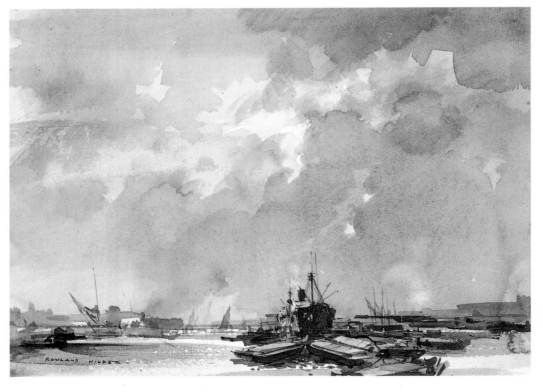

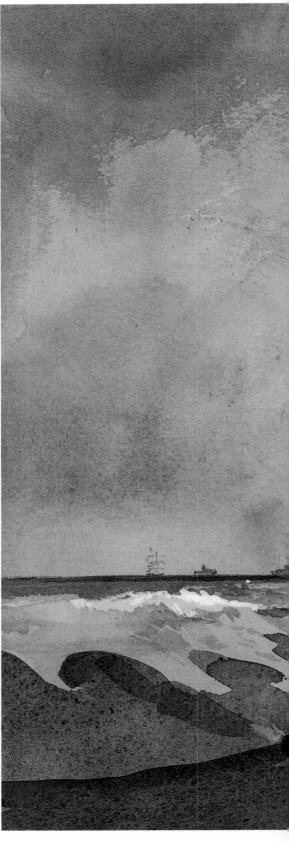

As late as the 1920s it was still possible to see steam and sail on the upper Thames and ocean paths. I made my earliest marine sketches from a metal lifeboat, made fast to a lighter or some other conveniently anchored craft. The scraps and studies I came ashore with contained material that serves me to this day.

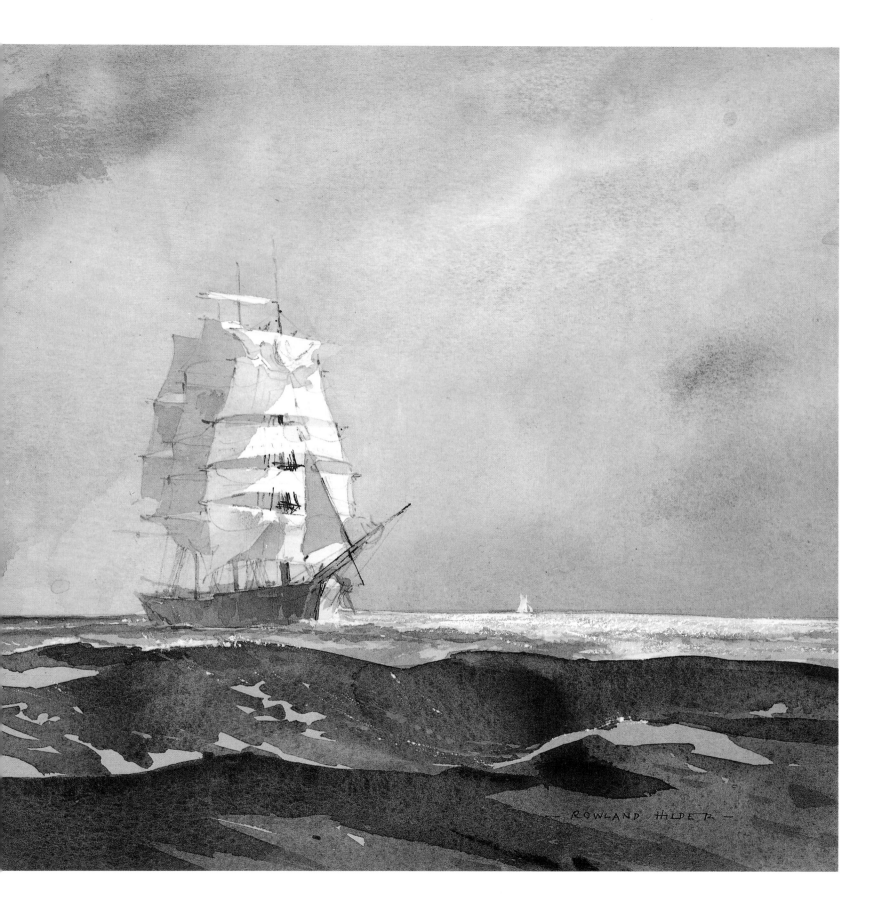

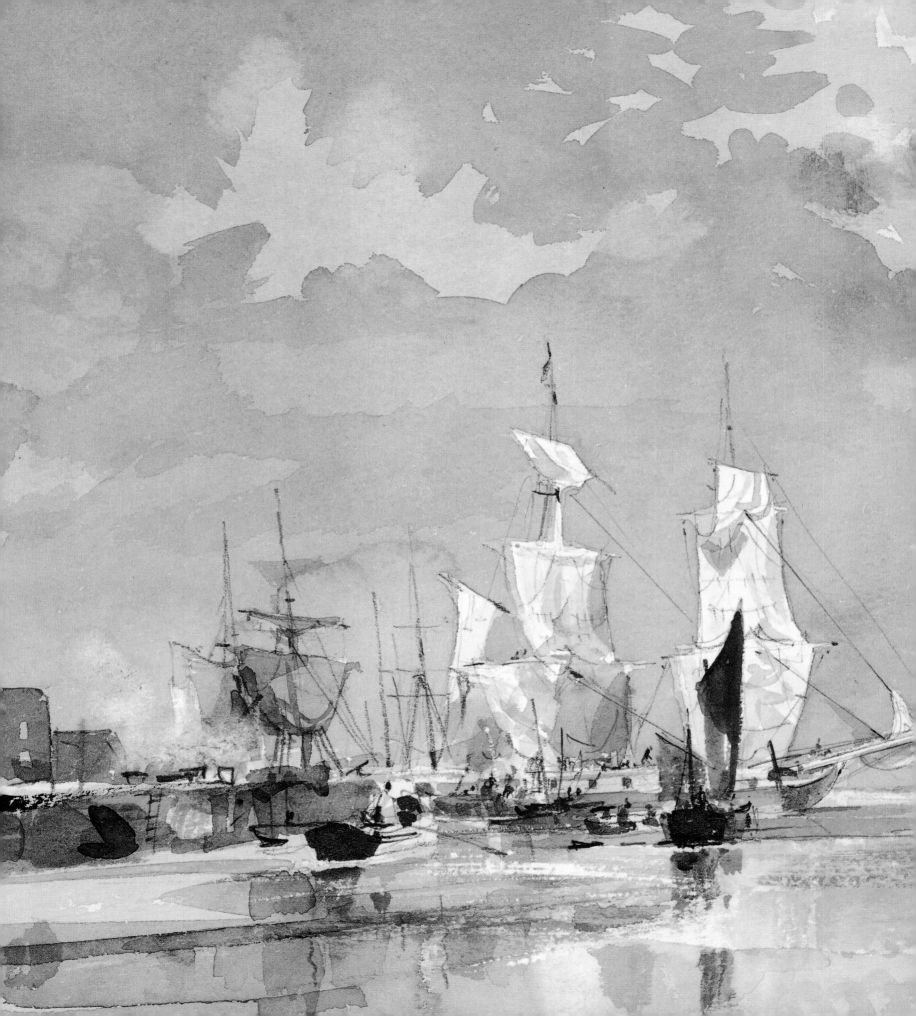

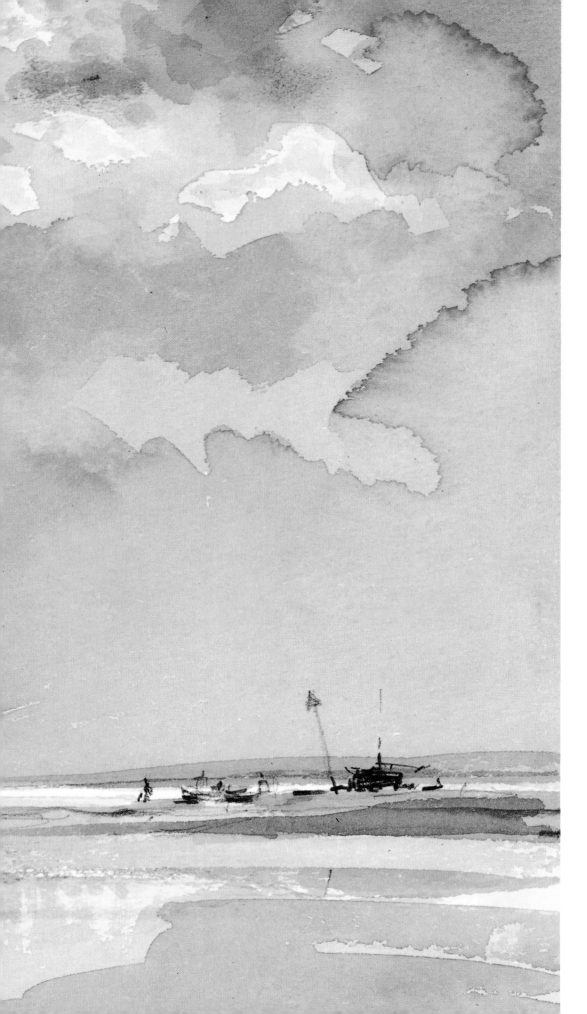

My earliest efforts were
more concerned with
accurate detail than
with sensations. That
began to change when I
took to sketching the
calm reaches of the
creeks and inlets where
the Thames pours down
to the sea

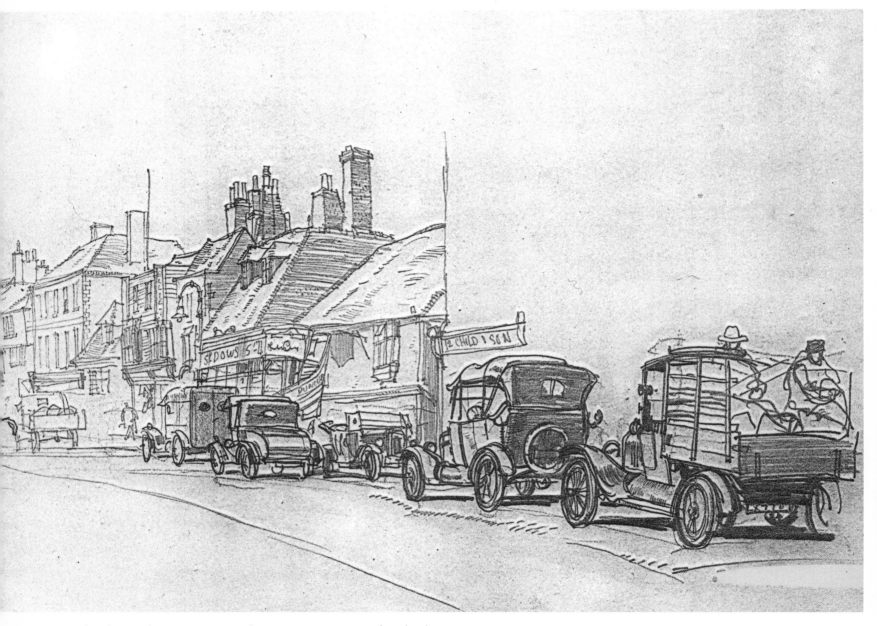

Sketches and studies done on the spot seem to retain their liveliness, even after the scenes they depict have long vanished. This little street scene is at Faversham, Kent, on what for those times was a busy day.

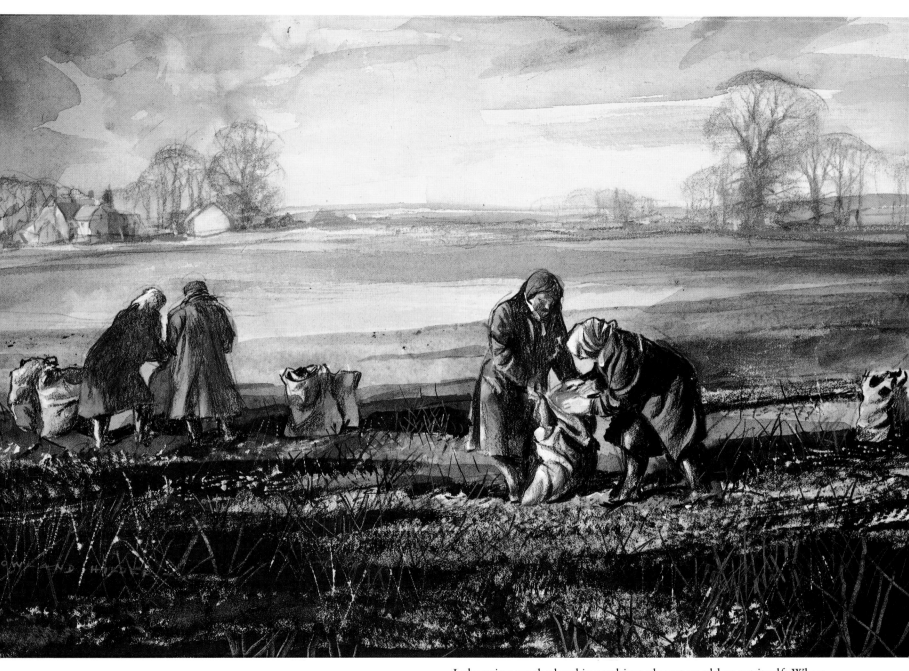

Labouring on the land is a subject almost as old as art itself. When I began looking for themes of country life there was almost always some sign of human activity in the fields. These potato pickers grew out of sketches made long before farms were mechanized; but they have survived.

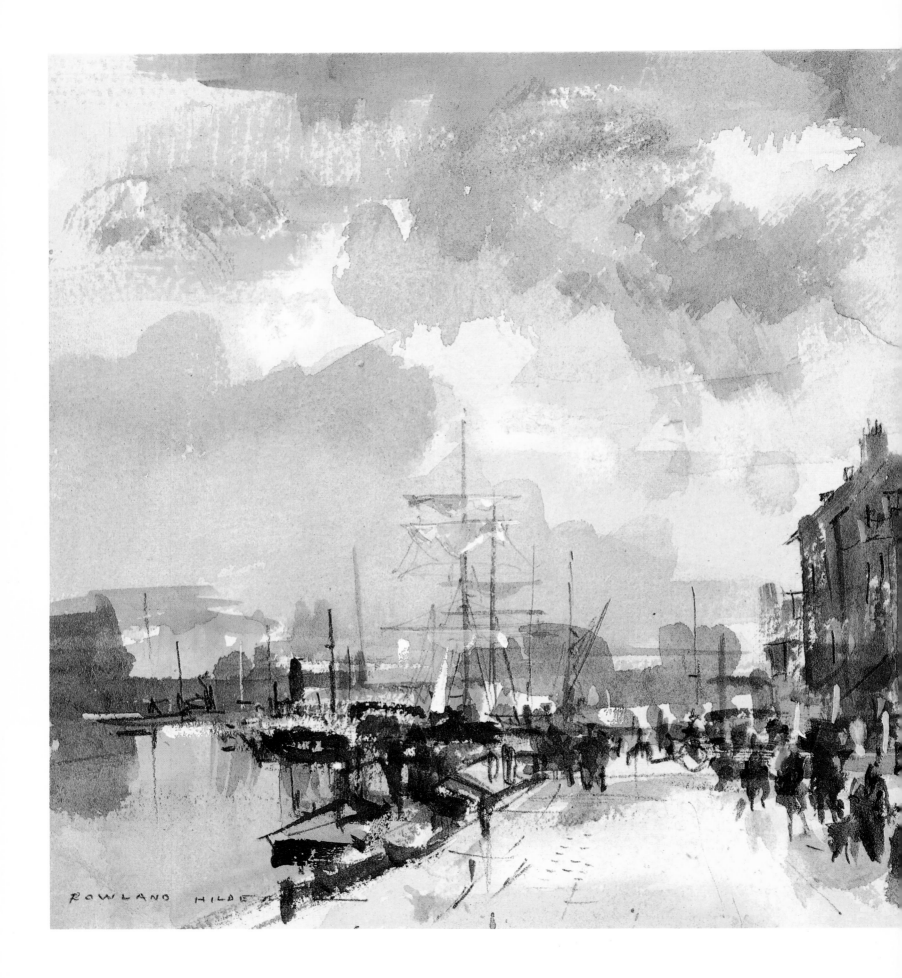

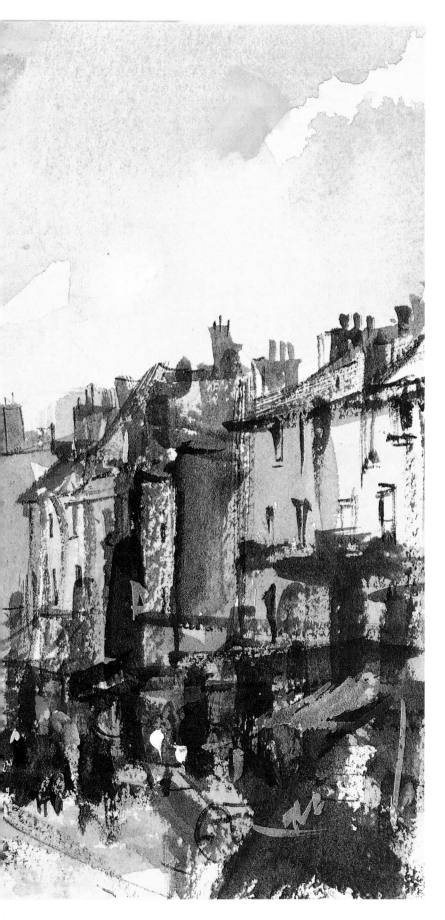

Street scenes often fall naturally into a pleasing relationship with the artist: a quick note will set down the essence of the place, the rhythms of the streets and buildings. On the left is Dieppe – a convenient port of call for English painters from Bonington onwards. Below is a little sketch of Greenwich, which I did in the early 1920s, at a time when I was being kept busy with book illustration. The colour sketch was done aboard a small tramp.

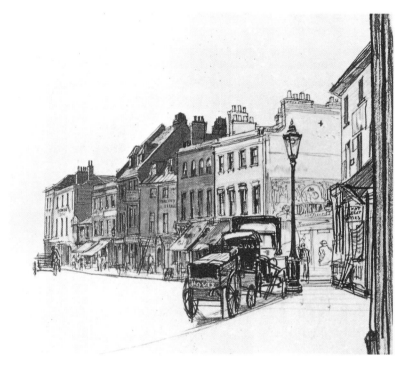

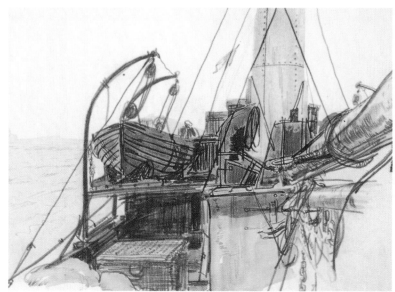

London's River

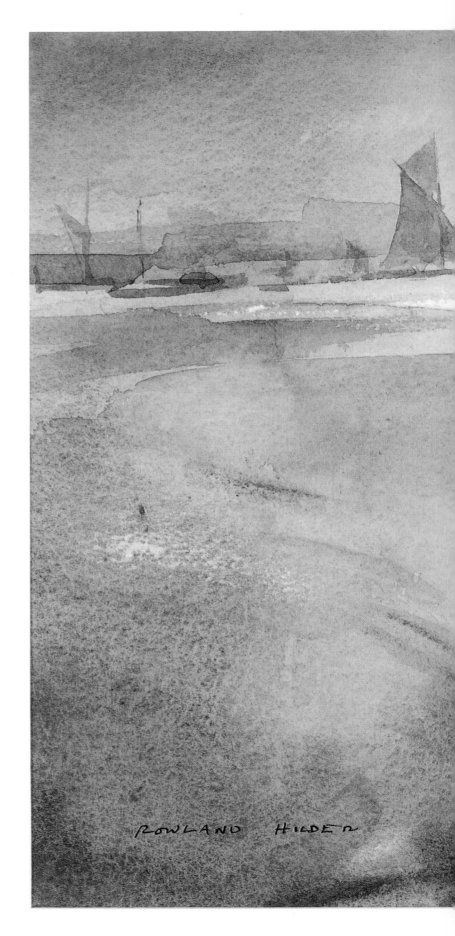

THIS IS where my education as an artist really began, with my art-college tuition topped-up with first-hand experience of a real, exciting, working world. I was fascinated by the daily scenes along the Thames, in days when it was rich in activity and drama – and in beauty, of a kind that compelled me to capture its workaday activity.

London's dockland was a dramatic scene for a young hopeful to set down – to the best of his abilities – on paper. Compelling as it all was, it also helped me to sharpen my eye for detail, the working practices of seamen and dockers, the jib of great ships, the intricacy of their shapes and rigging. Sail and steam shared the river in those days. I found each of them equally inspiring, and filled many a sketchbook with nautical detail.

These images have persisted in my work. Those little sketches grew into paintings in which I tried to catch the drama, as well as the delicacy and detail, of London's river as it then was. The jumble of old, historic buildings along its banks has always delighted me. My sketches of how they looked before the 'developers' got at them have enabled me to give them, perhaps, a more permanent home. Over the page I have included a typical example – a vanished scene around the Shipwright's Arms at low water.

I saw the Thames through Whistler's eyes, all 'pitchy and tarry and corny and coaly'

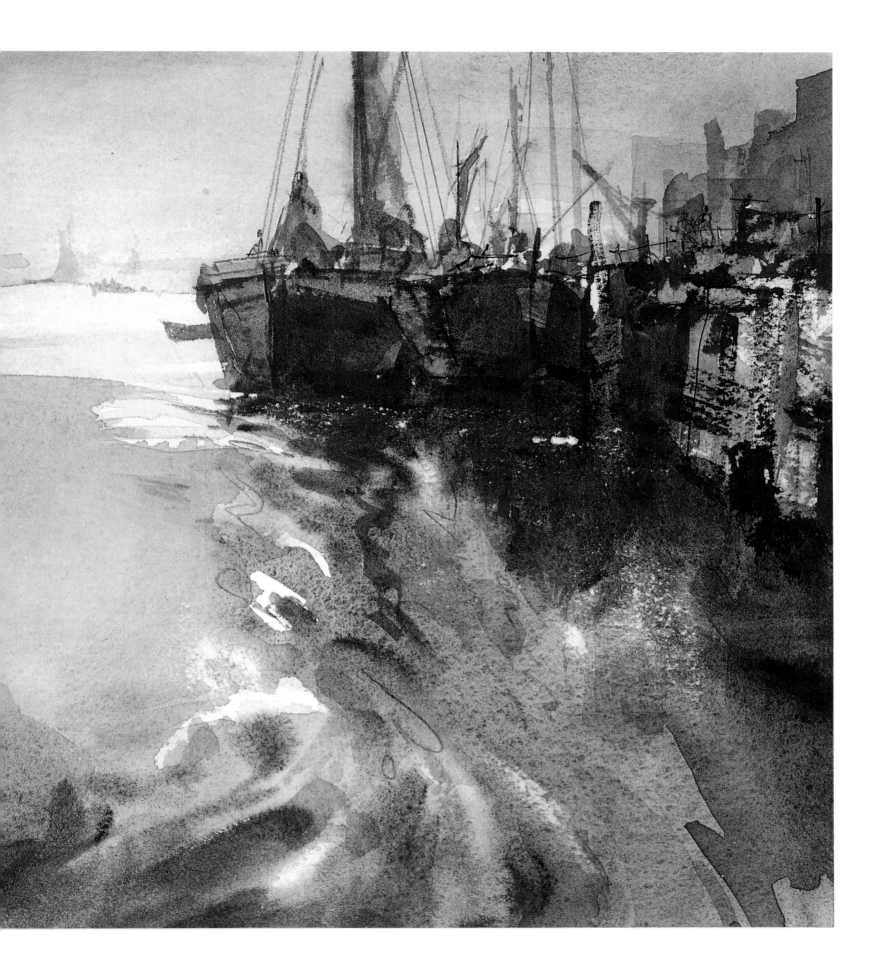

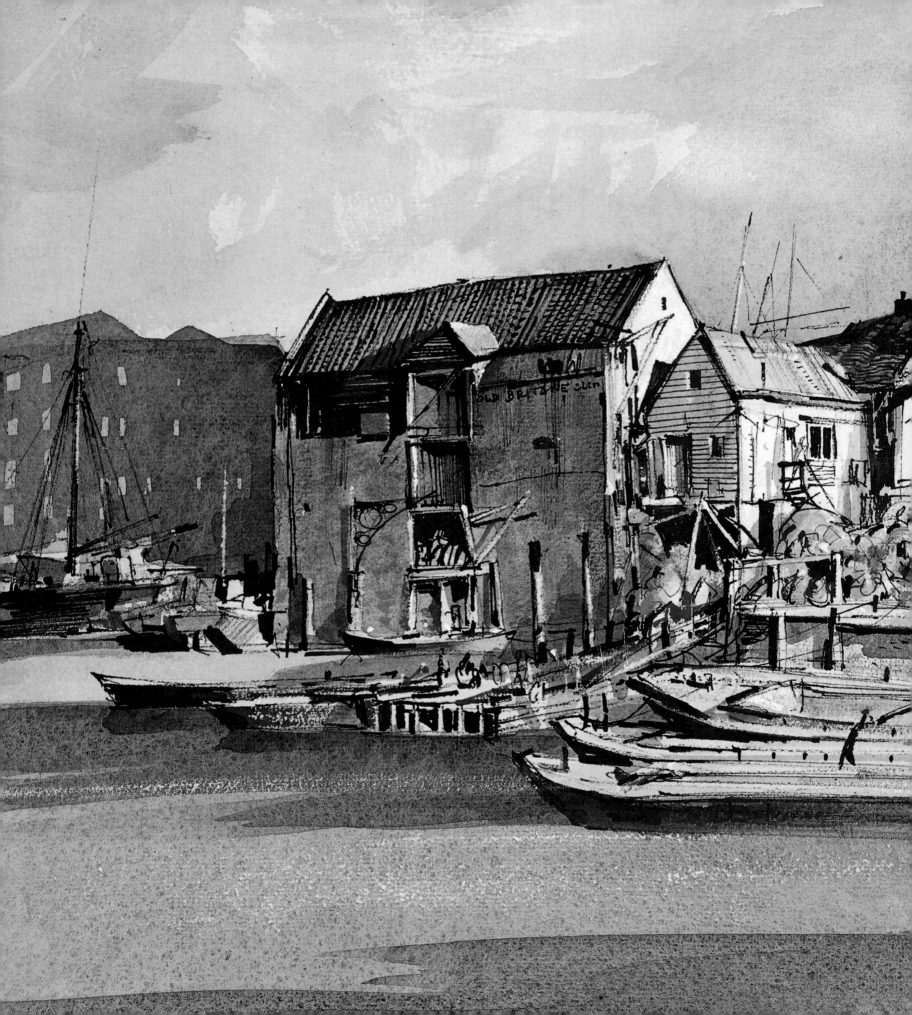

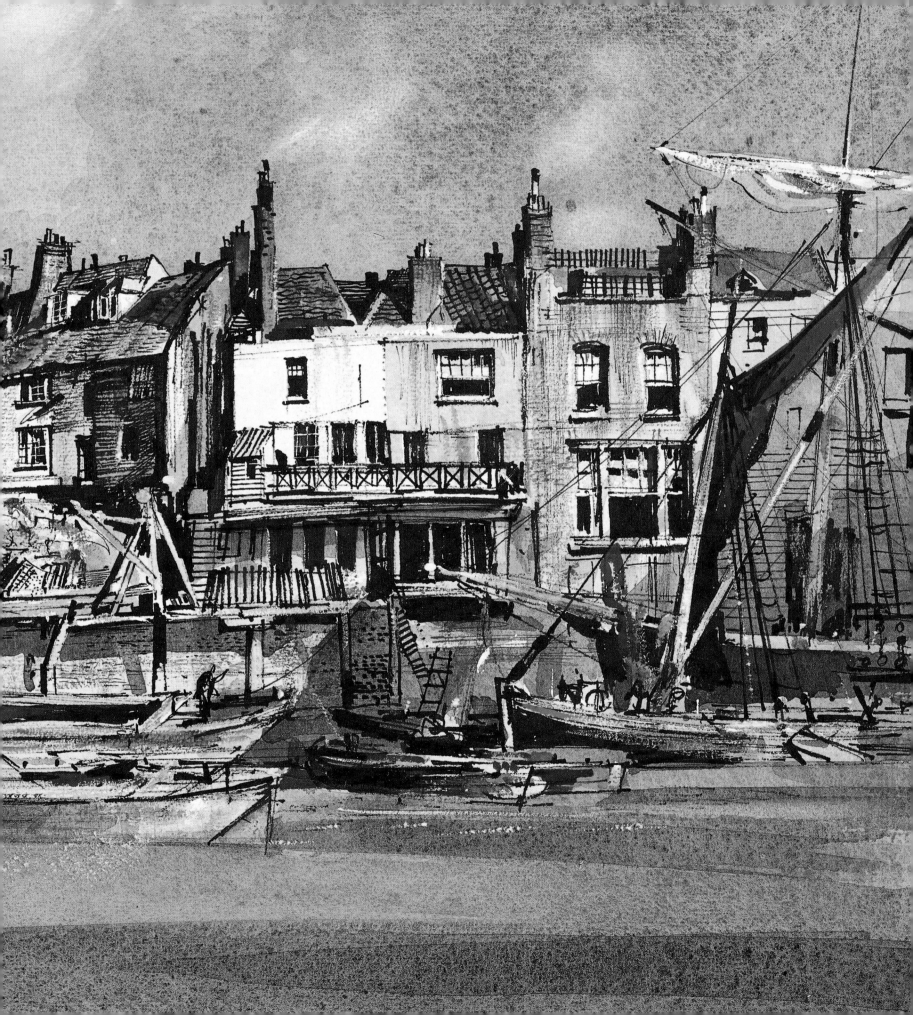

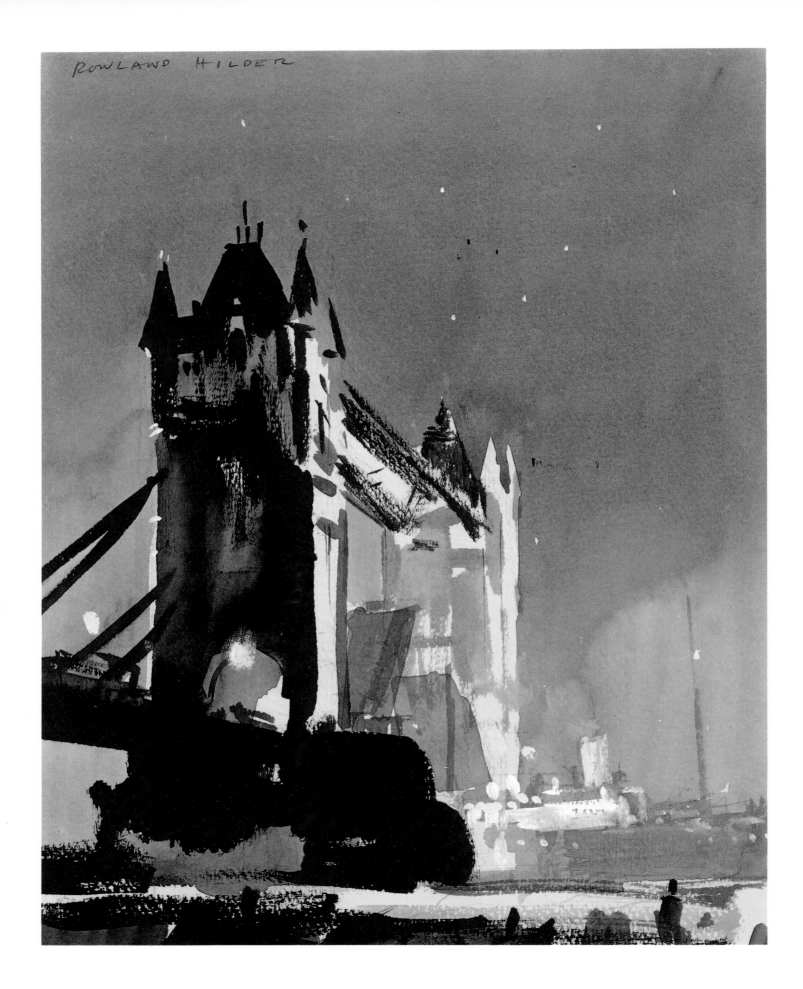

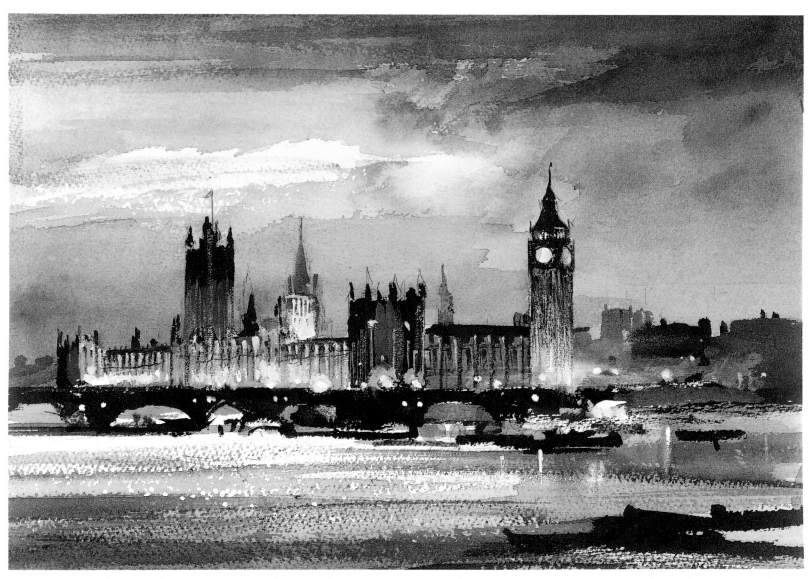

The structure of these familiar monuments can become almost ephemeral when dashed off as a sketch.

Over the page we venture much further down the river to a subject I have returned to many times, trying to invest it with the airiness that outdoor sketchers aspire to. It is a theme I am fond of: a sailing barge under a lowering sky.

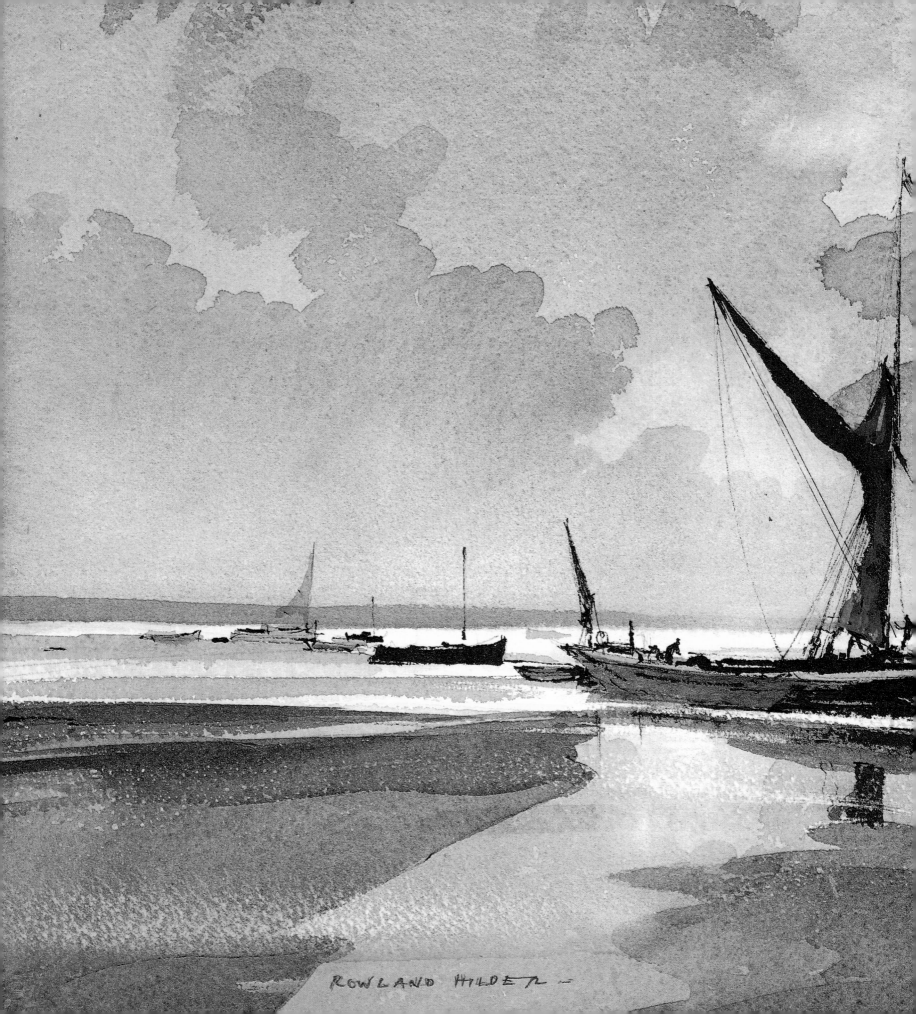

ROWLAND HILDER —

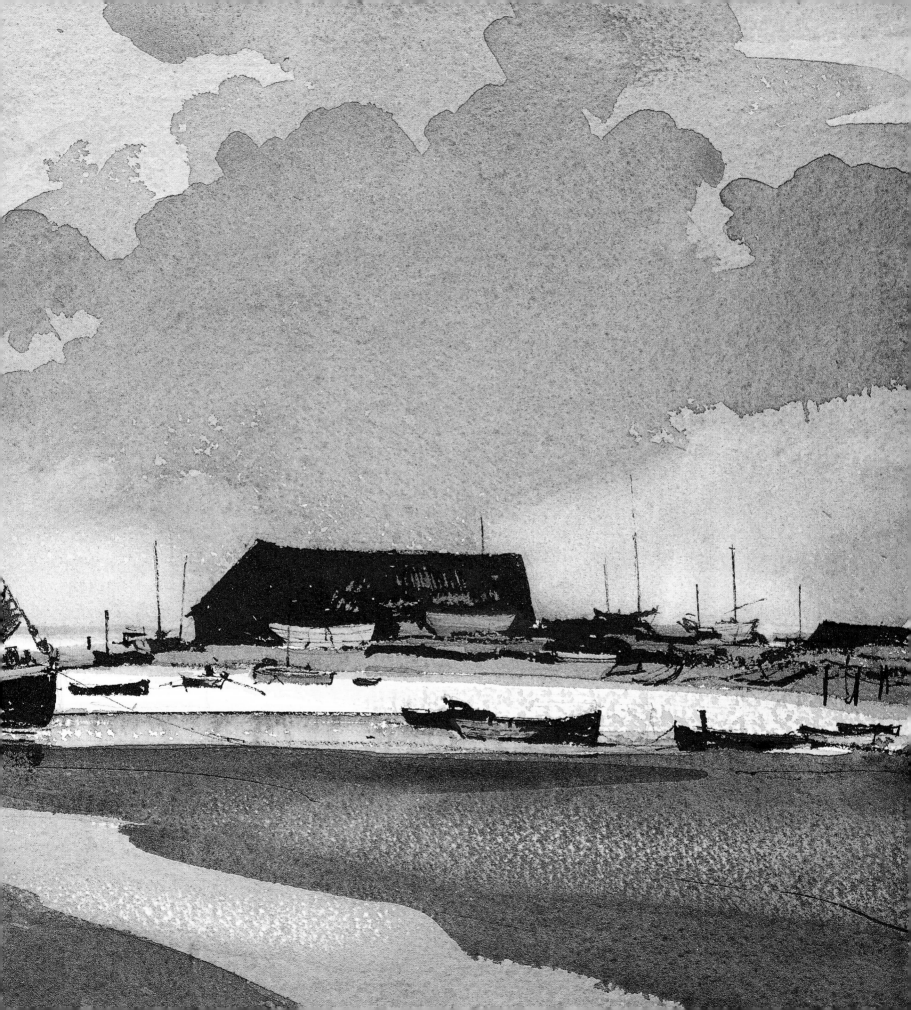

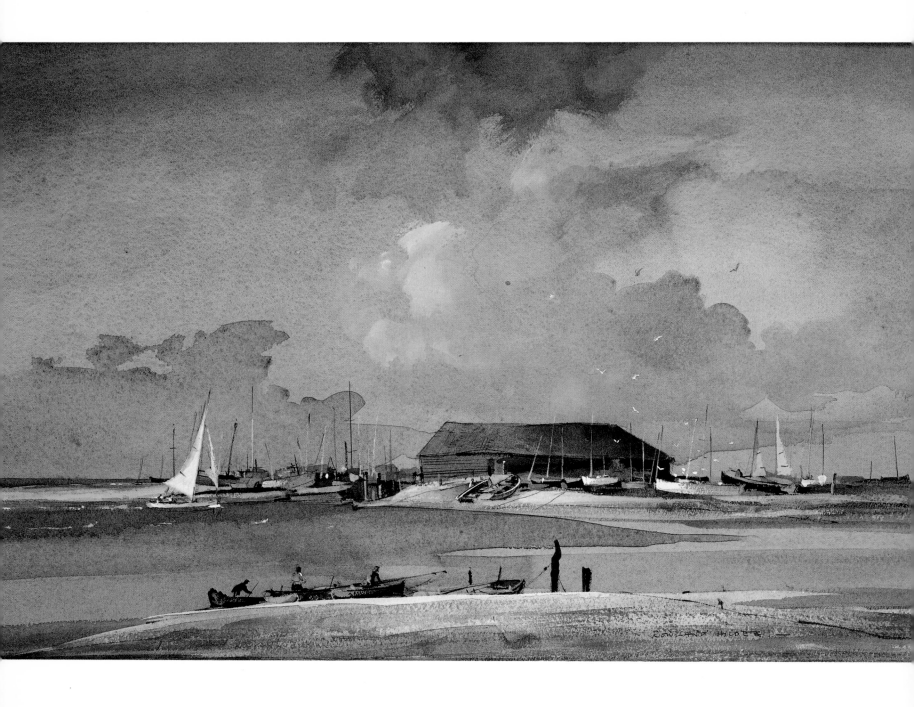

The sketcher whose senses are alert is aware of the sky as the source of all that goes into a picture – light, shade, fleeting variations of form, the brightening and fading of tones – even as his pencil or brush is poised to swoop on the paper

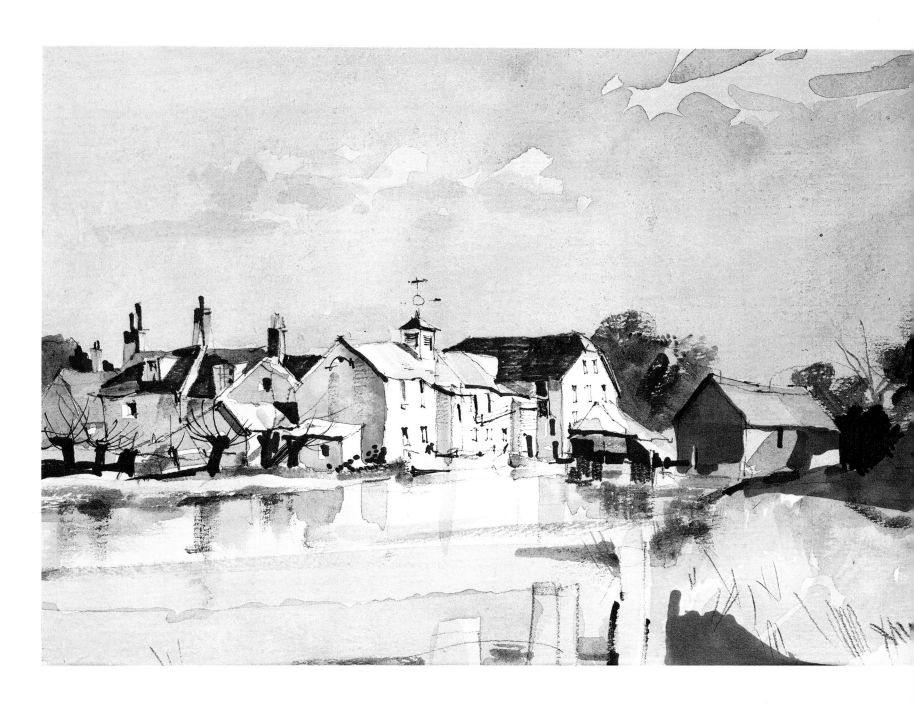

There is nowhere like England for producing clusters of delightful buildings that make an artist reach for his brushes, pen or pencil. Here we are at Mill End, Hambleden, an ancient white-boarded building in Chiltern country.

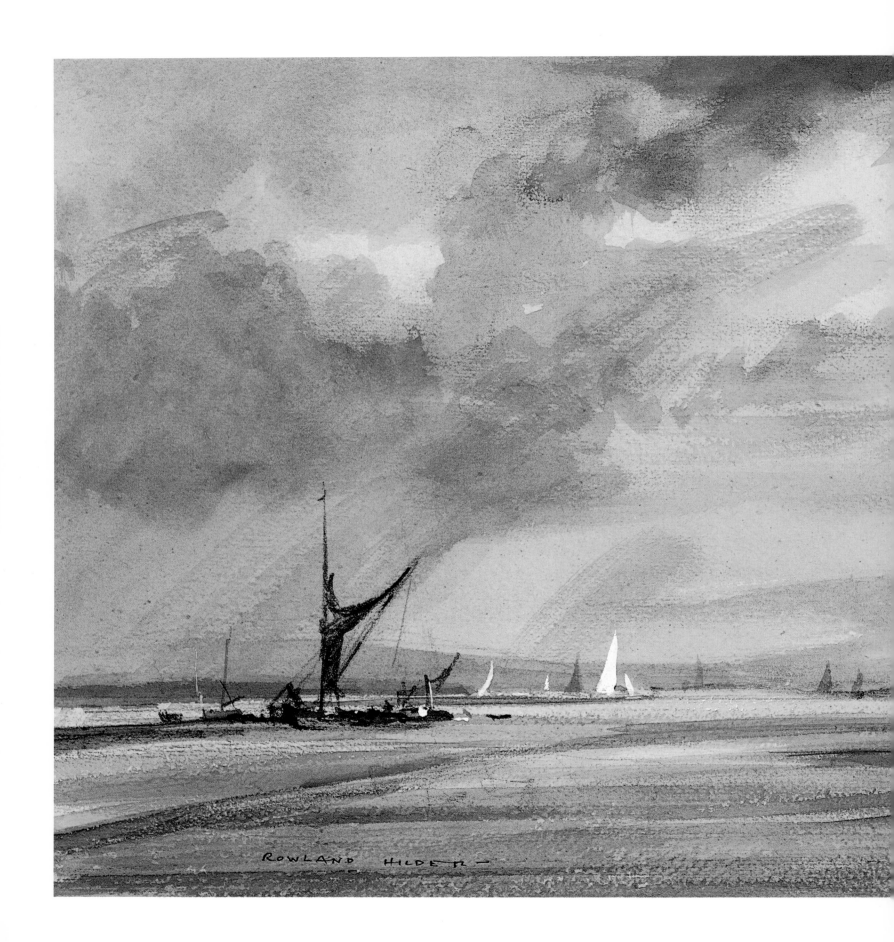

ROWLAND HILDER

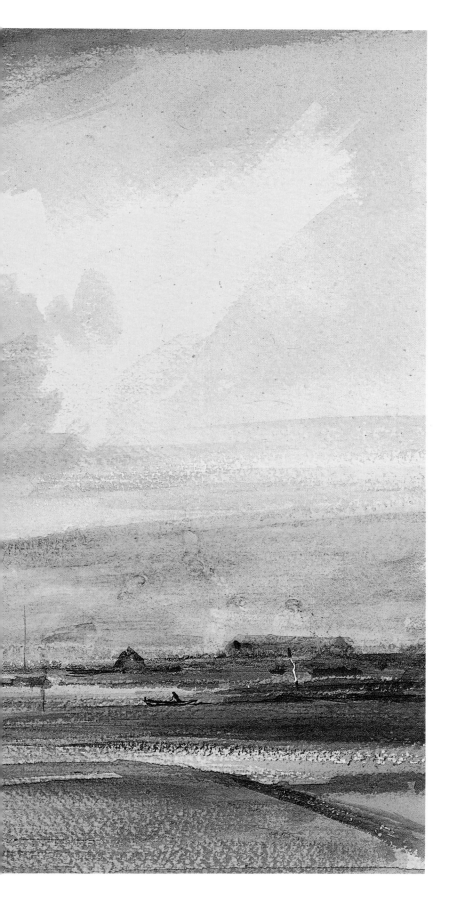

Seas, Sails and Skies

JOHN CONSTABLE's brother, Abram, once said: 'When I see a picture of one of John's windmills, I know from the clouds that the sails will go round.' That was a compliment any painter would be pleased with. There is a link between the sky and what is going on in the landscape below. If you add seas to skies there is even more to take account of. The artist, with continual practice, will learn for himself how skies form and how they break up, and how they filter, diffuse and soften light.

Obviously, that kind of knowledge is not acquired indoors, or in classrooms; it comes from observing, and from constant sketching. Like any other artist, I have developed ways of making sure, in my own terms, that the sky is 'right' in relation to the work as a whole. And as a sailing man, I know that any amateur mariner will quickly spot a weakness in the sky's relevance to the set of a jib.

One principle I stick to is to make a simple statement, a direct laying-on of paint or watercolour to catch that sudden illumination of land, air, sky and water that makes any artist grab his sketchbook – none of us can really hope to recall it later, away from the scene and the brilliance of the moment. I can hardly describe the exhilaration of picking up one's brushes, sensing that the sun's in his heaven and all's well with the world.

Sketching on the spot remains for me the very essence of the landscape painter's craft

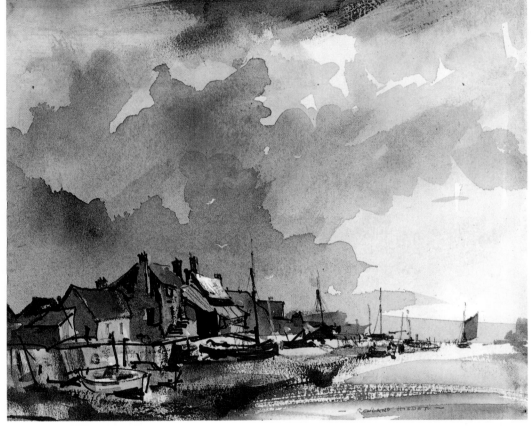

Boats, temporary floating homes, seem to go well with cottage-like buildings. I cannot resist jotting down scenes like these, usually from a dinghy. The subject opposite is the inner harbour at Queenborough on the Isle of Sheppey.

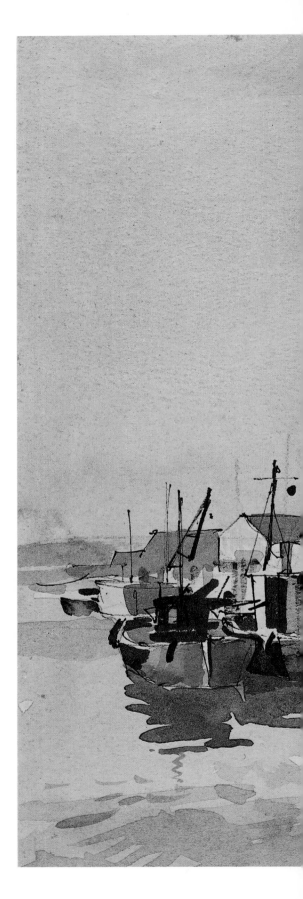

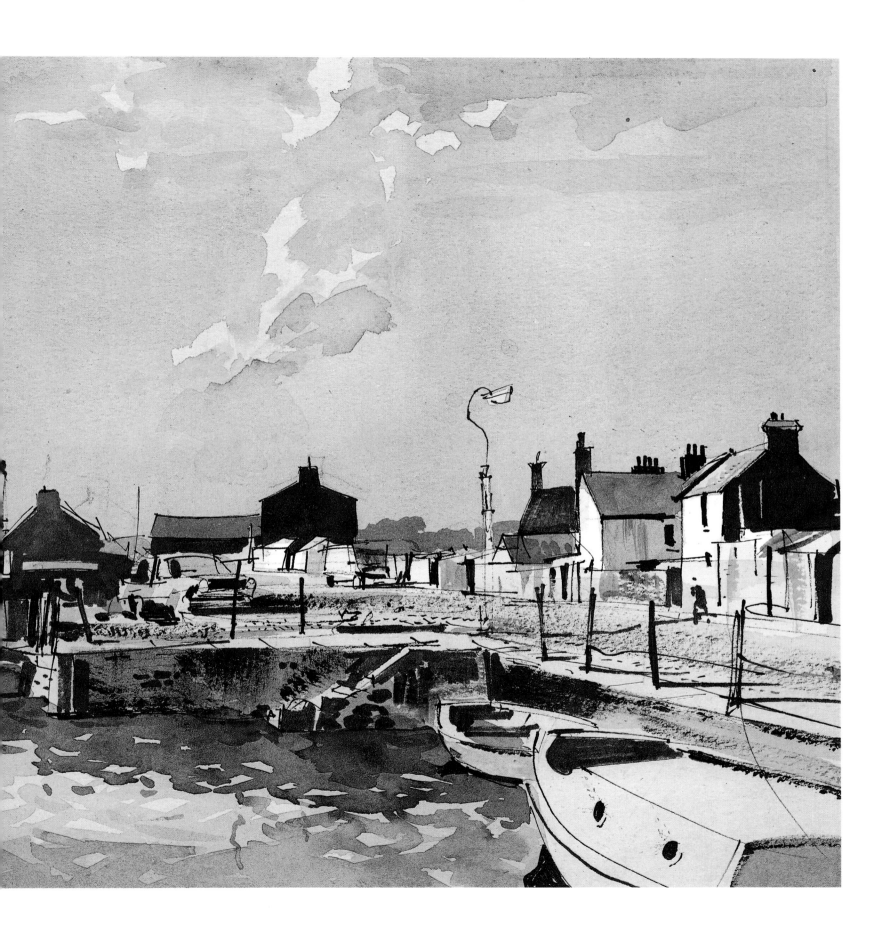

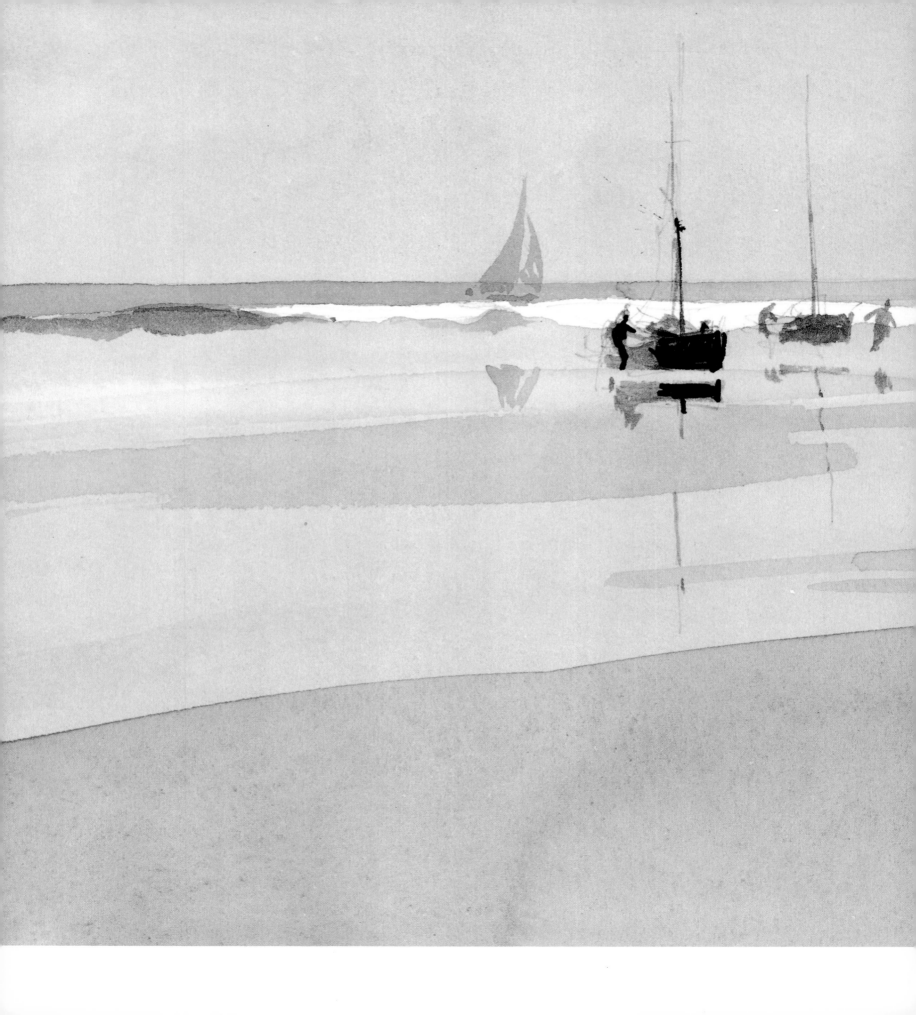

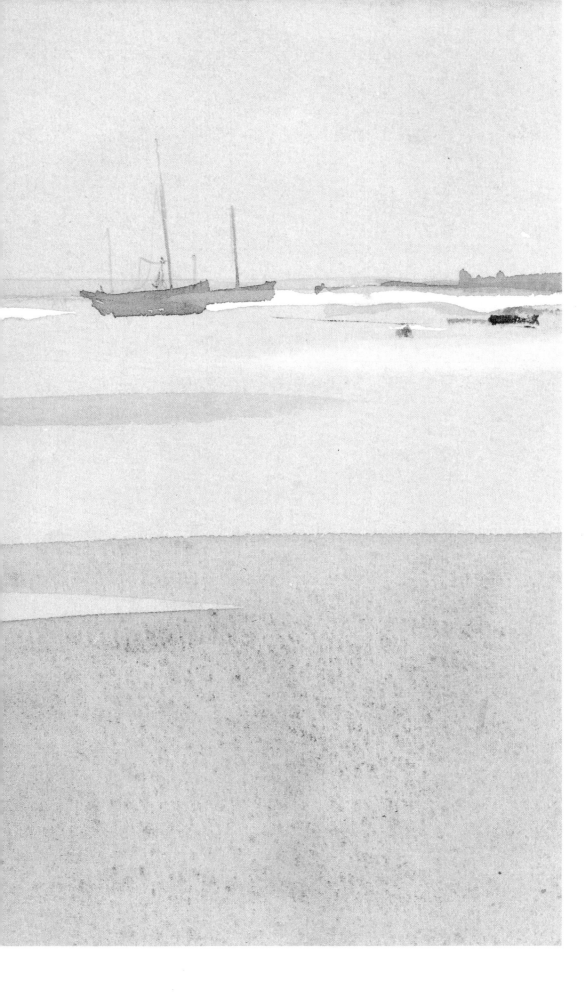

There are few satisfactions for a watercolour artist that surpass the achievement of laying a truly flat wash. 'A flat wash,' the great John Varley used to tell his pupils, 'is like a silence in which you can hear the faintest whisper'

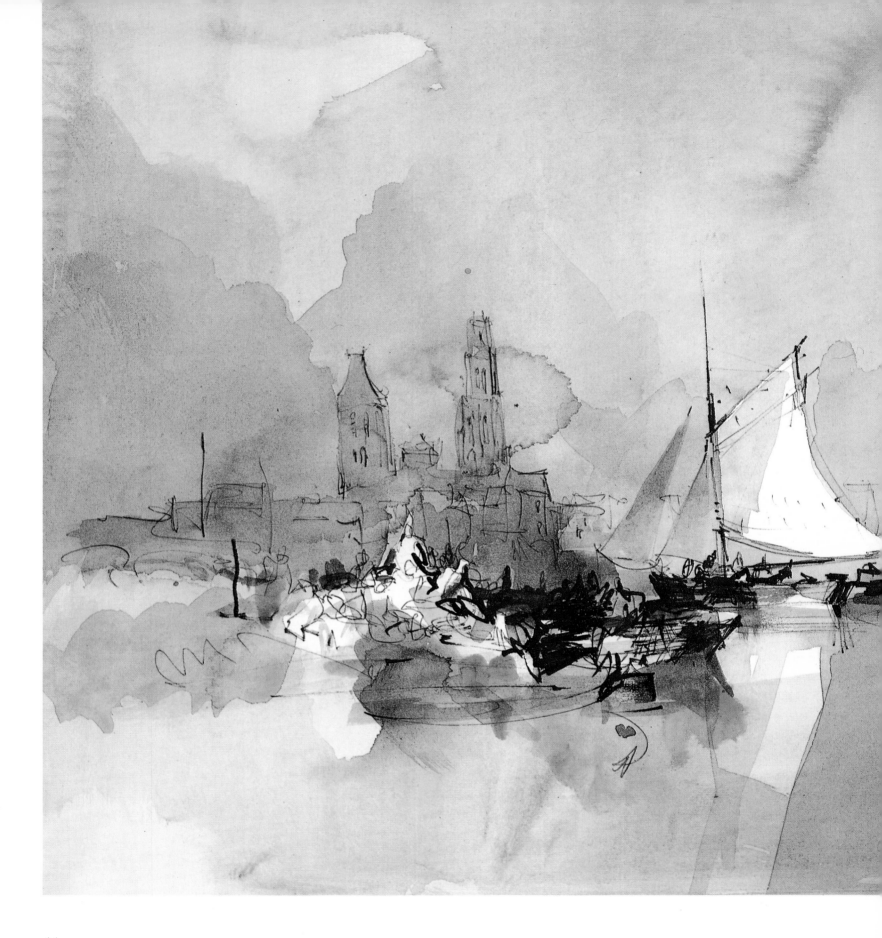

44

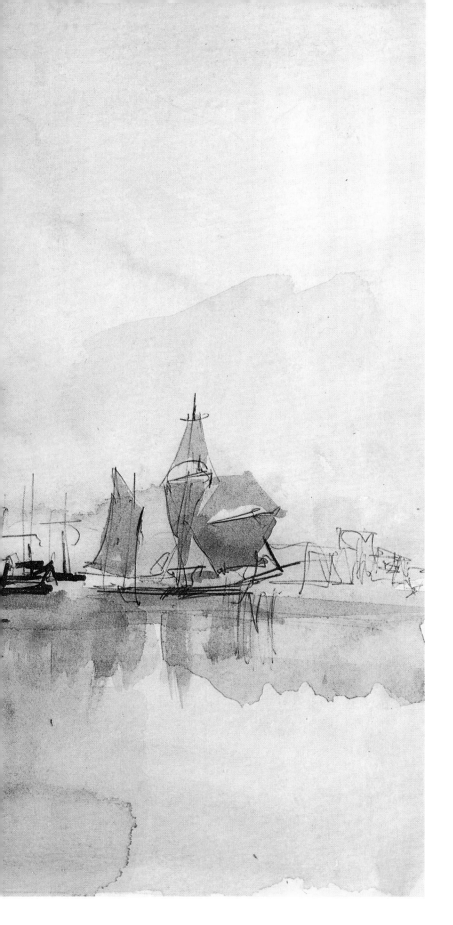

Those of us who are inveterate sketchers have a lot to thank Turner for . . .

I owe the subject on the left to Turner – it is an enlarged version of one of his masterly small sketches done on his foreign travels. The subject is Rouen. Any liberties I have taken with it are tokens of my lifelong admiration for the greatest sketcher of them all.

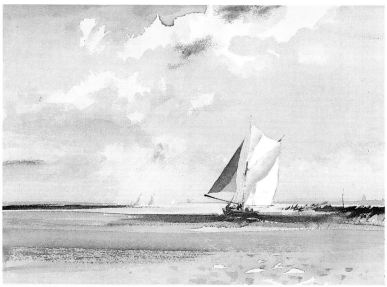

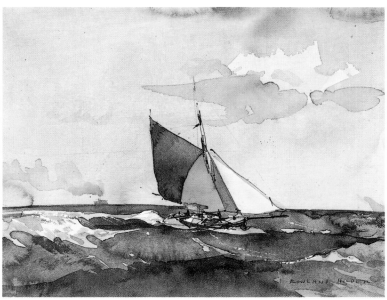

This sketch of the entrance to Whitstable harbour is the outcome of an experiment. It is on black paper and the medium is diluted watercolour with some gouache – a reversal of the normal technique, in which translucent colour is laid on white paper, the source of light.

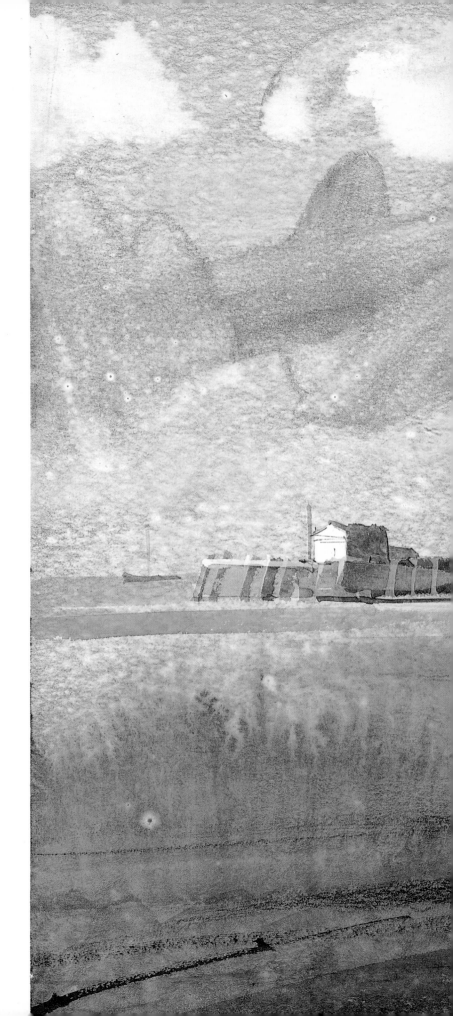

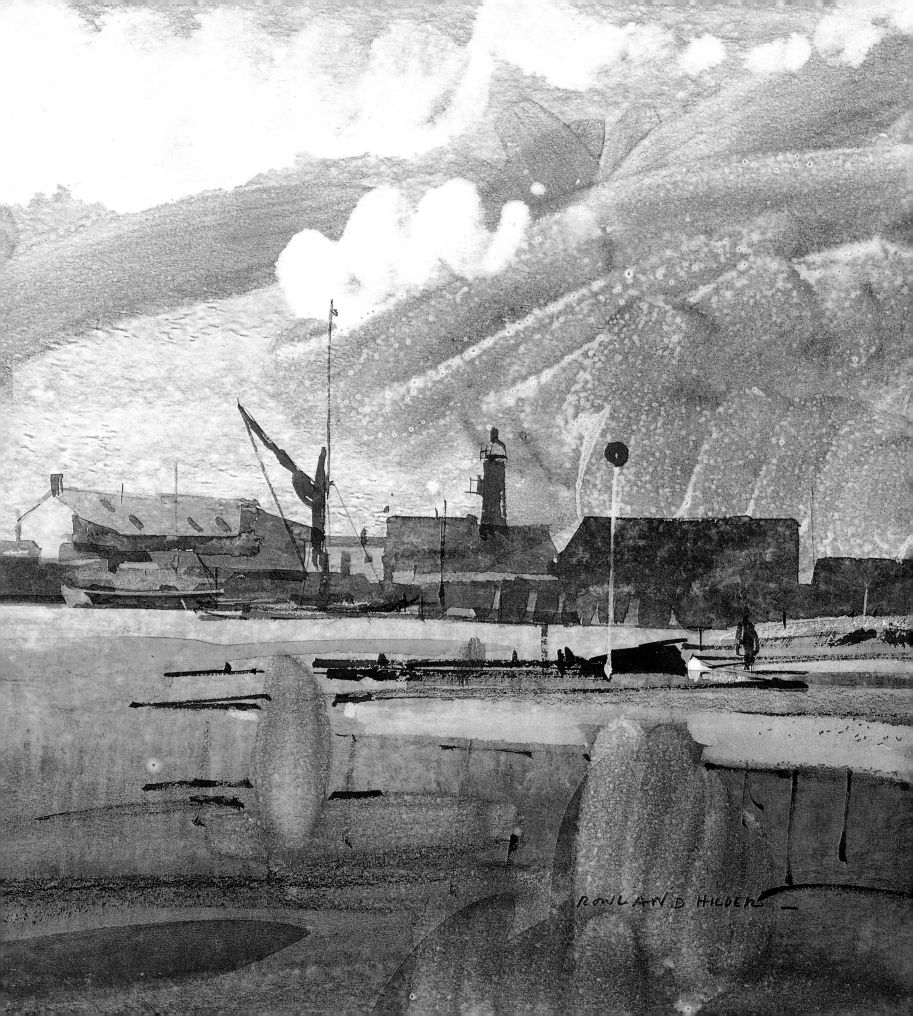

I often experiment by making small watercolours from sketches, which means composing ideas based on a group of notes. Several of the works in these pages were done this way

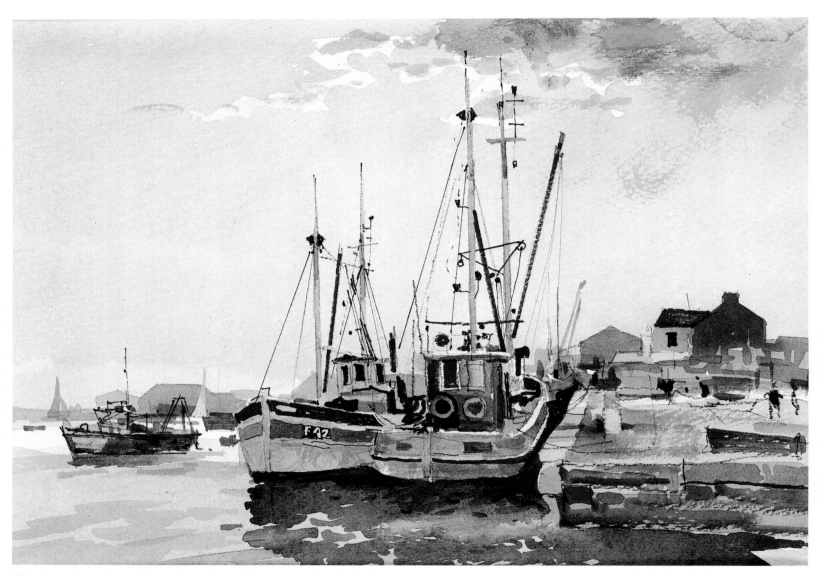

This is another Queenborough subject – I have already included one a few pages back. Opposite is a variant of one of my favourite subjects, a view on the Swale.

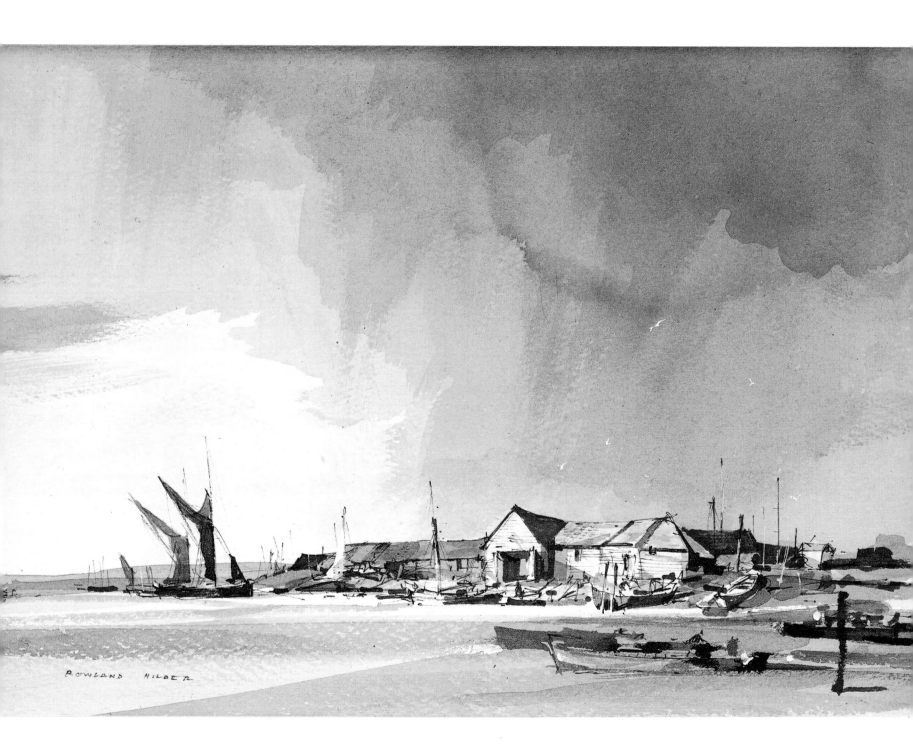

ROWLAND HILDER

49

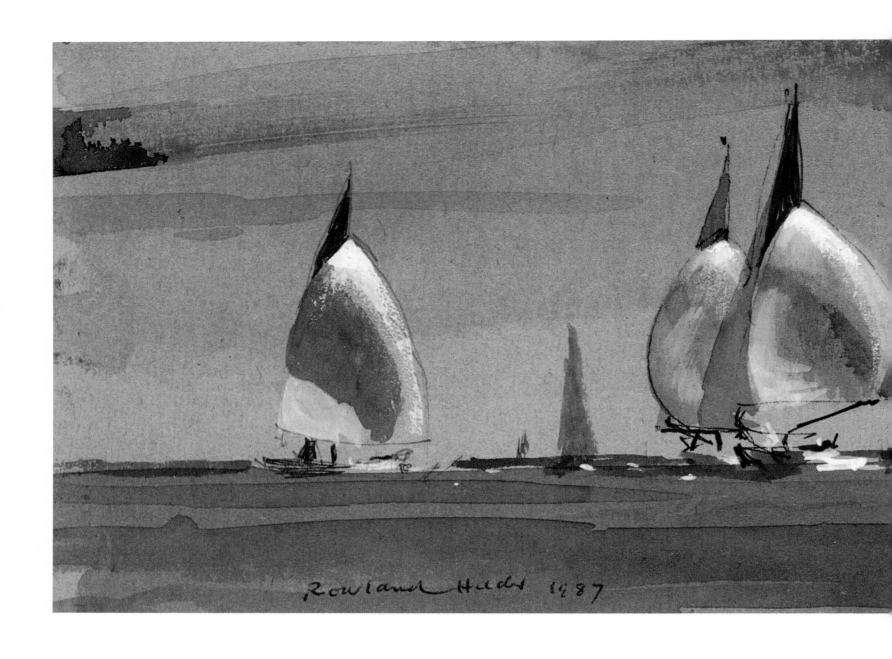

I am a believer in banishing from a watercolour the kind of detail which I have heard visitors to mixed exhibitions applauding as being 'true to life'

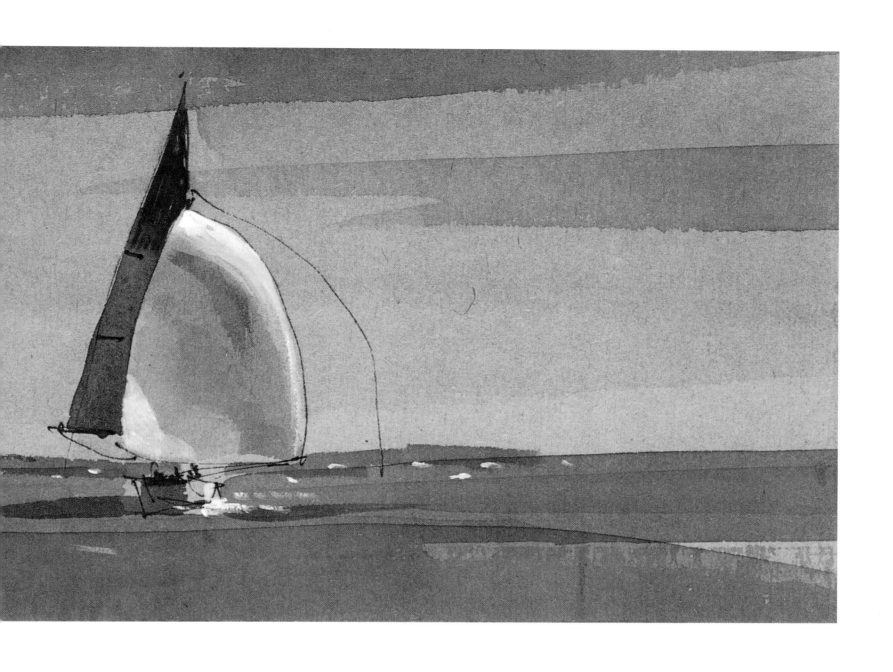

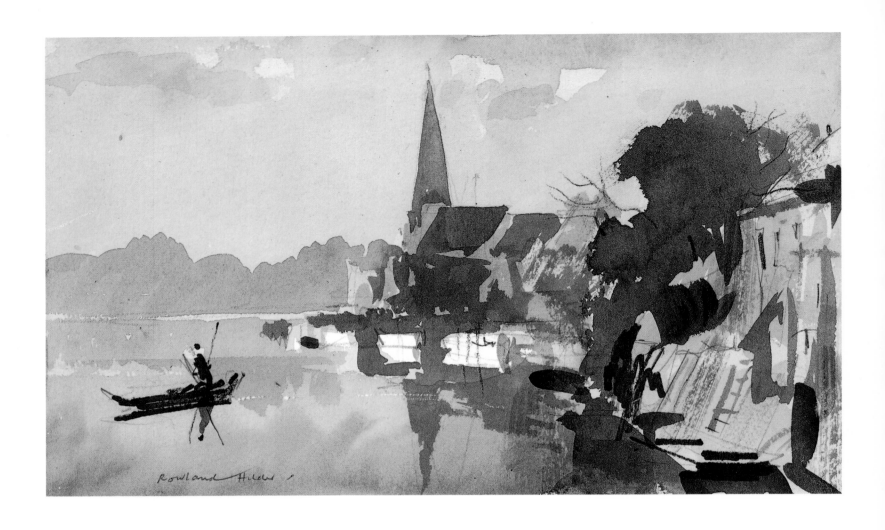

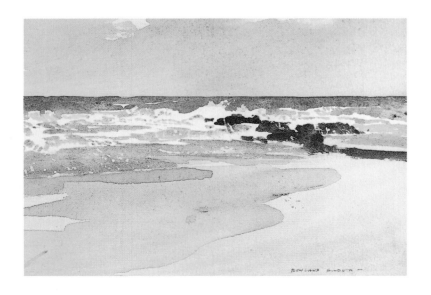

Studies of tides, in all lights and moods, have always appealed to me. Watercolour is the ideal medium for catching the elusive watery gleam, whether as a mirror image of the sky or enveloping a sea-shore lapped by breaking waves.

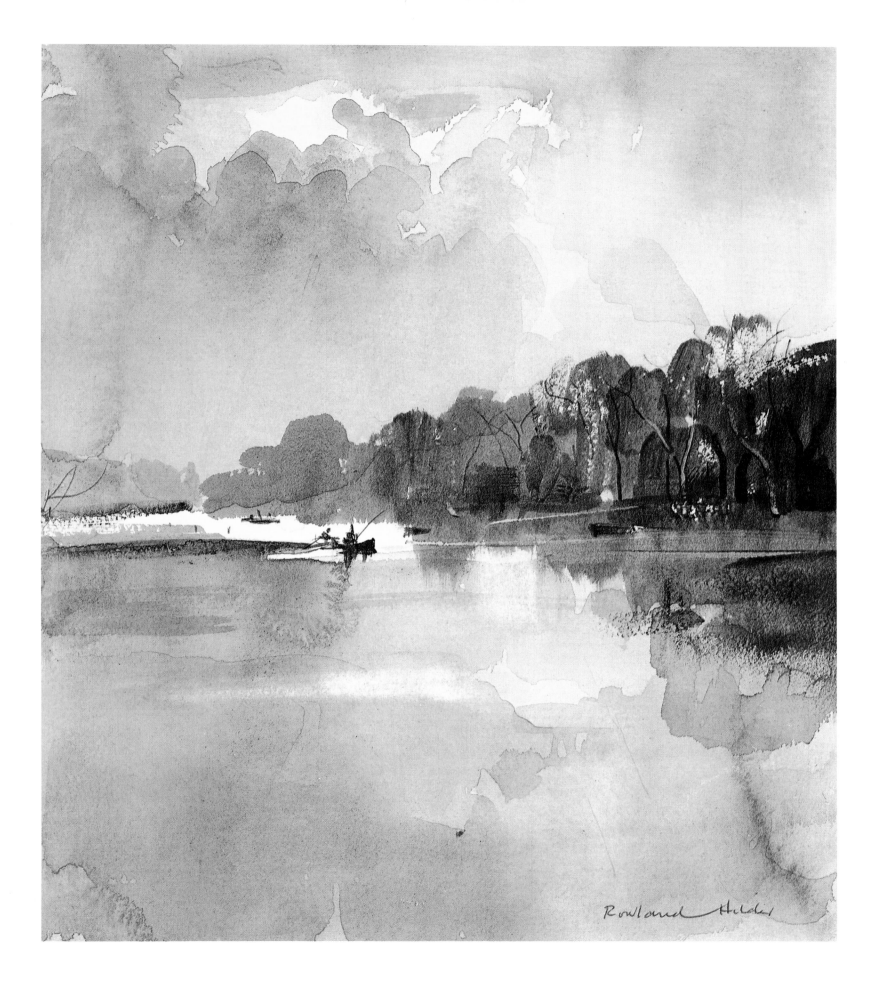

Rowland Hilder

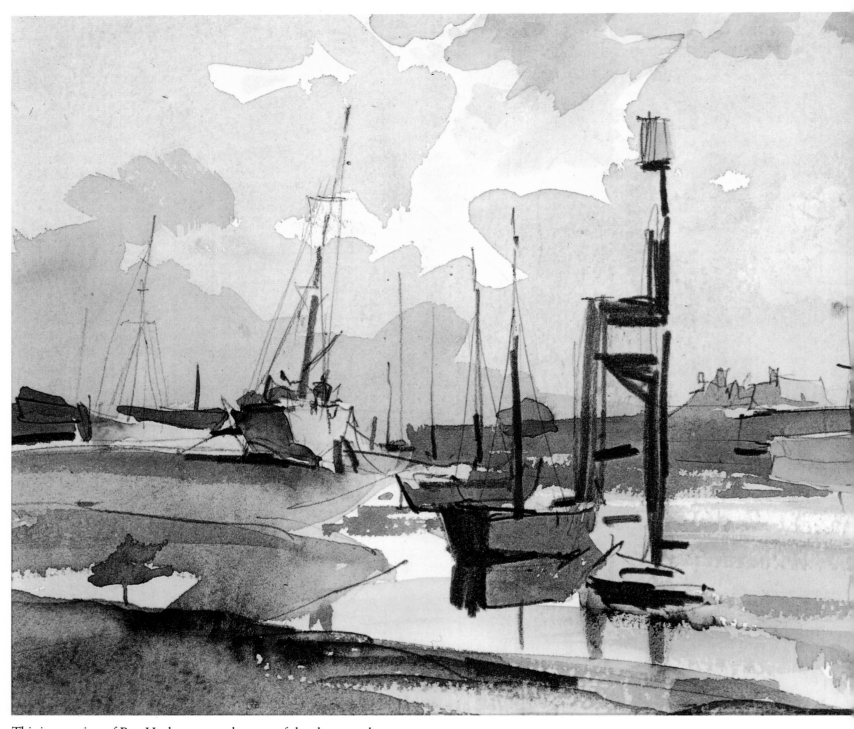

This impression of Rye Harbour records some of the elements that have made Rye such a popular subject with artists – its unchanging role as a sailors' haven, and the salty nearness of the Channel.

ROWLAND HILDER

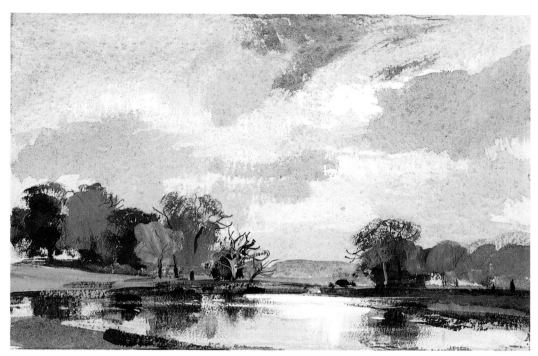

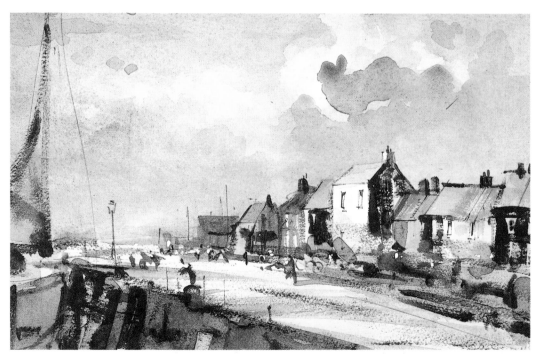

The upper sketch is of a lake in Rutland, which I visited with some friends while on a few days' leave in the war. The one above is a composition based on a group of old houses at Faversham, with its hospitable creek.

Over and again, in a lifetime of sketching and painting Nature, I have been thankful to belong to what one of my predecessors among English artists, Peter De Wint, called 'this beautiful profession'

A study of wind and tide on the Medway. The barges are following the tide 'up-along', as seamen say.

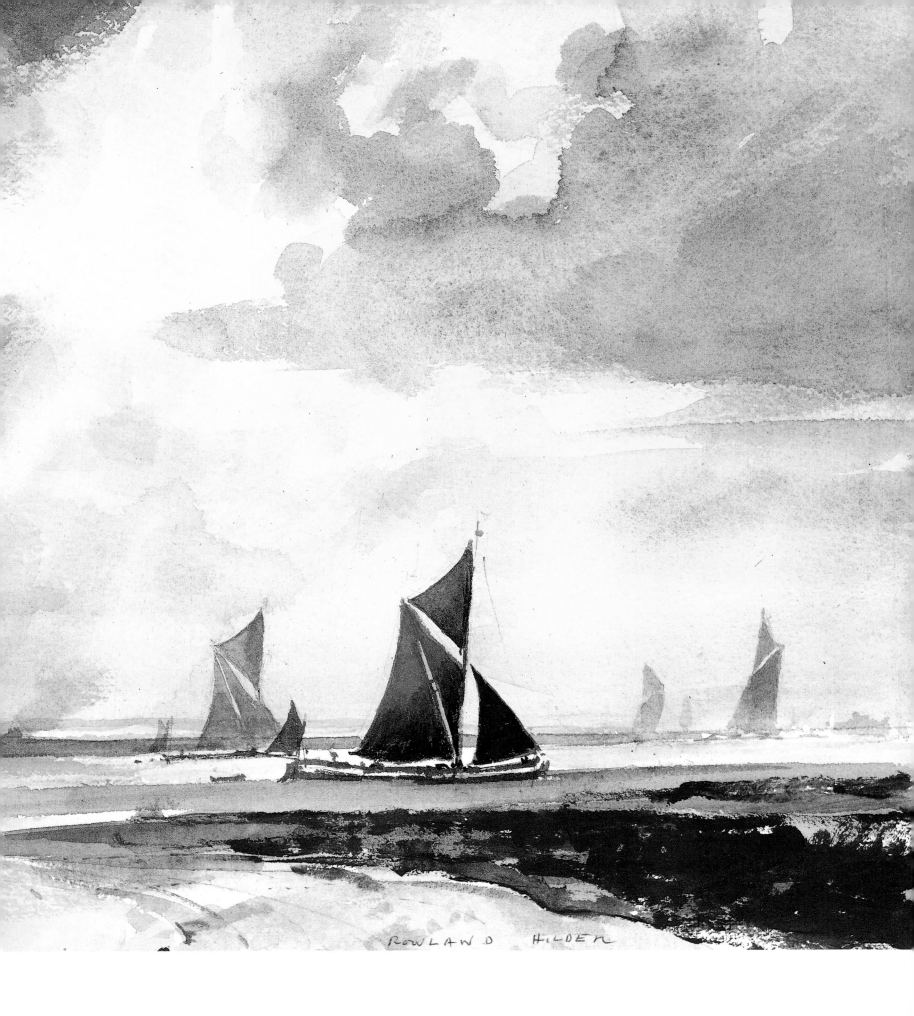

ROWLAND HILDER

I took my sketchbooks everywhere, ashore and afloat, concentrating on observation, which is harder than mere looking

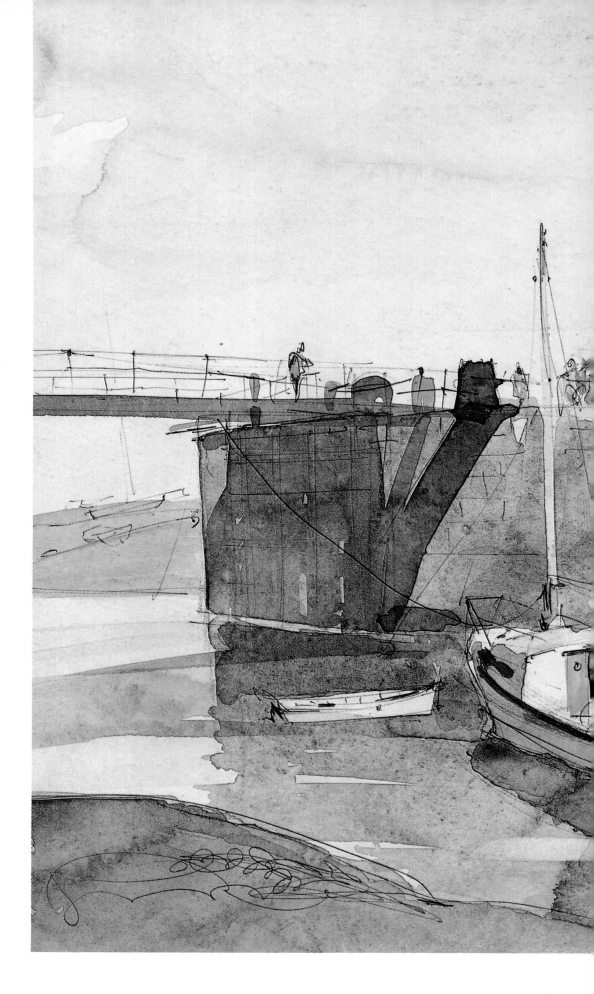

Porlock Weir, sketched on a holiday in Exmoor.

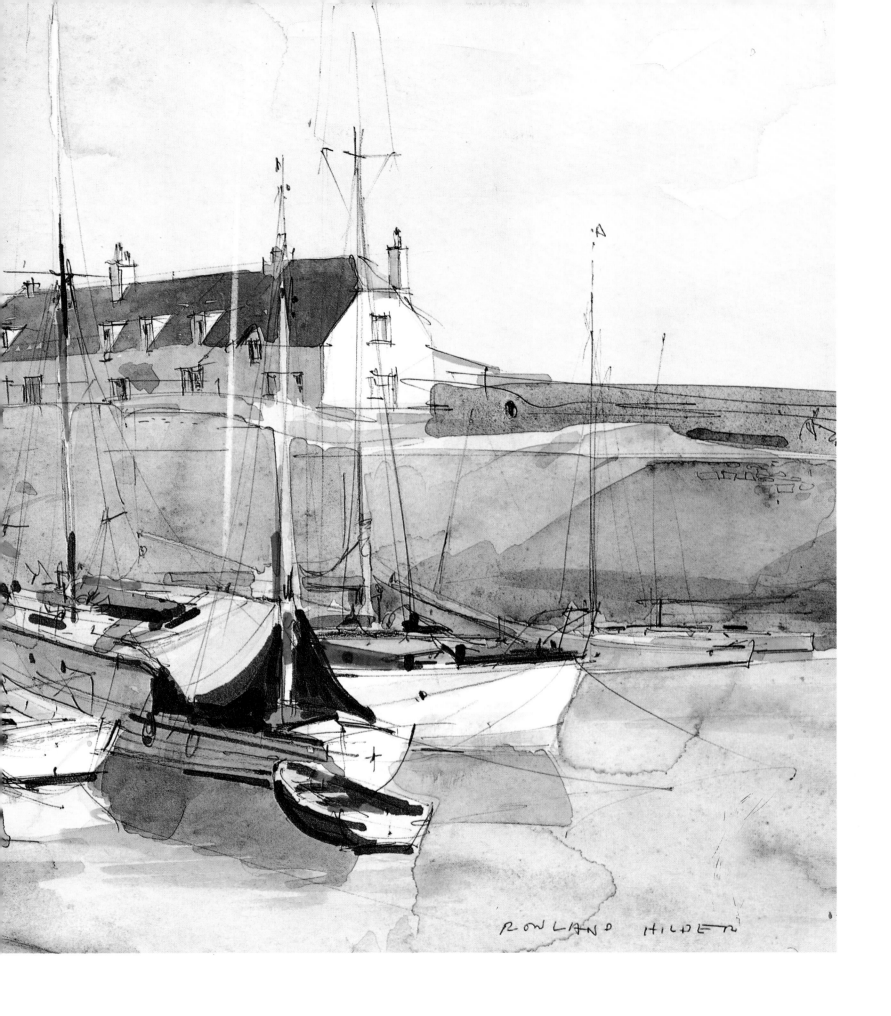

ROWLAND HILDER

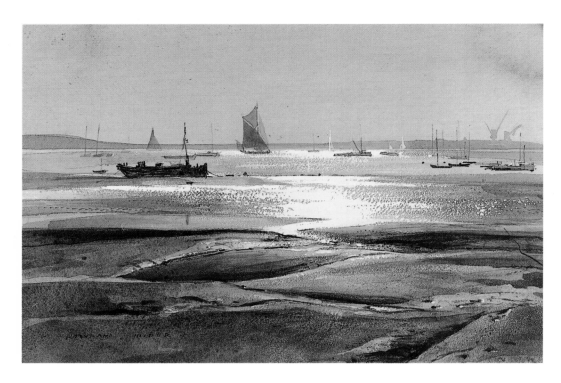

One's first sight of a subject, in a painter's terms, is of form and tones rather than its outlines. My own sketches are often of this kind

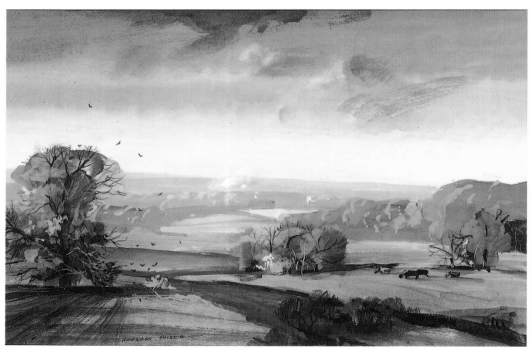

Summer in the Weald of Kent: a preparatory study.

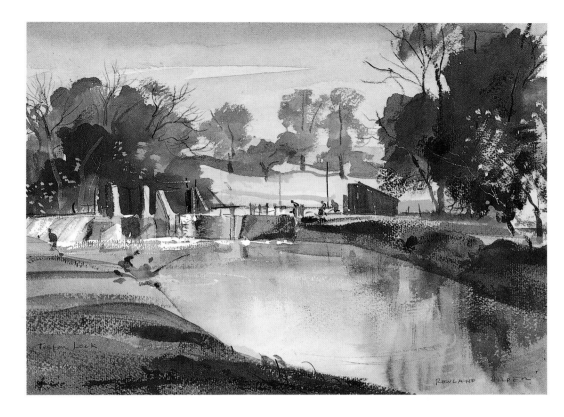

The bridge at Teston – 'Teeson' as they say in Kent – on the upper Medway.

A sketch for a summer composition near Underriver, near Sevenoaks.

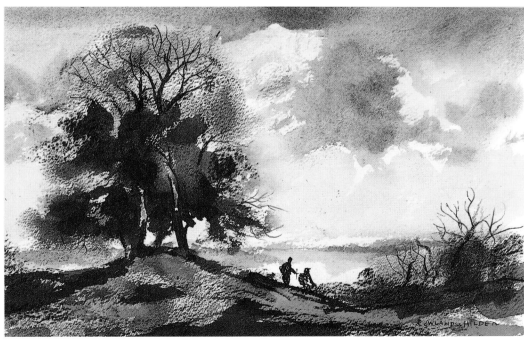

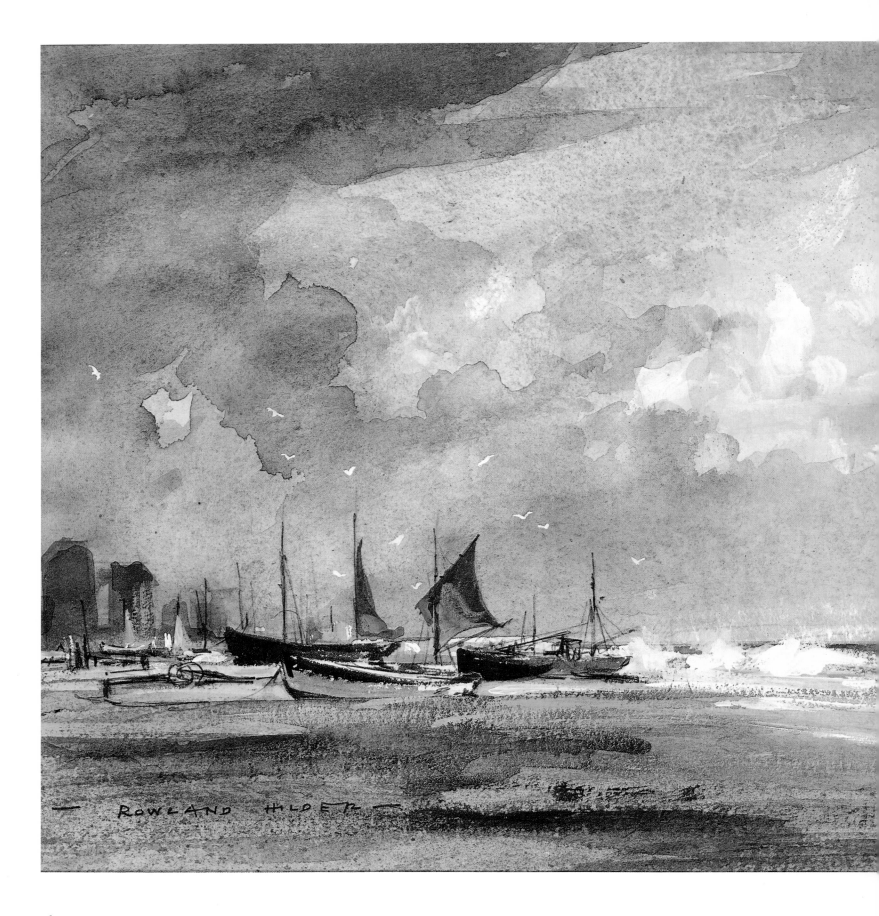

ROWLAND HILDER

Fishing boats ashore at Hastings, with its distinctive wheeled huts for drying nets. The sketches below are exercises on the theme of space and water.

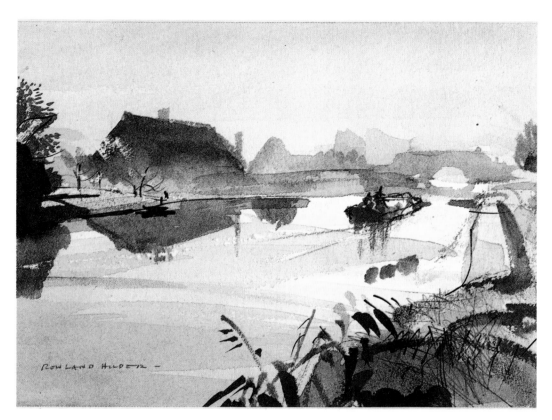

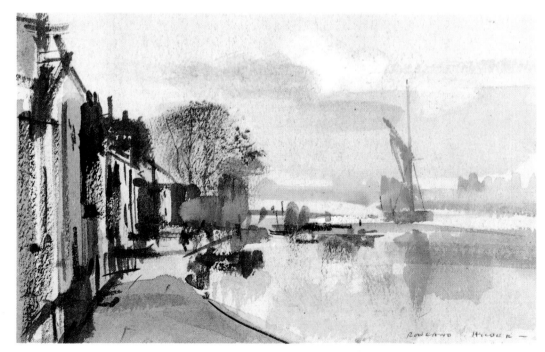

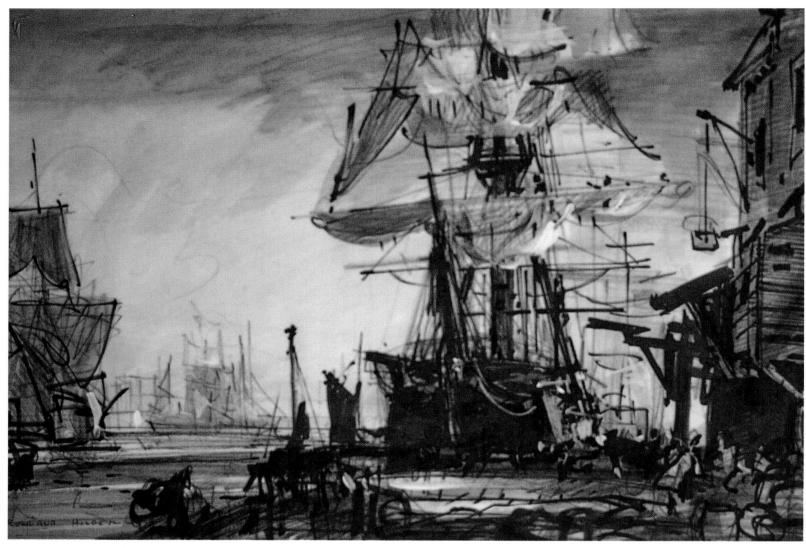

For me, images of the Thames in historic
times are as vivid as those of my own time.
Their origins lie partly in the numerous
jackets and illustrations for boys' adven-
ture yarns that occupied me at the outset of
my career.

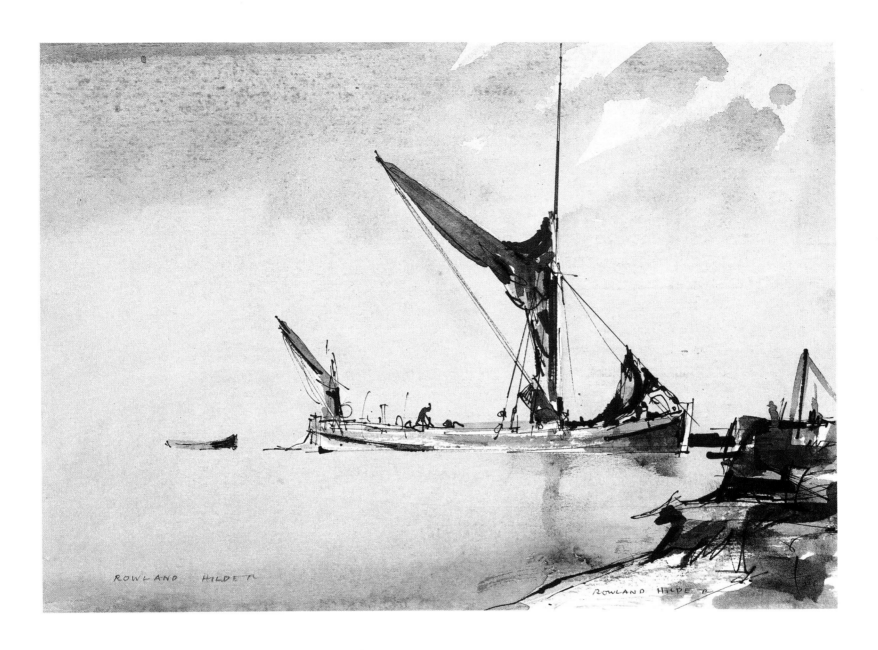

I have heard it said that drawings are ends, not means, that studies and sketches should be able to stand on their own. I like to think that both kinds of sketch have a value – the ones that are done with other work in mind, and those that are not

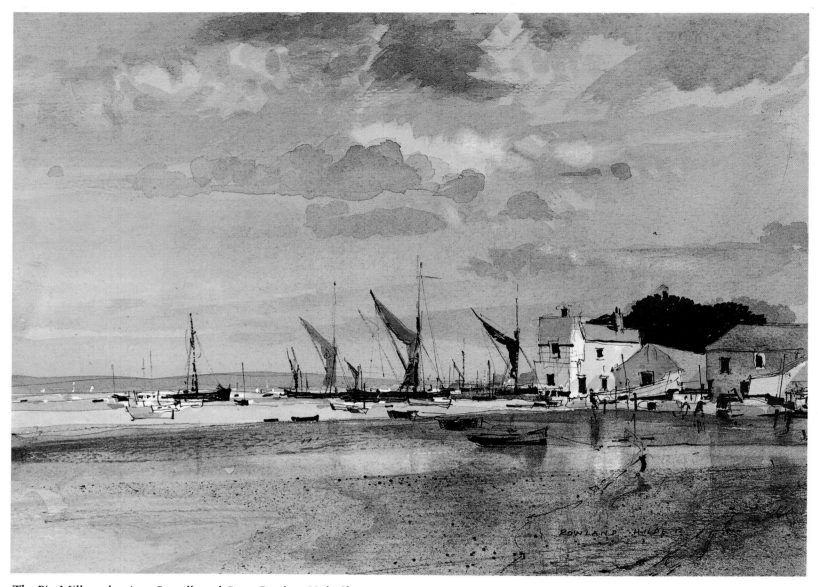

The Pin Mill on the river Orwell, and Oare Creek at Holy Shore, are typical of the kind of subject that brings a salty whiff into my painting-room.

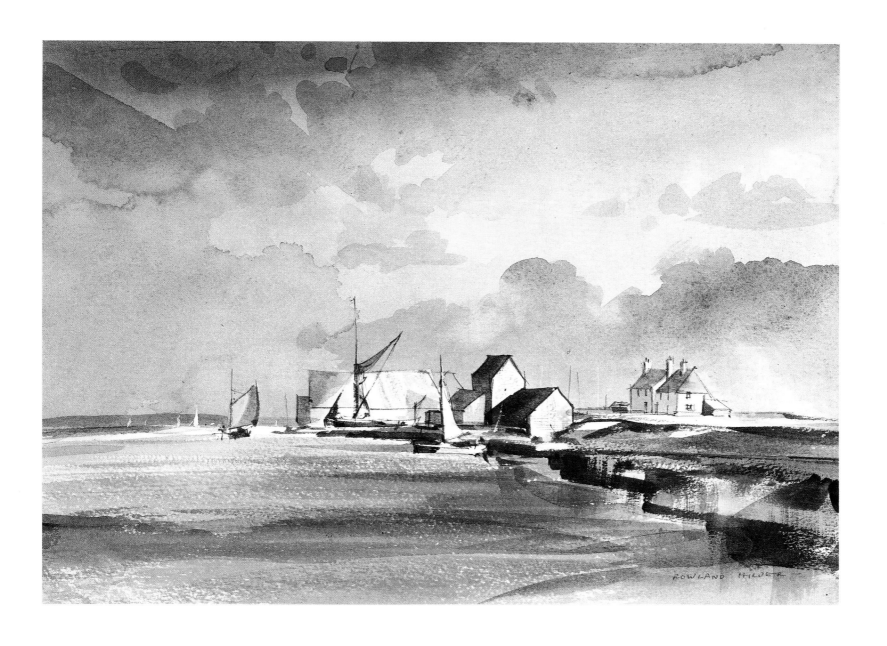

A Painter's Country

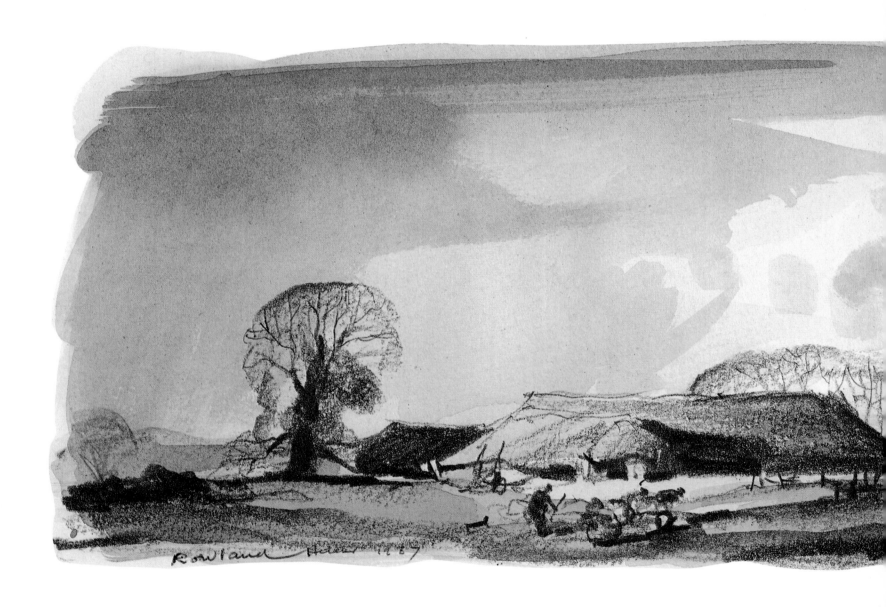

I have always been conscious of my predecessors
among English landscape painters in taking Nature
as she is, confronting the artist on the spot

So MANY English painters are associated with particular places, favourite painting-grounds which nourished them all their lives, that it is not too surprising that people have identified my own work with what they are kind enough to call 'Rowland Hilder country'. By this they mean that stretch of rural England near which I have lived most of my life: north Kent, below the Downs, in whose lovely sweep lies the Shoreham Valley. It is a stretch of England where my family roots lie, and where I feel most at home.

This book could well have turned out to be a celebration of its character and beauty, since I have spent so much of my time sketching and painting there. But I have also wandered further afield, finding subjects in lanes and byways, village streets, old farm buildings; and some of these have yielded works no less recognizable (to my eye) than the ones that are sometimes called 'Hilderscapes'. I could not, in every case, take you to the very spot where I sat down to sketch, usually with only the light and the breeze for company.

Generally, it is the mood rather than the place that lives on. Who is to say what a landscape sketch is 'about'? If you asked me, I doubt if I could give you an answer.

Sepham Barn, beloved of Samuel Palmer, survives in my early recollections of the 1920s, when I first discovered the Shoreham Valley. It tends to reappear in my own paintings to this day.

People talk about the 'nostalgic' element in my work. But much of it was done when the scenes I set down were not nostalgic at all: they were of contemporary life on the land, the farms and along the river banks. My sketchbooks are an artist's diary of his life and times

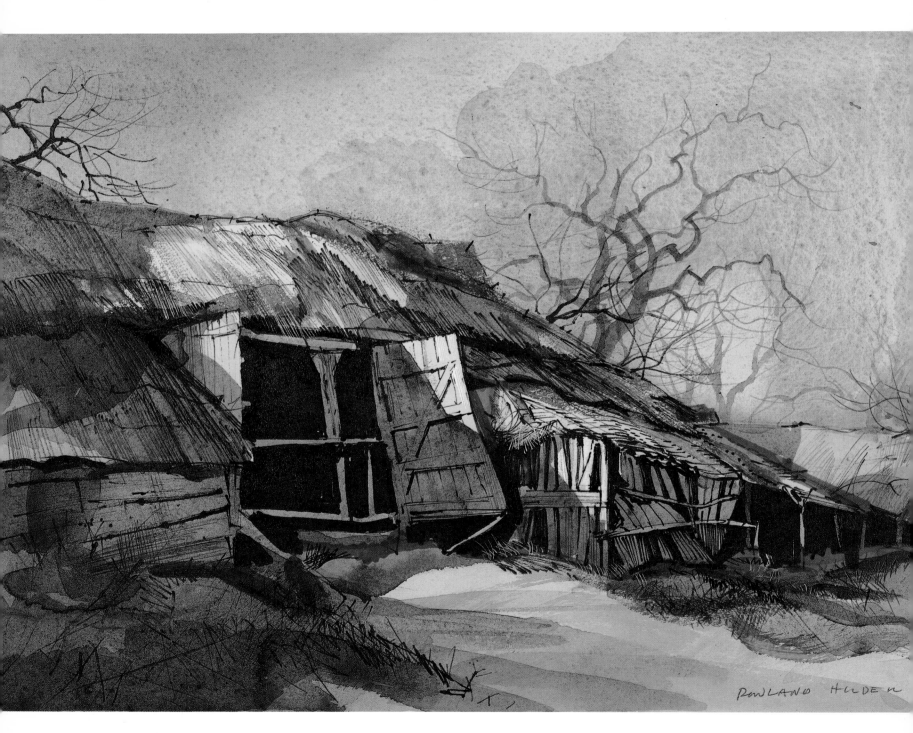

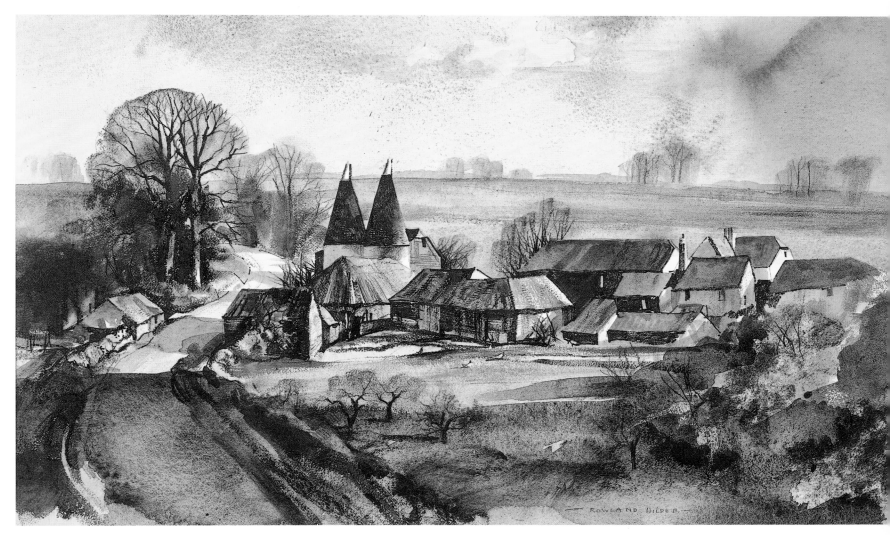

These two images have come to occupy a special place in my work:
the ancient barn at Sepham Farm and 'The Garden of England', my
re-creation of a hallowed homeland, in a version that still retains
elements of the original sketch.

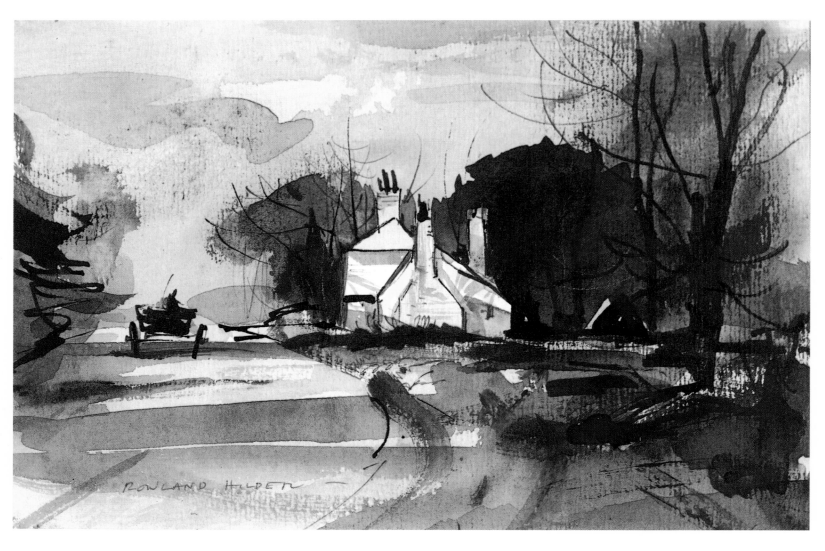

A cart lurching along a country lane has
been a typical feature in English painting
since Gainsborough introduced it over two
hundred years ago. Would I have made this
sketch if the cart had been just a tractor?

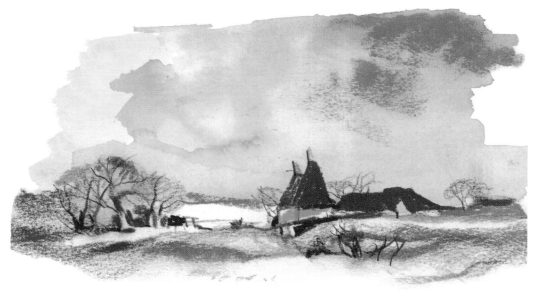

I had already started the sketch below, perched under a clump of trees near Kirby Lonsdale, when a young woman appeared and – unwittingly – sat on a rock to admire my view. So I put her in. Presently she went away. At that point I laid down my brush.

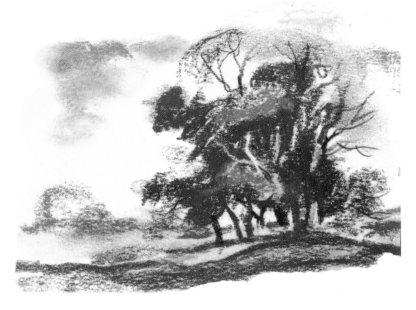

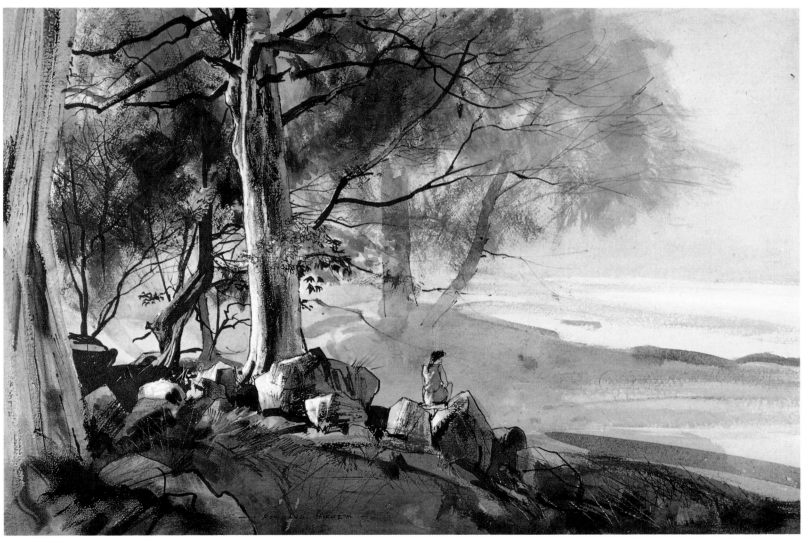

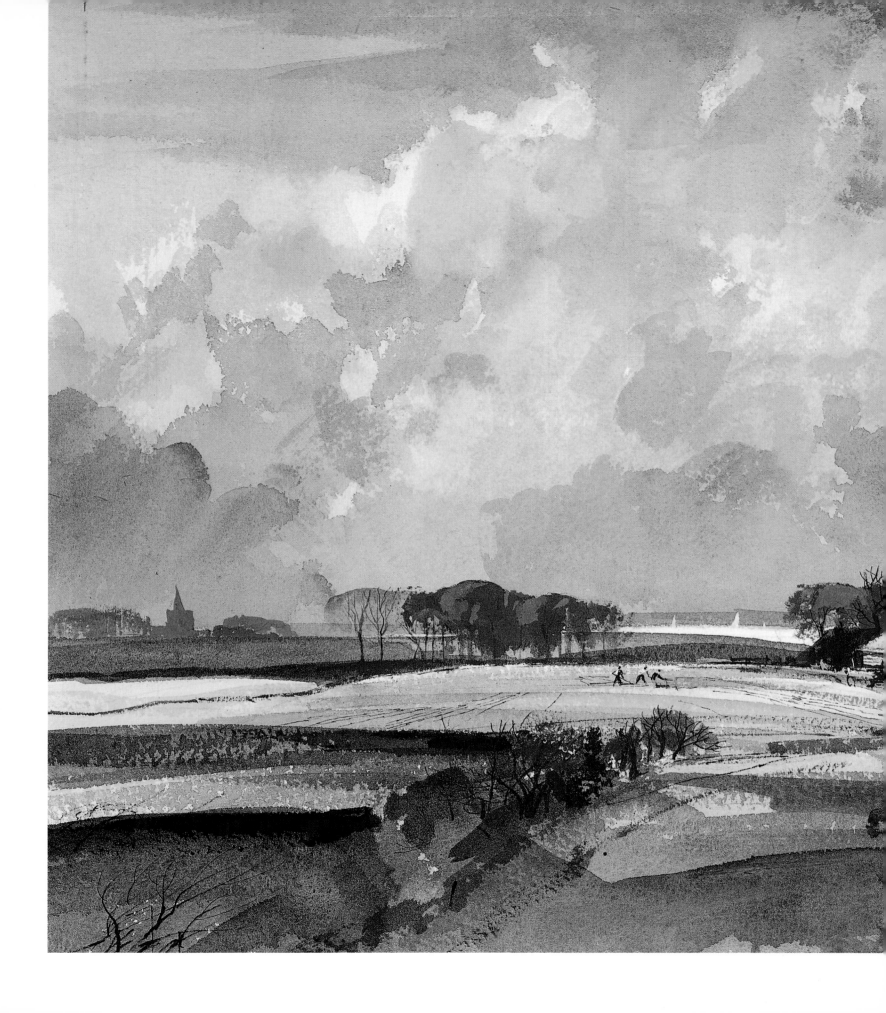

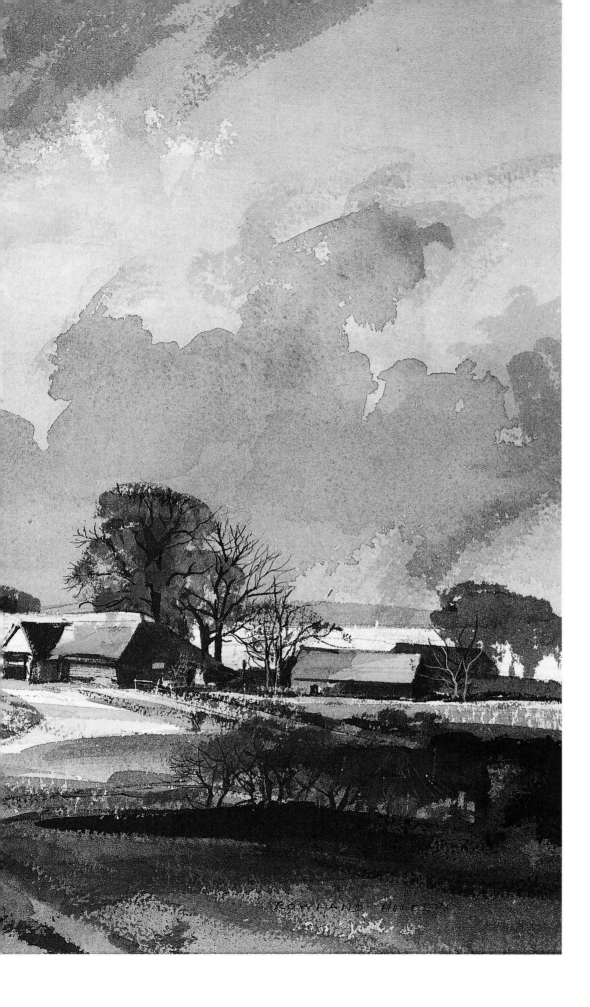

Often, a composition that includes as many of my favourite themes as this one does – rugged fields, low-slung Kentish barns, distant figures toiling, a glimpse of water under a rolling sky – is better left short of 'finish'. Why go on, when there is no more to say?

75

Those artistic heroes of mine have helped to transform the idea of a sketch as just a humble by-product of painting into an art form in its own right

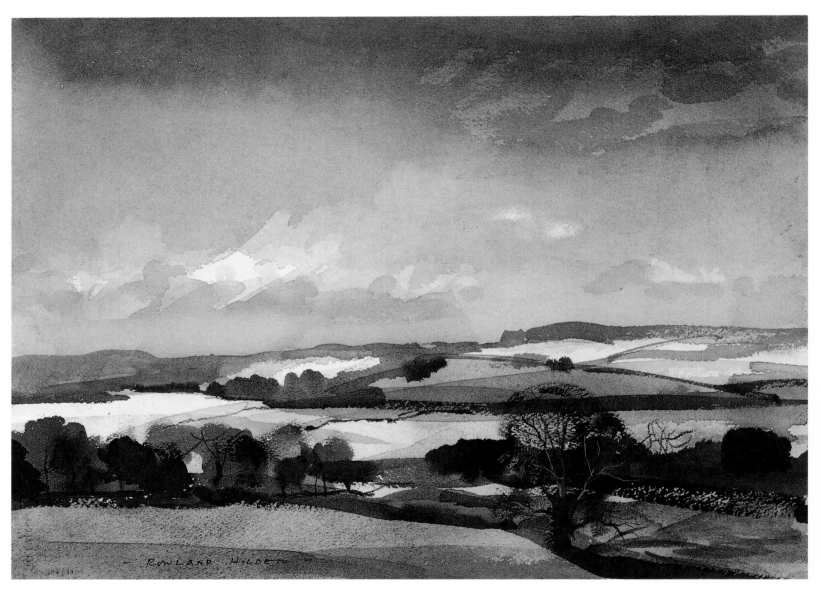

A sketch of the North Downs, from a lane near Westerham.

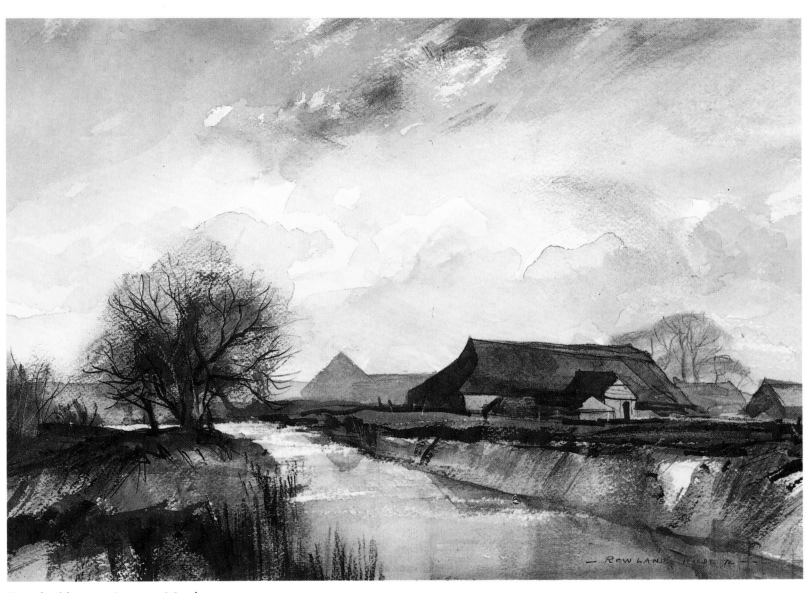

Farm buildings on Romney Marsh.

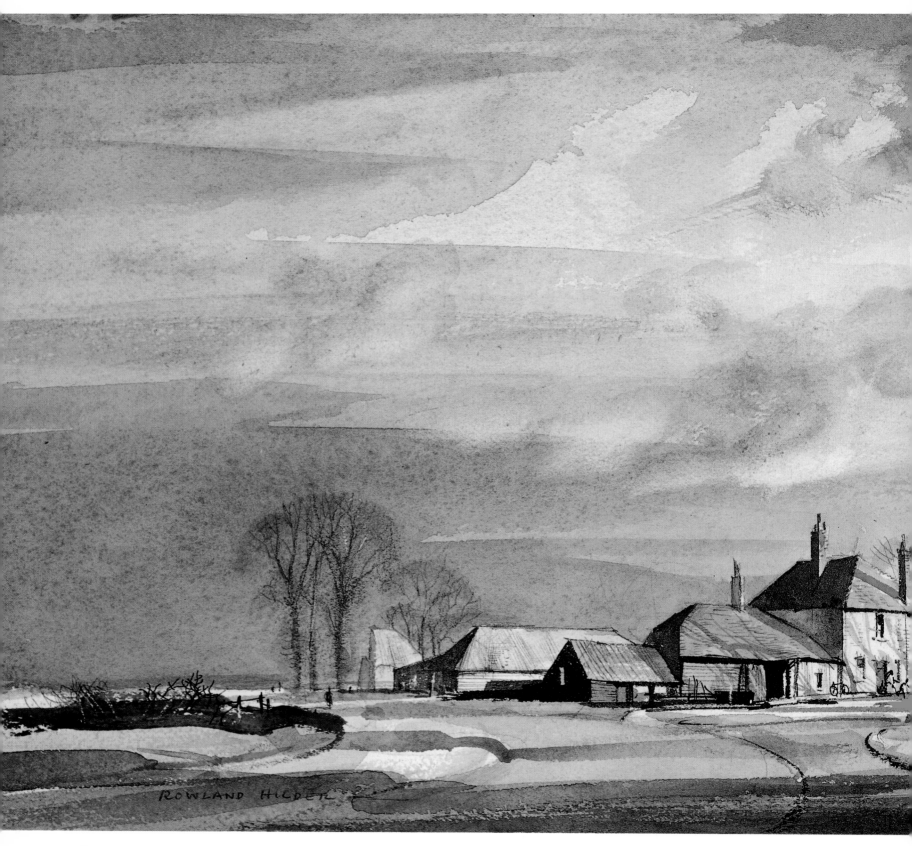

78

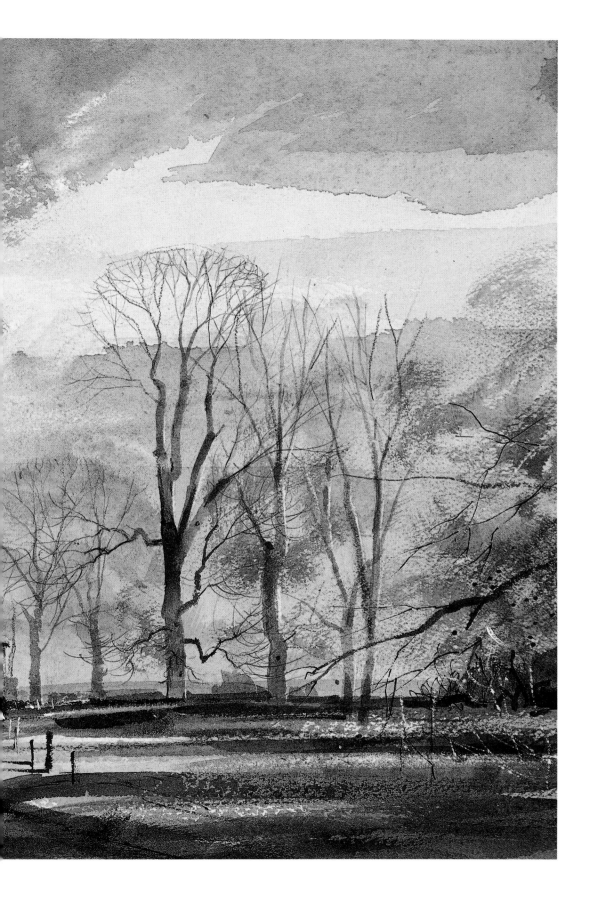

A Sussex farm, storm approaching.

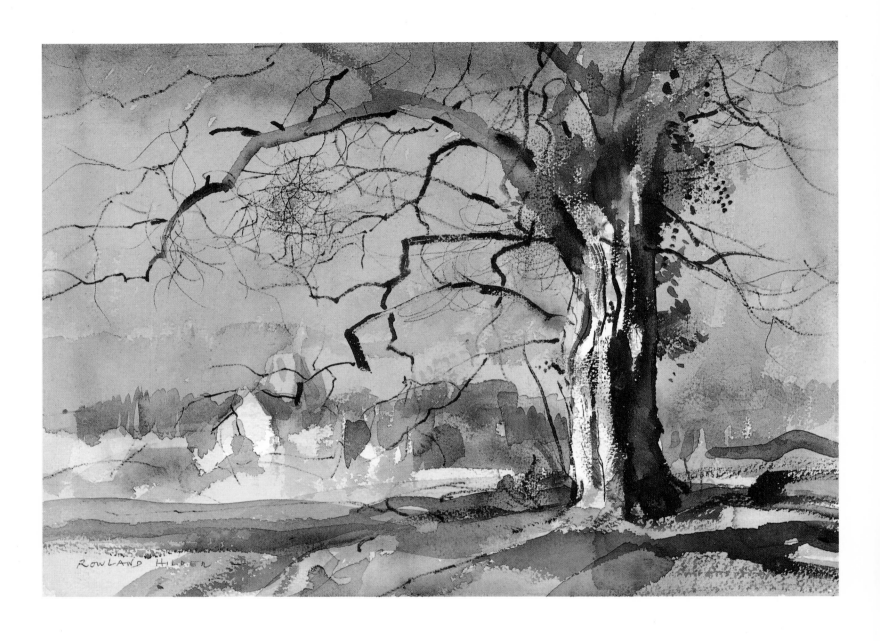

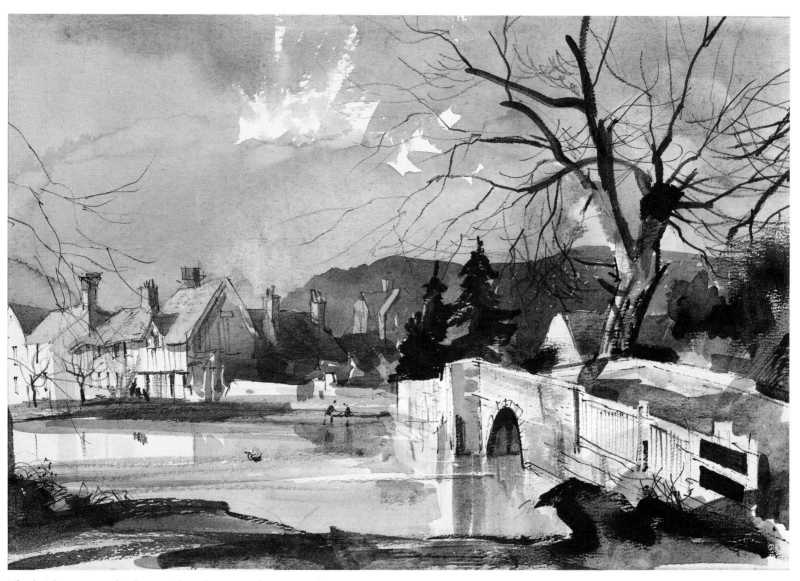

The bridge at Eynsford, near Shoreham, on the river Darent.

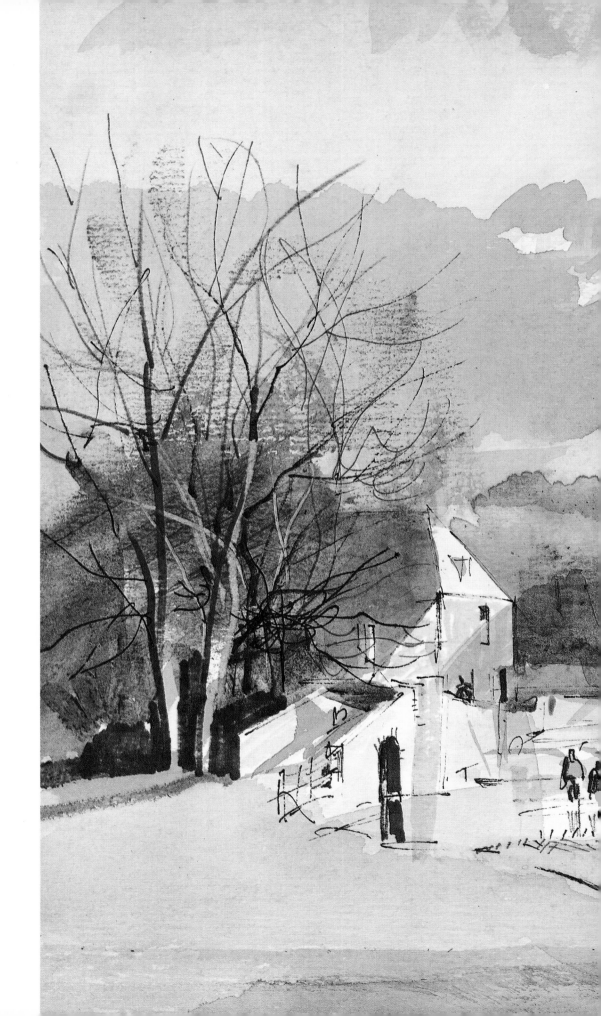

Eynsford from across the bridge, with a view of the church once painted by Samuel Palmer.

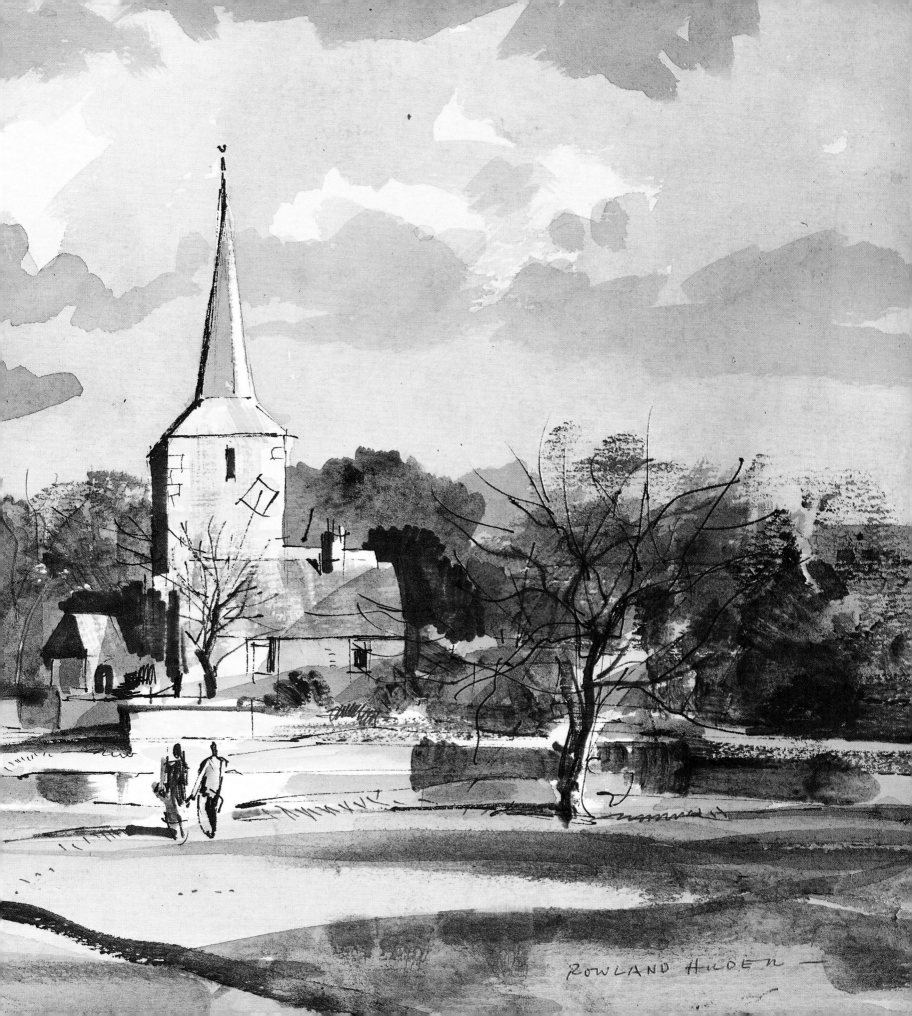

ROWLAND HILDER

I have found my sketch-book invaluable in helping to catch the elusive play of light, passing shade, and movement in an all-enveloping space

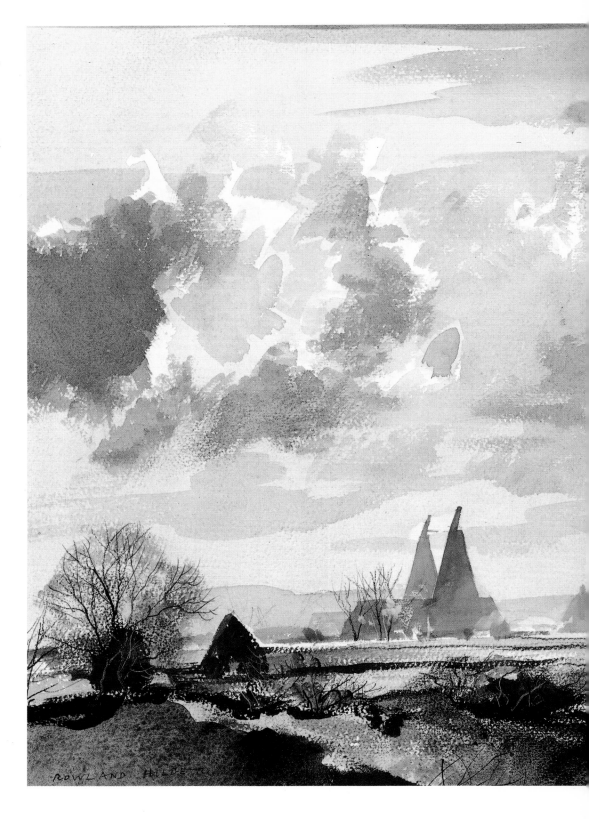

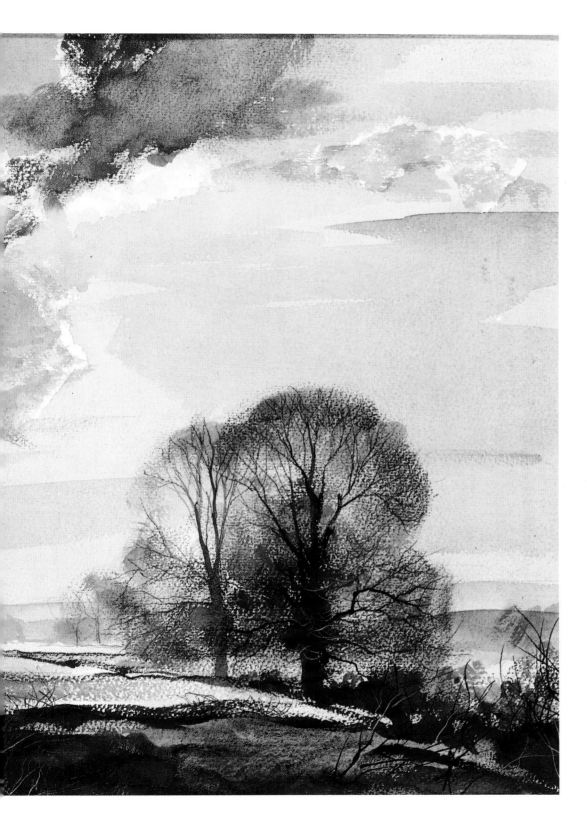

Those conical kilns, so typical of the Kentish hop-growing countryside in its heyday, are inseparable from my vision of this, my favourite sketching-ground.

I have found that a thumb-nail jotting can often be the seed of a full-scale work.

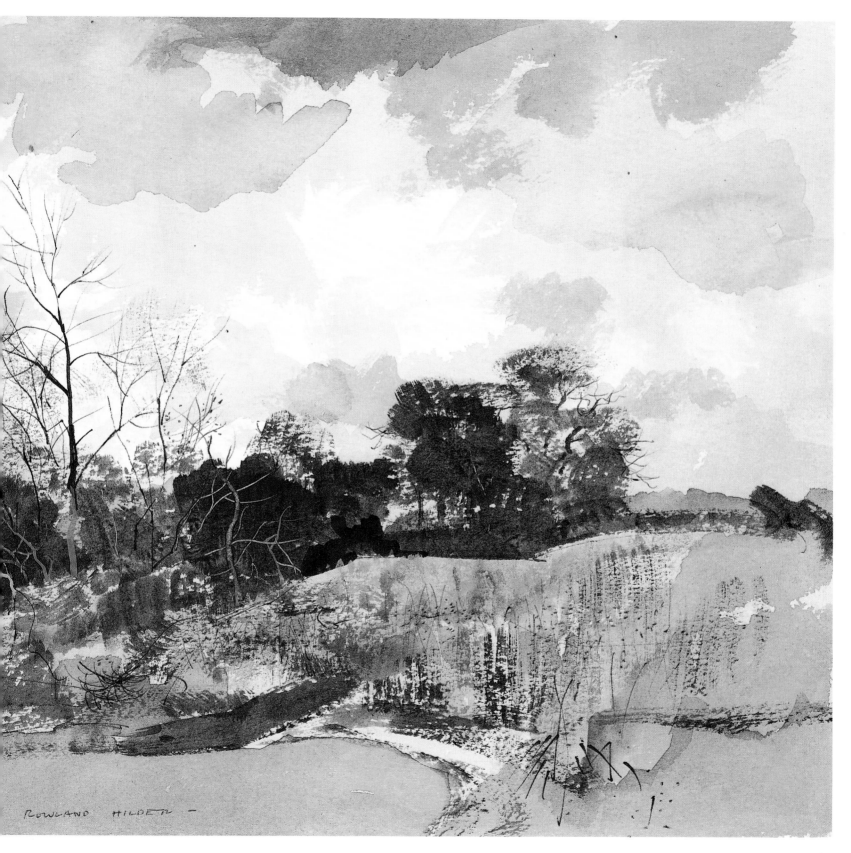

ROWLAND HILDER —

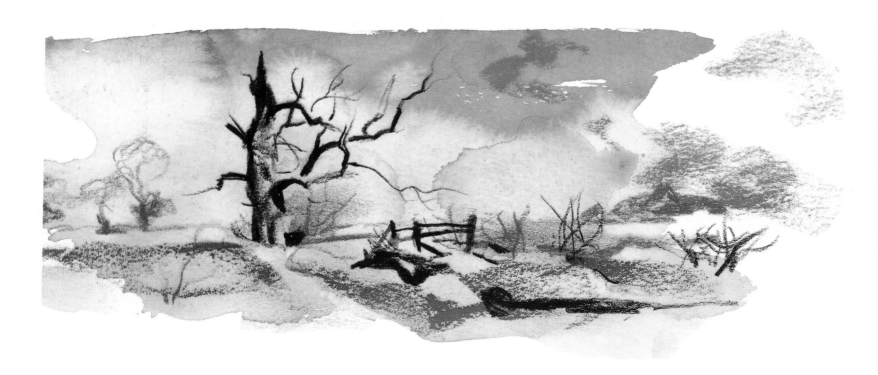

As a student, my little drawings done on the spot were starting points for more ambitious compositions, a process that has kept me happily occupied ever since

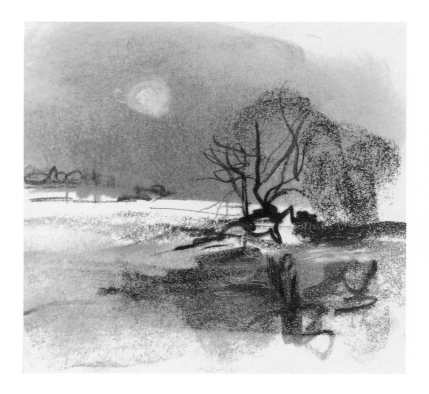

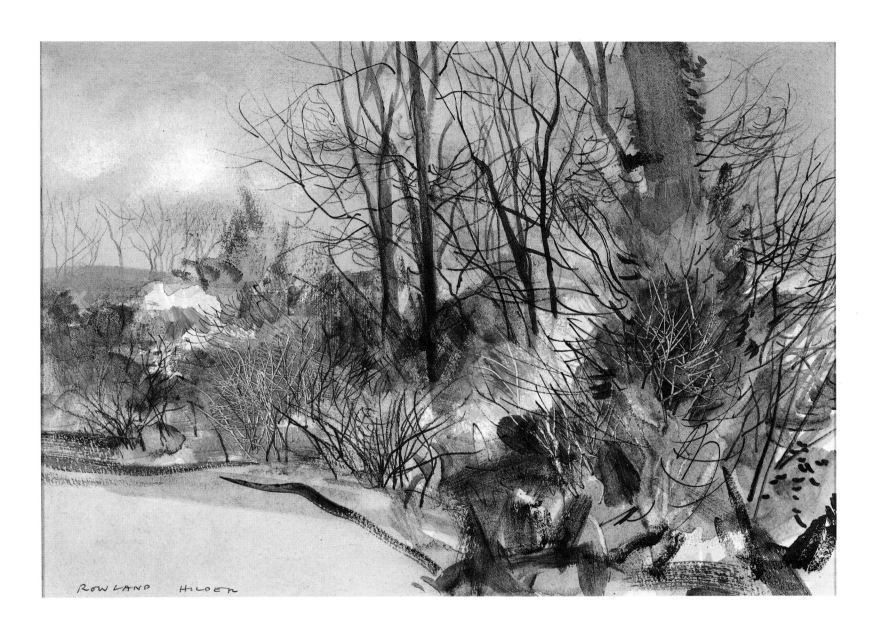

ROWLAND HILDER

I think of Constable, sticking to
his belief that there was room for
'a natural painter'

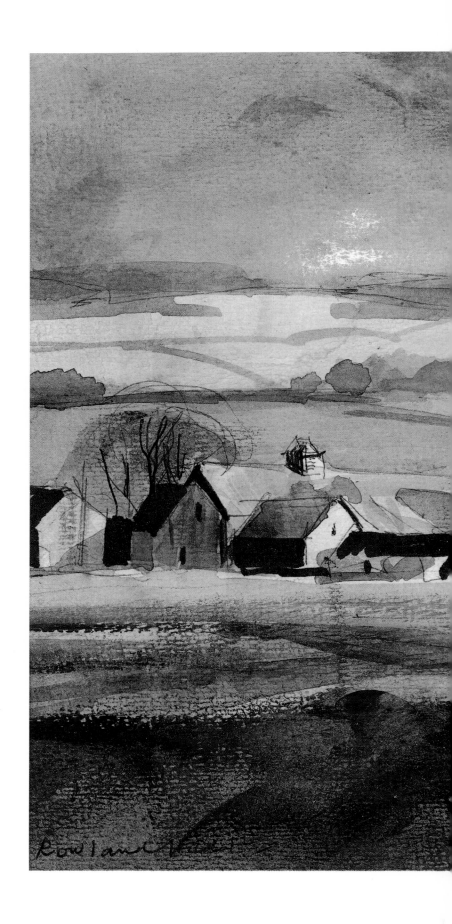

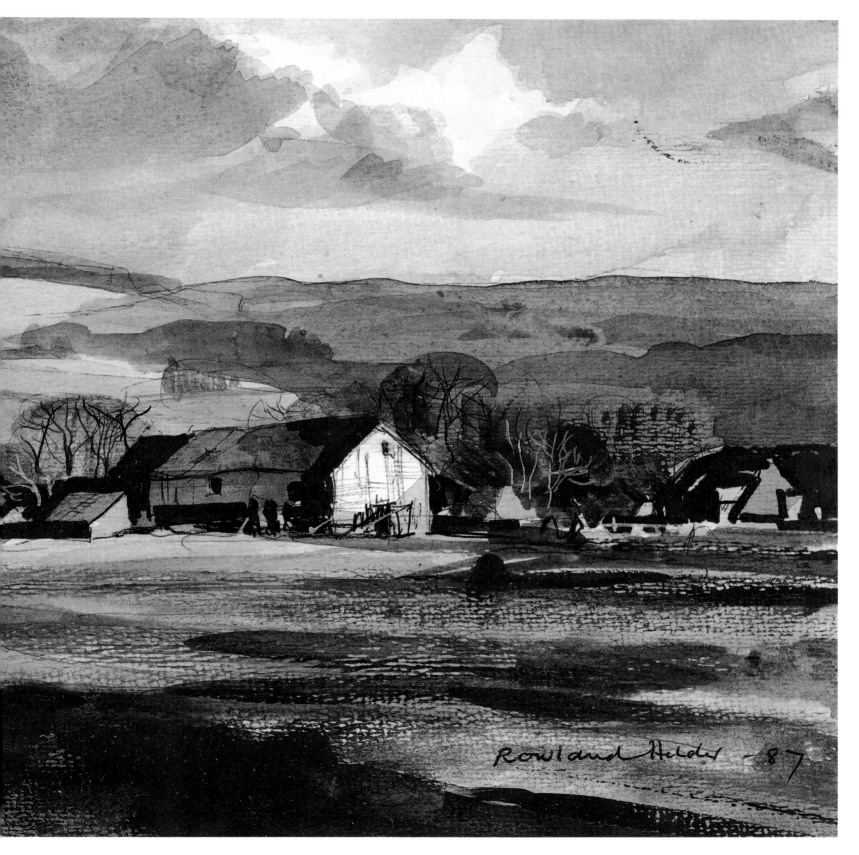

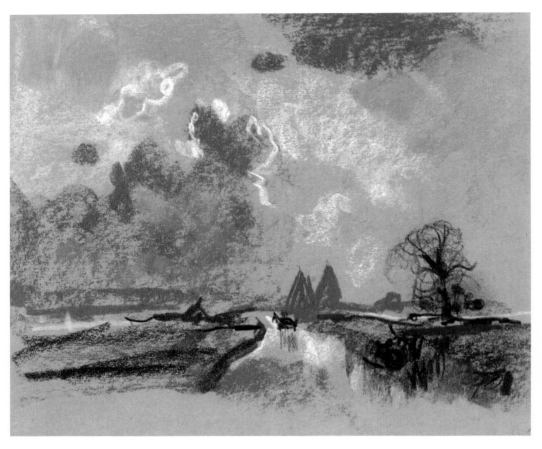

I found I could get down three or
four notes of changing light effects in
the time it would have taken me just
to assemble my apparatus

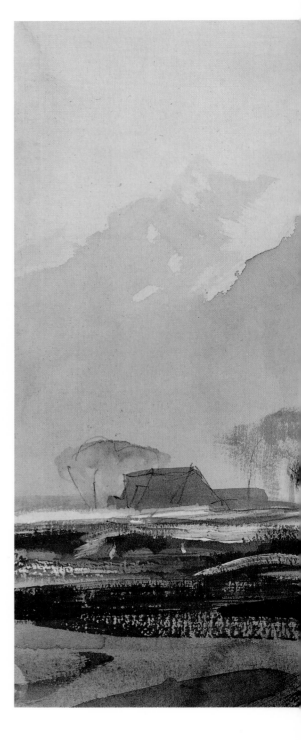

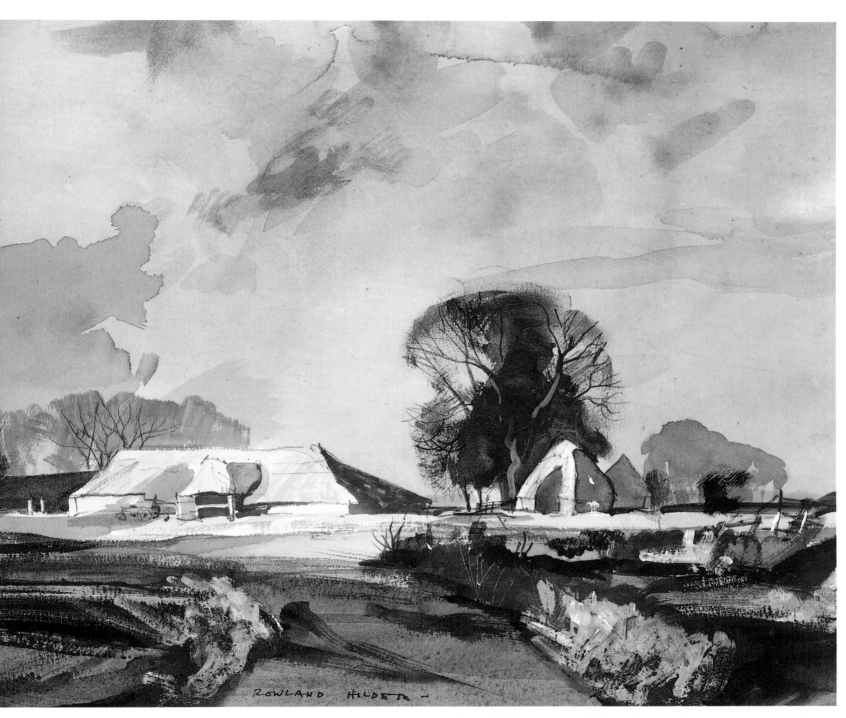

Samuel Palmer wrote: 'If the painter performed each work with that thirsting of mind and humility of purpose with which he did his first, how intense would be the result!'

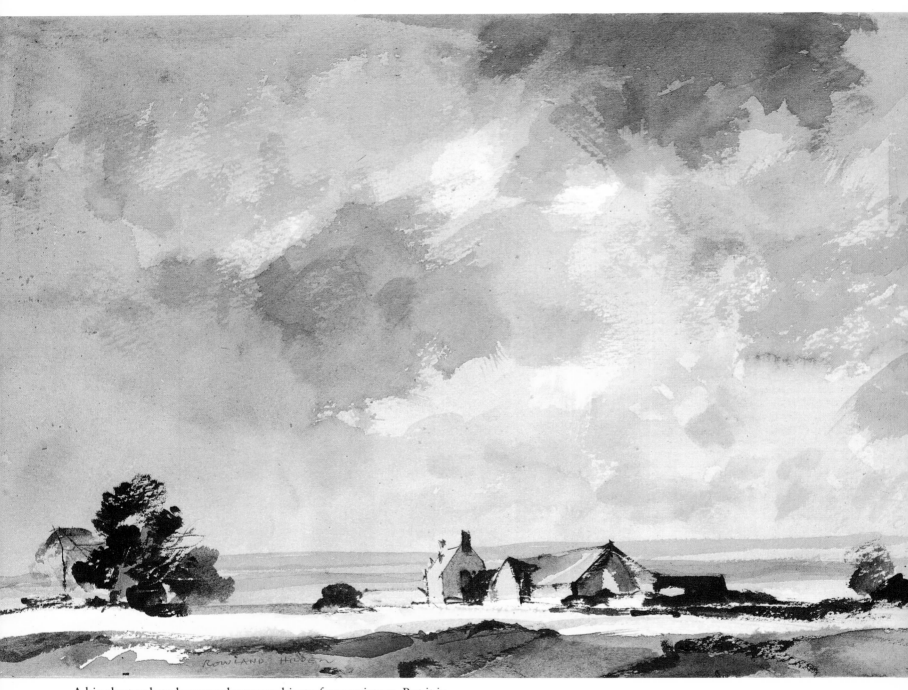

A big sky tends to become the true subject of your picture. But it is enhanced, to my mind, by signs of human habitation far below.

I am struck by the way in which water keeps getting in even when I thought I was sketching a landscape. Water, and after water, skies – these seem to sweep everything before them

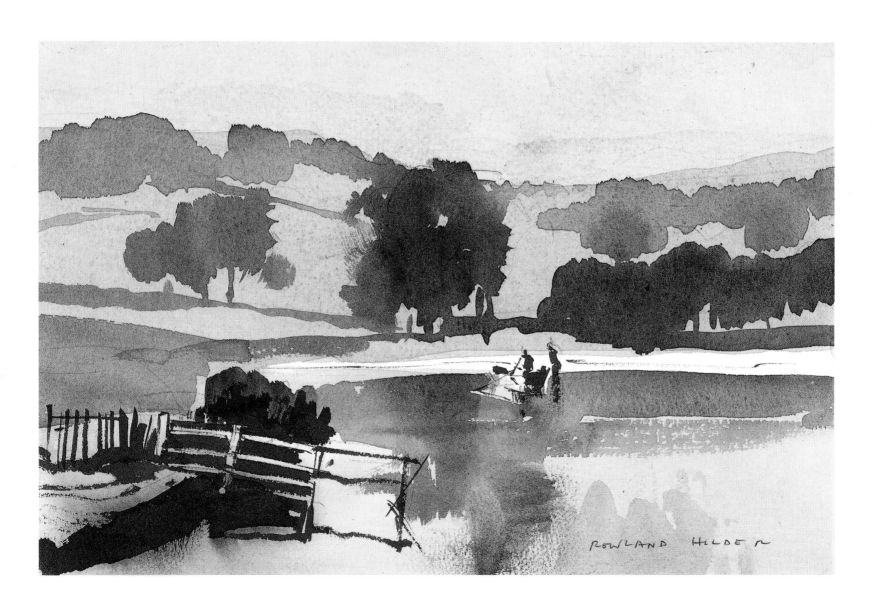

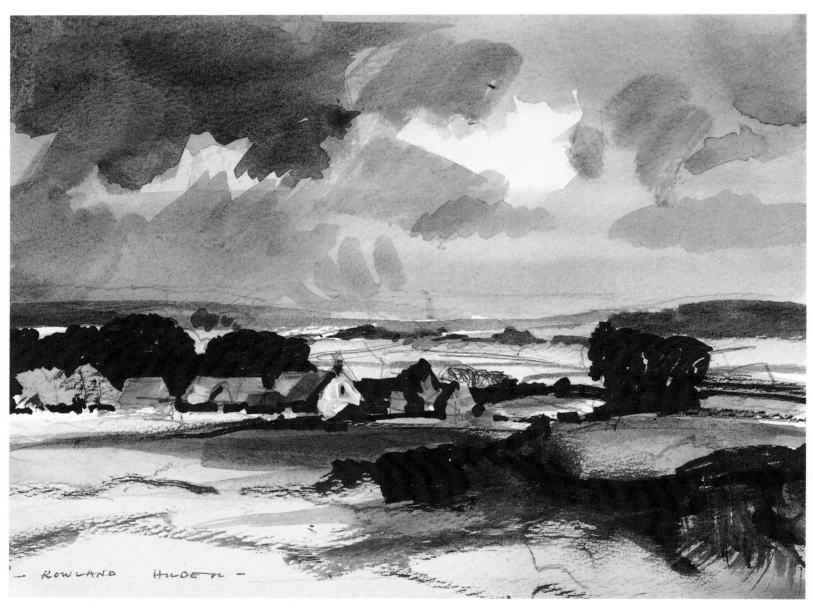

'Paint a sky a day!' was the advice of that great colourist,
Sir Alfred East. Who could disagree?

96

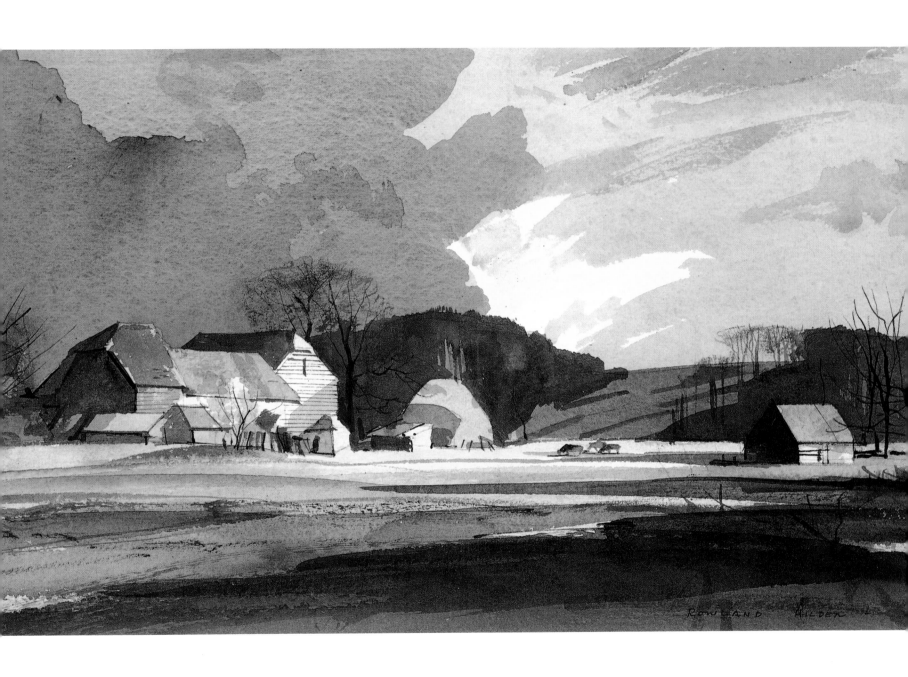

Generally, it is the mood rather than the place that lives on. Who is to say what a landscape sketch is 'about'? If you asked me, I doubt if I could give you an answer

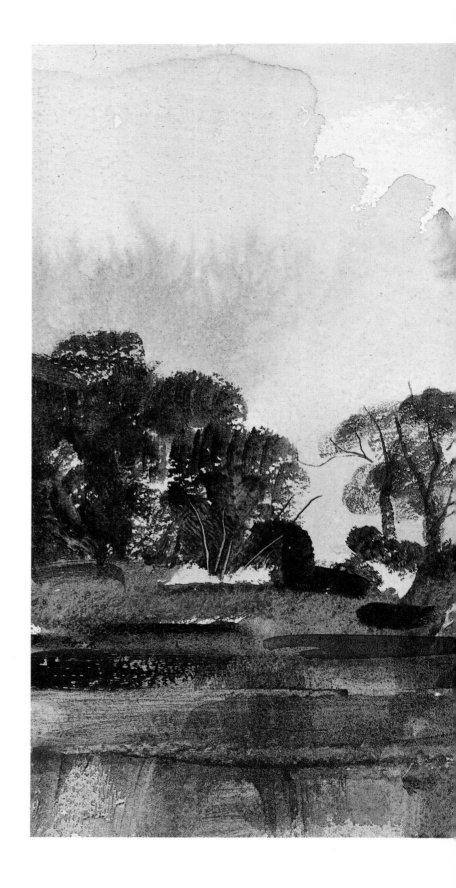

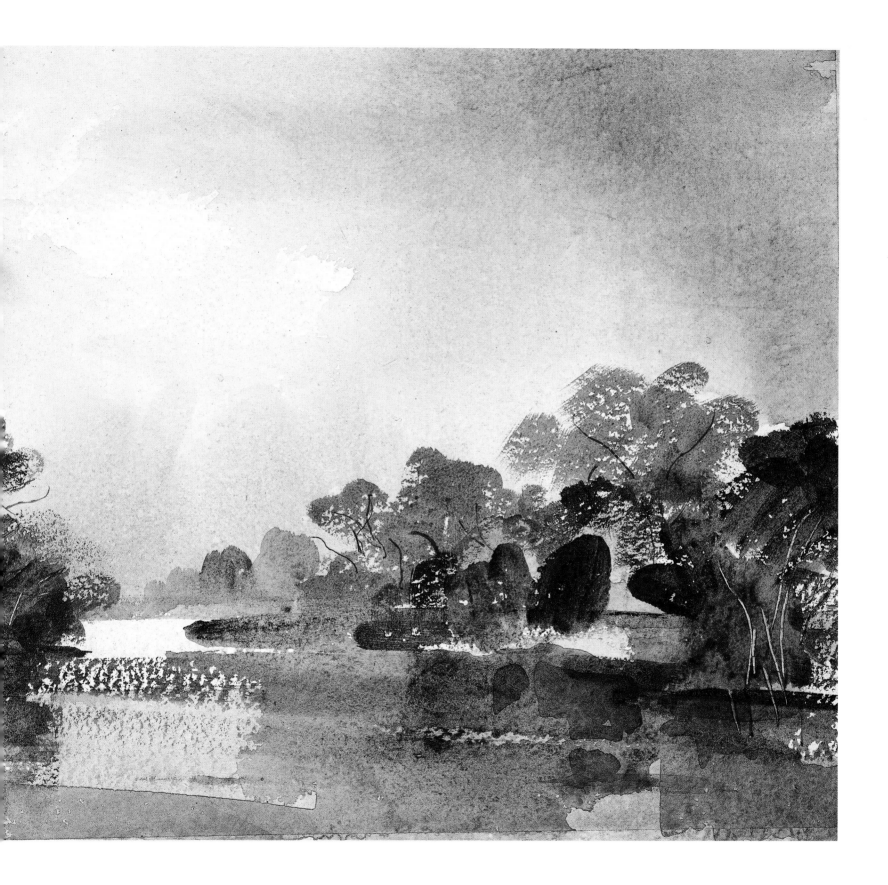

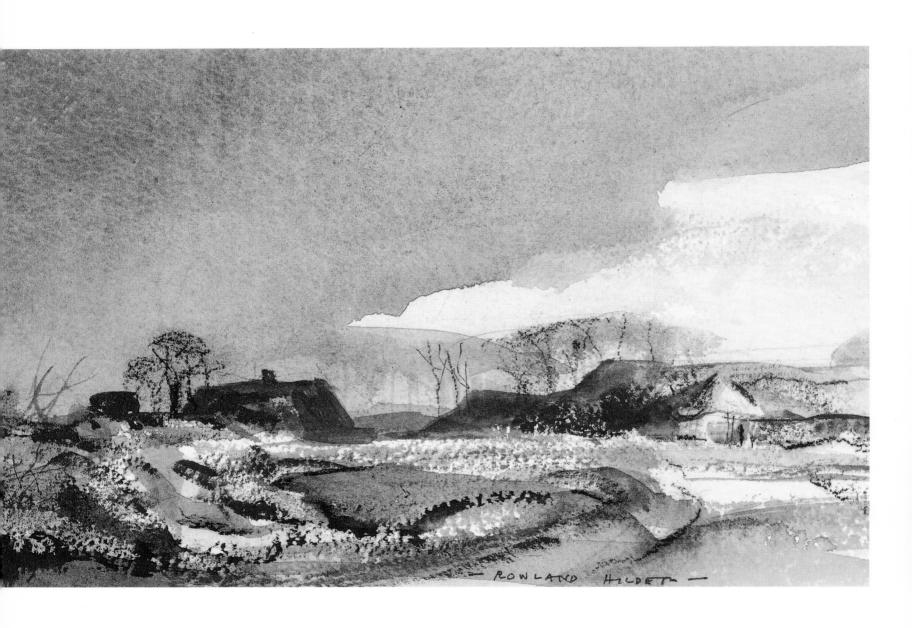

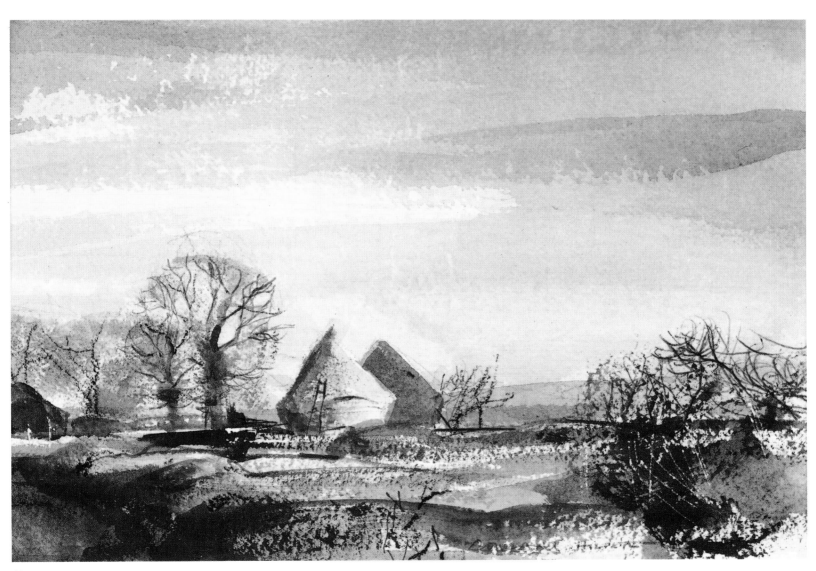

The techniques of sketching do not change – we are at one with the
landscape sketchers of old, responding with the same simple means.
But I do miss those Monet-shaped haystacks . . .

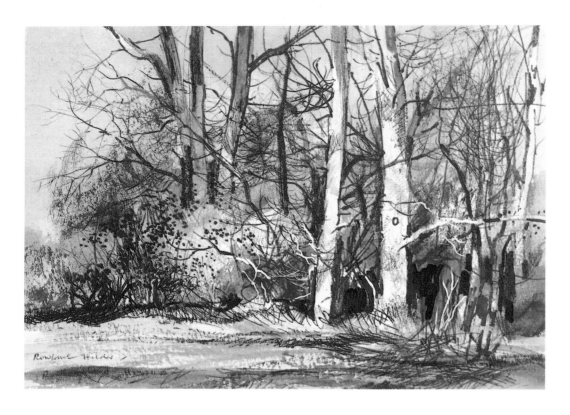

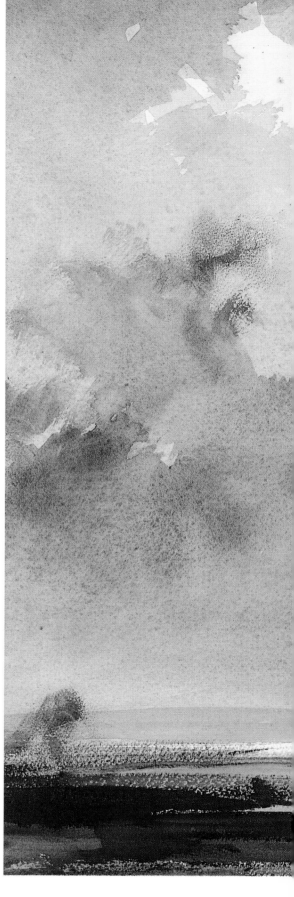

Some images stay in
the mind as places half-
remembered yet still,
somehow, within
our ken

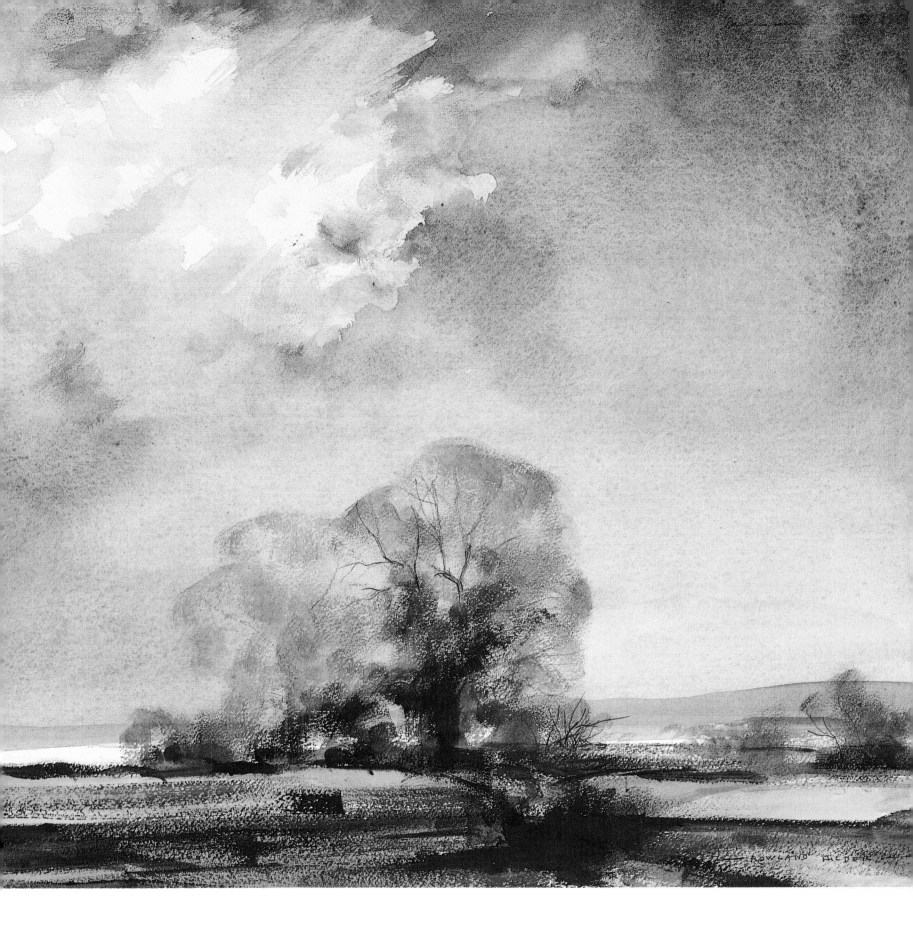

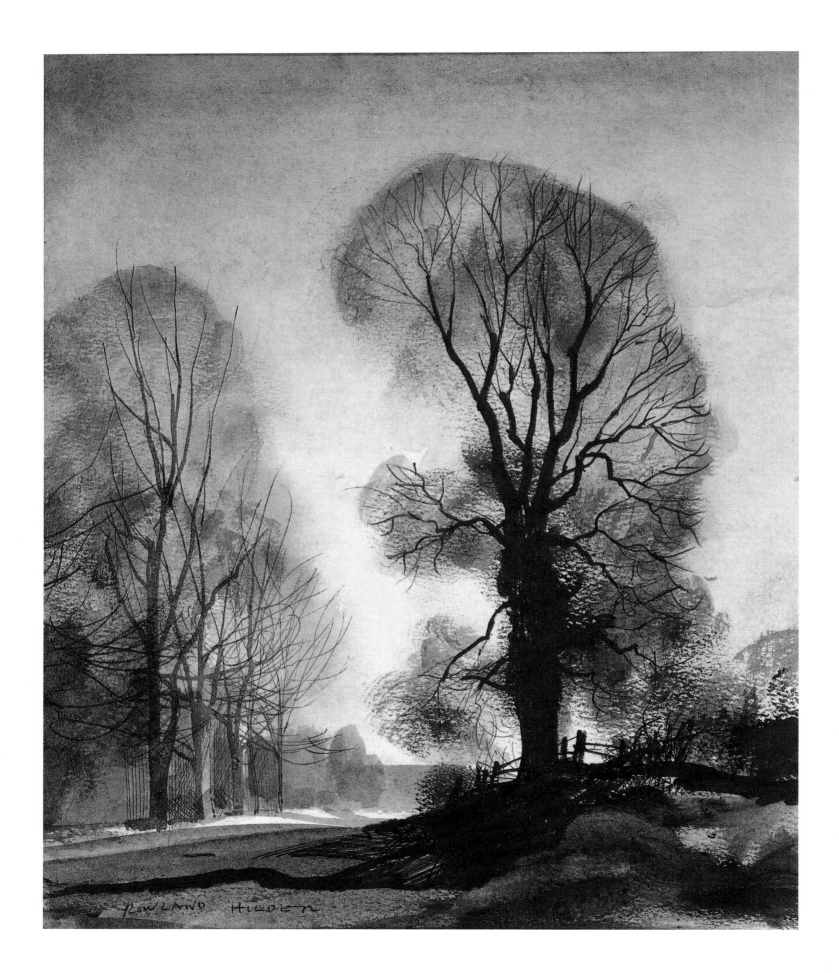

ROWLAND HILDER

Winter, for me, has been no less fruitful a season than spring or summer – a time when Nature lets her bones show through

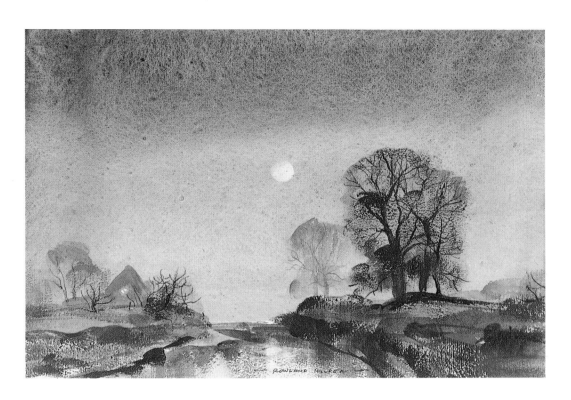

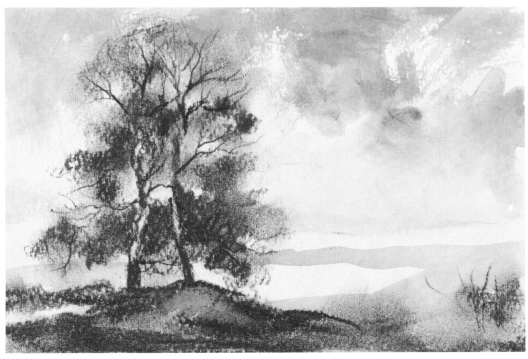

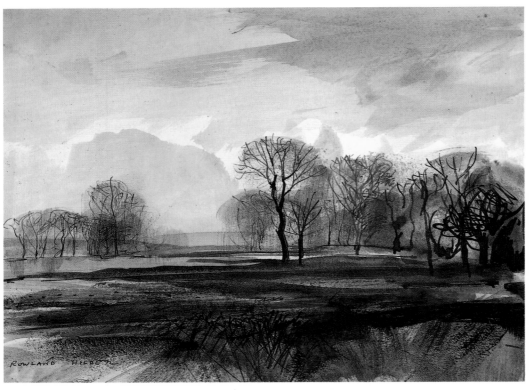

The satisfactions of landscape sketching have little to do with fine weather: that, at least, is my experience over these past sixty years.

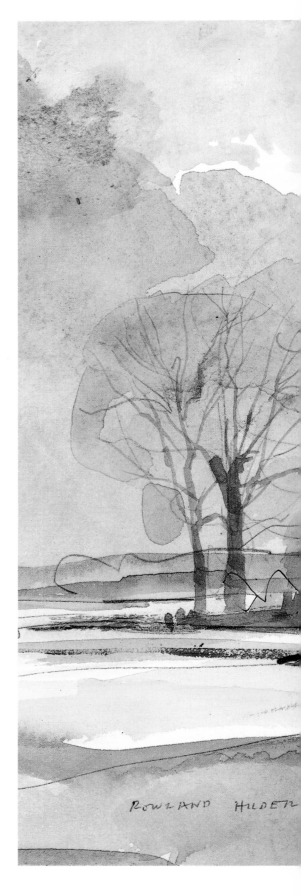

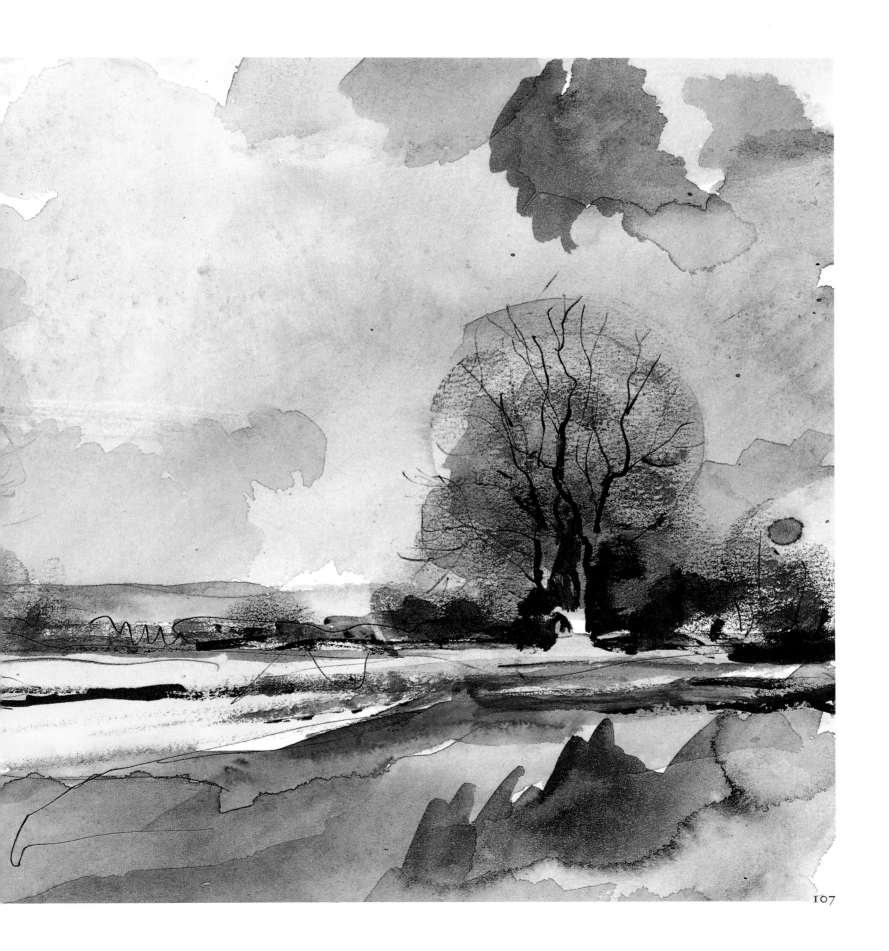

My 'discovery' of England's winter landscape led me into the countryside and to compositions that aimed at the age-old dignity of working on the land

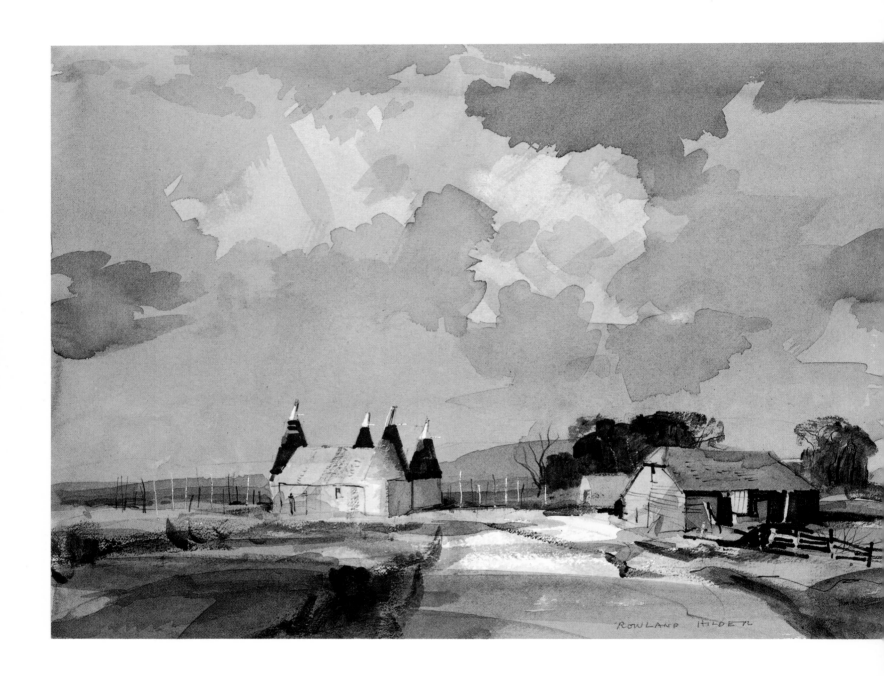

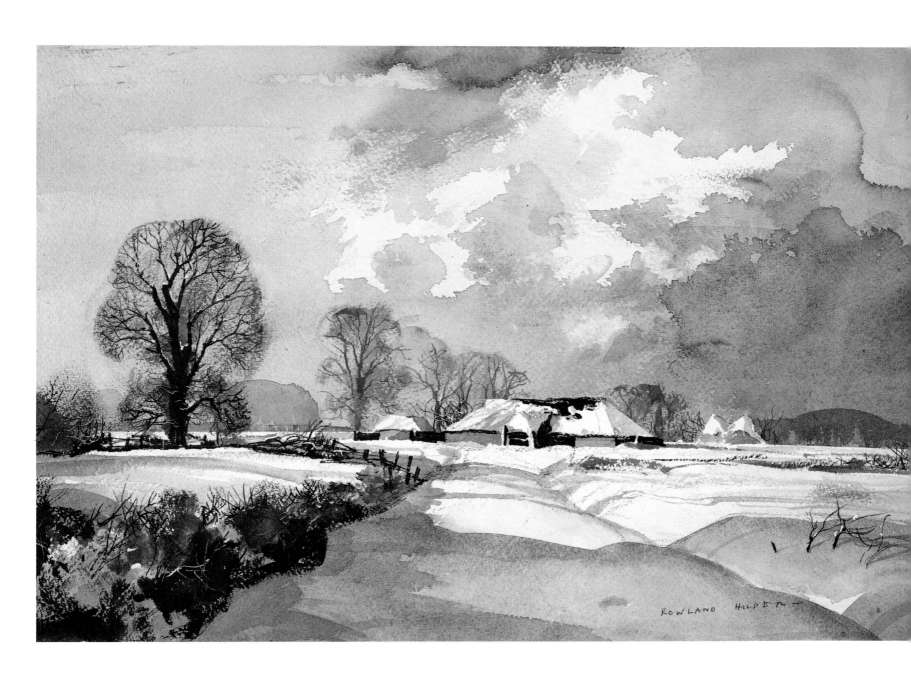

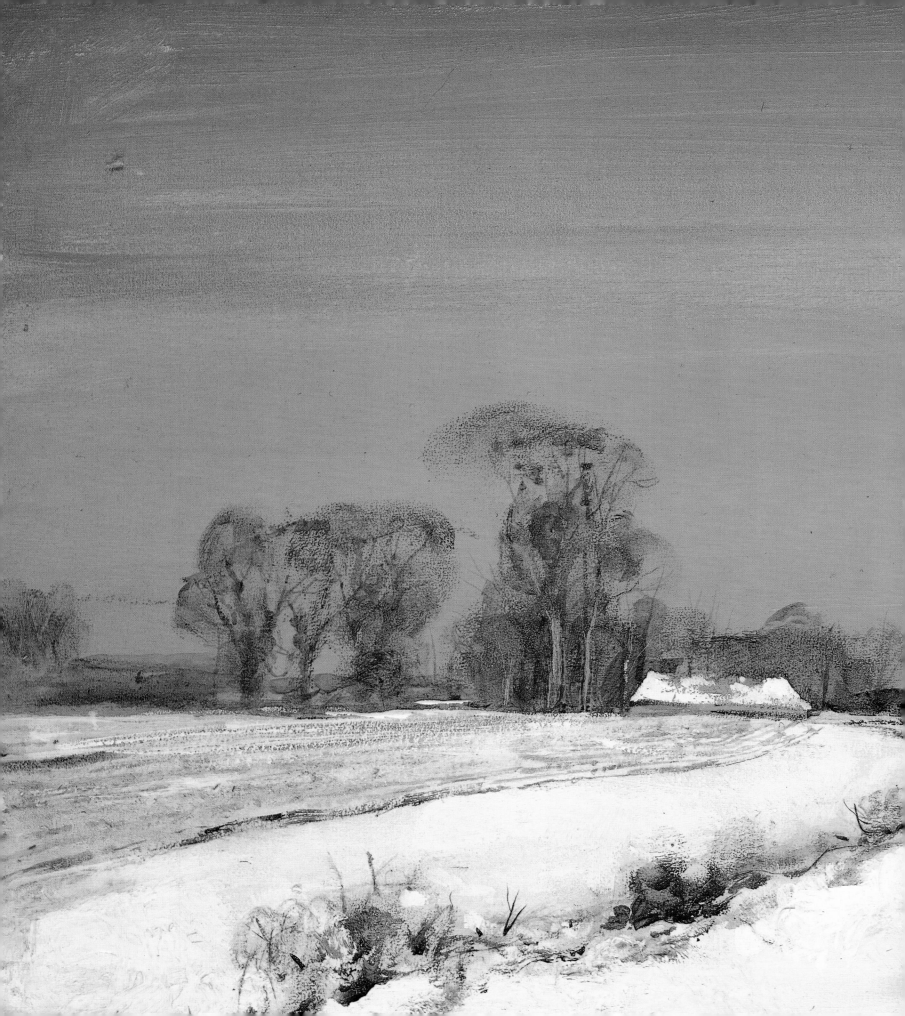

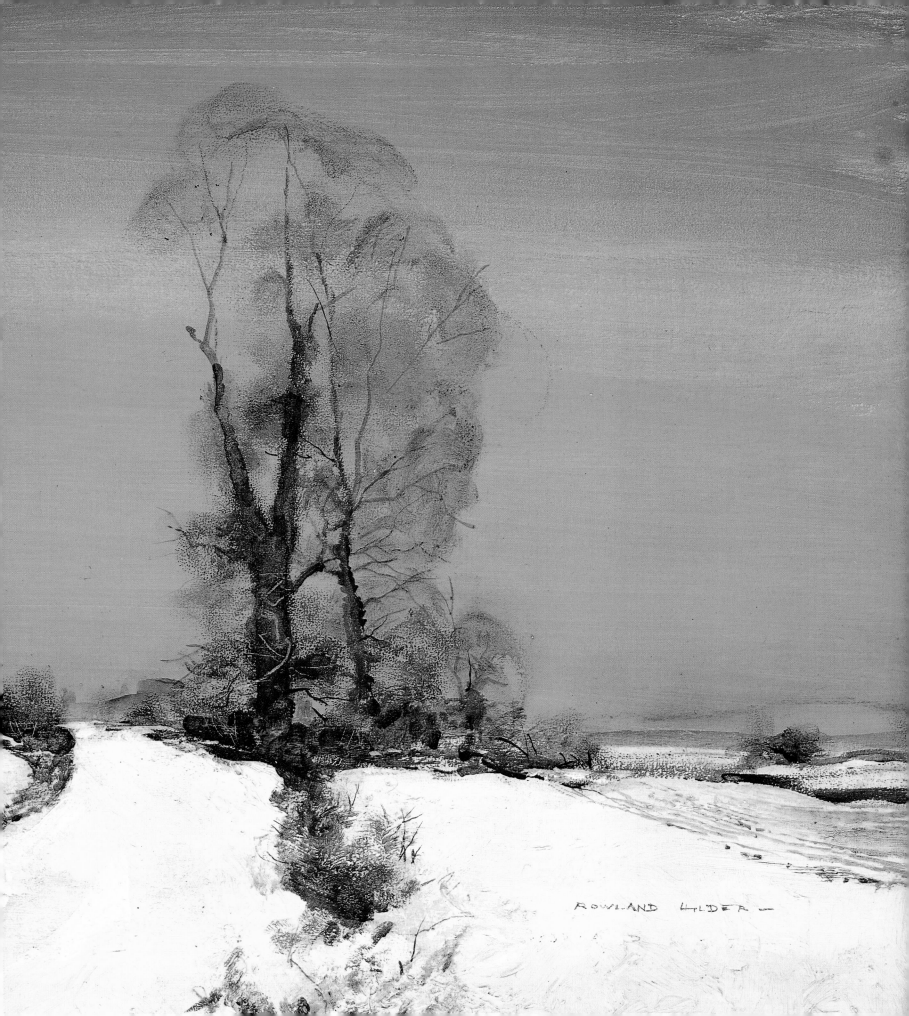

ROWLAND HILDER

A View from the Studio

As WELL AS fields, woods, rustic buildings and rolling skies, a landscape painter needs his studio. That is where sketches and studies brought home from excursions into the countryside may be developed into the kind of works that people hang on their walls. But the essential atmosphere of sketching on the spot – the spontaneity that few artists manage to recapture once they get home – remains for me the very essence of the landscape painter's craft.

My own studio is really an airy workroom, with large windows facing the garden, a high ceiling, and enough space for me to store paper, materials and other necessities, as well as deep shelves where I keep my stock of books on masters ancient and modern, from the early geniuses such as Claude Lorrain and Rembrandt to the great Victorians – if that is not too mundane a word for Constable, Turner, Palmer, Cox and their generation – and such contemporaries as Paul Nash, Seago and Topolski. Usually there are prints and postcards of other artists' work propped up around the place, which I change from time to time, to help keep me on the rails. These images have as their neighbours current works of my own, which I like to feel have a place in this jumble of mixed company.

As for my own exercises, brought back from visits to my various painting-grounds, I like to keep them small, so as not to have to worry too much about handling roomy areas of unpredictable watercolour. I have stressed, in my various accounts of my methods for the benefit (I hope) of others, that sky sketches done on the spot are the only way of handling light and cloud, and conveying the delicate essentials that made the subject worth sitting down to in the first place. It may seem a contradiction, but a subject worth sketching needs more attention than a glance. In the pages that follow I have picked out examples of how this process can lead to particular effects, without actually 'escaping' from what I might have had in mind when I started out, squatting on some handy tussock or in a gently rocking boat. However they come out, they speak for themselves.

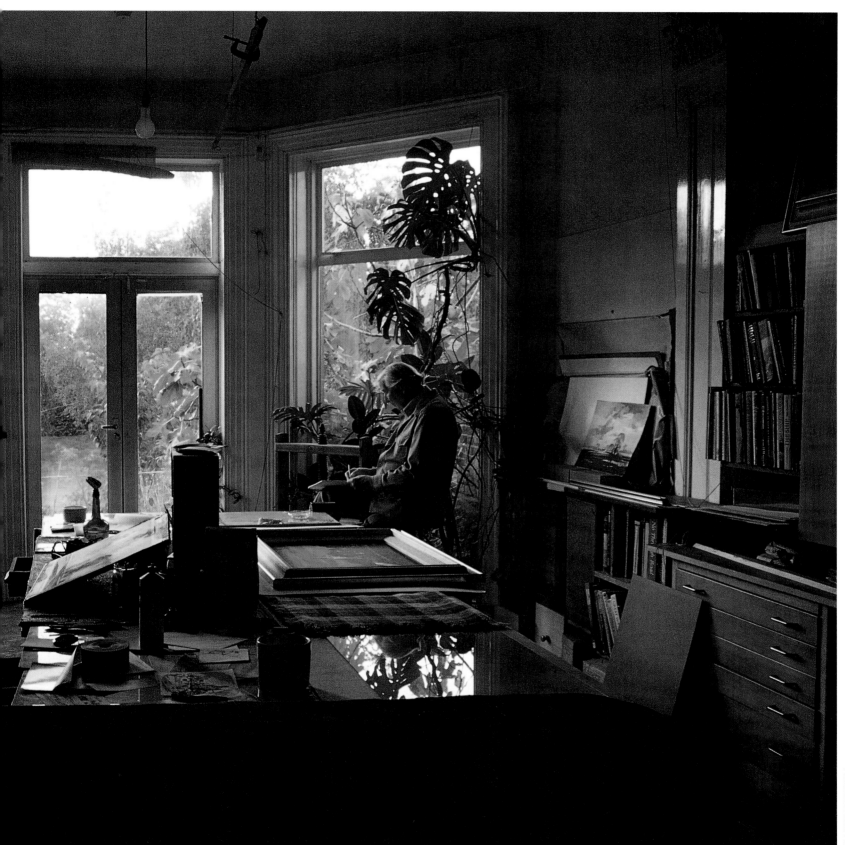

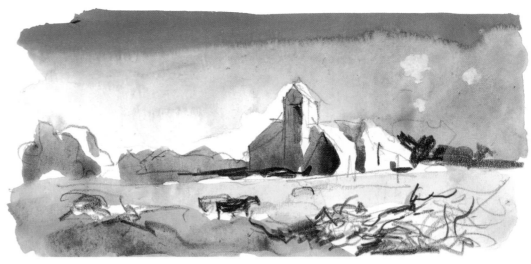

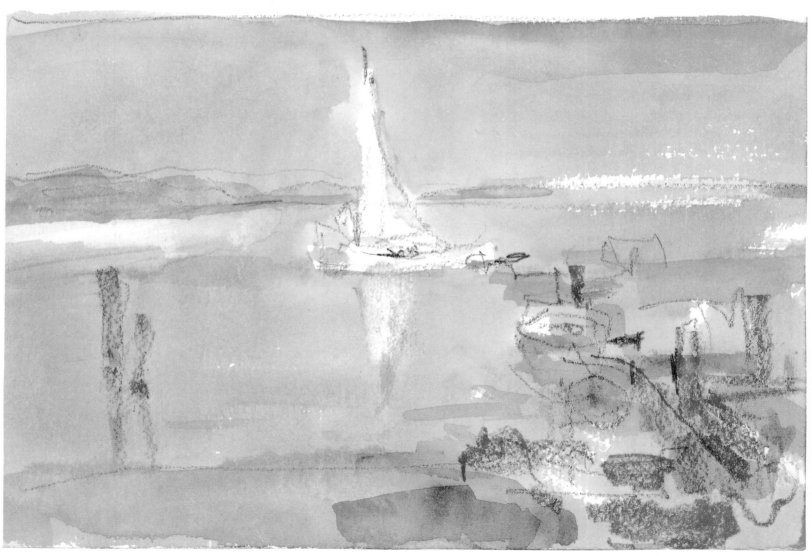

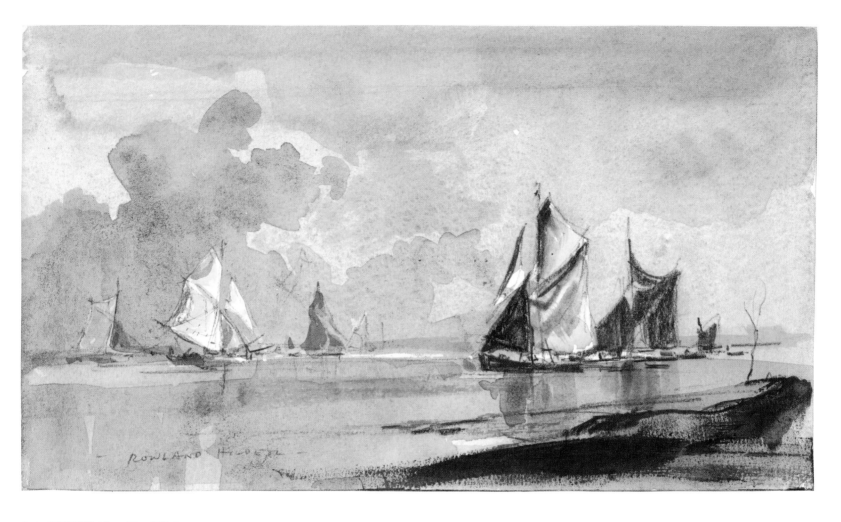

Sketches and studies brought home from excursions into the countryside may be developed into the kind of works that people are kind enough to hang on their walls.

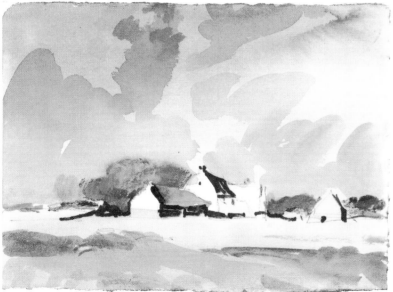

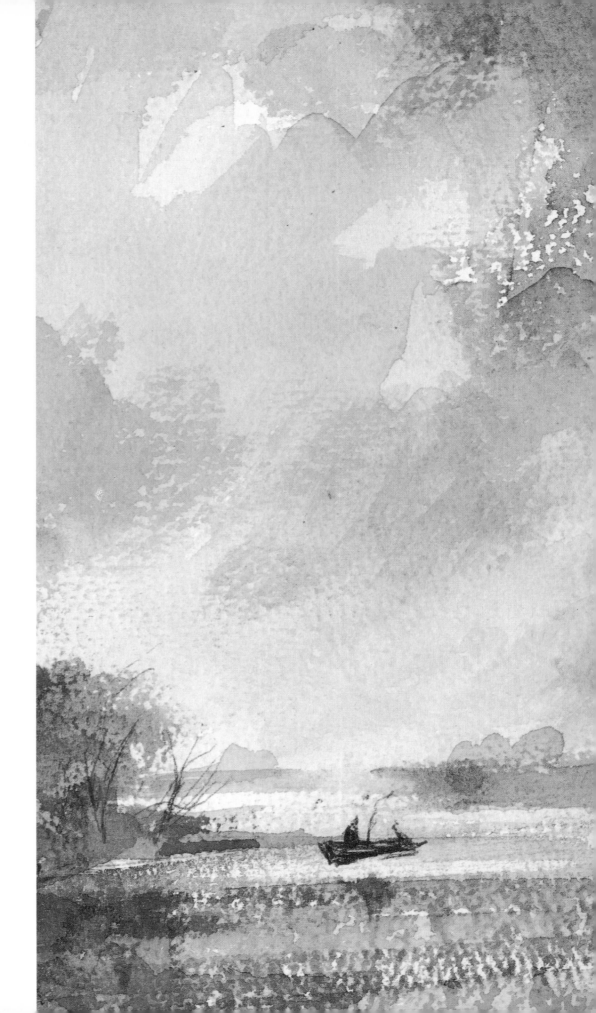

Ever since Claude Lorrain, the true landscape sketcher has allowed the light to work its mysterious way, infusing Nature with the spirit of the place

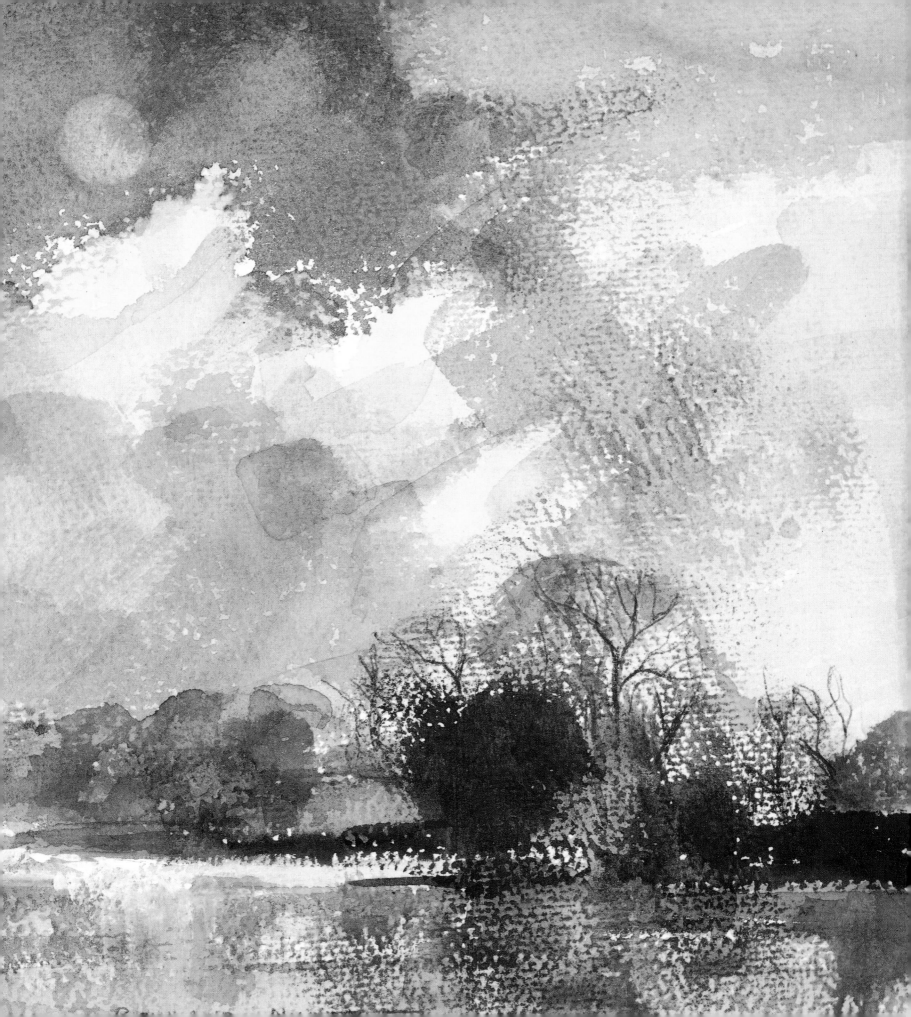

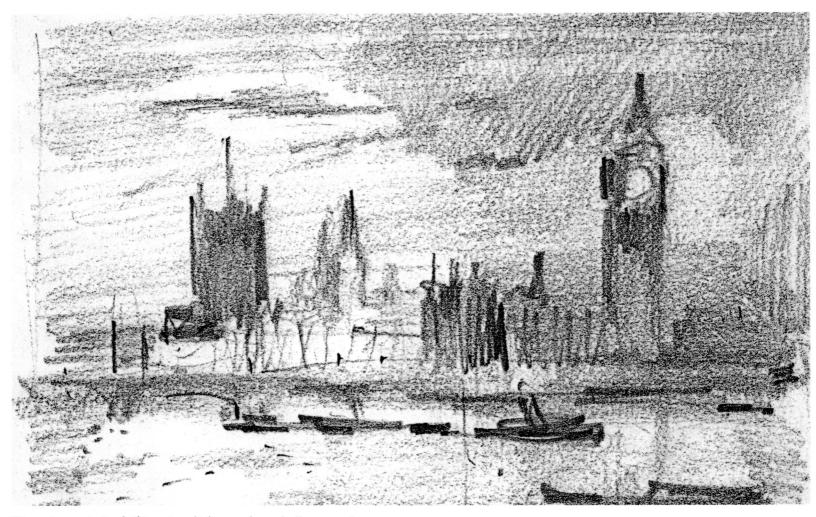

Westminster, in its drifting river light, can be a challenge to the
sketcher seeking an impression rather than a documentary record.
The soft-pencil sketch above was the basis of my more developed
– though still deliberately 'loose' – study on page 33.

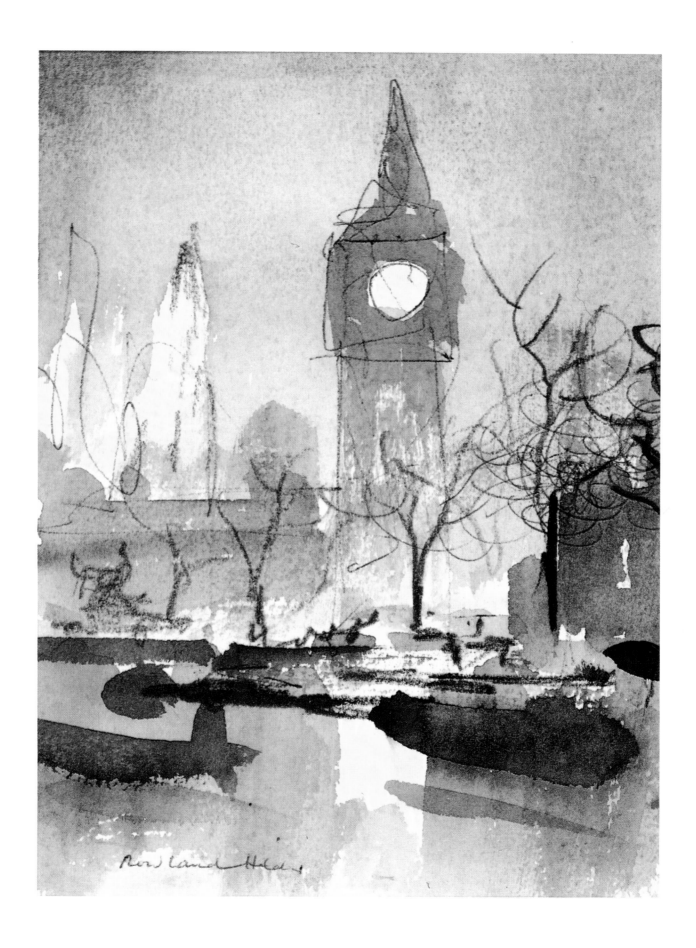

Rowland Hilder

It has taken some time for taste to change, to a point where a spontaneous colour note can sometimes take precedence over a 'finished' picture

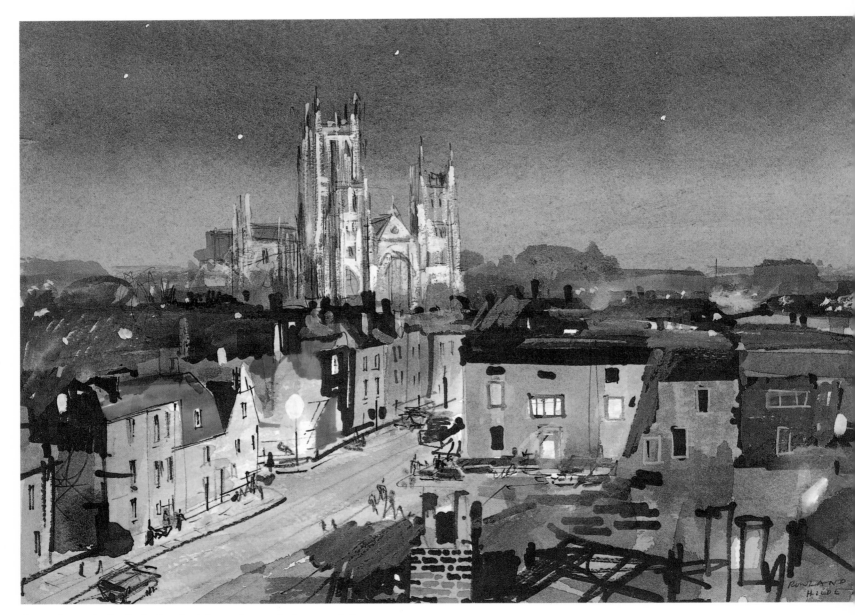

Canterbury Cathedral, sketched from the roof of a now defunct cinema close to the city centre.

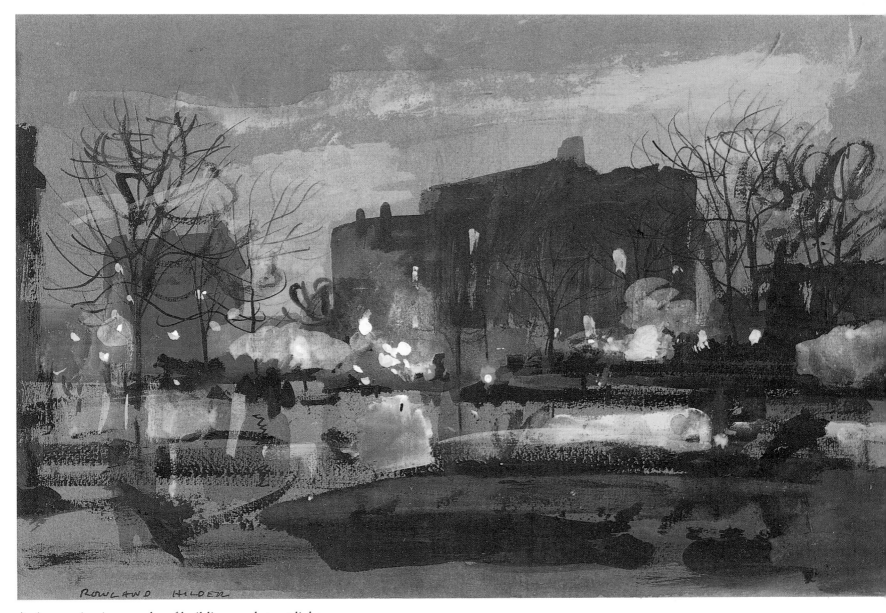

An impression in gouache of buildings and street lights
near Blackheath.

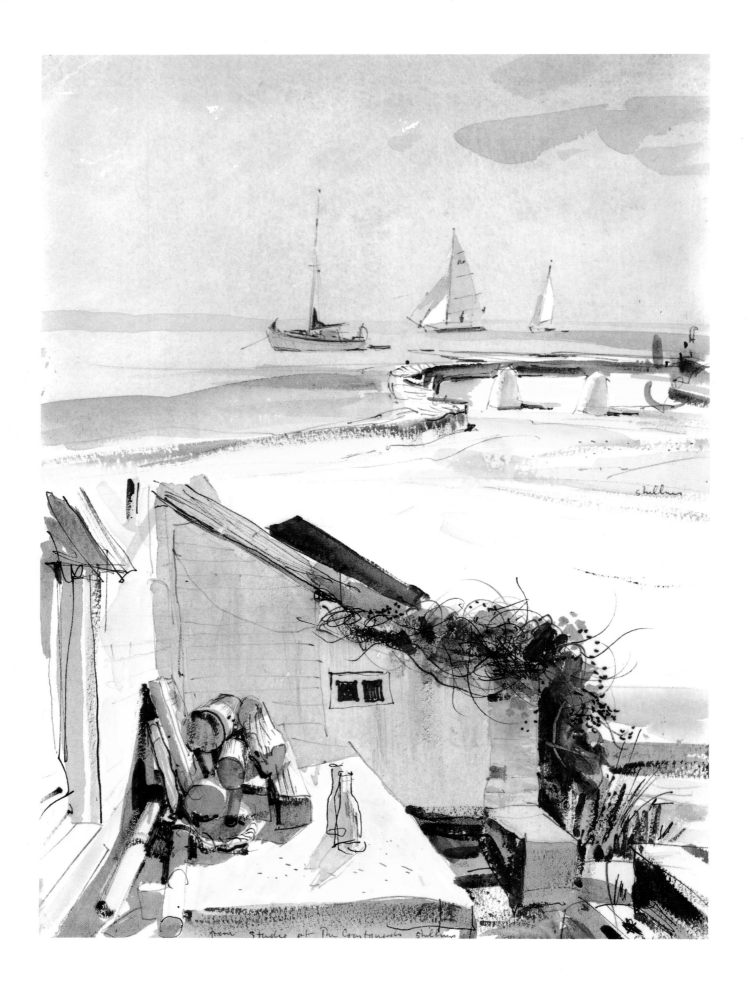

For years we have spent happy times sailing at Shellness, on the eastern tip of England, where we make ourselves as comfortable as we can in a former coastguard's cottage. Opposite is a page from a sketchbook showing the cottage and a boat of ours moored offshore. It is from this windy and salty base that several of the marine subjects in this book originated – fruits, you might say, of the sea.

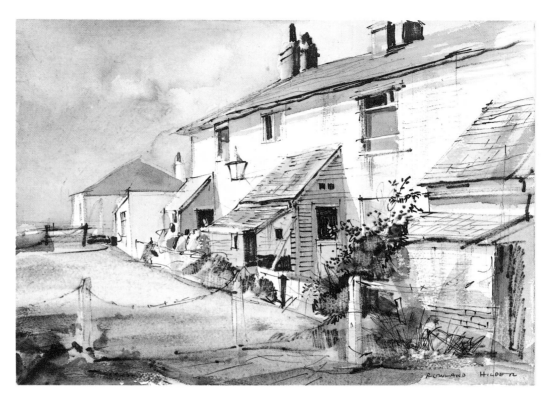

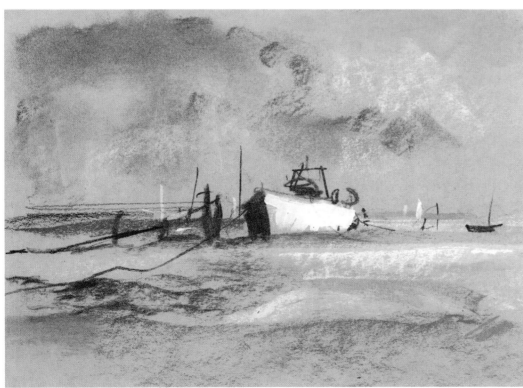

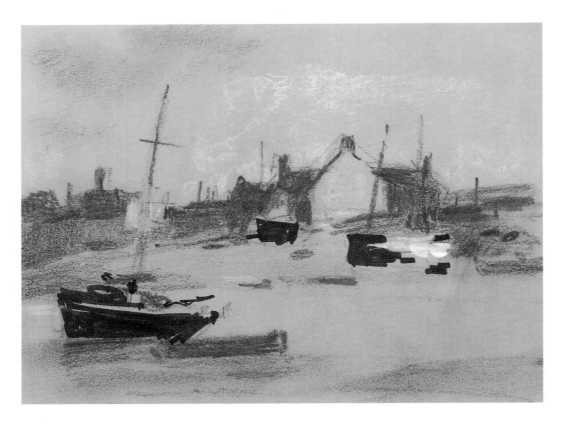

I like to keep my outdoor sketches small, so as not to have to worry too much about handling areas of unpredictable water-colour. With practice, 'small' can turn out to be 'beautiful'...

Opposite is a quick, unfinished figure study modelled by my wife Edith, who has shared the vagaries of an artist's life for over sixty years.

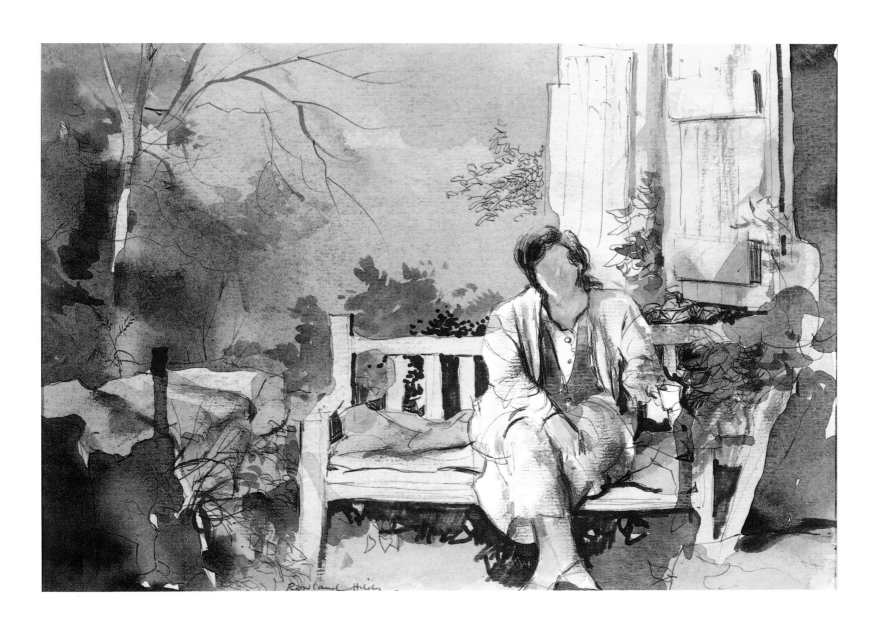

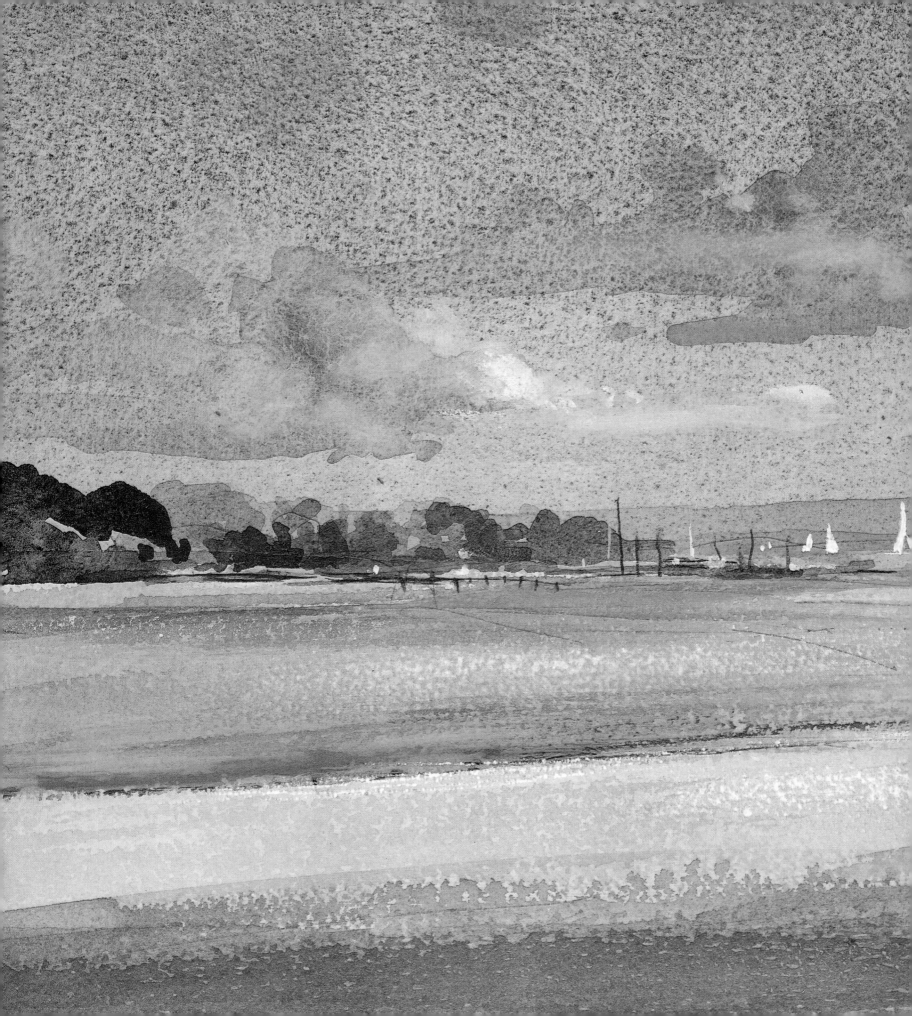

Retro Sydney

Nathan Mete is a civil engineer from the Northern Beaches of Sydney with a keen interest in the postwar history of Sydney, and the founder of the popular Instagram page @retrosydney_, which has attracted over 100,000 followers.

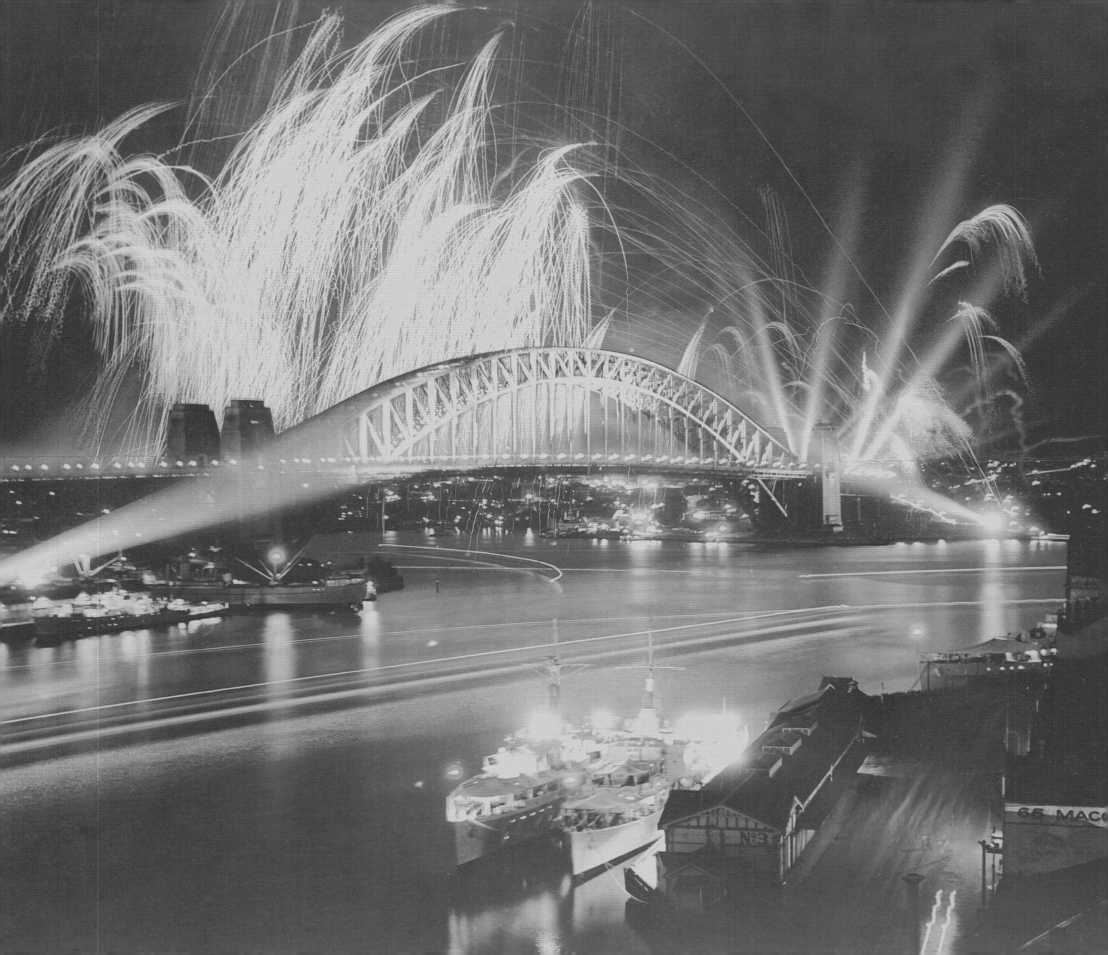

RETRO Sydney

1950–2000

NATHAN METE

SCRIBE
Melbourne • London

Scribe Publications
18–20 Edward St, Brunswick, Victoria 3056, Australia
2 John St, Clerkenwell, London, WC1N 2ES, United Kingdom
3754 Pleasant Ave, Suite 100, Minneapolis, Minnesota 55409, USA

Published by Scribe 2023

Typeset in Tiempos Text by the publishers

Printed and bound in China by 1010 Printing Limited

Scribe is committed to the sustainable use of natural resources and the
use of paper products made responsibly from those resources.

Scribe acknowledges Australia's First Nations peoples as the traditional
owners and custodians of this country. We recognise that sovereignty was
never ceded, and we pay our respects to their elders, past and present.

978 1 761380 53 2

A catalogue record for this book is available from the National Library of Australia.

scribepublications.com.au
scribepublications.co.uk
scribepublications.com

Contents

Introduction 1

the 1950s 3

the 1960s 27

the 1970s 53

the 1980s 93

THE 1990s 133

Author's note 154

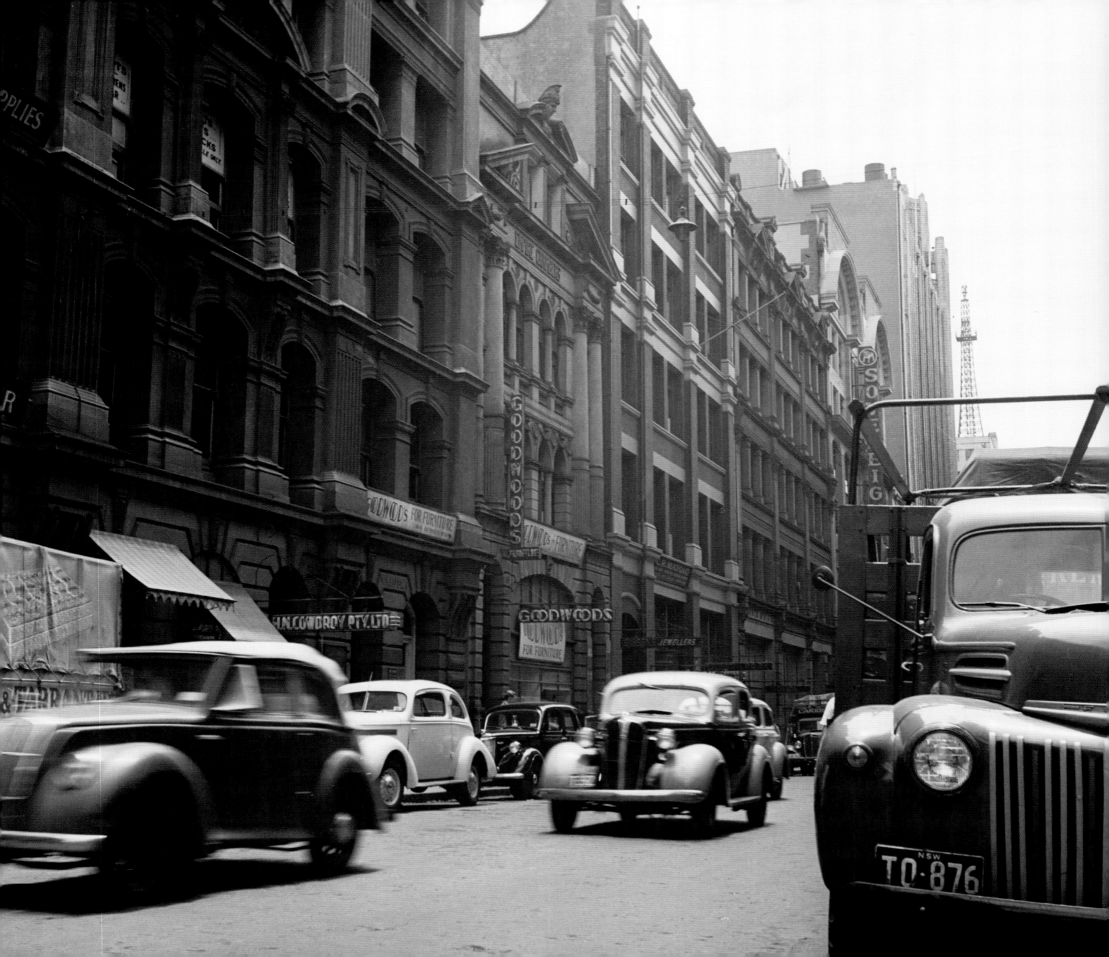

Introduction

I've always had a fascination with history, stemming mainly from the stories I used to hear from my migrant family. Both sets of my grandparents migrated to Australia from southern Italy in the 1950s to start a new life, settling on the Northern Beaches of Sydney, which, at that time, was a unique mishmash of beachside Australian suburbia and surrounding rural farming land. It would have reminded them, I imagine, of the farming pastures in the rural and hilly outcrops of southern Italy.

I often wonder what it would have been like coming to a country carrying a suitcase of clothes and a few possessions, with no money, no job, and no home, not even knowing the language, and yet hopeful of starting afresh after experiencing immense poverty after the Second World War. Out of that fascination with my family's experiences as migrants, I developed an obsession with the city of Sydney during the second half of the last century.

I was also obsessed with true crime (plot twist: yes, I love true crime podcasts), and places where the everyday Sydneysider could encounter the infamous underworld — the Cross, the nightclubs, bars, and nightspots.

Delving into the past, and watching Sydney grow into an international metropolis, has been exciting. The photographs that I have chosen to feature in this book are among some of my favourites, all of which I love researching and posting on my *Retro Sydney* Instagram account.

I hope that you will find this book immersive and that it will remind you of some of the reasons we love this city; hopefully it will bring back some wonderful memories, too, if you were lucky enough to experience what I like to call 'the golden age of Sydney'.

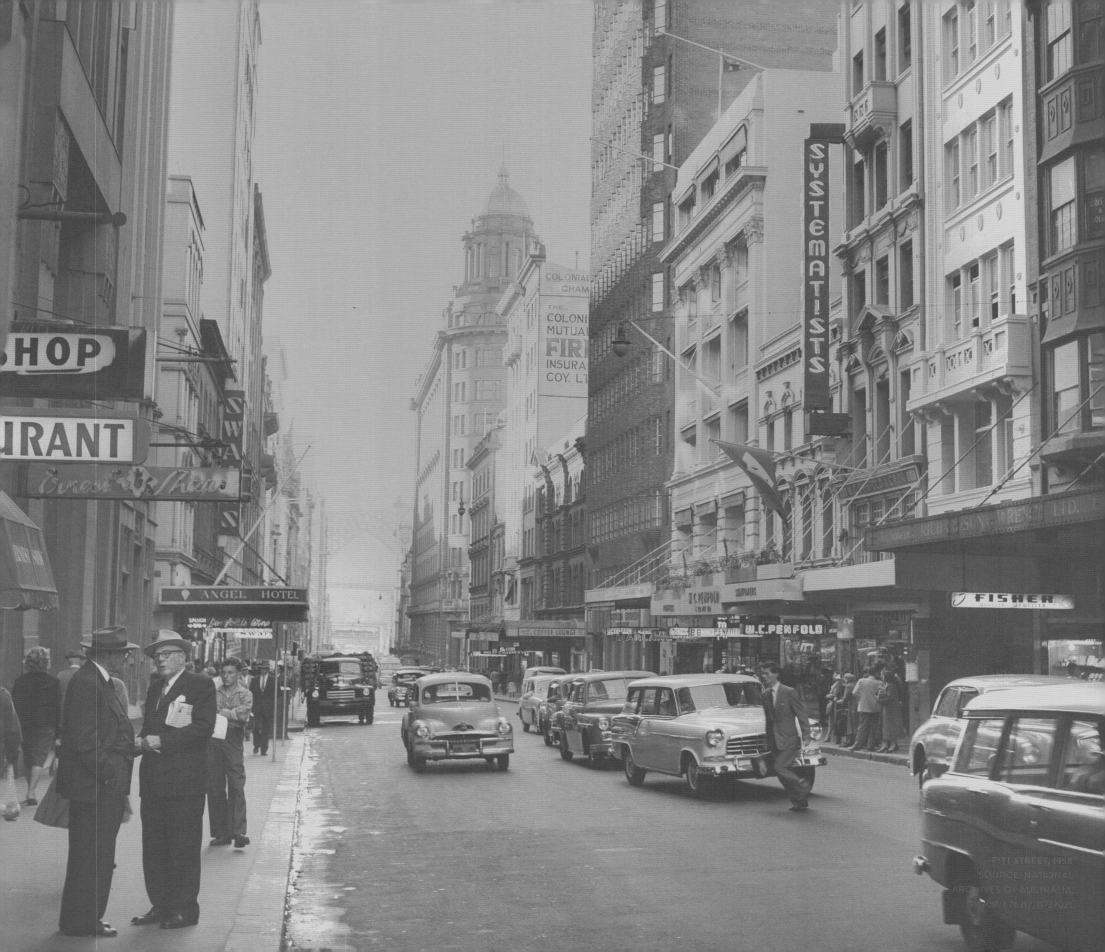

the 1950s

The 1950s in Australia brought great change — especially for Sydney. In the shadow of the Second World War, many migrants escaping from the extreme hardships of Europe saw Australia as a haven and a land of opportunity.

Sydney was growing rapidly, with new housing estates popping up on the outskirts of the city. Many services that we now take for granted became commonplace in homes and businesses — mains water, sewerage, and electricity, giving rise to the latest in technological advances for the home such as the refrigerator, which replaced the ice box, and fancy new appliances.

Much of the farming land, particularly around the outer-western regions, started to be replaced with brick or fibro bungalows and new housing estates.

Along with the increase of urban sprawl and an influx of migrants was the rise of motor vehicle ownership. The manufacture of 'Australia's own car' — the Holden — in 1948 put vehicle ownership within reach for many Sydneysiders by the end of the decade. In 1941, there were 205,906 registered vehicles on New South Wales roads; by 1959, in Sydney alone, that number had grown to 515,297 private cars, 49,217 business vehicles, 88,653 trucks, and 12,841 buses.

The ageing tram system was also in decline, with many lines being replaced by diesel-powered buses. Tram services started to decline in 1949, and the first major closure affected the North Shore tram services, in June 1958, which were replaced with the Cahill Expressway on the Harbour Bridge.

One of the highlights of the decade for both Australia and Sydney was the visit of Queen Elizabeth II and the Duke of Edinburgh in 1954, when as many as 1 million onlookers crowded Sydney for their arrival in early February 1954. (To provide some context, the population of Sydney was 1,863,161 in the 1954 census.)

Sydney was starting to grow up. The completion of the AMP Building and other skyscrapers, and the beginning of construction in 1959 of our new Opera House, were changing the face of our city.

Southern Pylon lookout
Harbour Bridge
1950s

PHOTOGRAPHER: MAX DUPAIN
SOURCE: MITCHELL LIBRARY, STATE LIBRARY OF NEW SOUTH WALES, V1-FL19449176

A couple admire the view of the harbour from the Southern Pylon lookout on the Harbour Bridge in the early 1950s.

This vantage point provided an excellent view of what the CBD looked like at the start of the decade, with no high-rise buildings, many of the charming and original Victorian and Federation-style commercial buildings in the CBD, and the original Overseas Passenger Terminal at Circular Quay West, the grand old fleet of ferries heading to and from Circular Quay, and Campbells Cove still a working dock.

Coogee Beach ▸
1950

SOURCE: NATIONAL ARCHIVES OF AUSTRALIA, A1200, L12996, 6849859

Here is a packed Coogee Beach well before the beachfront was landscaped, when motorists could drive along Beach Street, with a similar layout to its sibling Bondi. It's amazing to see the series of Norfolk Island pines that line the top of Baden Street on the right, at Dunningham Reserve.

You can also see one of the incarnations of the Coogee Palace on the corner of Beach and Dolphin Streets. The building was designed and built in 1887, originally housed pleasure gardens, baths, and an aquarium, and covered the whole block between Arden and Beach streets, as well as a series of shops underneath, as seen here.

However, it became rundown by the late 1970s. A conservation order was placed on the building in 1982, and then the dome collapsed in 1984. It was redeveloped and restored as The Beach Palace Hotel in 1987 before being purchased by the Merivale Group in 2014 and reopened as the Coogee Pavilion.

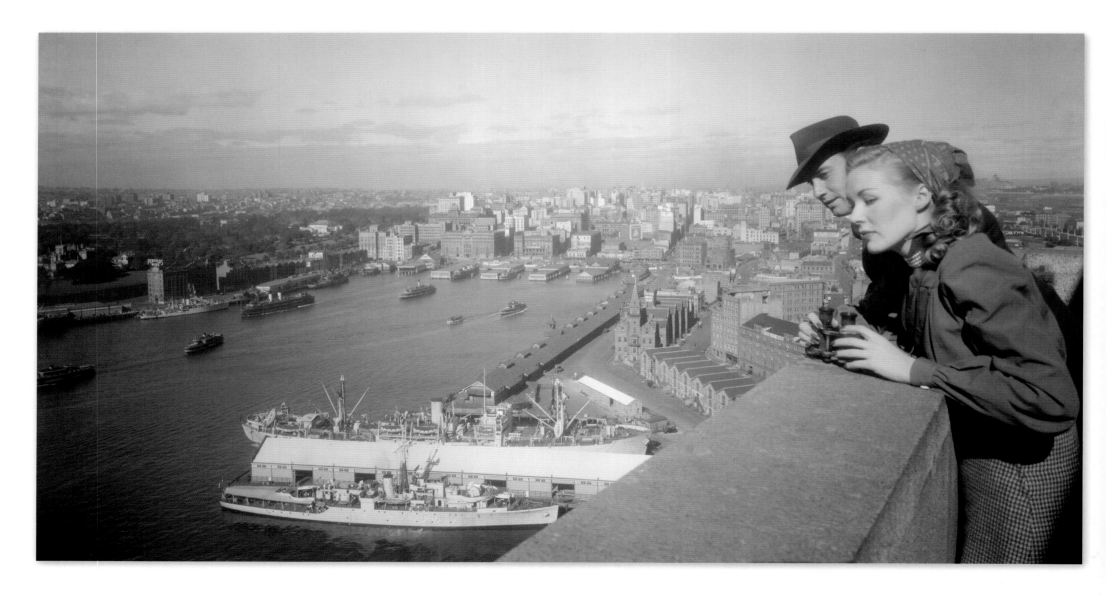

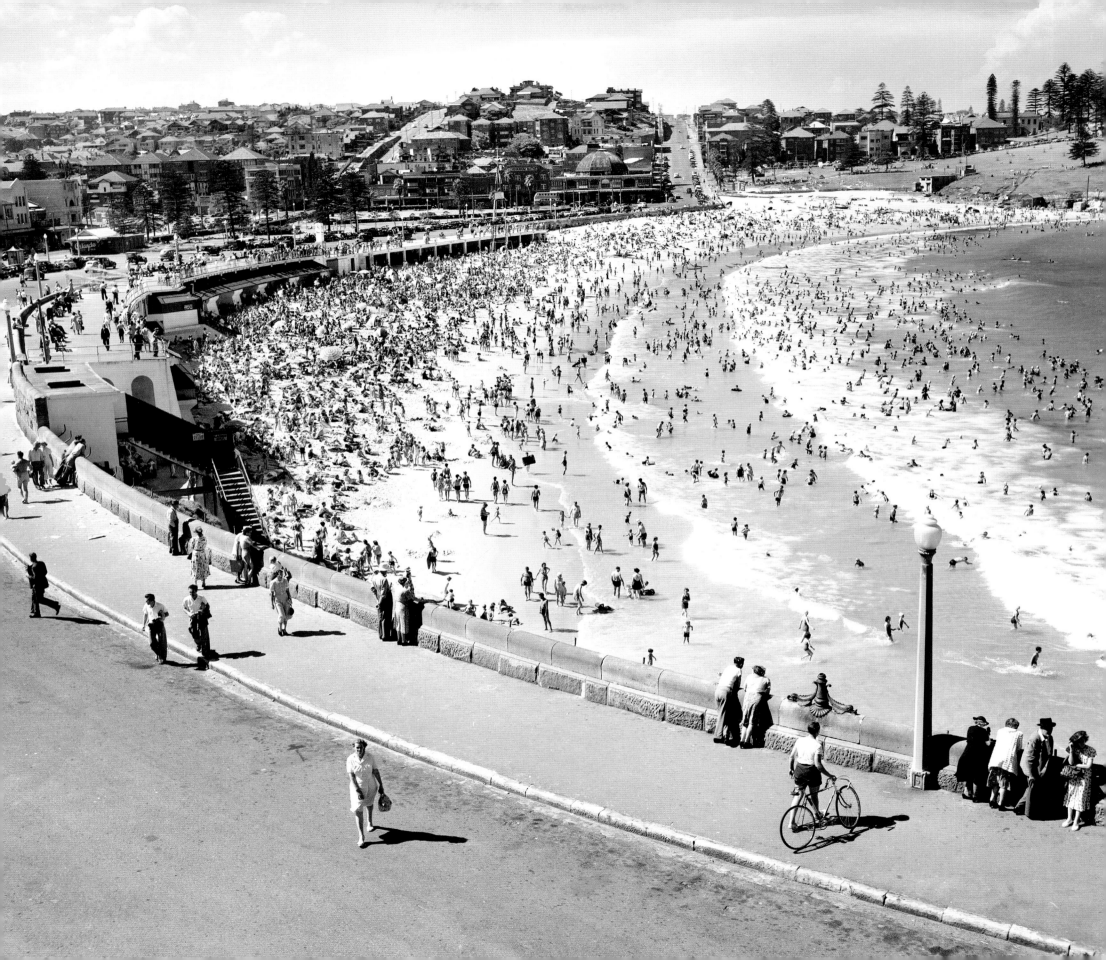

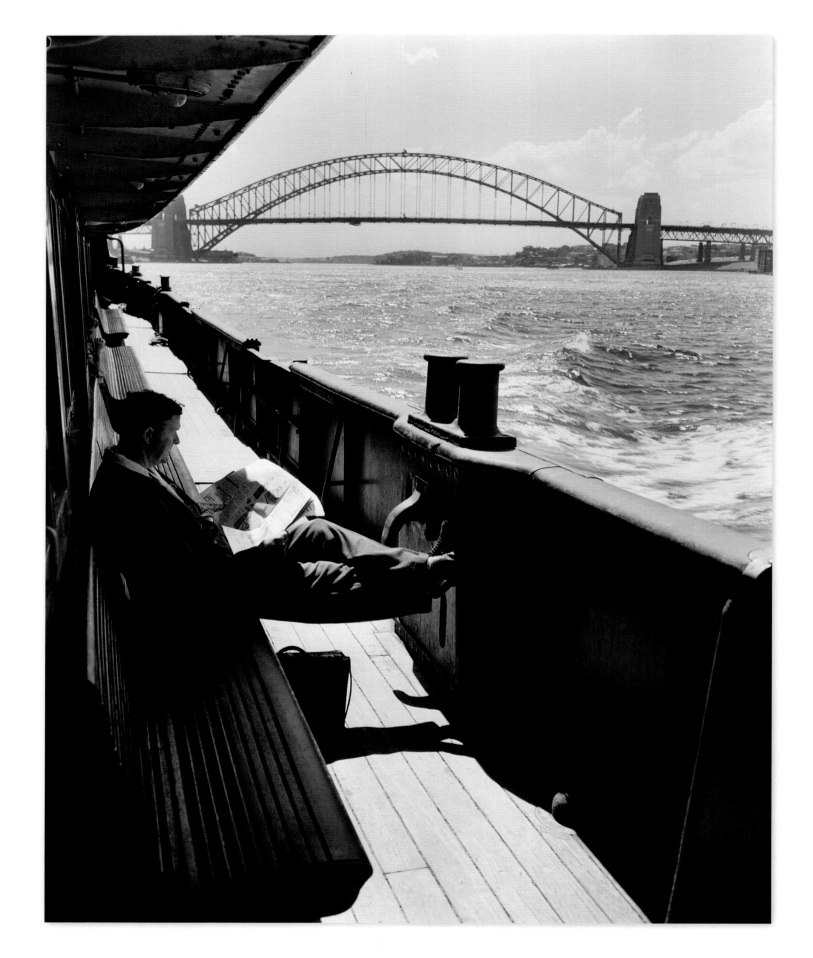

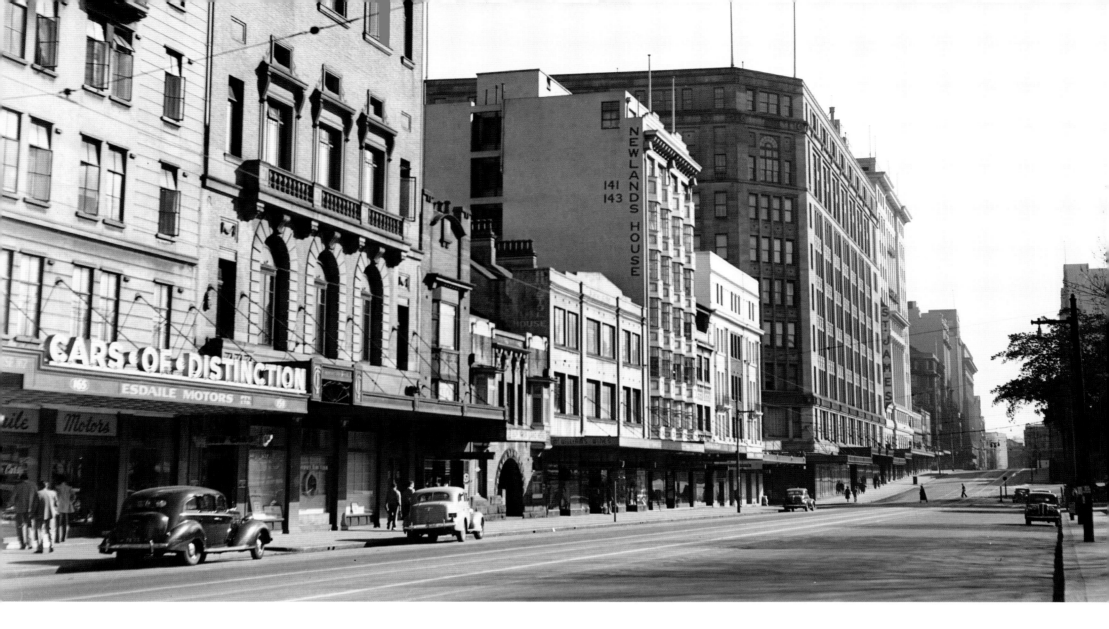

Sydney Harbour
1951

SOURCE: NATIONAL ARCHIVES OF AUSTRALIA, A1200, L13525, 7534031

A gentleman enjoys the commute from Manly to Circular Quay while reading the paper, with the backdrop of the Harbour Bridge to enhance the trip. This route is still enjoyed by many commuters and tourists as a way of getting to the CBD, and as an alternative to travelling by bus from the Lower Northern Beaches and Lower North Shore.

Elizabeth Street
1951

SOURCE: MITCHELL LIBRARY, STATE LIBRARY OF NEW SOUTH WALES
AND COURTESY ACP MAGAZINES LTD, V1-FL18935932

A very quiet Elizabeth Street outside Hyde Park, looking north towards the intersection of Market and Elizabeth streets in August 1951.

Some of the original buildings that lined Elizabeth Street are on the left, such as New Zealand House and Bristol House, which are now an office block and part of the Sheraton Grand Hotel, and in the distance the David Jones store on the corner of Market and Elizabeth streets.

You can also see the tram tracks along Elizabeth Street, which are yet to be removed.

Luna Park, Olympic Drive, Milsons Point
1952

PHOTOGRAPHER: IVAN IVES
SOURCE: MITCHELL LIBRARY, STATE LIBRARY OF NEW SOUTH WALES
AND COURTESY ACP MAGAZINES LTD, V1-FL9764475

Frocked up and riding the rollercoaster at Luna Park against the idyllic backdrop of the Harbour Bridge in November 1952.

Bondi Beach ▸
1952

SOURCE: NATIONAL ARCHIVES OF AUSTRALIA, A1200, L14518, 11413671

Miss Pacific finalists, Mary Clifton Smith, Pamela Janse, and Judy Worrad, running along the shore at Bondi Beach. These lovely ladies were scouted while attending the drive-in open-air motion picture theatre at Bondi. The accompanying note to this photograph states: 'Although all the girls were amateurs, they gave such an outstanding mass display of eye-catching charm that some later had modelling offers. Australia's beach girls are acknowledged to be among the world's loveliest.'

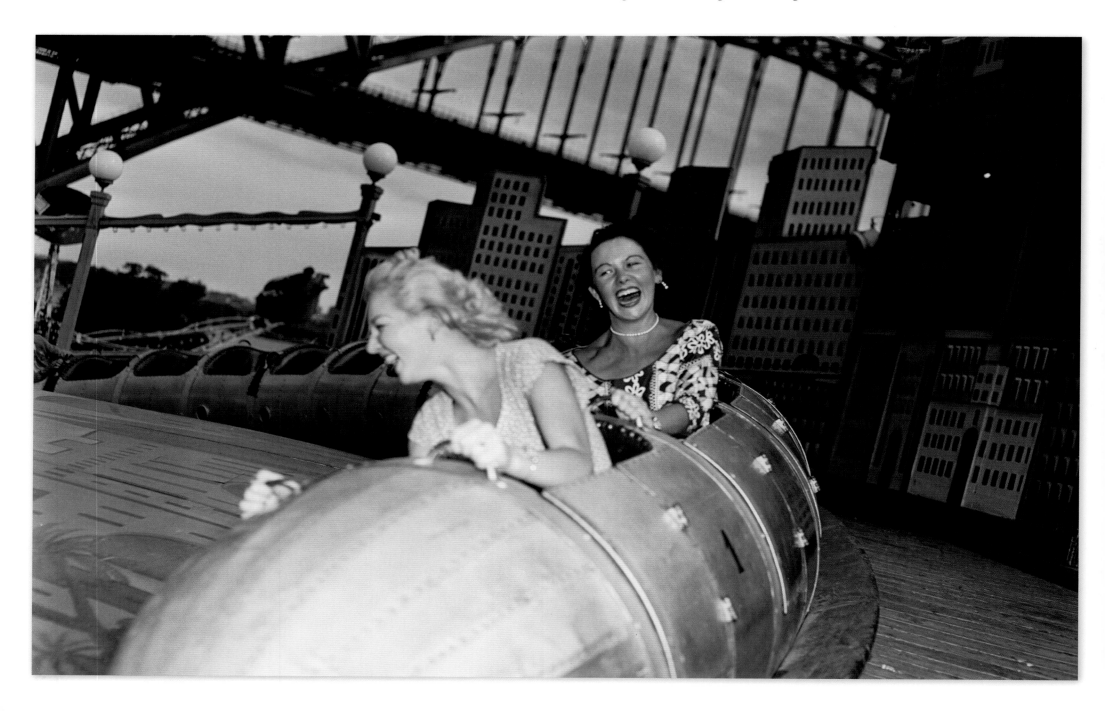

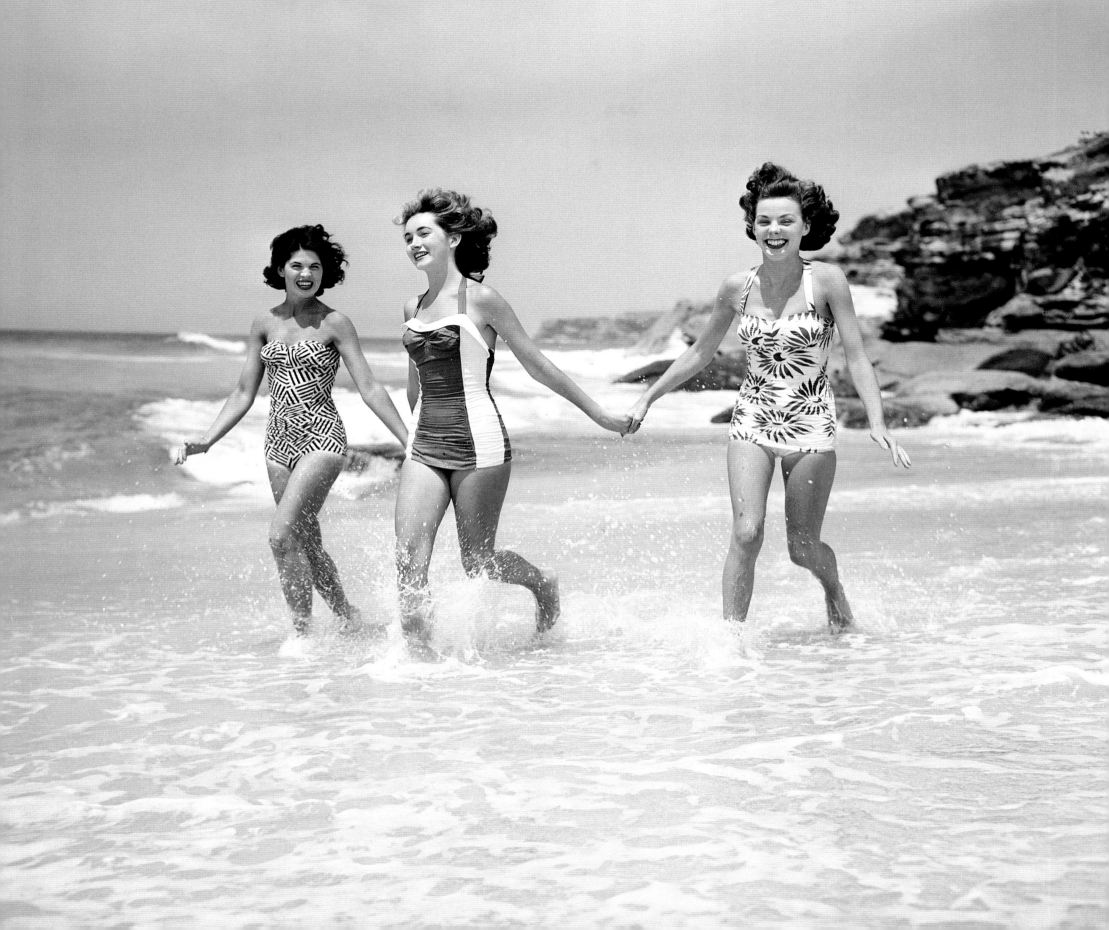

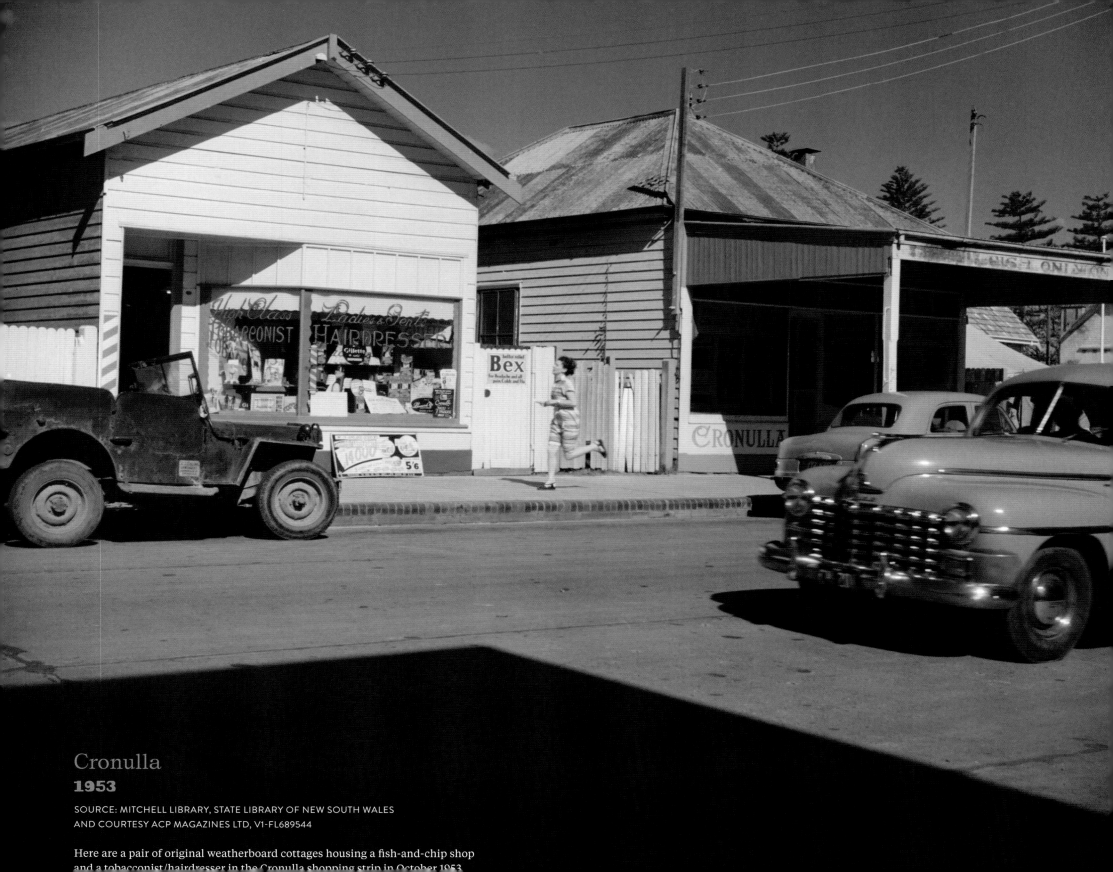

Cronulla
1953

Here are a pair of original weatherboard cottages housing a fish-and-chip shop
and a tobacconist/hairdresser in the Cronulla shopping strip in October 1953.

Sammy Lee's, Oxford Street, Paddington
1953

SOURCE: NATIONAL ARCHIVES OF AUSTRALIA, A1200, L16101, 11742896

Not quite the Folies Bergère, nightclubs and theatre restaurants were popular for a night out in Sydney during the 1950s — with their dancing girls and other floorshow entertainment, these became a weekly destination for many.

Clubs like The Roosevelt in the 1940s, then Sammy Lee's on Oxford Street in the 1950s and 1960s, and Chequers and The Latin Quarter during the 1960s were Sydney's hot spots of entertainment, headlined by some of the most famous international stars of the day, such as Frank Sinatra and Sammy Davis Jnr.

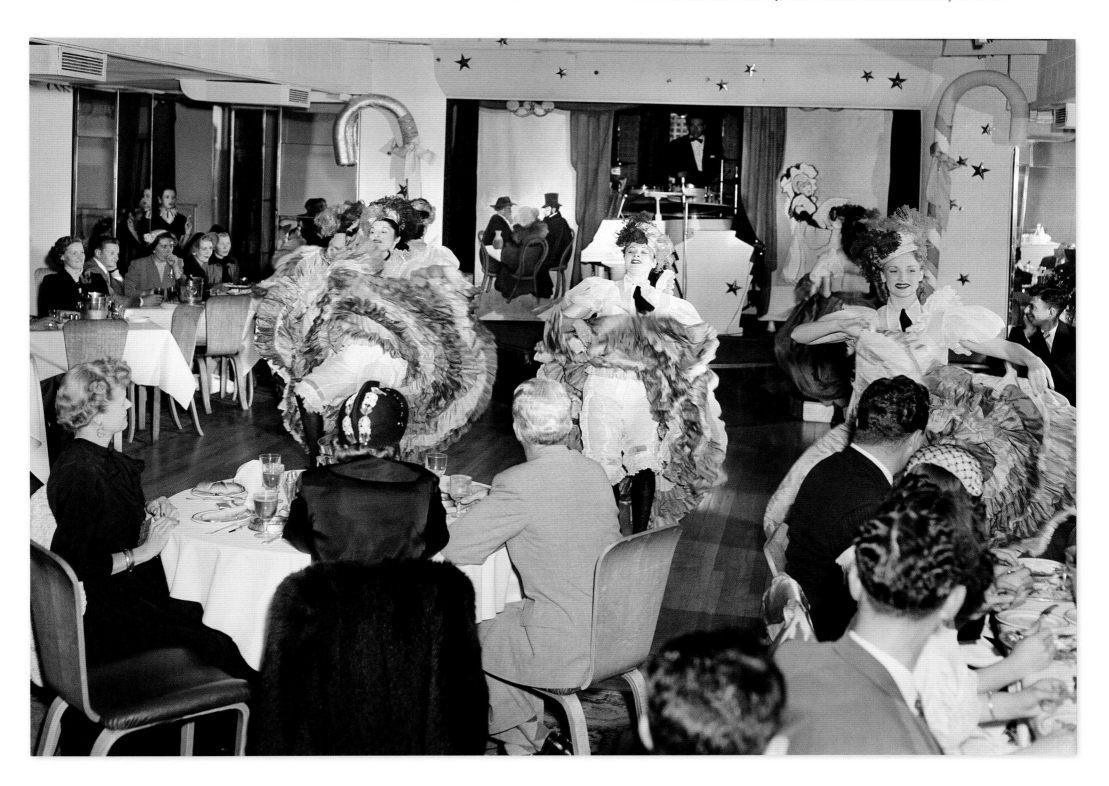

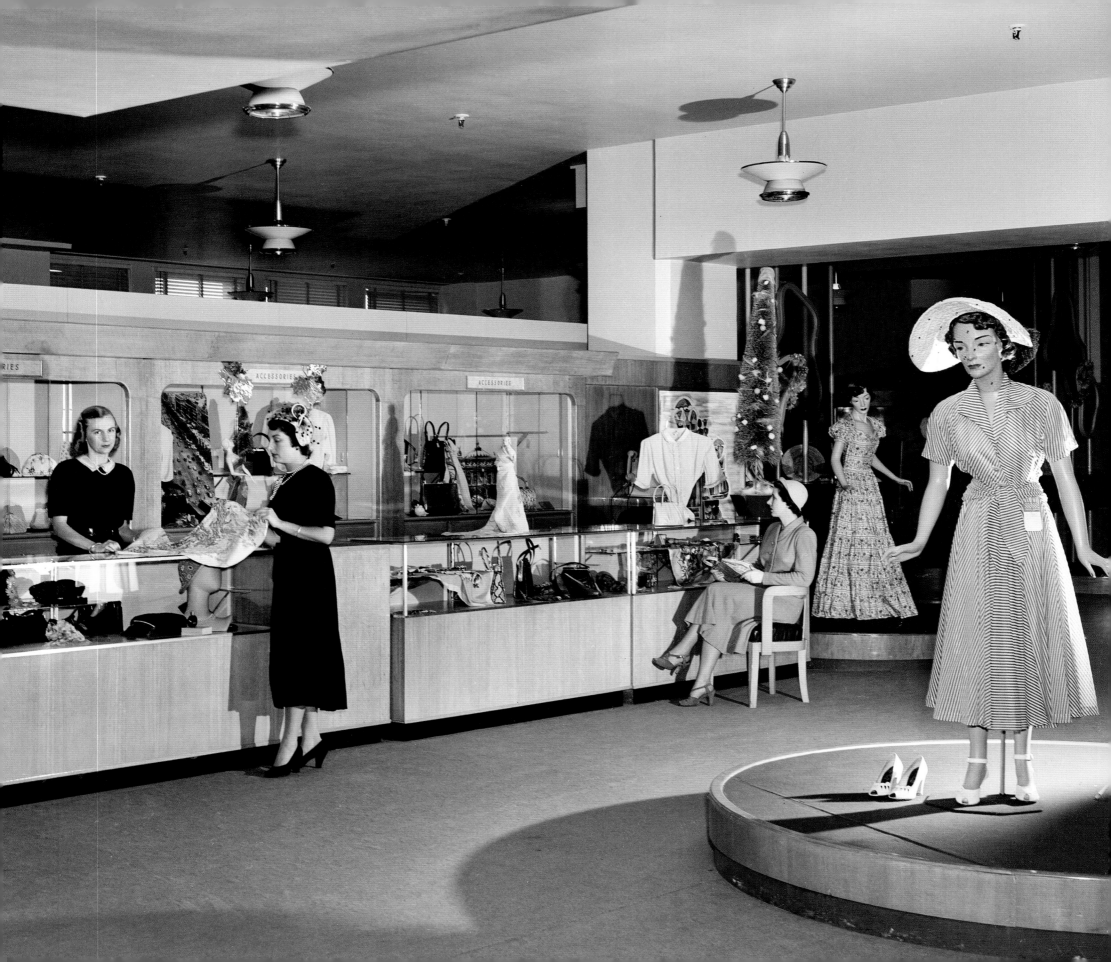

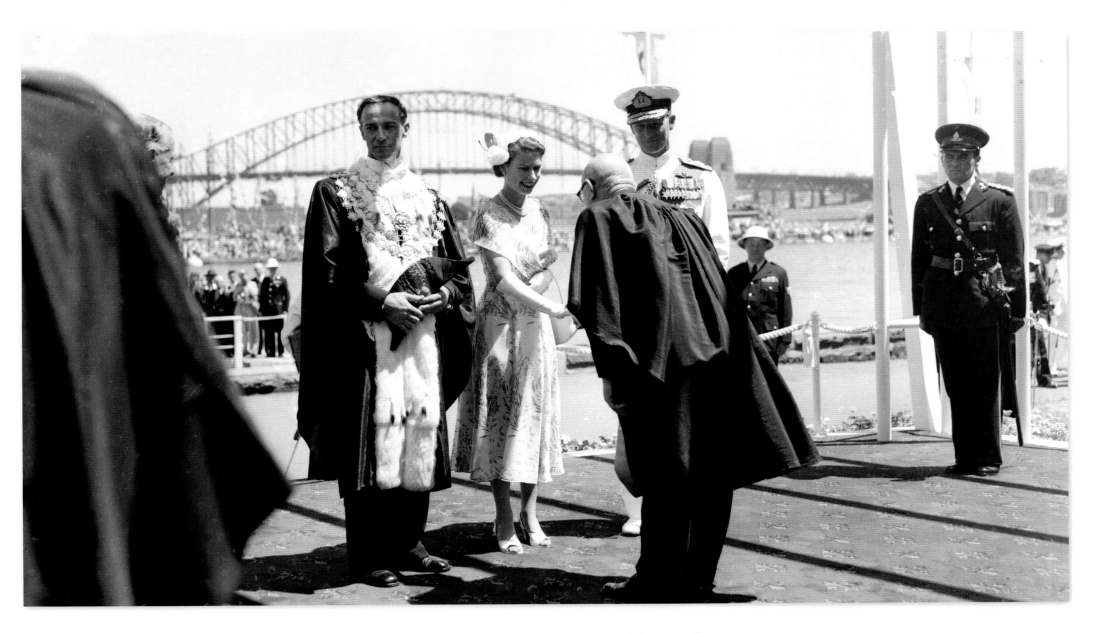

David Jones, Elizabeth Street
1954

SOURCE: NATIONAL ARCHIVES OF AUSTRALIA, A1200, L17232, 7462183

The real-life 'ladies in black' (the title of a fabulous film set in this era, based on a novel by Madeleine St John) in the frock and accessories section of the David Jones Elizabeth Street store. In many such photographs taken around the CBD at the time, I love the sense of occasion of people 'going to town', dressed in their Sunday best. This was also a time when street photography was still popular, so I guess it was almost obligatory to dress up in case you were papped while heading to DJs!

Farm Cove
1954

SOURCE: MITCHELL LIBRARY, STATE LIBRARY OF NEW SOUTH WALES AND COURTESY ACP MAGAZINES LTD, V1-FL19185342

Queen Elizabeth II is welcomed after disembarking from the Royal Barge with her husband, the Duke of Edinburgh, alongside the lord mayor of Sydney, Pat Hills, on their arrival in Sydney to commence their royal tour of Australia and New Zealand in early February 1954.

Her Majesty was the first reigning monarch to visit Australia, and as many as 1 million onlookers came to Sydney to see the young royal couple.

Bankstown

1954

PHOTOGRAPHER: MAX DUPAIN
SOURCE: MITCHELL LIBRARY, STATE LIBRARY OF NEW SOUTH WALES, V1-FL19449293

Dirt roads, open air, and signs of freshly planted trees signal a new housing development in Bankstown, a suburb in Sydney's south-west, in July 1954.

As Sydney's population grew steadily due to the influx of European migrants in the 1950s seeking a better life, many new suburbs and housing estates were established in the outer areas. At the same time, the development of fibro-cement sheeting and board provided cheaper and quick-and-easy home construction.

Bankstown was one of many such suburbs, and also attracted people from the inner city chasing the Australian dream of the quarter-acre block.

Wynyard Street

1955

SOURCE: NATIONAL ARCHIVES OF AUSTRALIA, A1200, L18306, 11377688

We're looking west up Wynyard Street here, from near the intersection of Wynyard and George streets in 1954. Notably, the street is fully open to traffic — the Regimental Square memorial was not completed until 1976.

The building straight ahead, one of the most iconic in Sydney and reputed to be the city's first 'skyscraper', is the Amalgamated Wireless Australasia Tower (or AWA Tower, if you're in a hurry).

Completed in 1939, it was the tallest building in Sydney until the AMP Building on Alfred Street was completed in 1962. The AWA Tower was added to the state's Heritage Register in April 1999.

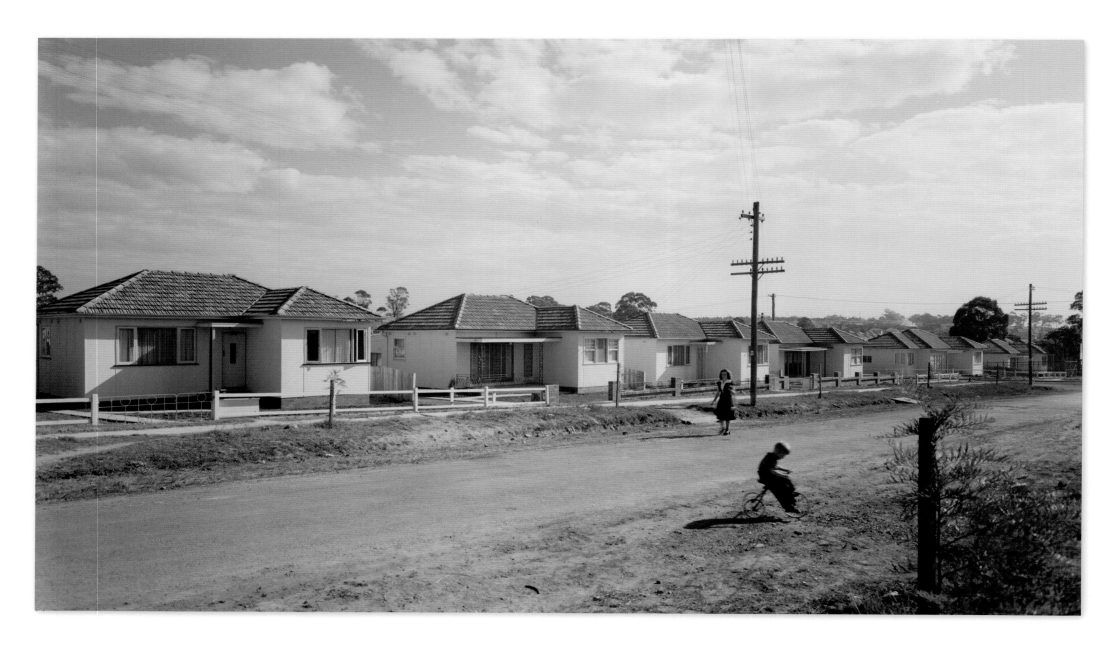

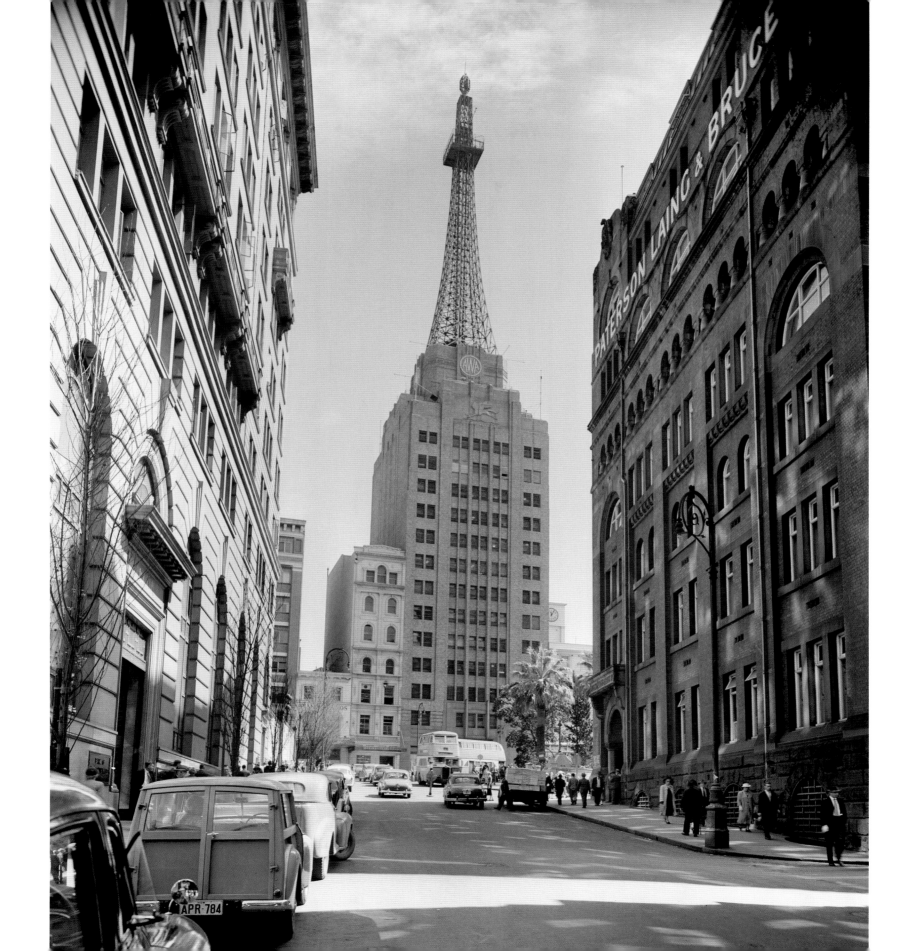

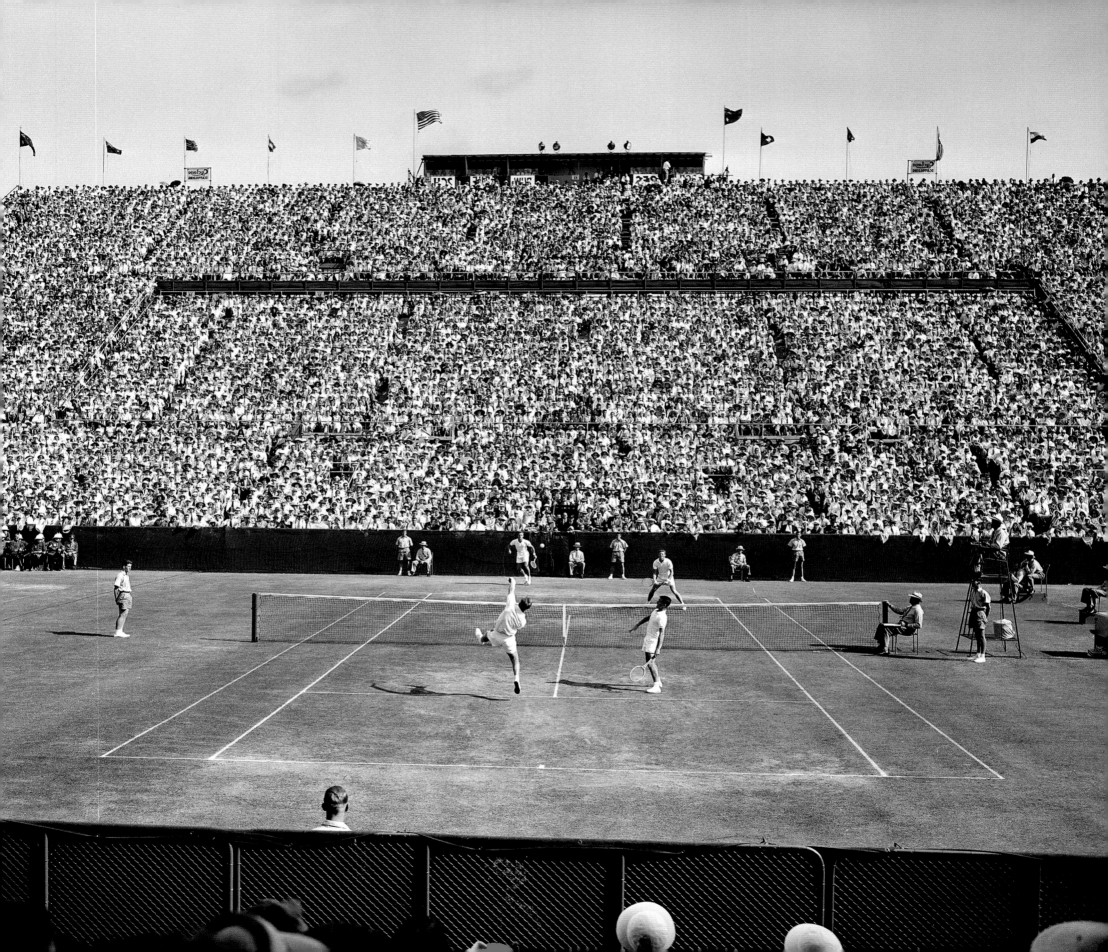

Davis Cup, White City Stadium, Alma Street, Paddington
1954

SOURCE: NATIONAL ARCHIVES OF AUSTRALIA, A1200, L20971, 11952596

Australia's Lew Hoad and Ken Rosewall in action in the doubles match against the US's Vic Seixas and Tony Trabert during the Davis Cup final at the White City tennis courts in Paddington in late December 1954. Seixas and Trabert won in four sets, helping the US defeat Australia by three matches to two.

International tennis matches were held at White City until the late 1990s, when most events were moved to Sydney Olympic Park after the 2000 Games. It is currently undergoing a major redevelopment.

Pittwater Road, Bayview
1957

SOURCE: NATIONAL ARCHIVES OF AUSTRALIA, A1200, L22206, 8363035

Members of the Bayview Yacht Racing Association rig their Vee Jays before a race at Bayview, a suburb on the shores of Pittwater located on the Northern Beaches.

Racing Vee Jays was a popular sport at the time, and still is for many teenagers in Sydney. Vee Jays were named after the harbourside suburb of Vaucluse in 1931 by Sylvester 'Sil' Rohu, and were designed by Charles Sparrow of the Vaucluse Sailing Club as training boats for younger sailors. ('Vee Jays' stood for 'Vaucluse Juniors'.)

The Yacht Racing Club building seen here is still standing, although it was extended significantly during the 1960s. The club still runs Vee Jays on most weekends.

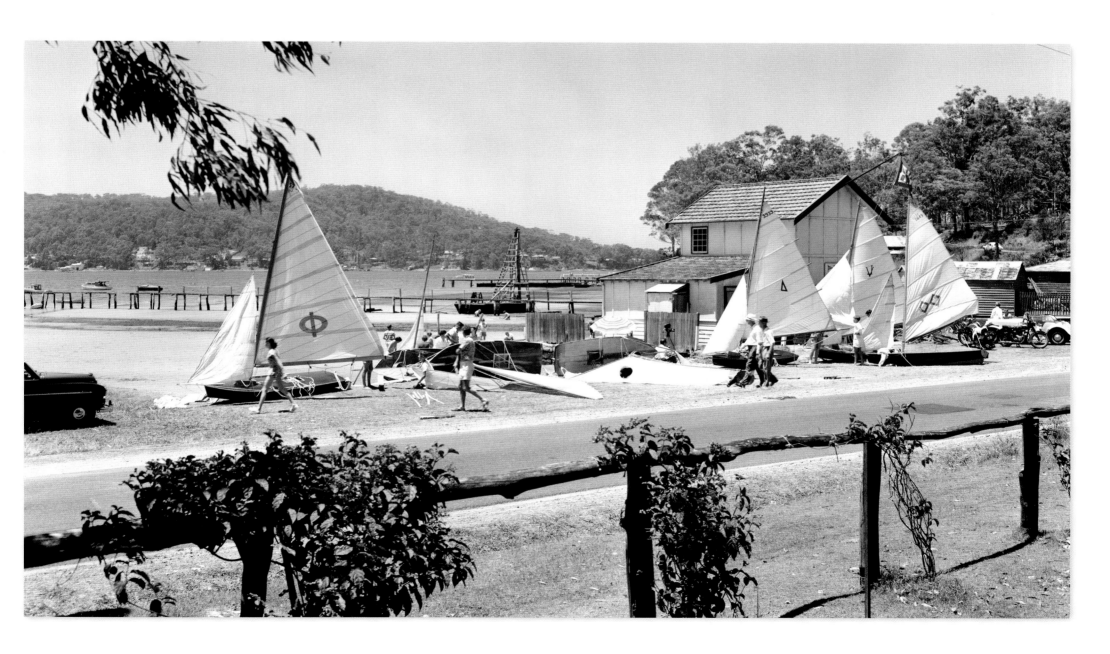

North Sydney Olympic Pool, Alfred Street, Milsons Point
1956
SOURCE: NATIONAL ARCHIVES OF AUSTRALIA, A1200, L19923, 7527629

Patrons enjoy a swim and a lie in the sun against the stunning dual backdrops of Sydney Harbour and the Sydney Harbour Bridge during the summer of 1956.

In the background you can see the skyline of the Sydney CBD in its original form, with the AWA Tower being the tallest building. How different Bennelong Point looks without the sails of the Opera House, which is a few years away from construction.

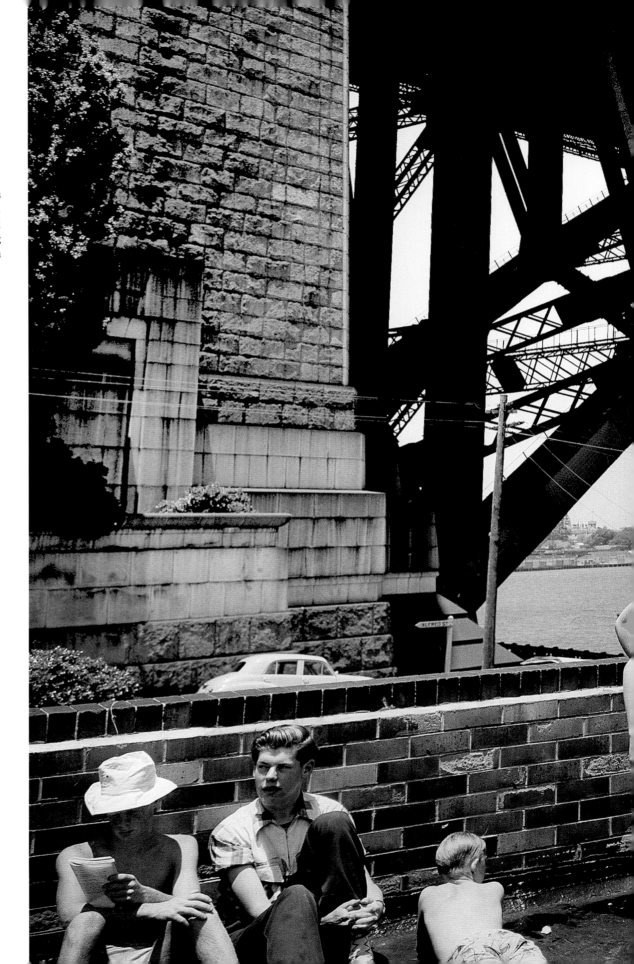

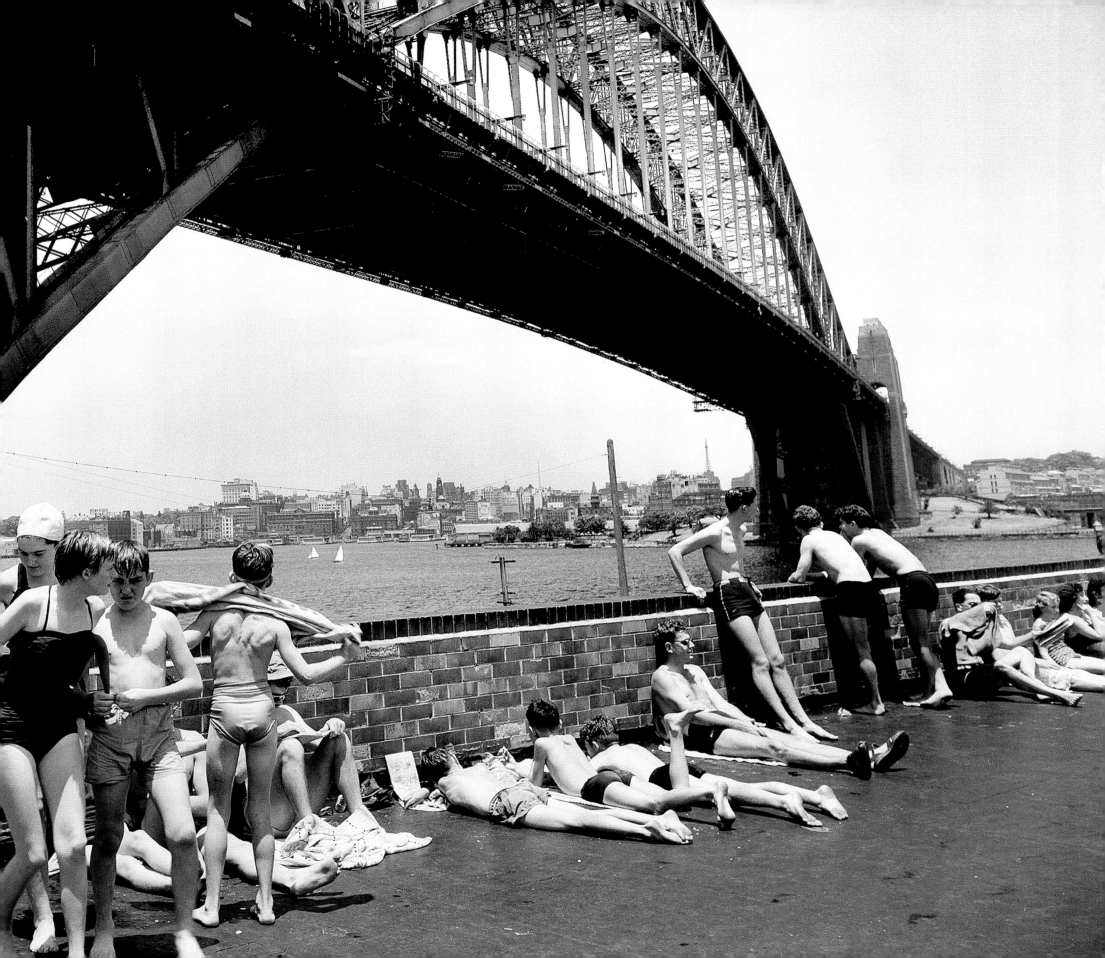

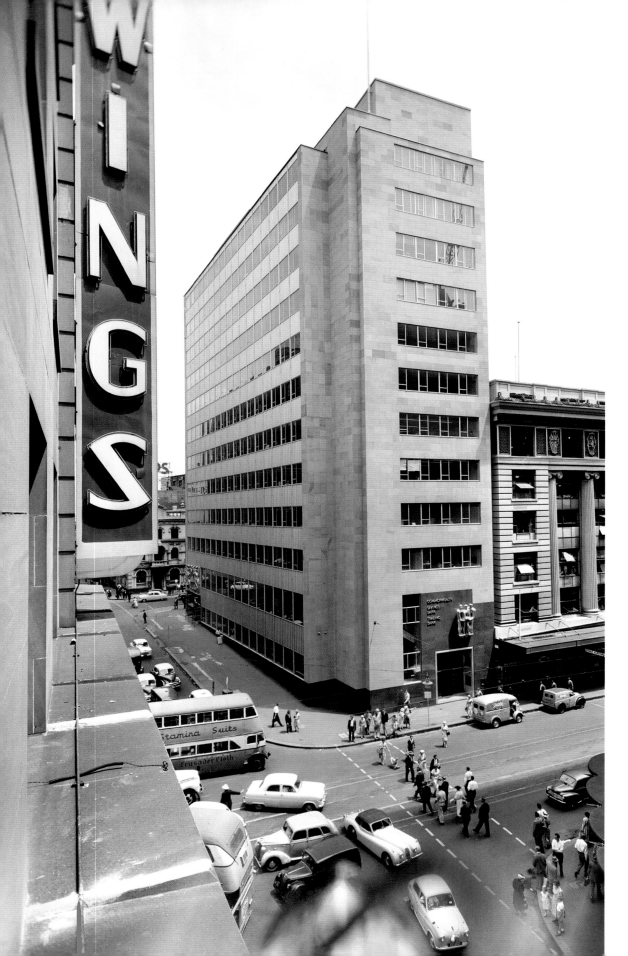

Gowings Building, Market Street
1957

SOURCE: NATIONAL ARCHIVES OF AUSTRALIA, A1200, L22230, 11756201

Here is the view from the window of the iconic Gowings building, looking down at the intersection of George and Market streets in 1957.

On the opposite corner at 46–48 Market Street is the Commonwealth Savings and Trading Bank building, which was less than a year old when this photograph was taken. It was reputed to be one of the first modern office buildings in the city, featuring an integrated air-conditioning system, with distribution through ducting and metal-perforated ceiling tiles on each floor.

Strand Arcade, Pitt Street ▸
1958

SOURCE: NATIONAL ARCHIVES OF AUSTRALIA, A1200, L26809, 11756479

Browsing the boutique shops in the Strand Arcade in 1958. Many will note that the arcade is missing its gorgeous tessellated floor. That's because it was only put in after the arcade was renovated and restored after a fire in the late 1970s.

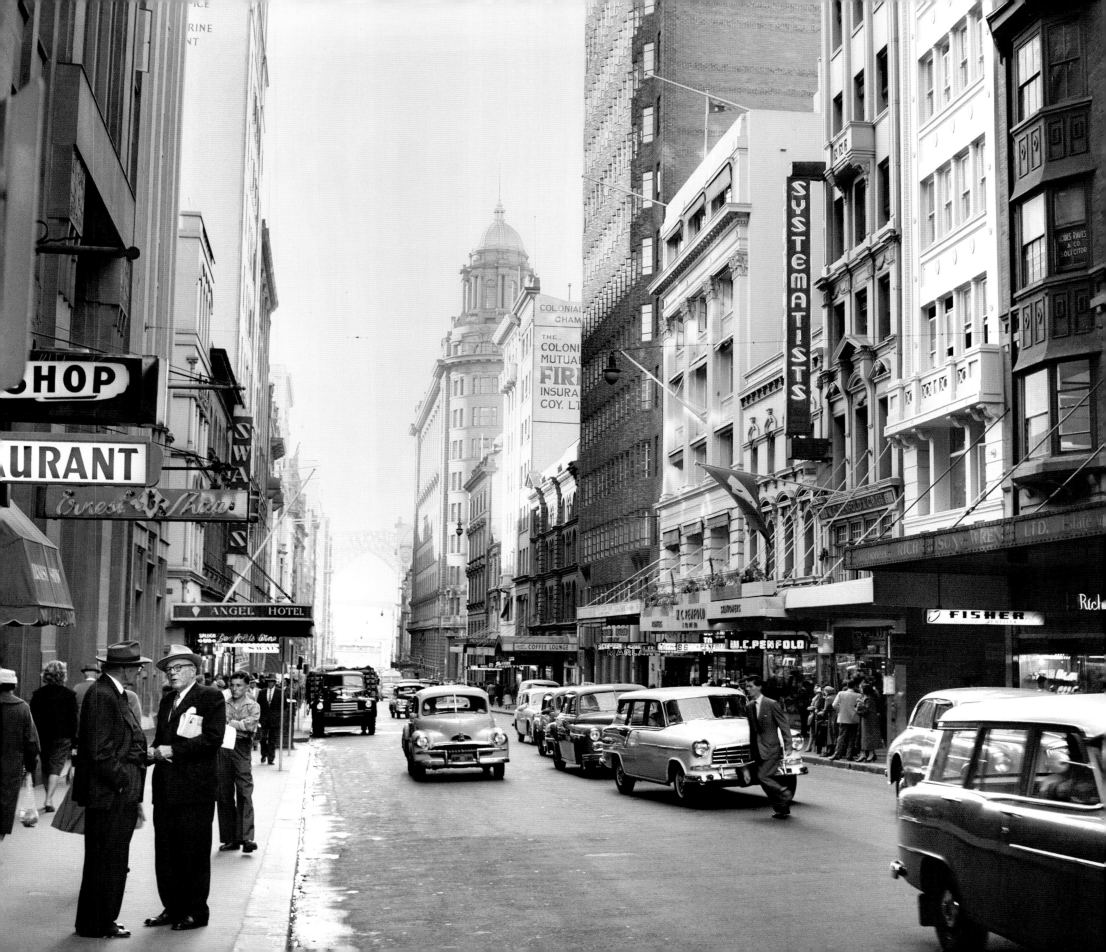

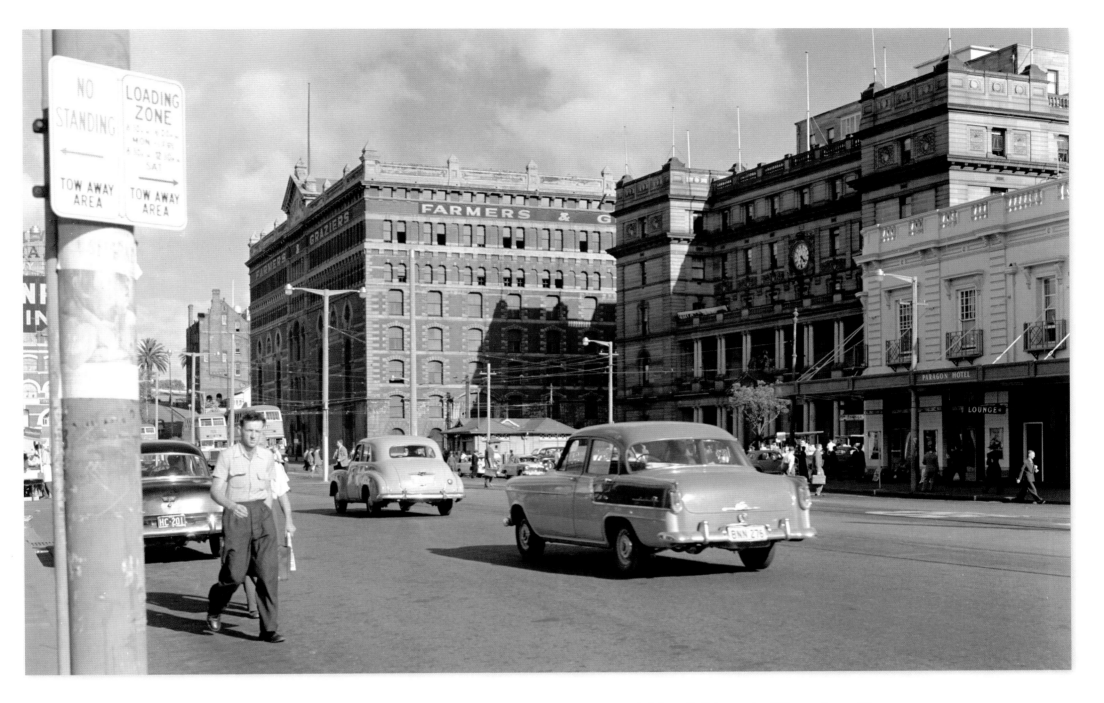

Pitt Street

1958

SOURCE: NATIONAL ARCHIVES OF AUSTRALIA, A1200, L26317, 11727021

Here we are looking north towards Hunter Street from near the intersection of Martin Place and Pitt Street in 1958.

I love the period signage on the buildings, and in the distance you can see Wales House on the corner of Hunter, Pitt, and O'Connell streets, which at the time was occupied by the Bank of New South Wales (the bank we now know as Westpac). It was added to the state's Heritage Register in April 1999, just before it reopened in its current form as a hotel.

Alfred Street, Circular Quay

1958

PHOTOGRAPHERS: MAX DUPAIN AND JILL WHITE
SOURCE: MITCHELL LIBRARY, STATE LIBRARY OF NEW SOUTH WALES, V1-FL19479604

In view among the light road traffic are the Customs House and the Farmers and Graziers building.

The latter building was demolished in 1958 to make way for the AMP Building, which was completed in 1962 and became one of the first modern high-rise office blocks in Sydney.

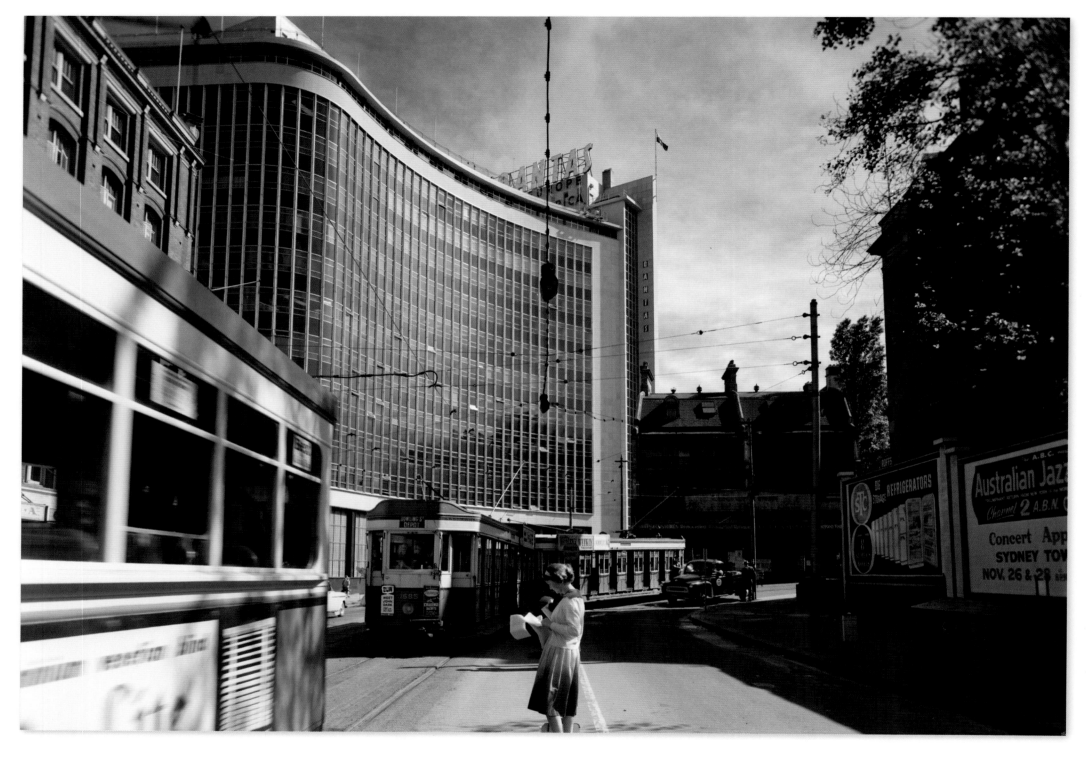

Chifley Square
1958

PHOTOGRAPHERS: MAX DUPAIN AND JILL WHITE
SOURCE: MITCHELL LIBRARY, STATE LIBRARY OF NEW SOUTH WALES, V1-FL19481292

Looking north towards Chifley Square from Elizabeth Street, here is one of my favourite buildings in Sydney — the sleek new Qantas House on the corner of Chifley Square and Hunter Street in October 1958.

Its curved facade, or 'curtain wall' design was praised in Australia at the time. It was designed by Rudder Littlemore & Rudder, and was voted as the Best New Building in the British Commonwealth by the Royal Institute of British Architects in 1959.

How cool are the trams! You can also see the terrace buildings on Hunter Street, where the Chifley Tower stands today.

Lavender Bay
1958

PHOTOGRAPHERS: MAX DUPAIN AND JILL WHITE
SOURCE: MITCHELL LIBRARY, STATE LIBRARY OF NEW SOUTH WALES, V1-FL16358973

Luna Park is on the left, with the bridge dominating the skyline, and the buildings of the CBD are in the distance, as well as Circular Quay. The bridge must have been a striking structure at the time, when there were no skyscrapers or tall towers in the CBD.

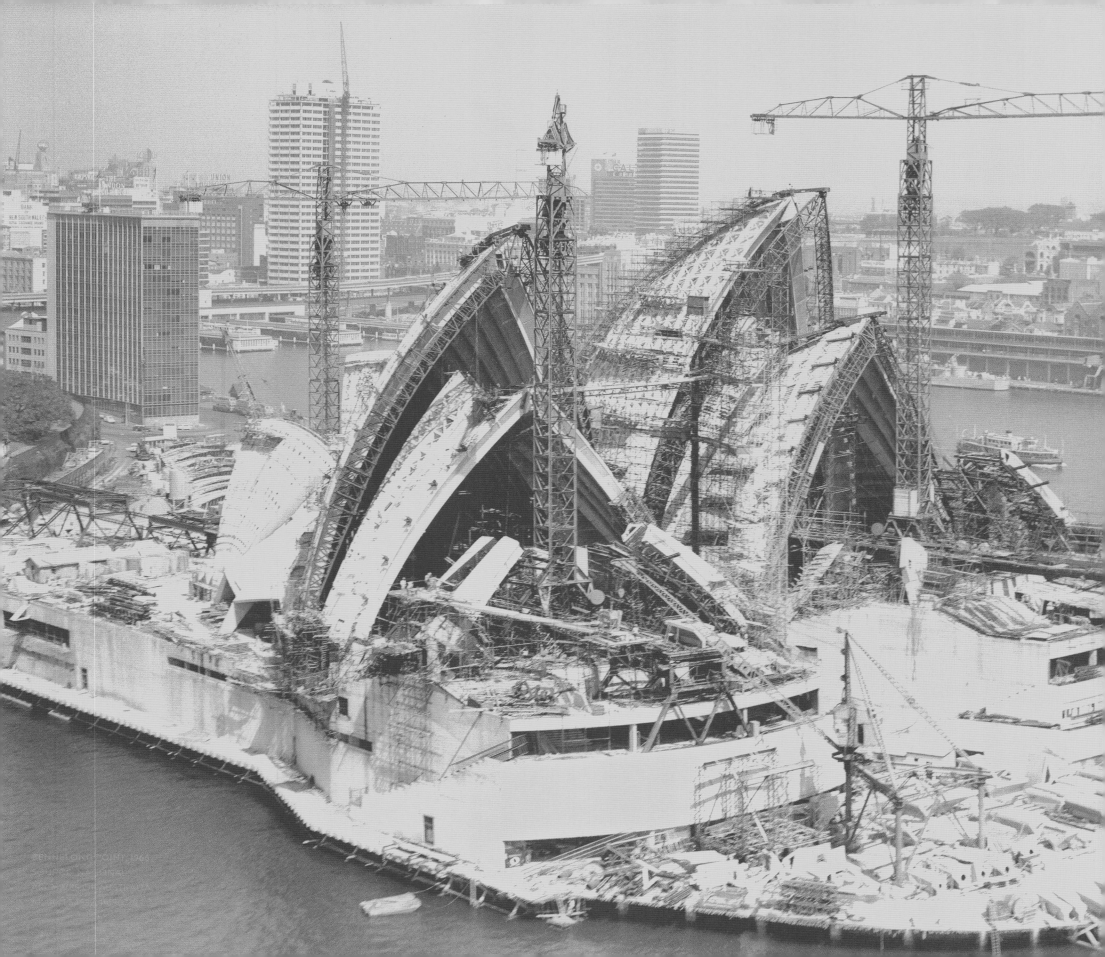

the 1960s

The exciting swinging 1960s in Sydney. Migration was still rapidly increasing the city's population — with just over 2 million people residing in Sydney in 1960 rising to just under 3 million by the end of the decade. The face of the city was also rapidly changing, with the erection of buildings such as Australia Square (completed in 1966), the AMP Tower (1962), and the State Office Block (1967). The development of infrastructure such as the Warringah Freeway and the expansion of Sydney Airport was also transforming the way residents moved around.

The Opera House was still a good decade away from being completed, and was not without its controversies — starting in 1960 with the kidnapping and murder of young Graeme Thorne after his parents, Bazil and Freda, won the Opera House Lottery weeks earlier in July 1960. Many would recall the change from a carefree Sydney of unlocked doors and open windows, to a city of increased security, and the advent of a new term — 'Stranger Danger'. Our Opera House would then suffer delays and adverse publicity, including reports of growing animosity between designer Jørn Utzon and his team and the New South Wales government, leading to Utzon's controversial resignation in February 1966.

We were also shopping differently, with shopping malls popping up around the suburbs, and large supermarkets opening with a range of goods all under the one roof. Places such as the Roselands Shopping Centre — the largest shopping mall in the southern hemisphere at the time of its opening in 1965 — and others such as Warringah Mall (1966), St Ives Shopping Centre (1962), and Bankstown Square (1966) revolutionised the way retailers and customers bought and sold goods. It was also the start of city department stores opening offshoots in the suburbs, removing the need for the famed trip to town to shop at stores such as Waltons, David Jones, Grace Bros, and Myer.

The 1960s was also a period of iconic nightlife in Sydney that blurred the lines between the glitz, glamour, and buzz of nightclubs and the gritty and seedy underbelly of Sydney's underworld. Believed to be led by some of Australia's most powerful and notorious organised-crime bosses, the underworld of SP book-making, illegal casinos, brothels, and card clubs filtered into the Sydney suburbs.

Clubs such as Chequers in Goulburn Street, the Whisky-Au-Go-Go in William Street, and, of course, Les Girls on Darlinghurst Road became some of the most iconic nightspots in the country and an attraction for international visitors.

With the wider use of airline travel, Australia — and Sydney — became an easier destination to reach for thousands of international visitors and celebrities. Some notable events included the tour of The Beatles in 1964, The Rolling Stones in 1966, and, of course, the visit by US president Lyndon Baines Johnson in October 1966.

The Silver Spade Room at the Chevron-Hilton Hotel in Potts Point was a landmark establishment for several international stars of the time, with Roy Orbison, Eartha Kitt, Shirley Bassey, Nat King Cole, Ella Fitzgerald, and Judy Garland among the performers who played at the nightspot on Macleay Street.

Sydney was becoming more cosmopolitan, and, in a way, was encapsulating the change in sensibility of the nation. By the end of the decade, Australia had been a part of the Vietnam War for nearly eight years, the 1967 referendum had amended the constitution to recognise First Nations people, the currency had changed to decimal, and the main source of entertainment had become television, which increased in popularity during the 1960s — making iconic shows such as *Skippy* and *Homicide* household names.

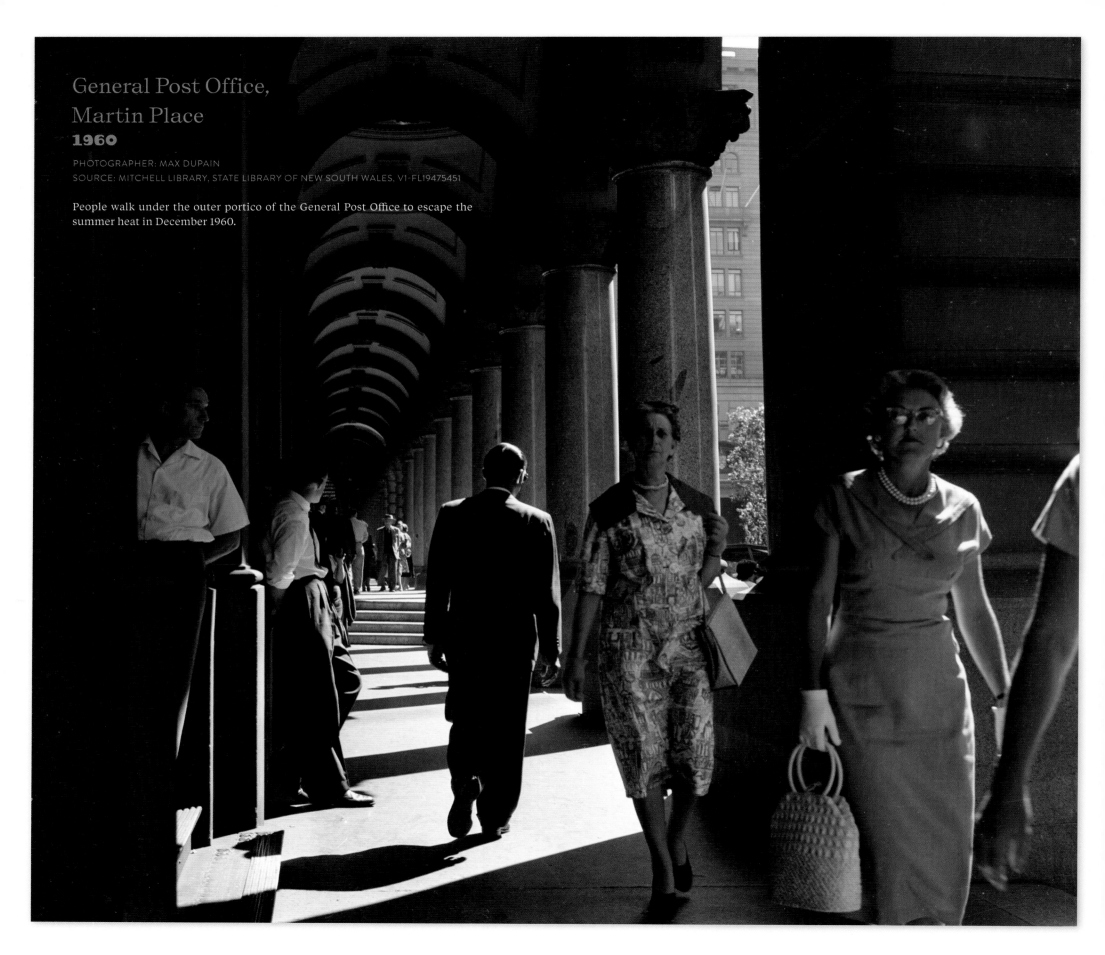

General Post Office, Martin Place
1960

PHOTOGRAPHER: MAX DUPAIN
SOURCE: MITCHELL LIBRARY, STATE LIBRARY OF NEW SOUTH WALES, V1-FL19475451

People walk under the outer portico of the General Post Office to escape the summer heat in December 1960.

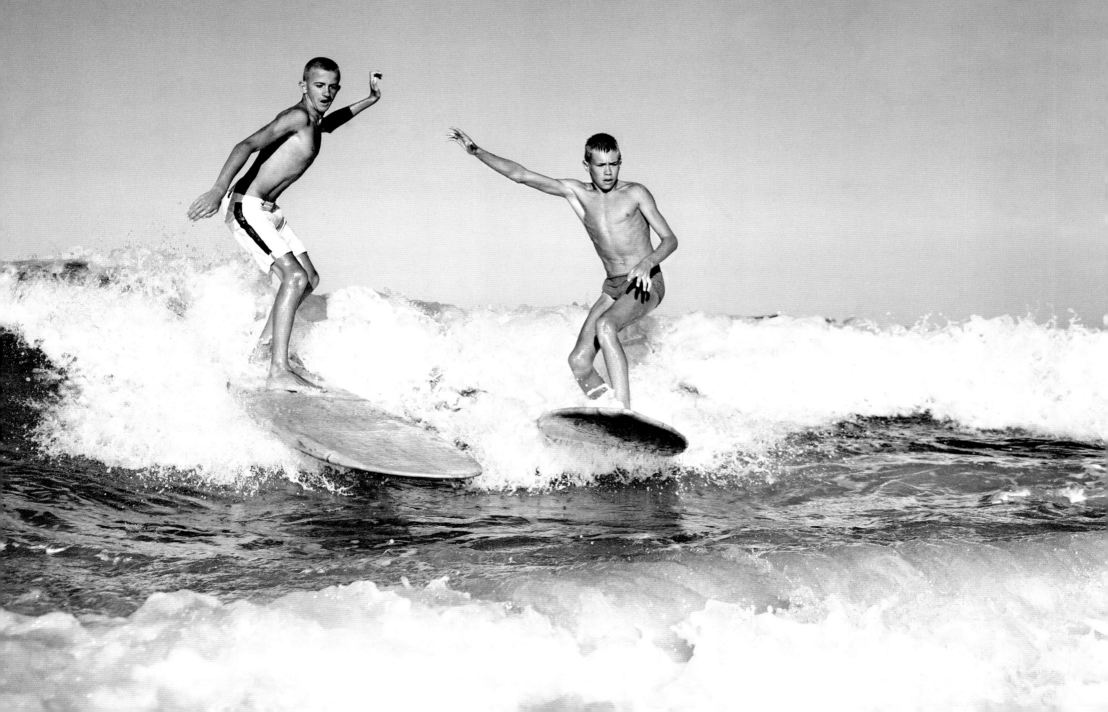

Tamarama Beach
1960

SOURCE: NATIONAL ARCHIVES OF AUSTRALIA, A1200, L34988, 11950618

Surf's up! Riding the breakers at Tamarama in 1960.

The 1960s saw the start of the trend of 'surfies', who began to take up surfing as a popular recreational sport across Sydney and Australia — so much so that Australia became a hit with surfing tourists, with many Sydney beaches reputed to be among the best for surfing around the world.

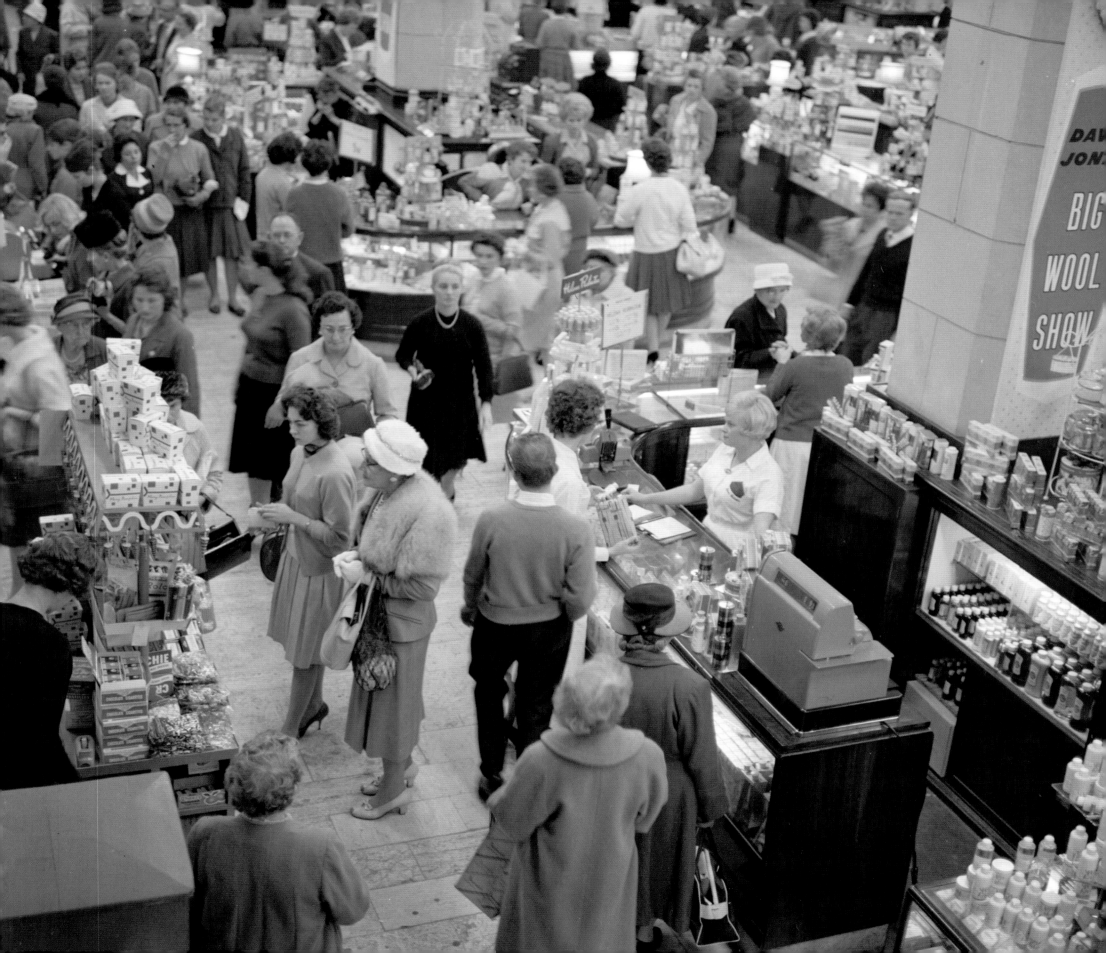

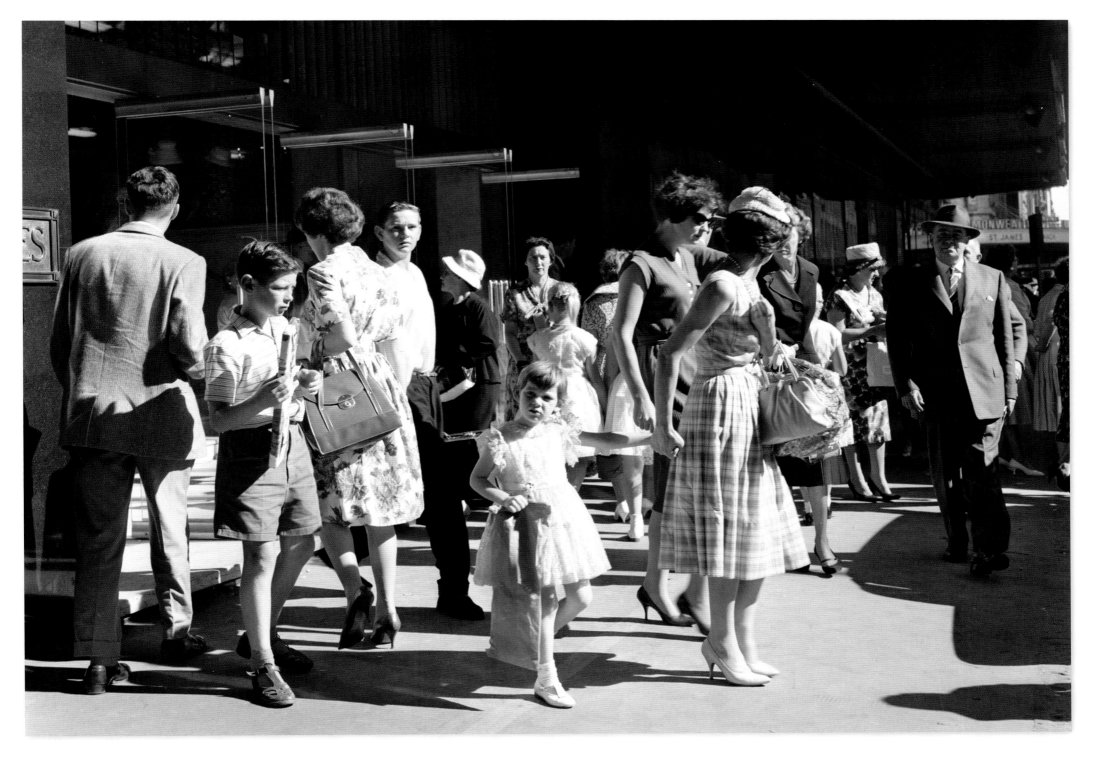

David Jones, Elizabeth Street
1961

PHOTOGRAPHERS: MAX DUPAIN AND JILL WHITE
SOURCE: MITCHELL LIBRARY, STATE LIBRARY OF NEW SOUTH WALES,
V1-FL19482645 AND 19482674

A spot of shopping among the (very stylish-looking) crowds in the David Jones Elizabeth Street store in May 1961.

Opened in 1927, the Elizabeth Street store was the luxury department store's flagship, and the second to be opened — the first being on the corner of George Street and Barrack Lane in May 1838.

A state banquet was held for Queen Elizabeth II during the 1954 royal tour in the restaurant of the Elizabeth Street store.

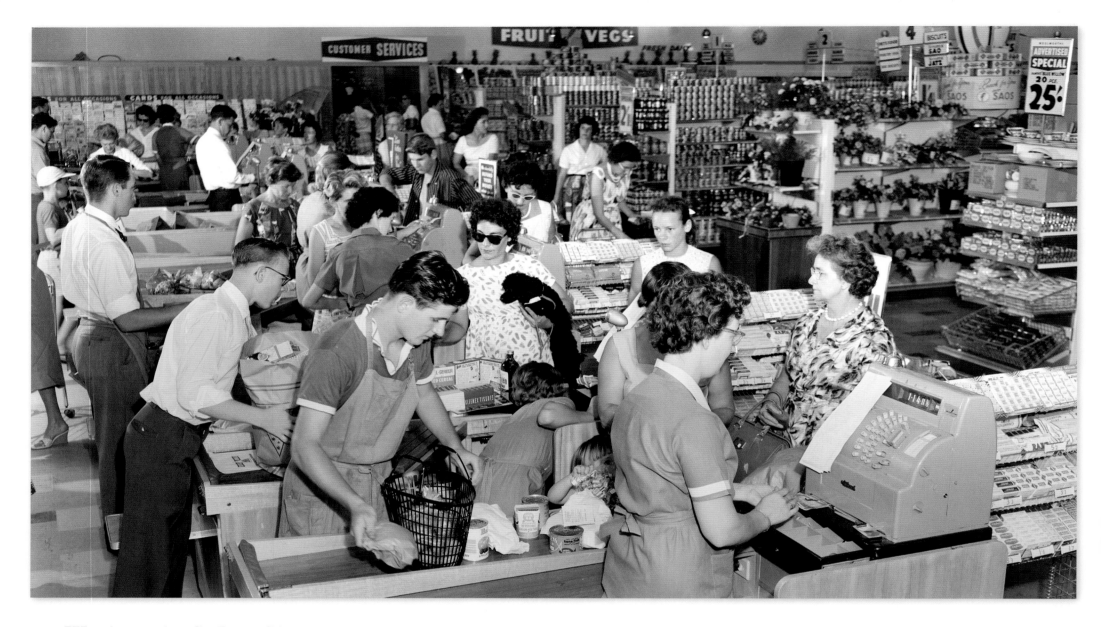

Woolworths St Ives Shoppingtown
1961

The latest shopping centre in Sydney to sprout up, at St Ives on Sydney's leafy and growing Upper North Shore. A bit like in the movies, and almost a forgotten memory now, packing boys were at each checkout to ensure that bags were properly filled. This is a quintessentially Sixties image.

The supermarket was a revelation for many Australians. With the boom in the construction of shopping malls in suburban Sydney, supermarkets became anchor tenants, adding to the ease and convenience for customers, with everything all under one roof.

Darlinghurst Road, Potts Point ▸
1961

Welcome to the golden era of nightlife in Sydney. Kings Cross in the 1960s was glamorous, dangerous, naughty, and gritty. If you wanted a good night out away from the quaint and cute suburbs, you came to Darlinghurst Road, with its cafes and bars that would stay open until late; or if that was too tame, you could go to a nightclub like Tabou for more thrills and dancing.

Tabou was located where The Bourbon is today, near the intersection of Darlinghurst Road and Macleay Street (or Bourbon and Beefsteak in its heyday, which closed in late 2022).

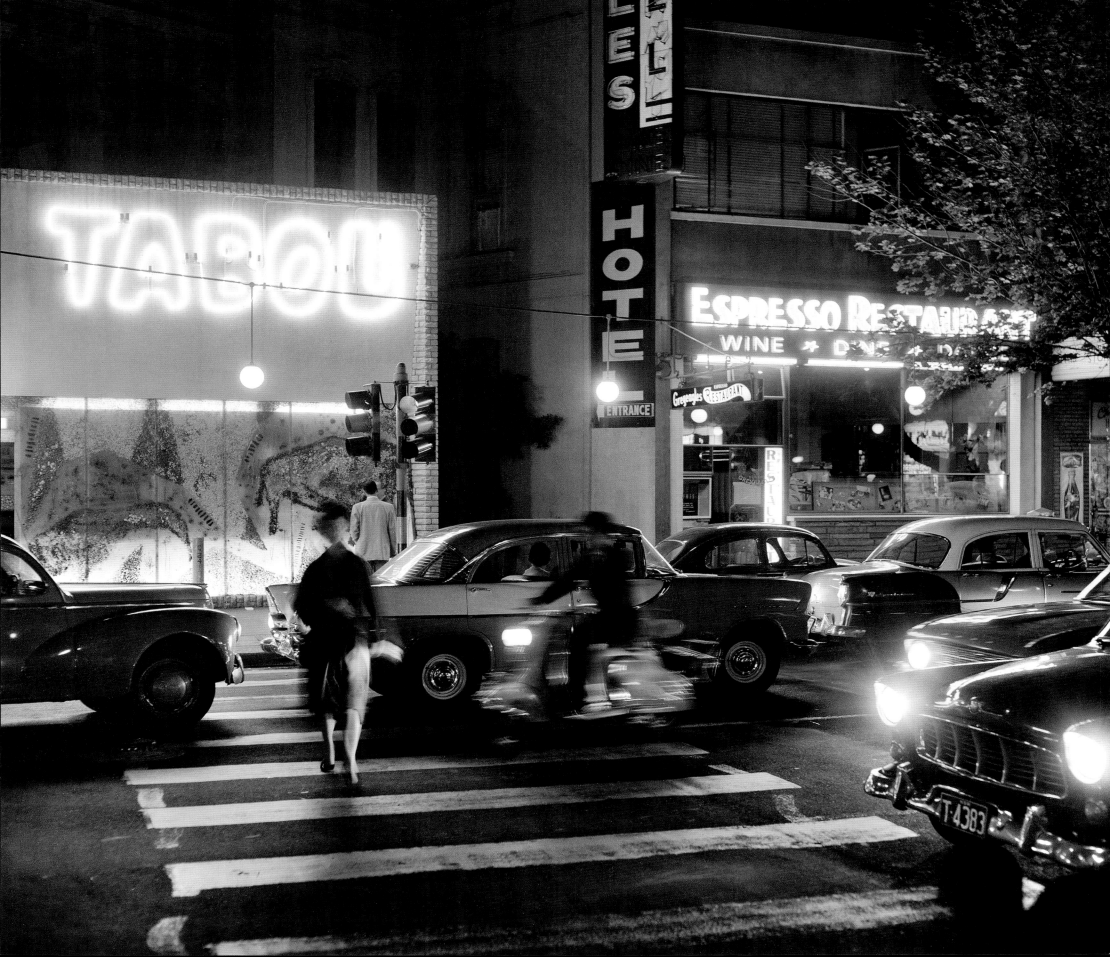

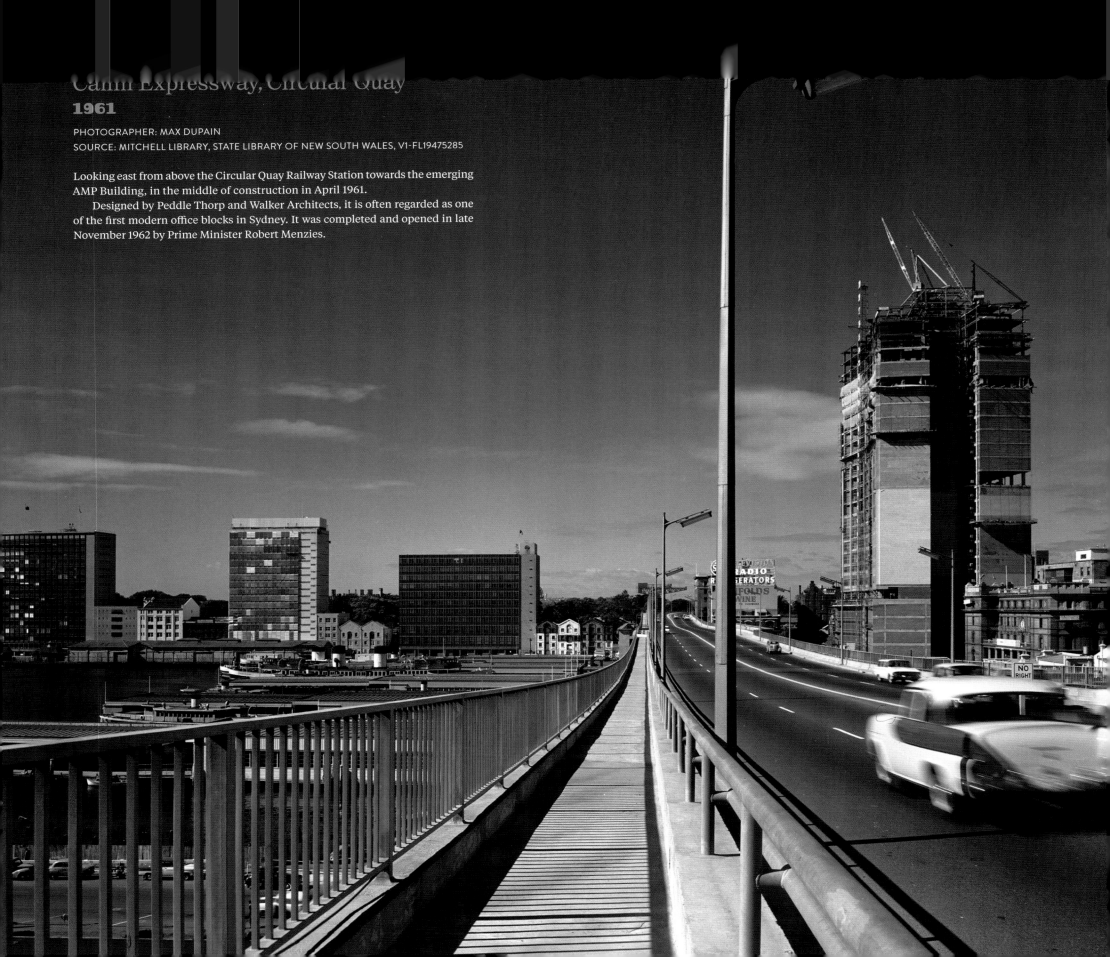

Cahill Expressway, Circular Quay

1961

PHOTOGRAPHER: MAX DUPAIN

SOURCE: MITCHELL LIBRARY, STATE LIBRARY OF NEW SOUTH WALES, V1-FL19475285

Looking east from above the Circular Quay Railway Station towards the emerging AMP Building, in the middle of construction in April 1961.

Designed by Peddle Thorp and Walker Architects, it is often regarded as one of the first modern office blocks in Sydney. It was completed and opened in late November 1962 by Prime Minister Robert Menzies.

AMP Building, Alfred Street, Circular Quay
1962

PHOTOGRAPHER: ROBERT DONALDSON
SOURCE: AUSTRALIAN CONSOLIDATED PRESS AND CONSOLIDATED PRESS,
MITCHELL LIBRARY, STATE LIBRARY OF NEW SOUTH WALES, V1-FL18990148

No, this is not a set on a James Bond film, or *The Italian Job*, or a live-action adaptation of the *Thunderbirds* — this is a trainee data-entry clerk inputting information into the new IBM 1401 super-computer in the new AMP Building in May 1962.

It's amazing to think that a hand-held scientific calculator is more powerful than the super-computer seen here.

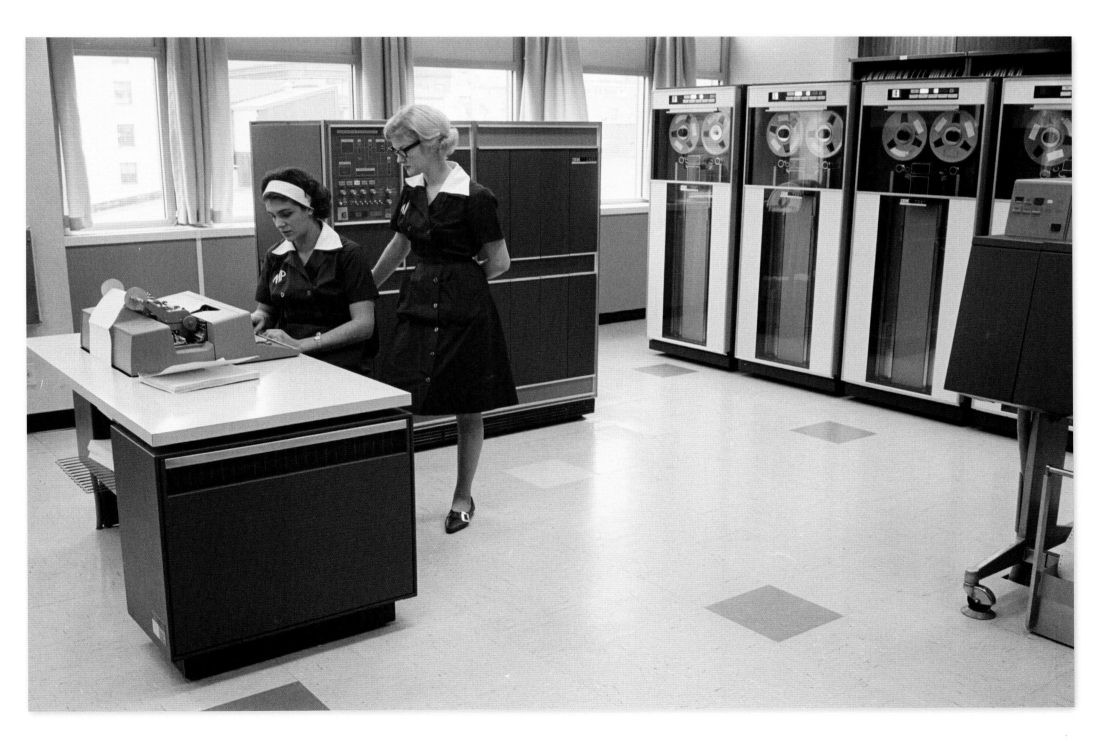

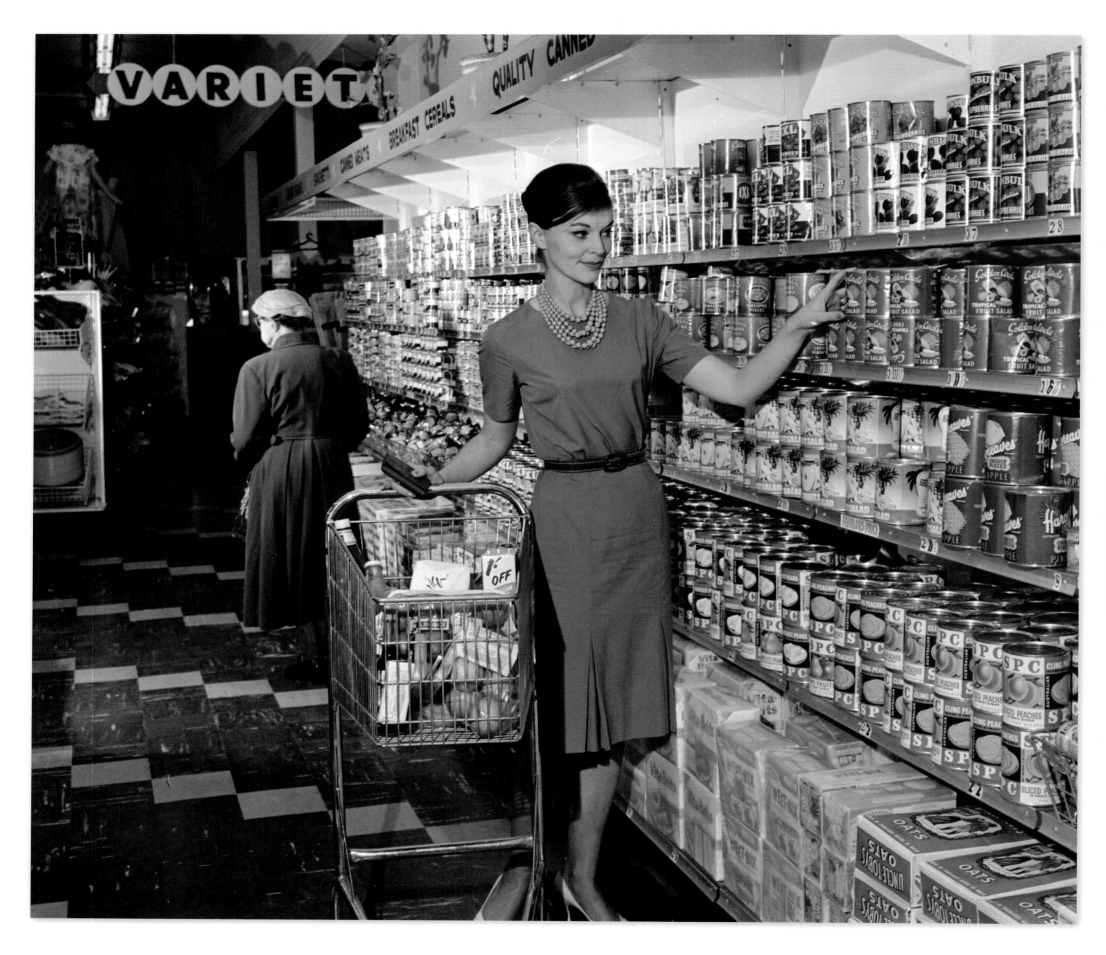

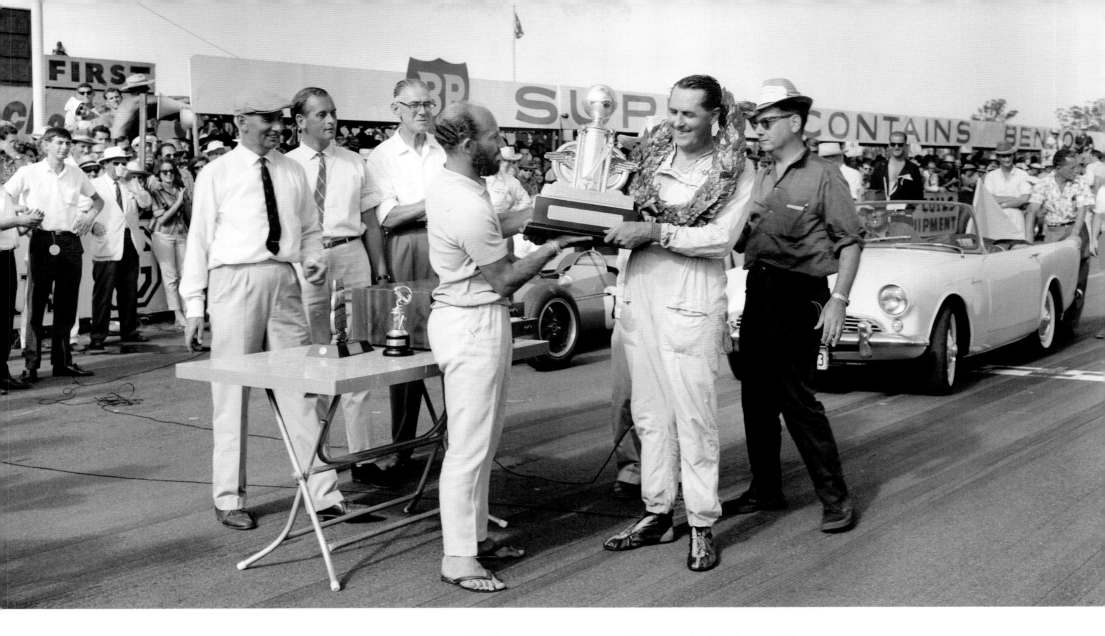

Flemings Food Store, Bondi Junction
1963

PHOTOGRAPHER: ALEC IVERSON
SOURCE: AUSTRALIAN CONSOLIDATED PRESS AND CONSOLIDATED PRESS, MITCHELL LIBRARY, STATE LIBRARY OF NEW SOUTH WALES, V1-FL16427925

At the new Flemings in Oxford Street in early October 1963, a chic shopper has selected some pantry staples and has her hand on a tin of Golden Circle tropical fruit salad, maybe to follow a recipe from the latest issue of *Australian Women's Weekly*.

Flemings was a grocery chain similar to Woolworths or Coles (then known as Coles New World), with the first store having been opened in 1930 by Jim Fleming Snr and George Fleming.

All Flemings stores were eventually rebranded after a takeover by competitor Woolworths from the late 1990s; however, many continued to operate well into the late 2000s. The last store to close was at Jannali, in Sydney's Sutherland Shire, in May 2020, after which it was rebranded as a Woolworths Metro.

Warwick Farm Raceway
1963

SOURCE: NATIONAL ARCHIVES OF AUSTRALIA, A1200, L38208, 11445717

Sir Jack Brabham collects the trophy for winning the 28th Australian Grand Prix held at Warwick Farm Raceway in early February 1963.

Brabham also clocked the fastest lap time (1 minute 40.2 seconds) in his Repco Brabham BT4 (which you can just see behind him) — his own car, which he launched the year before with Ron Tauranac. Brabham would become the largest manufacturer of custom racing cars in the world during the 1960s. Not bad for a boy from Hurstville!

The Gladesville Bridge
1963

SOURCE: NATIONAL ARCHIVES OF AUSTRALIA, A12111, 1/1963/16/37, 7450523

Looking from the foreshore at Hunters Hill, we can see the sheer size of the arch construction on the new Gladesville Bridge in early 1963. Carrying traffic on Victoria Road, a major arterial, and connecting the Lower North Shore and inner west, it was a vital piece of infrastructure and a beacon of engineering in Australia during the 1960s.

Half of the 120 workers who built the bridge were 'new Australians' who, like my grandparents, emigrated to Australia during the 1950s and 1960s for a new life away from the UK and Europe.

Bennelong Point ▸
1964

PHOTOGRAPHERS: MAX DUPAIN AND JILL WHITE
SOURCE: MITCHELL LIBRARY, STATE LIBRARY OF NEW SOUTH WALES, V1-FL16397102

We're looking from the roof of Unilever House (where 'The Toaster' is now located) down on the Opera House, which is midway through construction in late July 1964.

You can see the pre-cast yard and on-site batch plant on the forecourt, where segments to make up the sail structures that were to give the Opera House its unique shape were cast in the huge moulds lining Circular Quay East. One mould in the middle looks like it's midway through being stripped.

In the background, you can see the Lower North Shore suburbs that line the harbour, as well as Kirribilli House to the right and Admiralty House to the left at Kirribilli Point. Incredibly, it would be another nine years before the Opera House would be completed and opened in October 1973.

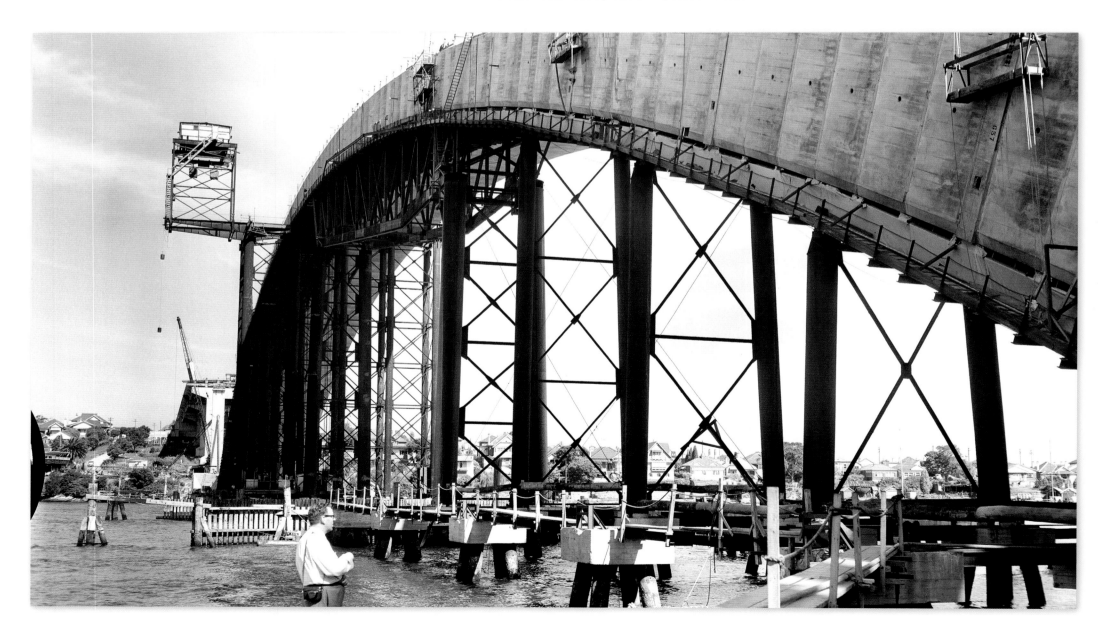

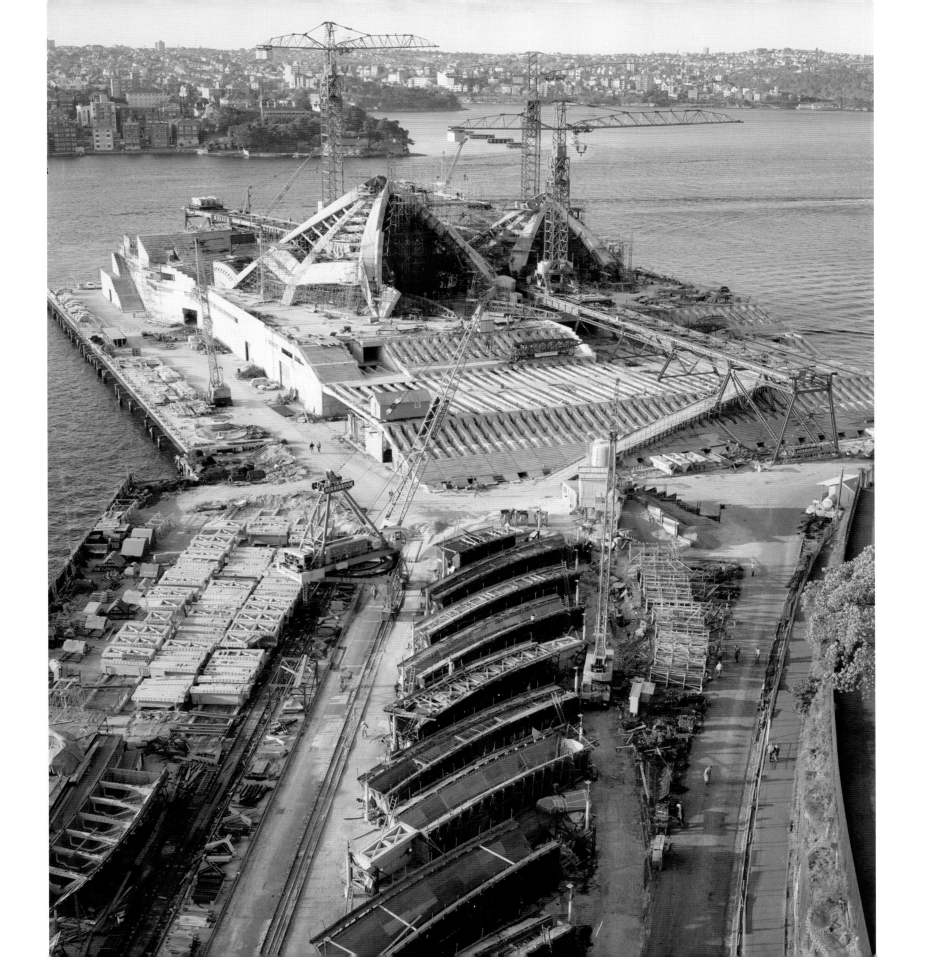

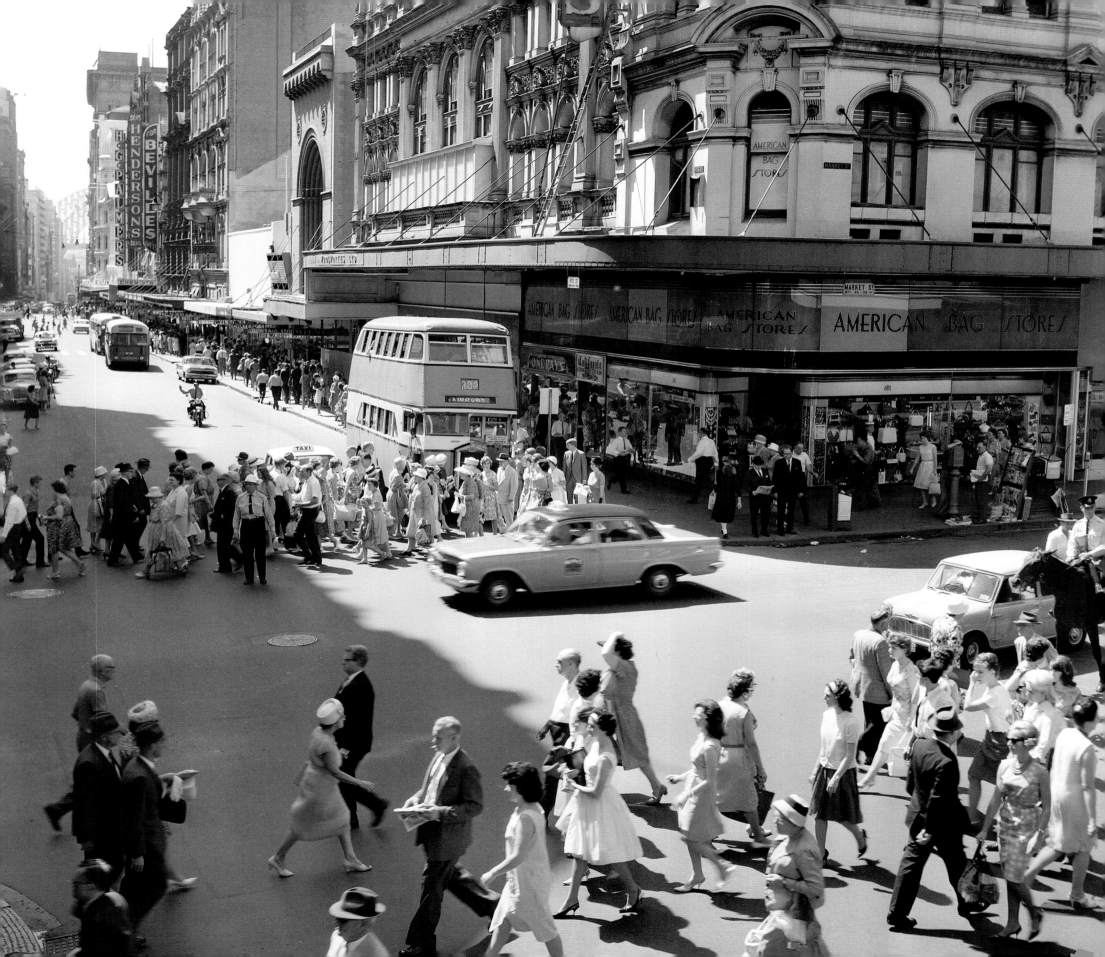

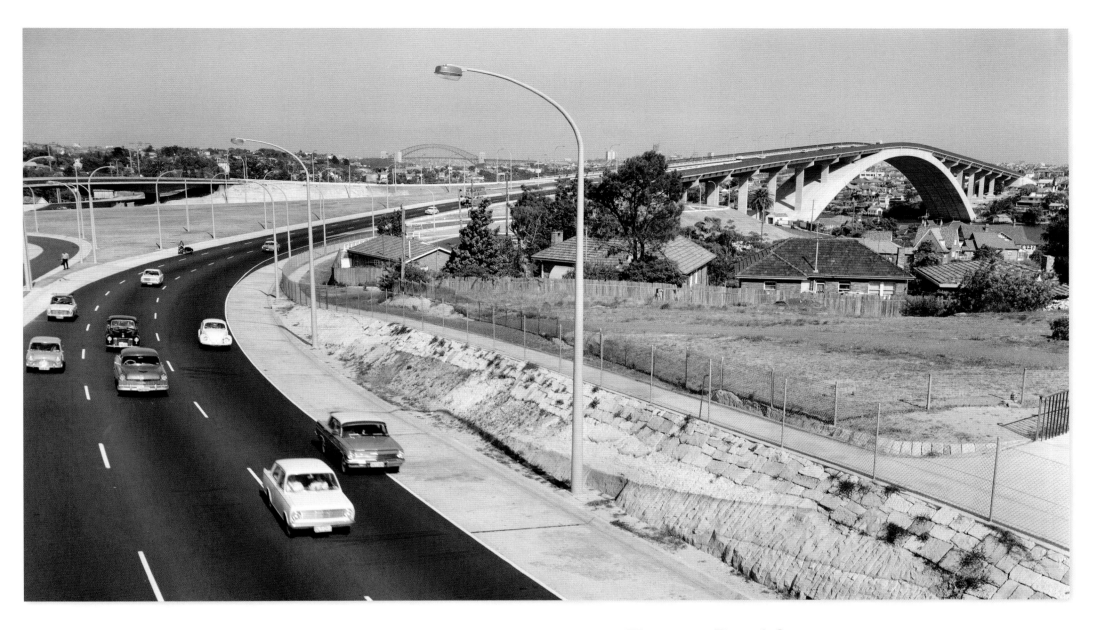

Pitt Street
1964

SOURCE: NATIONAL ARCHIVES OF AUSTRALIA, A1200, L47269, 11727135

We are at the intersection of Market and Pitt streets, looking at the American Bag store and Woolworths, in a quieter time. Pedestrians are crossing the street with the aid of traffic police, a double-decker bus headed for the airport waits for the all-clear, and behind it in the distance are vertical street signs advertising the long-departed Bevilles, Henderson's, and HG Palmers stores.

This is where the Pitt Street Mall is located today, with the corner in view now occupied by the Centrepoint Tower Westfield, and the Myer store just out of view on the left. You can also get a glimpse of the Harbour Bridge in the far background.

Victoria Road Overpass, Huntleys Point
1965

SOURCE: NATIONAL ARCHIVES OF AUSTRALIA, A1200, L50322, 11701703

There's not much traffic on Burns Bay Road after coming off the new Gladesville Bridge from the Victoria Road overpass.

It's amazing how different the bridge looks without the trees that line Burns Bay Road on the right, and of course with that enviable backdrop of the harbour and dominating Sydney Harbour Bridge in the distance.

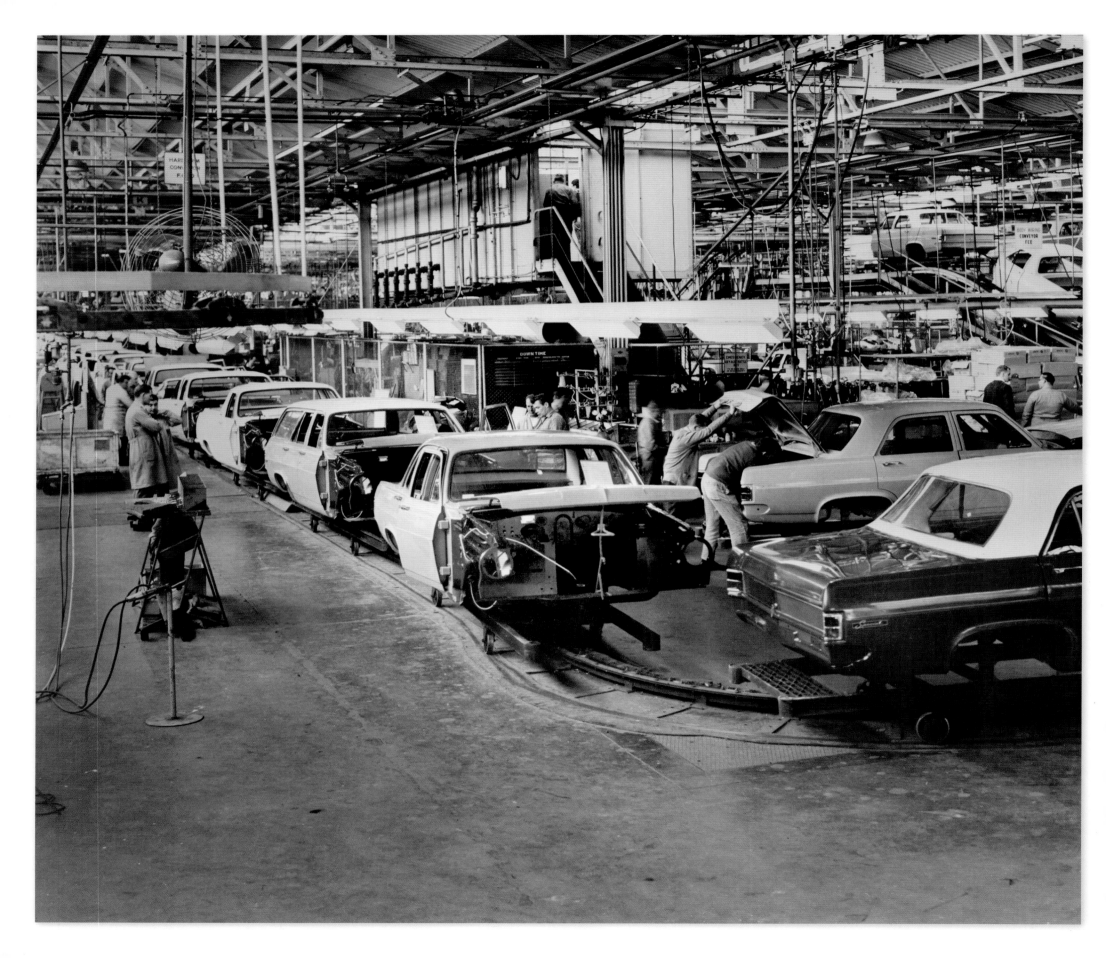

General Motors Holden, Pagewood
1966

SOURCE: NATIONAL ARCHIVES OF AUSTRALIA, A1200, L53442, 11406329

Back in the 1960s, and even until the 1990s, not only were we making our own cars in Australia, but we were making them in Sydney!

This is the Holden plant in Pagewood, seen here making HD Holdens in early 1966. The production of Holdens in Sydney ceased in August 1980, and the site became the location of the Westfield Eastgardens shopping centre.

Kings Cross Motel, Bayswater Road, Potts Point
1966

PHOTOGRAPHER: DAVID CUMMING
SOURCE: AUSTRALIAN CONSOLIDATED PRESS AND CONSOLIDATED PRESS, MITCHELL LIBRARY, STATE LIBRARY OF NEW SOUTH WALES, V1-FL19228532

A stylish group of girls wait for their auditions for go-go dancing at the Kings Cross Motel beside a Nissan Fairlady 1600 Roadster in July 1966.

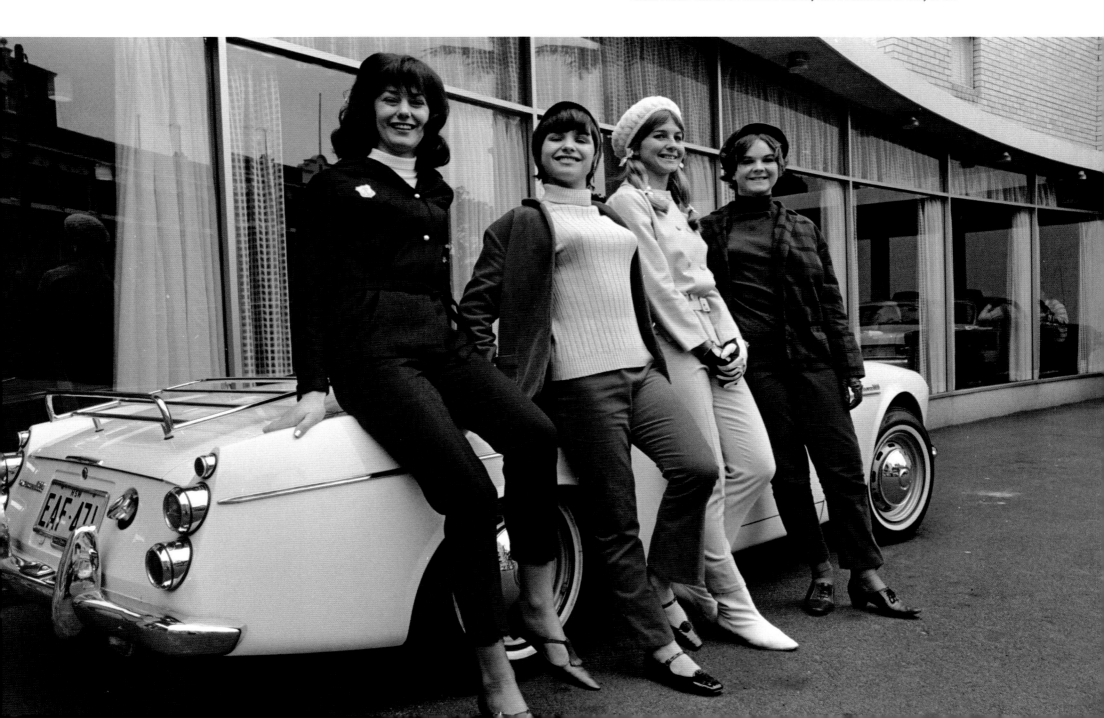

Bennelong Point

1966

SOURCE: NATIONAL ARCHIVES OF AUSTRALIA, A1200, L54532, 11680779

The Opera House in March 1966 during construction of the famous sails, with Sydney Cove, Circular Quay, and the CBD in the background.

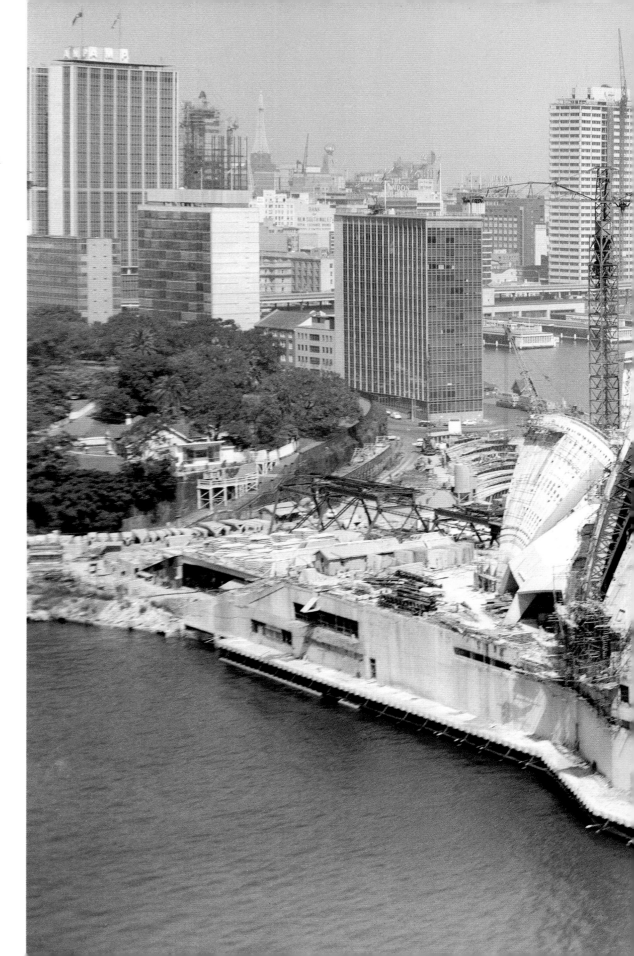

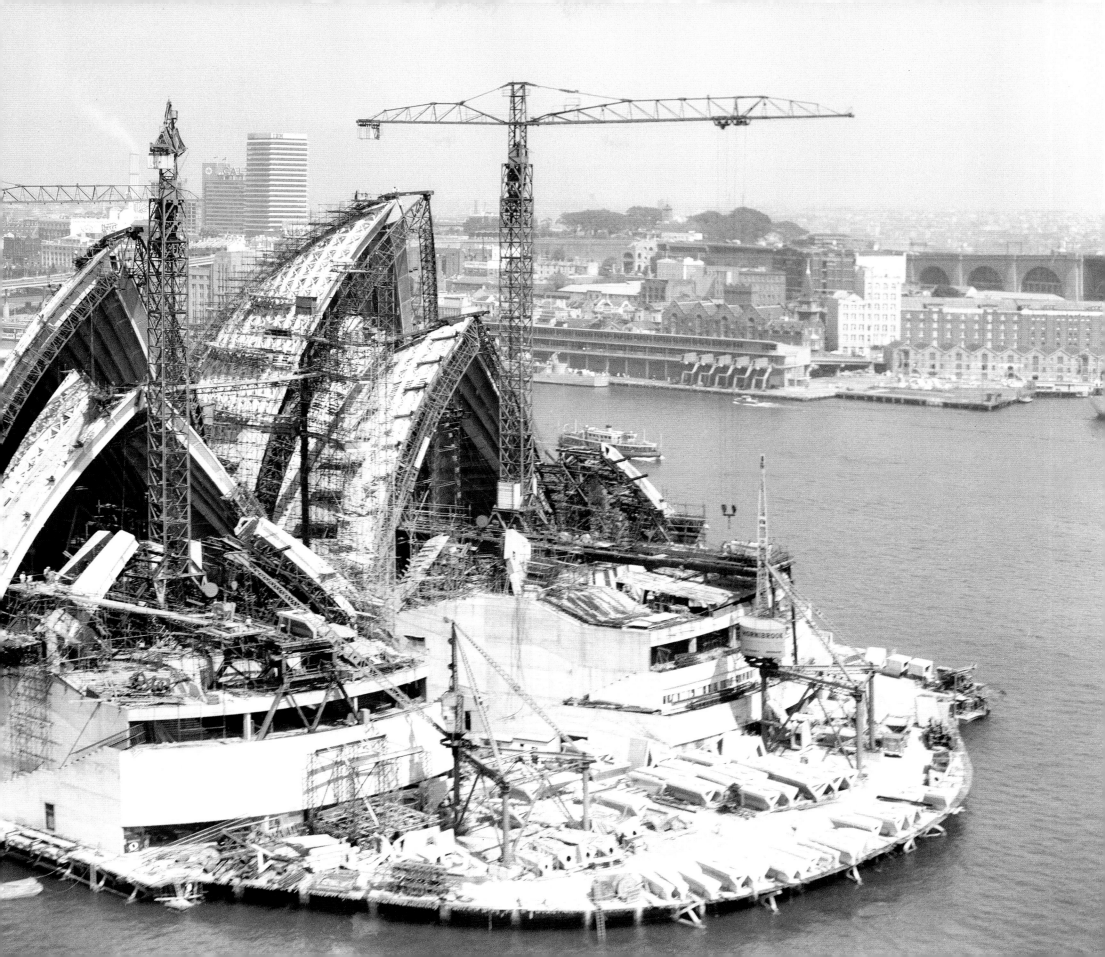

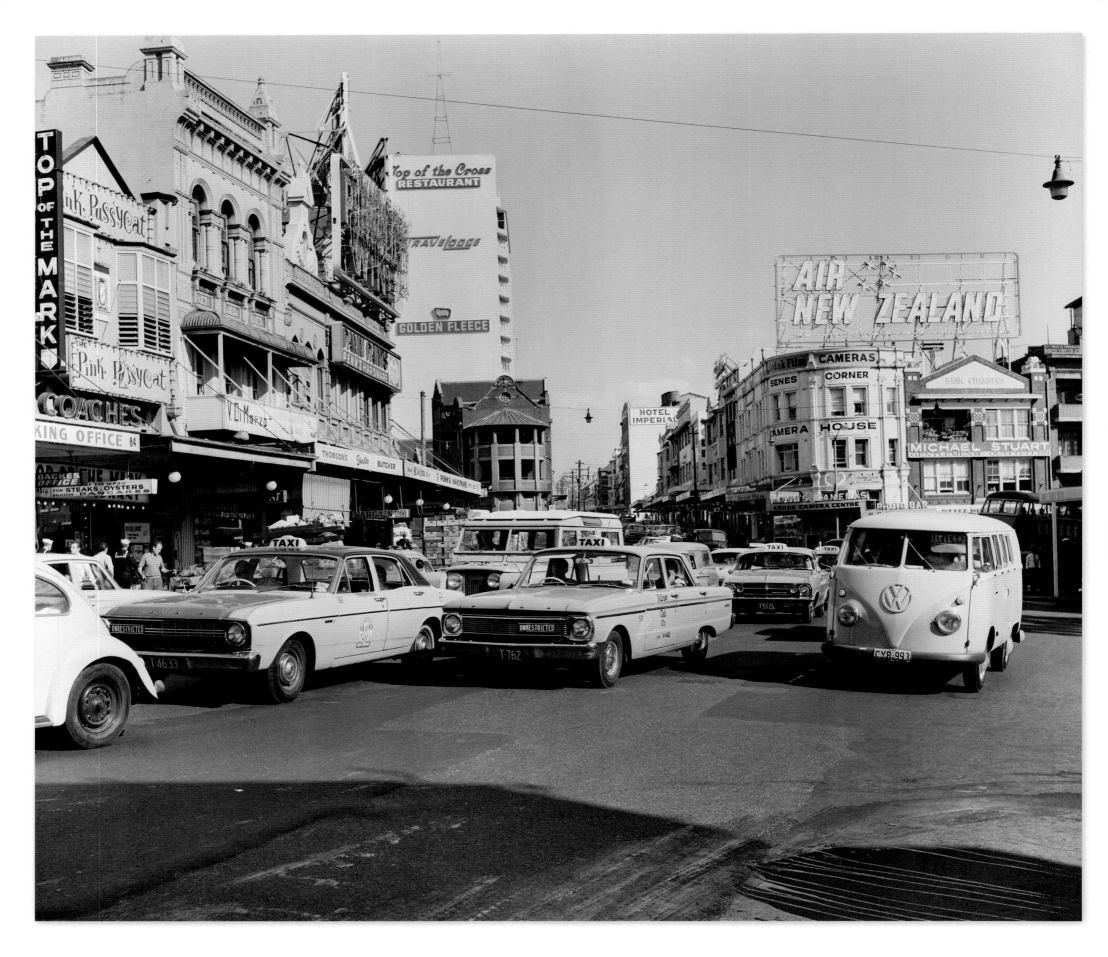

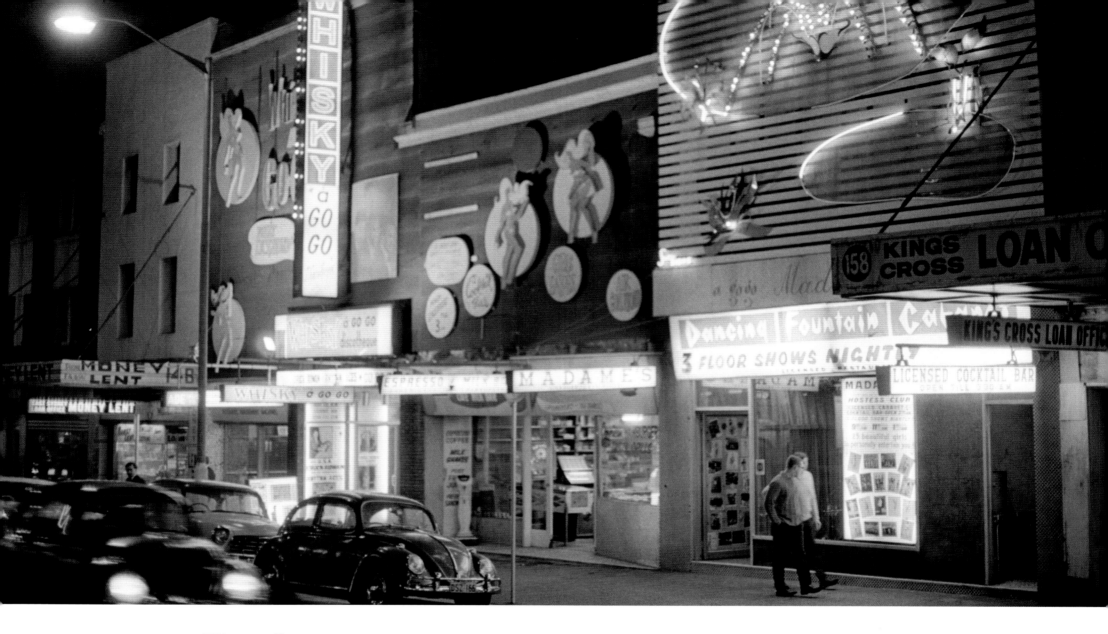

Kings Cross
1967

SOURCE: NATIONAL ARCHIVES OF AUSTRALIA, A1200, L62704, 11406333

A bustling Kings Cross during the afternoon peak in 1967, with its iconic signage and period buildings where the Kings Cross Tunnel is located today. You can see the Top of the Cross building on Darlinghurst Road, as well as the various other shops and businesses such as the Top of the Mark Restaurant, the Pink Pussycat in its original location, and the Senes Camera House, to name a few.

While Kings Cross is often associated with the strip of Macleay Street and Darlinghurst Road, its name is in fact derived from this complex intersection of Darlinghurst Road, Victoria Street, William Street, Bayswater Road, and Kings Cross Road. This location is also often referred to as 'Ground Zero', after the strip of shops seen at the top of William Street on the left.

Whisky-Au-Go-Go, William Street
1967

PHOTOGRAPHER: ROBERT DONALDSON
SOURCE: AUSTRALIAN CONSOLIDATED PRESS AND CONSOLIDATED PRESS, MITCHELL LIBRARY, STATE LIBRARY OF NEW SOUTH WALES, V1-FL19288708

I don't think we can talk about nightclubs in Sydney during the 1960s without talking about the Whiskey-Au-Go-Go, pictured here in September 1967.

The club became synonymous with Sydney nightlife during the 1960s and 1970s, and was known for its go-go dancers and entertainment, particularly popular with visiting servicemen during the Vietnam War, as it was a short walk from the Garden Island Naval Base.

Spit Road, Mosman
1968

PHOTOGRAPHER: JOHN WARD
SOURCE: CITY OF SYDNEY ARCHIVES, A-01112512

A classic coastal-road scene, if you can ignore the traffic, looking towards The Spit and the crawl up Spit Hill before it was widened from four lanes to six in late November 1968.

Australia Square ▸
1968

SOURCE: NATIONAL ARCHIVES OF AUSTRALIA, A1500, K18601, 11727879

At the Australia Square quadrangle, office workers are having a break during the lunchtime rush.

Australia Square would have been fully open for just under a year when this photograph was taken. It's fascinating seeing how beautifully dressed people were, and how incredibly diverse (and colourful) fashions were in the 1960s.

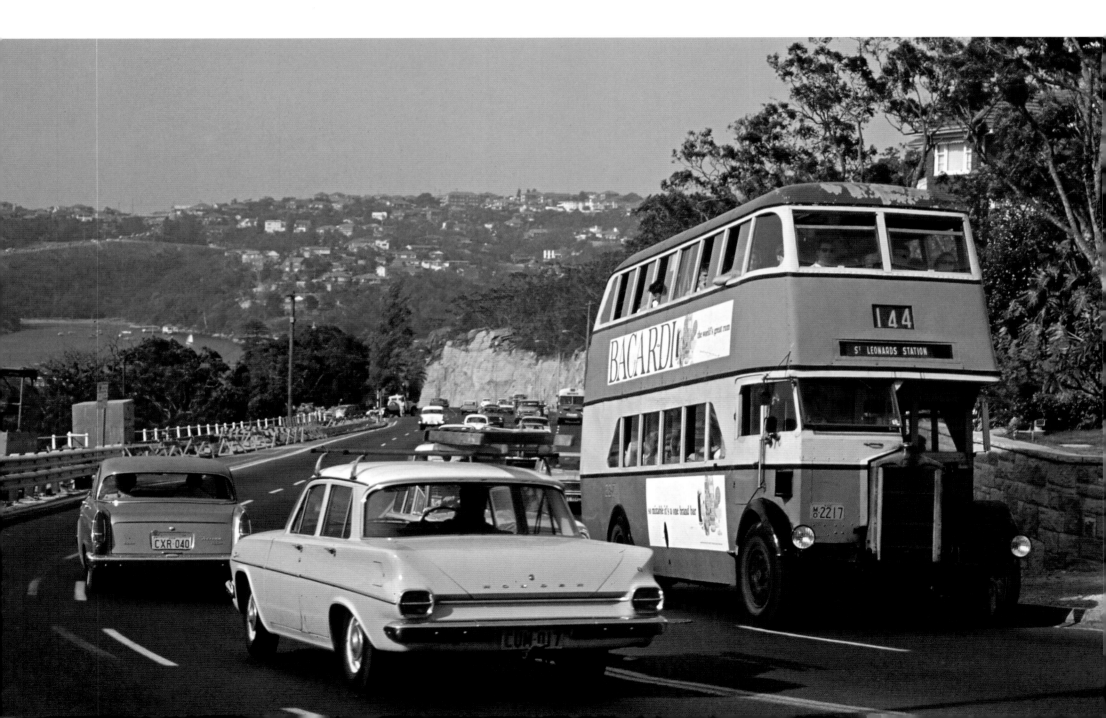

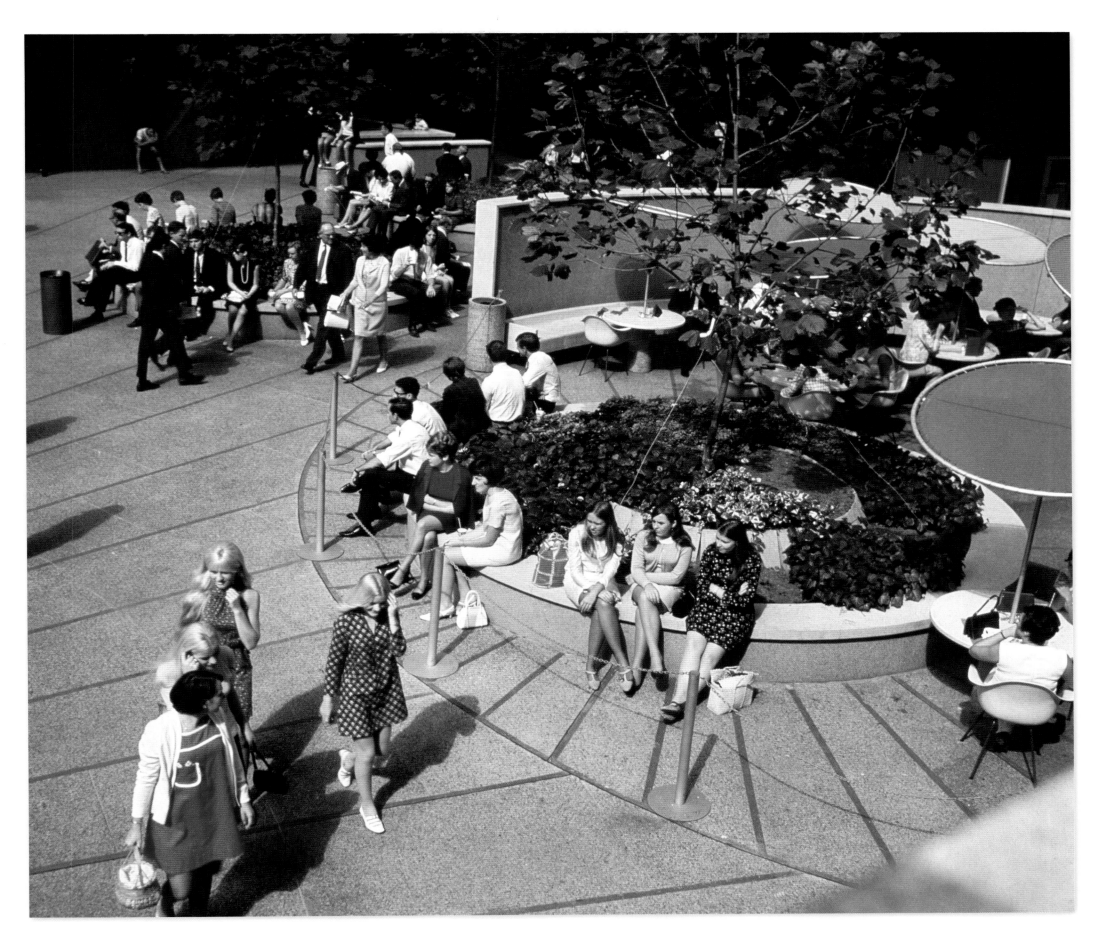

Barrenjoey Road, Newport
1969

PHOTOGRAPHER: JOHN WARD
SOURCE: CITY OF SYDNEY ARCHIVES, A-01112467

Seaside Sydney, looking over Newport Beach and Barrenjoey Road as the 190 bus snakes up the bends towards Avalon in early February 1969.

You can see Newport headland in the distance and the main drag down towards the right.

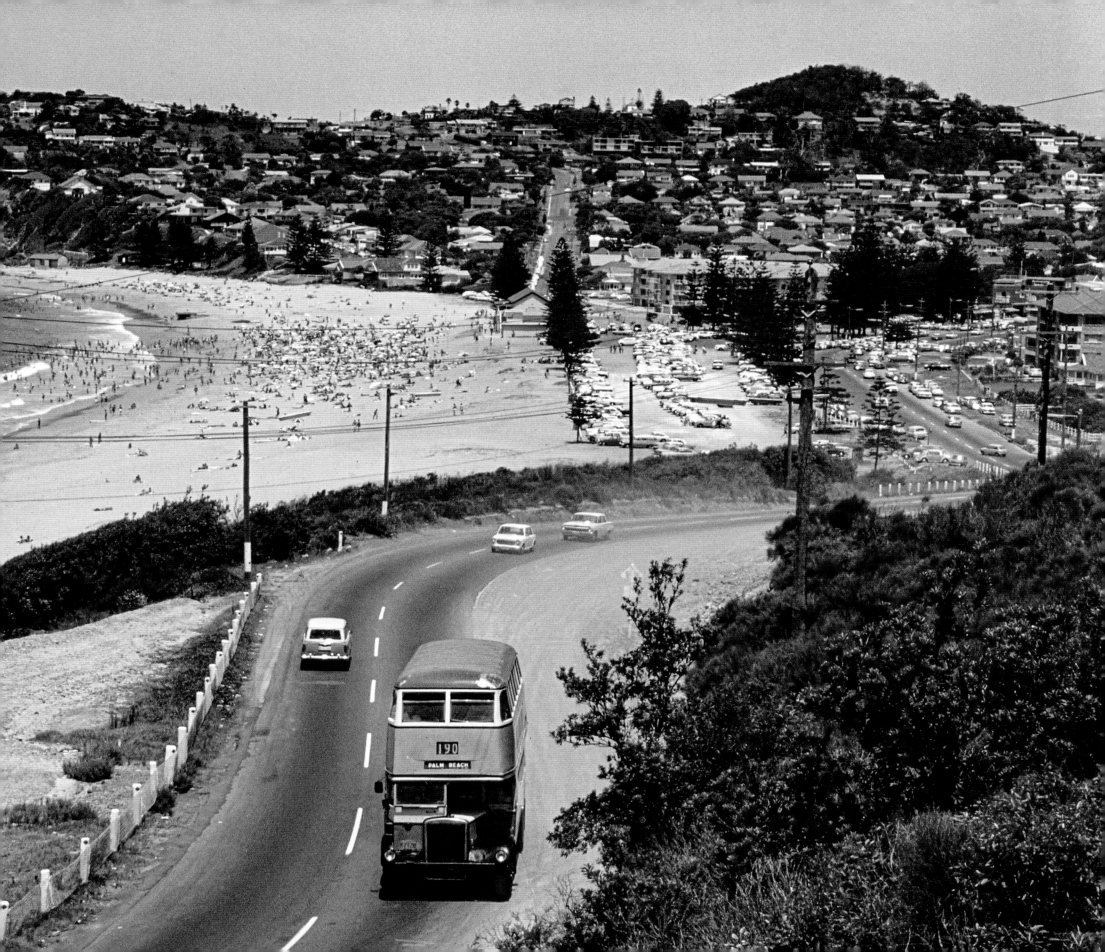

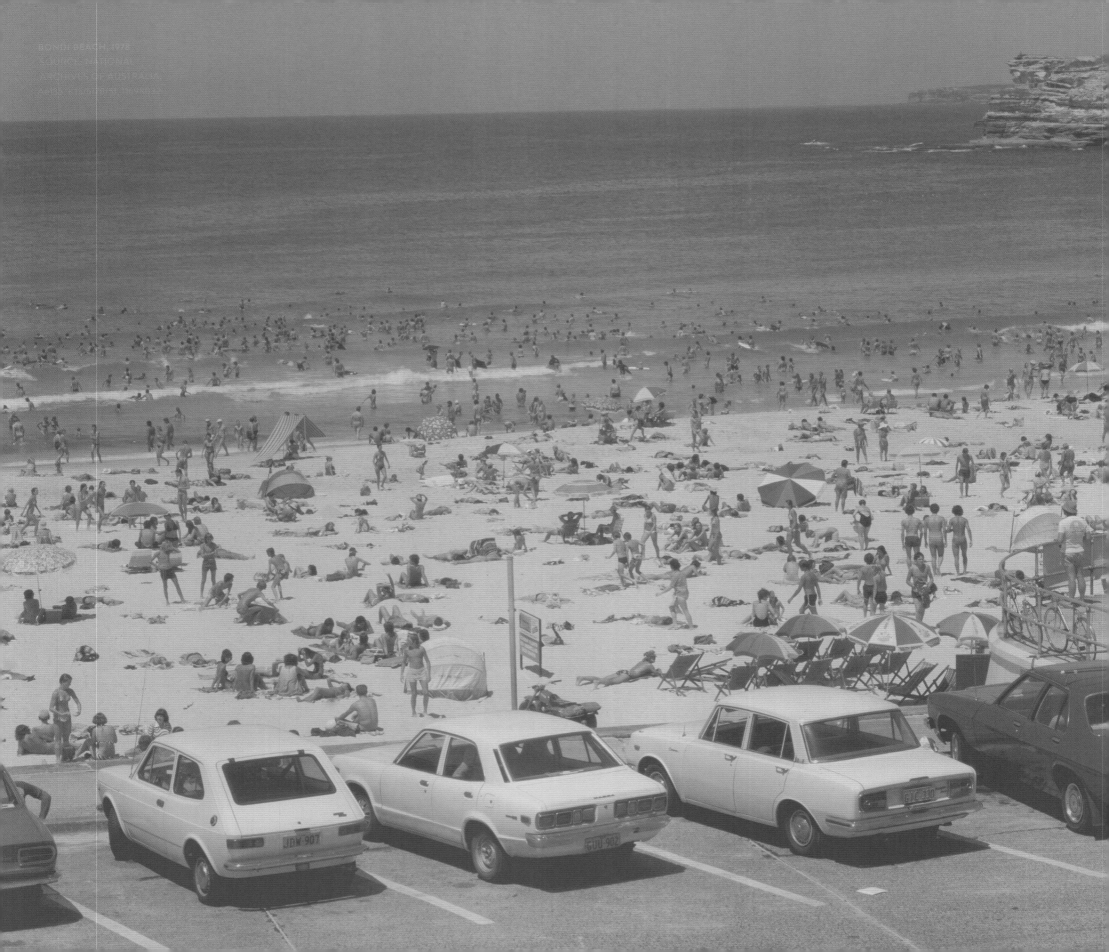

THE 1970s

Welcome to the decade of liberation — we waved goodbye to the Swinging Sixties with its folk music and flower power, and entered a period of rapid change in sensibility — mission brown, corduroy, rock, and disco. Australia was changing — probably more rapidly than ever before. We were finally watching television in colour, pushing the boundaries with television shows such as *Number 96*, the rise of feminist publications highlighting women's inequality such as *The Female Eunuch* by Germaine Greer, the fallout of the Vietnam War, the abolishment of the White Australia policy in favour of multiculturalism, and the first Mardi Gras held in Sydney in 1978.

The face of Sydney also continued to evolve during the 1970s, and we were going out as well as up — the Opera House was completed and opened by Queen Elizabeth II in October 1973, becoming one of the most important buildings of the 20th century. A second AMP building, the AMP Centre at 50 Bridge Street, was completed in 1976, as was National Mutual's remodelling of 350 George Street, the Hyatt Kingsgate building on Darlinghurst Road in 1972, and the MLC Centre in 1978. Construction of a new landmark building in the CBD, Centrepoint Tower, started in the mid-1970s. Martin Place started its rolling program of pedestrianisation throughout the 1970s, and there was also further expansion across the pond, with office towers starting to sprout up in North Sydney as it became Sydney's financial district.

The further expansion of shopping malls such as the Westpoint Shopping Centre and Westfield Parramatta in the suburbs also ushered in convenience shopping, as did the advent of late-night shopping on Thursdays, introduced in December 1971. This was a result of the government passing legislation to allow retailers to trade until 9.00 pm on 16, 23, and 30 December, in a response to rolling industrial action by bus drivers in the lead-up to Christmas. The initiative was so popular that on the first night of late trading, traffic in the CBD was bought to a standstill. From then on, Thursday-night shopping became a weekly affair for many families.

The Seventies also occasioned a revolution in the kind of food we ate and where we bought it. The first McDonald's opened in Yagoona in 1971, entering the market that other overseas-originated fast-food chains such as Kentucky Fried Chicken had started to tap when it had opened a few years earlier in Guildford in 1968.

It was also a decade not without its dire moments for our city: the 1971 Qantas bomb hoax by Peter Macari and Raymond Poynting, extorting $500,000 from Qantas outside its Chifley Square headquarters after a bomb had puportedly been planted on Flight 755 from Sydney to Hong Kong; the disappearance of Juanita Nielsen from the Carousel Club in Kings Cross in July 1975; the Savoy Hotel fire on Christmas Day 1975; the Grandville rail disaster in January 1977; the Hilton Hotel bombing in February 1978; and the Ghost Train fire at Luna Park in June 1979. The decade also saw the start of what many refer to as the 'golden age of bank robbery', with robberies becoming a frequent occurrence at many banks in the CBD and in the suburbs.

Pittwater Road, Collaroy (Long Reef)
1970

PHOTOGRAPHER: JOHN WARD
SOURCE: CITY OF SYDNEY ARCHIVES, A-01112289

A view across Pittwater Road looking towards a packed Long Reef Beach car park as beachgoers escape the summer heat in late January 1970.

Most of the eastern side of Pittwater Road is covered by dense scrubland today, as are the sand dunes that surround Dee Why Lagoon, which are very visible here. You can see a busy Dee Why Beach in the distance, and looking along towards Dee Why Headland, and further in the distance, North Head.

What's most amazing to me in this photograph is that the majority of the vehicles would have been either manufactured or assembled in Australia.

Kings Cross ▸
1970

SOURCE: NATIONAL ARCHIVES OF AUSTRALIA, A1200, L84008, 11484935

This is one of my favourite photographs — at the intersection of William Street and Darlinghurst Road, with the iconic neon signs lit up during the golden era of the Cross. Gorgeous.

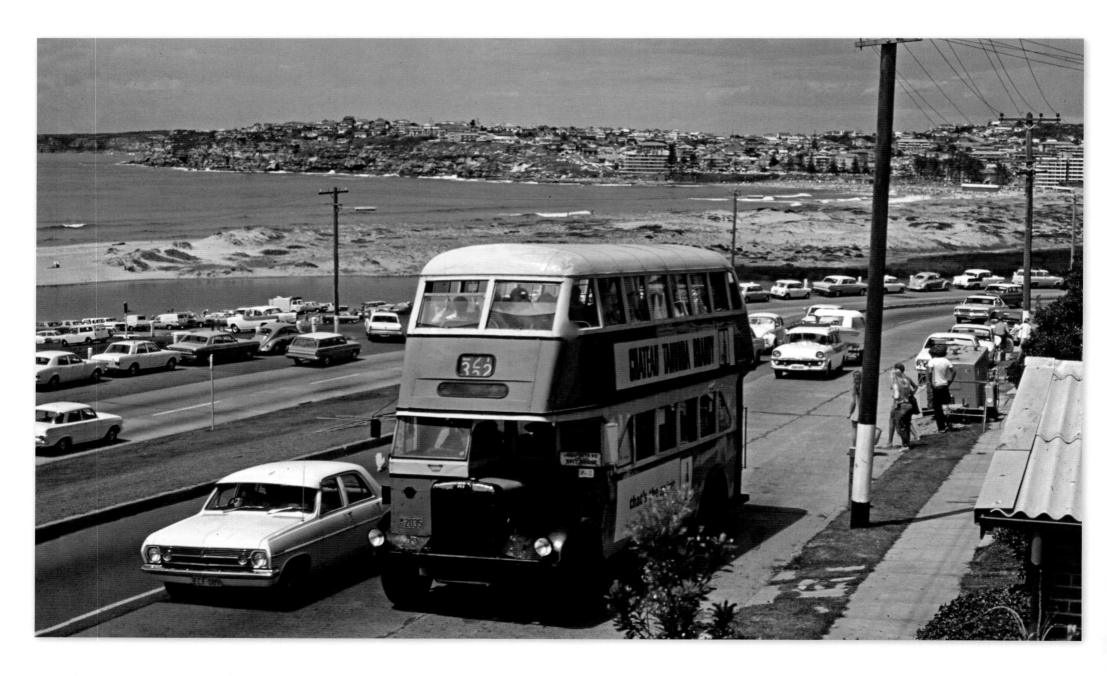

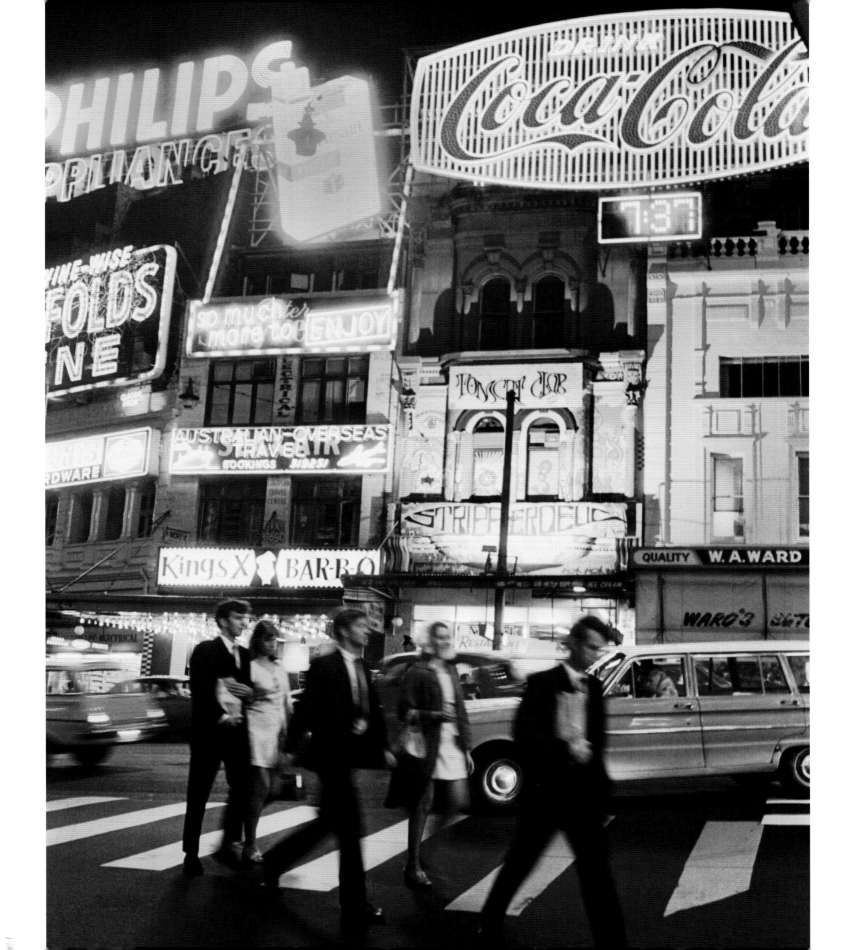

55

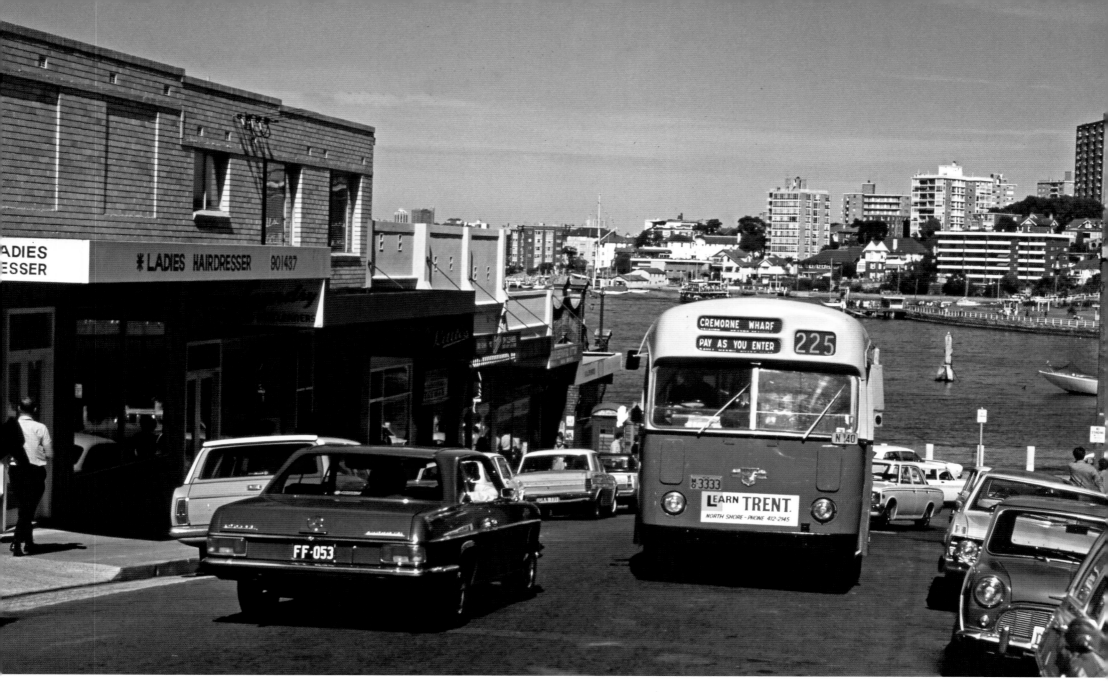

Hayes Street, Neutral Bay
1970

PHOTOGRAPHER: JOHN WARD
SOURCE: CITY OF SYDNEY ARCHIVES, A-01112232

The 225 bus heads up towards Kurraba Road from Neutral Bay Wharf in late April 1970. The shops seen here on the left are still there today; however, the backdrop of Kirribilli looks a little bit different these days. Some great cars of the day here include a very special Mercedes-Benz 250CE, a Valiant Pacer, an original Austin Mini, a HT Kingswood, and an EH Holden.

Barrack Street
1971

PHOTOGRAPHER: JOHN WARD
SOURCE: CITY OF SYDNEY ARCHIVES, A-01112025

Looking down Barrack Street from near the intersection of Barrack and Clarence streets in mid-January 1971, you can see the GPO on the corner of George Street and Martin Place in the background, as well as the lovely period buildings that line Barrack Street. The section of Barrack Street between George and York streets is now pedestrianised.

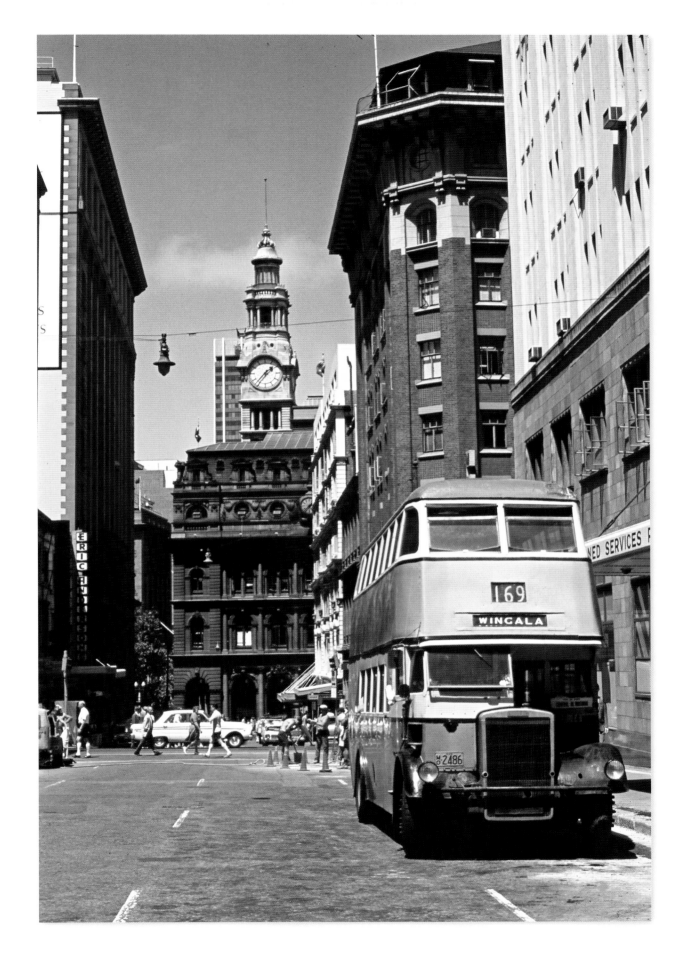

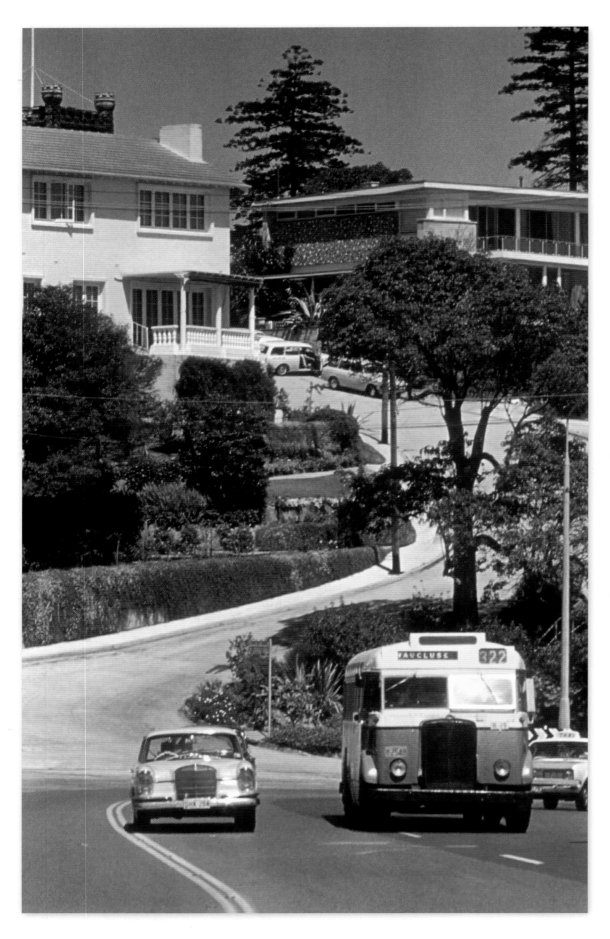

New South Head Road, Rose Bay
1971

PHOTOGRAPHER: JOHN WARD
SOURCE: CITY OF SYDNEY ARCHIVES, A-01111761

Looking southbound from near the intersection of Tivoli Avenue and New South Head Road towards a very manicured Fernleigh Gardens as the 322 snakes up Heartbreak Hill in mid-October 1971 — complete with a Mercedes 220S 'Finnie', a Kingswood taxi, and a few Volkswagen Type 3 'Squarebacks' in Fernleigh Gardens.

Fernleigh Gardens is now heavily vegetated, and you can no longer see the properties from the street. At the top left-hand corner, you can just see the roofline of Fernleigh Castle, a Victorian-style mansion completed in 1892 that was put on the register of the National Estate in 1978 and heritage listed in 1995. It has had some notable tenants over the years, including Dame Nellie Melba, who lived in the mansion in the 1920s.

Hickson Road Reserve, The Rocks ▷
1972

PHOTOGRAPHERS: MAX DUPAIN AND JILL WHITE
SOURCE: MITCHELL LIBRARY, STATE LIBRARY OF NEW SOUTH WALES, V1-FL16401604

Looking east from Hickson Road Reserve across to the nearly completed Opera House in December 1972.

Despite being designed in the late 1950s, the Opera House still looked fresh — as it does today. It would be opened in October 1973, and has since become synonymous with Sydney and Australia.

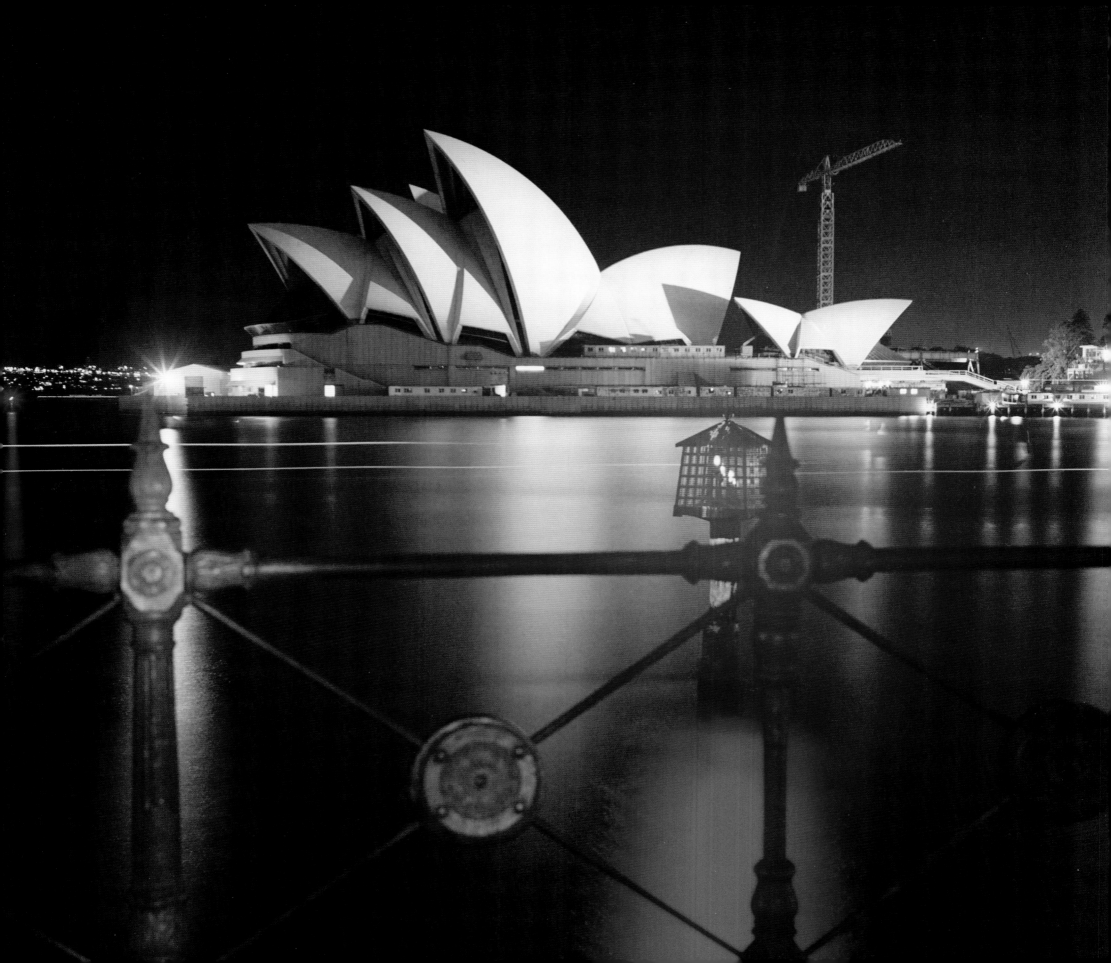

West Head Lookout, Northern Beaches
1972

PHOTOGRAPHERS: MAX DUPAIN AND JILL WHITE
SOURCE: MITCHELL LIBRARY, STATE LIBRARY OF NEW SOUTH WALES, V1-FL19447037

Looking out towards Palm Beach headland from West Head Lookout in September 1972.

While this is usually a tourist attraction these days (and, if you're into bike riding, a rest stop), many people would picnic here from time to time — my mum remembers many family picnics being held here. The stonework is still there today; however, the rock wall is undergoing an upgrade to provide more adequate protection against rock falls.

George Street, Railway Square ▸
1973

PHOTOGRAPHER: JOHN WARD
SOURCE: CITY OF SYDNEY ARCHIVES, A-01111063

We're looking north towards the intersection of Quay, Lee, and George streets outside Railway Square as the 438 to Abbotsford is ready to head up Broadway to Parramatta Road.

You will notice in the distance, a bit further up from where this photograph was taken, a zebra crossing. It's quite amazing to think that there was a zebra crossing along George Street at one point, considering how busy this intersection is now! Most of the buildings in this photo are still there today, although Railway Square has been heavily redeveloped — first in the late 1970s, and again, into its current form, in the late 1990s.

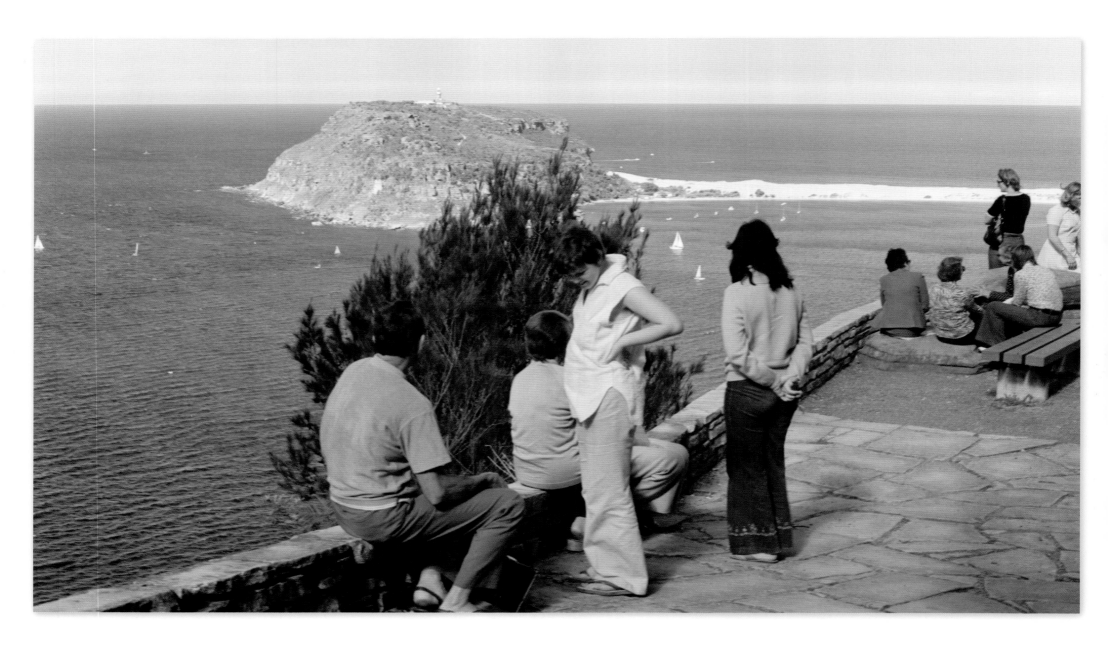

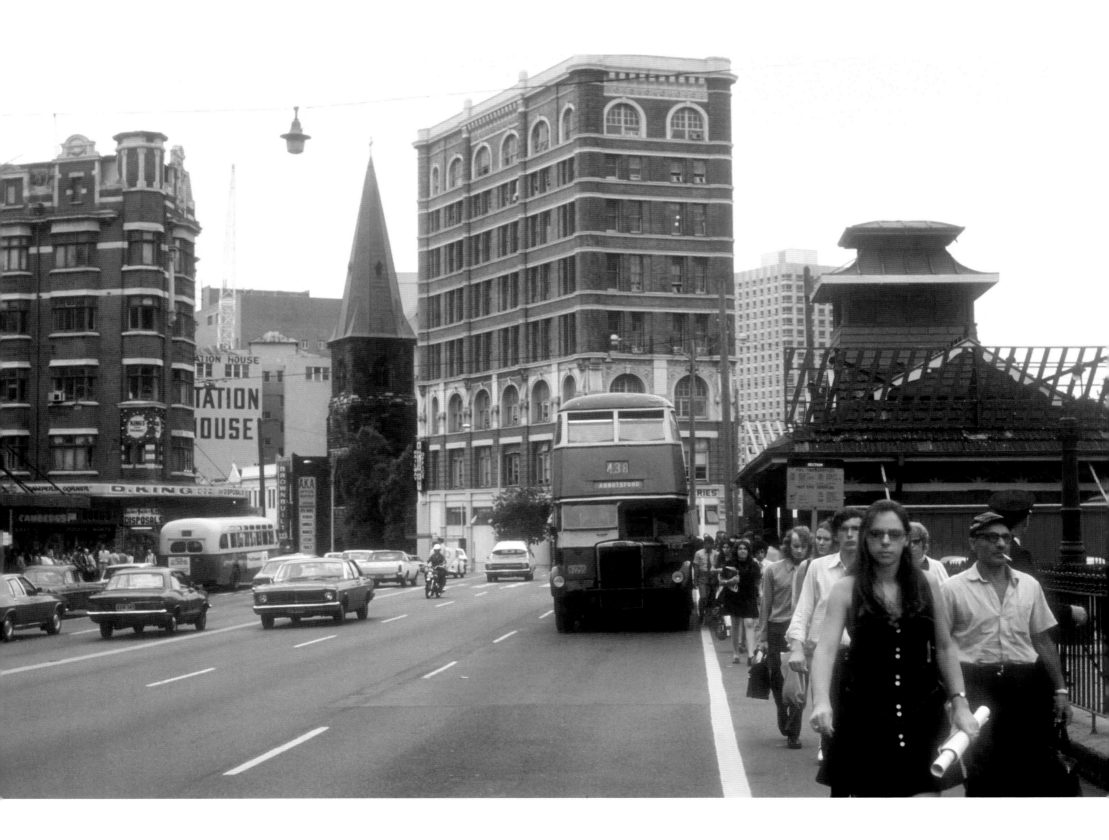

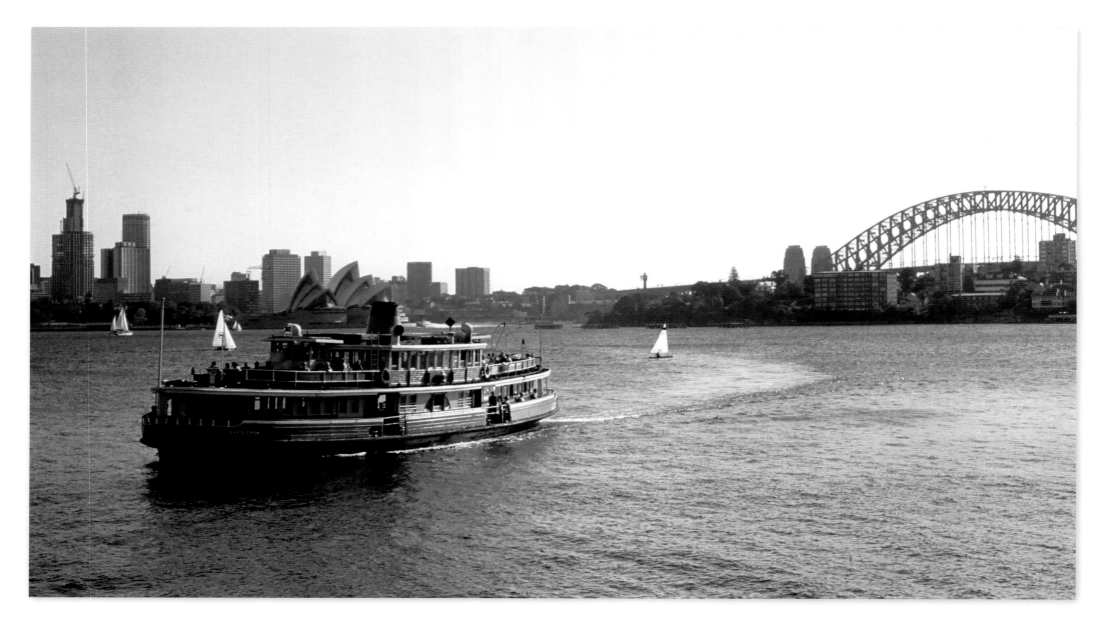

Cremorne Point
1973

PHOTOGRAPHER: JOHN WARD
SOURCE: CITY OF SYDNEY ARCHIVES, A-01076435

The ferry *Karingal* approaches Cremorne Wharf from Sydney Harbour in March 1973. In the background you can see Bennelong Point and the AMP Centre being built on Bridge Street (now the recently redeveloped Quay Quarter Tower).

Named after the Aboriginal word meaning 'happy home', *Karingal* was in service from April 1913 until its decommissioning in early 1984, after its sister ferry *Karrabee* infamously sank at Circular Quay in January 1984 following the Great Ferry Boat Race.

Karingal was sold to new owners in Melbourne, but on its delivery voyage it sank off Cape Conron in June 1985.

Kirribilli ›
1973

PHOTOGRAPHER: FRED MURRAY, COURTESY FAIRFAX MEDIA

On one of Sydney's most momentous days, 20 October 1973, the city's brand-new Opera House at Bennelong Point was opened, with thousands of Sydneysiders coming together to mark the occasion on the gleaming harbour.

The Opera House was designed by Danish architect Jørn Utzon after he won an international competition in 1957 for his unique and ambitious concept. Despite several controversies arising during its construction, and the ousting of Utzon, the building was recognised as a triumph upon its completion and has become an internationally recognised icon. The Sydney Opera House was declared a World Heritage Site in 2007.

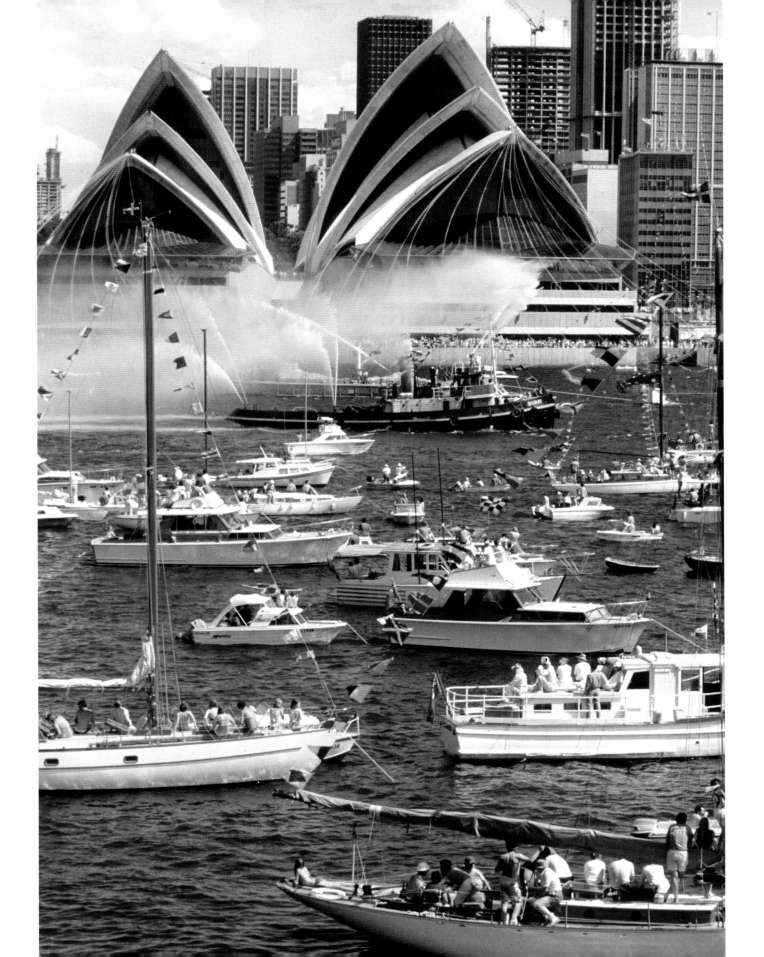

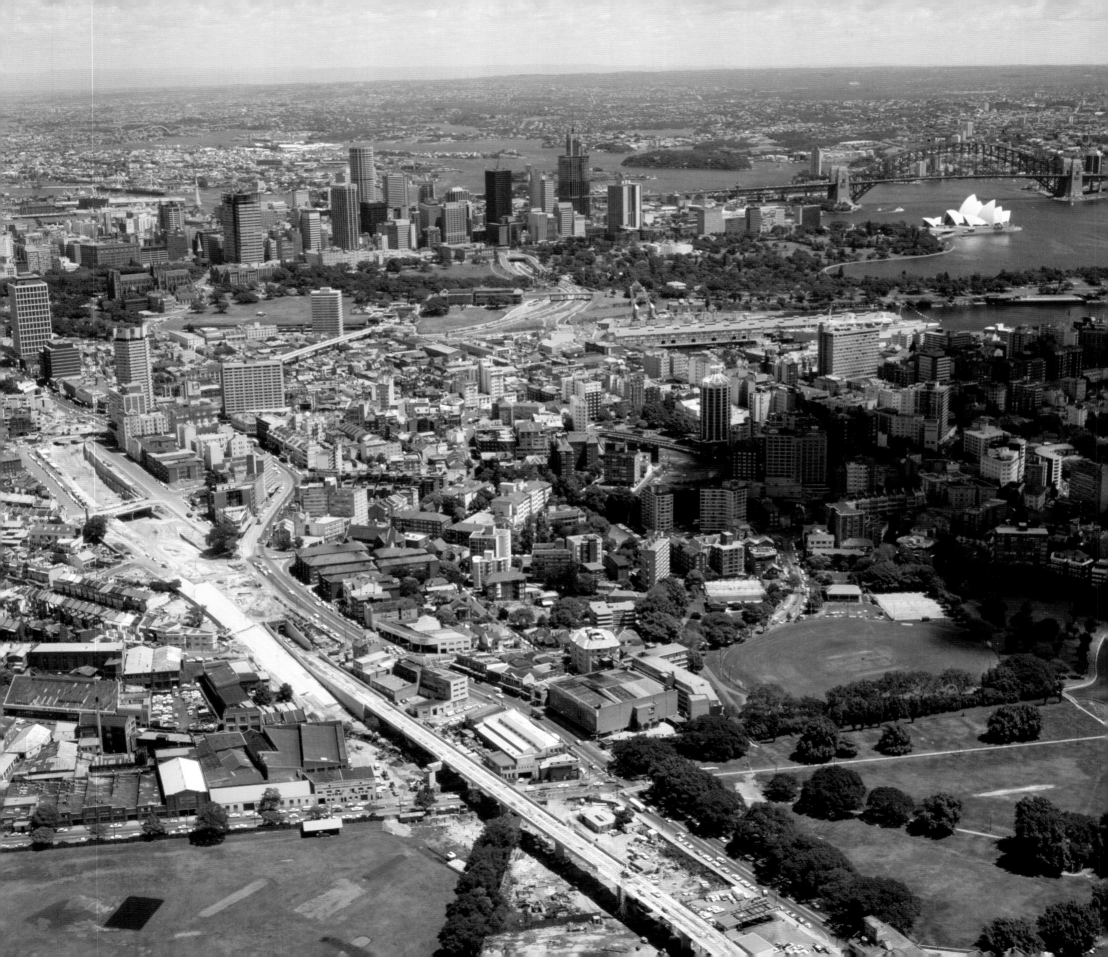

Edgecliff

1973

SOURCE: STATE OF NEW SOUTH WALES (TRANSPORT FOR NSW) 2016,
DEPARTMENT OF MAIN ROADS, 100329-56

Hovering above the fringe of Edgecliff and Paddington, this image shows a north-westerly view of the Kings Cross area, Elizabeth Bay, and Rushcutters Bay during the construction of the Kings Cross Tunnel (now part of the Cross City Tunnel) in November 1973.

Tunnel roadwork can be seen on the left, just above the Rushcutters Bay and Edgecliff portion of the Eastern Suburbs Railway viaduct development, which cuts across the centre of the image, at the bottom.

You can also just see Hyde Park on the fringe of the CBD and, to the right, the partially constructed Eastern Suburbs Railway elevation, which cuts across Woolloomooloo towards St Mary's Cathedral, the Art Gallery of New South Wales, and the Domain. Beyond lie the Royal Botanic Gardens, the Sydney Opera House and Harbour Bridge, and the Lower North Shore.

Rose Bay

1974

PHOTOGRAPHER: JOHN WARD
SOURCE: CITY OF SYDNEY ARCHIVES, A-01078908

An Ansett Short S-25 Sunderland Flying Boat VH-BRF lands in the harbour at Rose Bay in April 1974.

The Rose Bay Water Airport first opened in early August 1938, and was the first international airport in Sydney — used on a temporary basis for the Sydney-to-London flights operated by Qantas and Imperial Airways at the time.

It continued to operate as an airport until its closure in 1974, mainly servicing flights by Ansett to Lord Howe Island before its land airport opened the same year.

The flying boat seen here was built in 1944 and commissioned for the Royal Air Force in the UK, before making its way to New Zealand's Air Force in the early 1950s; it was sold to Ansett in 1963 for flying boat charters until 1974, before making its way to the US. It was also used in the films *Mr & Mrs Edgehill*, starring Dame Judi Dench, and *Tenko Reunion* in 1985.

Today it sits in the Fantasy of Flight Museum in Florida, in the US.

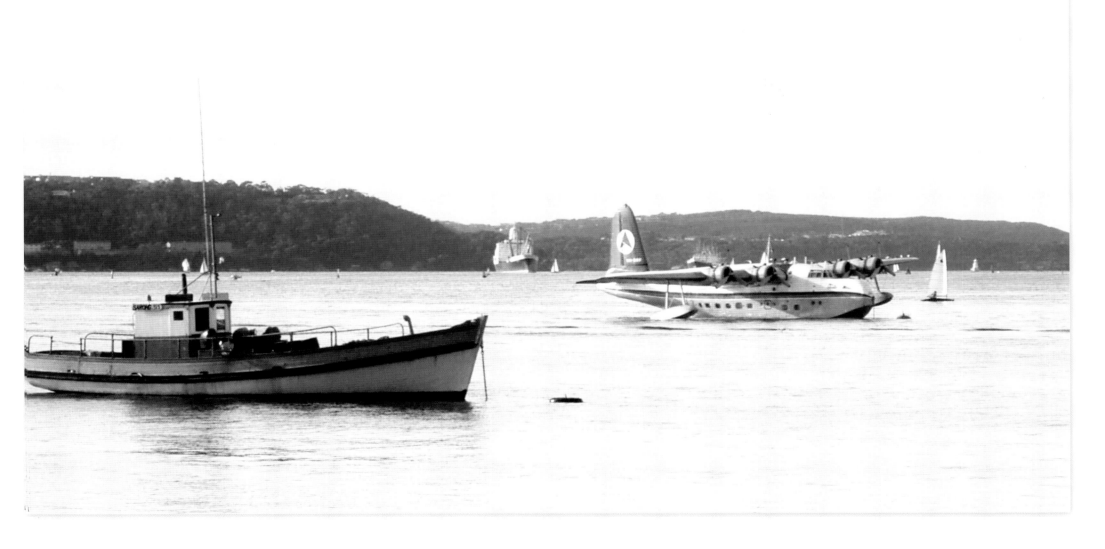

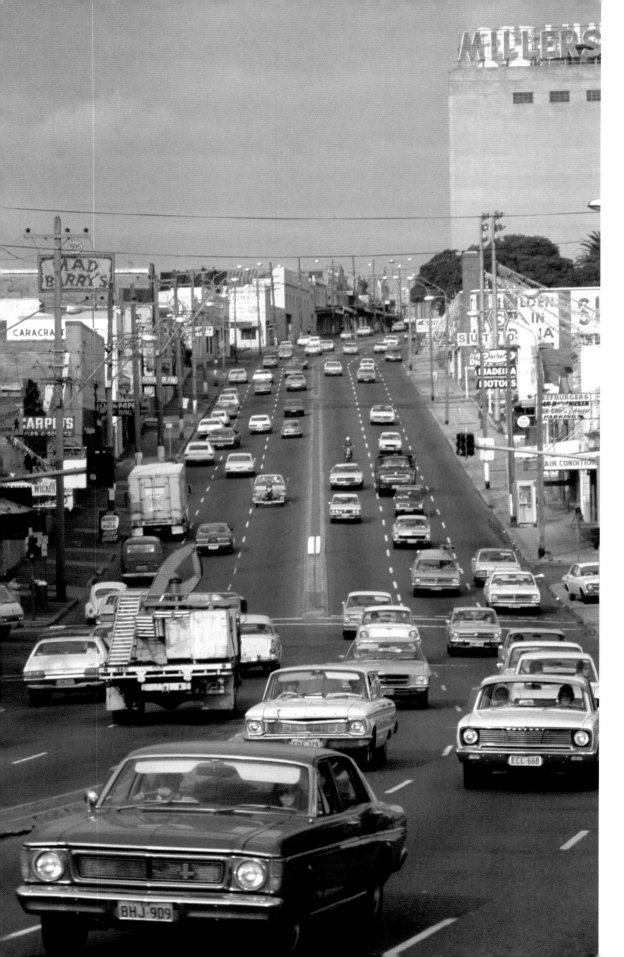

Parramatta Road, Leichhardt

1974

SOURCE: NATIONAL ARCHIVES OF AUSTRALIA, A6135, K7/3/74/42, 11963148

Looking east from the Lewisham side of Parramatta Road towards the intersection of Flood Street and West Street in late February 1974. On the right, you can see the Suttons Daihatsu dealership up Taverners Hill, which is where the old Rick Damelian site was for many years — or 'cars to the stars', as it was known — and the old Millers Brewery, which is bright orange and the home of Kennards Storage these days; and, on the left, Mad Barry's for all your discount kitchen hardware needs (complete with a Laminex benchtop in a lairy shade).

There are plenty of 1960s and 1970s Aussie classics in this shot — a Falcon, a Valiant, a Kingswood, a few EH and EK Holdens, and some Minis — plus several Japanese suburban staples of the time — Datsuns, 180Bs, and a Corona, to name a few.

And, yes, Parramatta Road has always been this busy.

Circular Quay West ▸

1974

SOURCE: NATIONAL ARCHIVES OF AUSTRALIA, A6135, K15/2/74/19, 11681409

Looking towards the new Opera House from Circular Quay West in February 1974, in front of the Maritime Services Board building, which is now part of the Museum of Contemporary Art. Circular Quay West was closed to traffic in the mid-1980s, when it became pedestrianised.

Circular Quay
1974

PHOTOGRAPHER: JOHN WARD
SOURCE: CITY OF SYDNEY ARCHIVES, A-01076280

The P&O liner *Canberra* is in port, and passengers disembark from the ferry *Kanangra* on its Cremorne–Mosman run from Circular Quay in early March 1974.

Kanangra was built in 1912, and ran the Cremorne–Mosman route for the majority of its time in service — first as a steam ferry, and then, from the late 1950s as a diesel-powered ferry. It was removed from service in 1985, and was moored in Darling Harbour as an exhibition vessel for a time in the late 1980s. The ferry lives on, and is being restored by the Sydney Heritage Fleet crew.

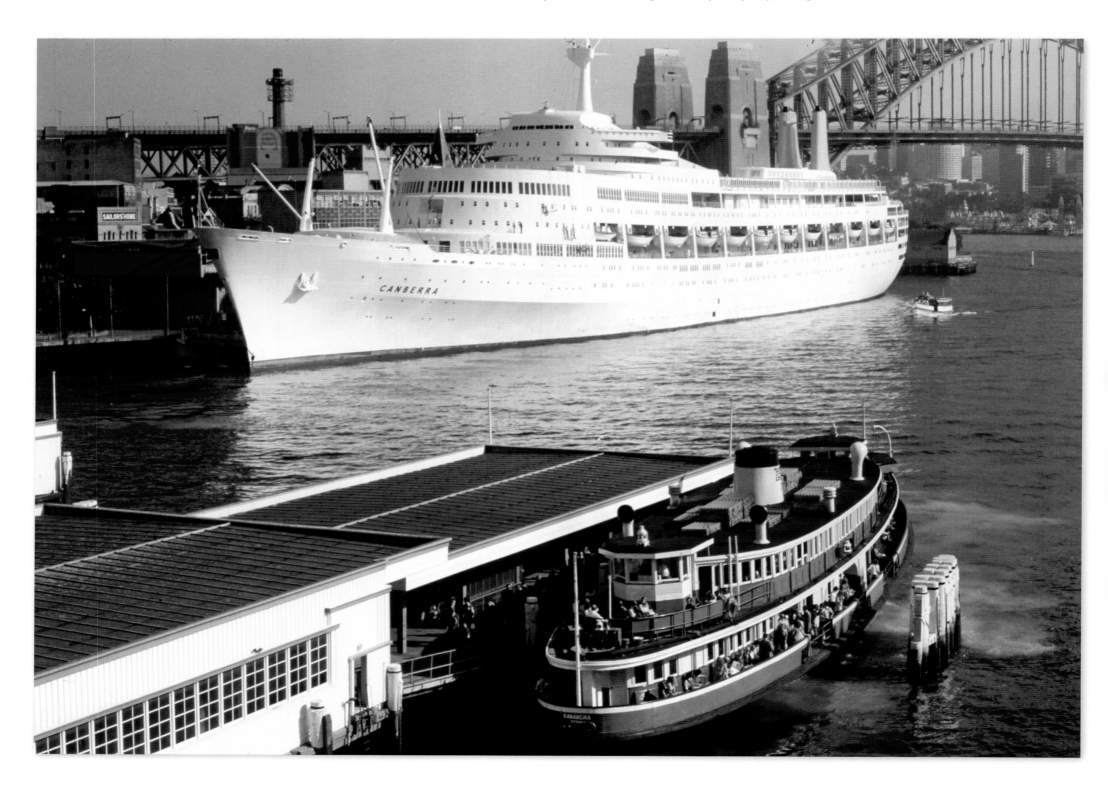

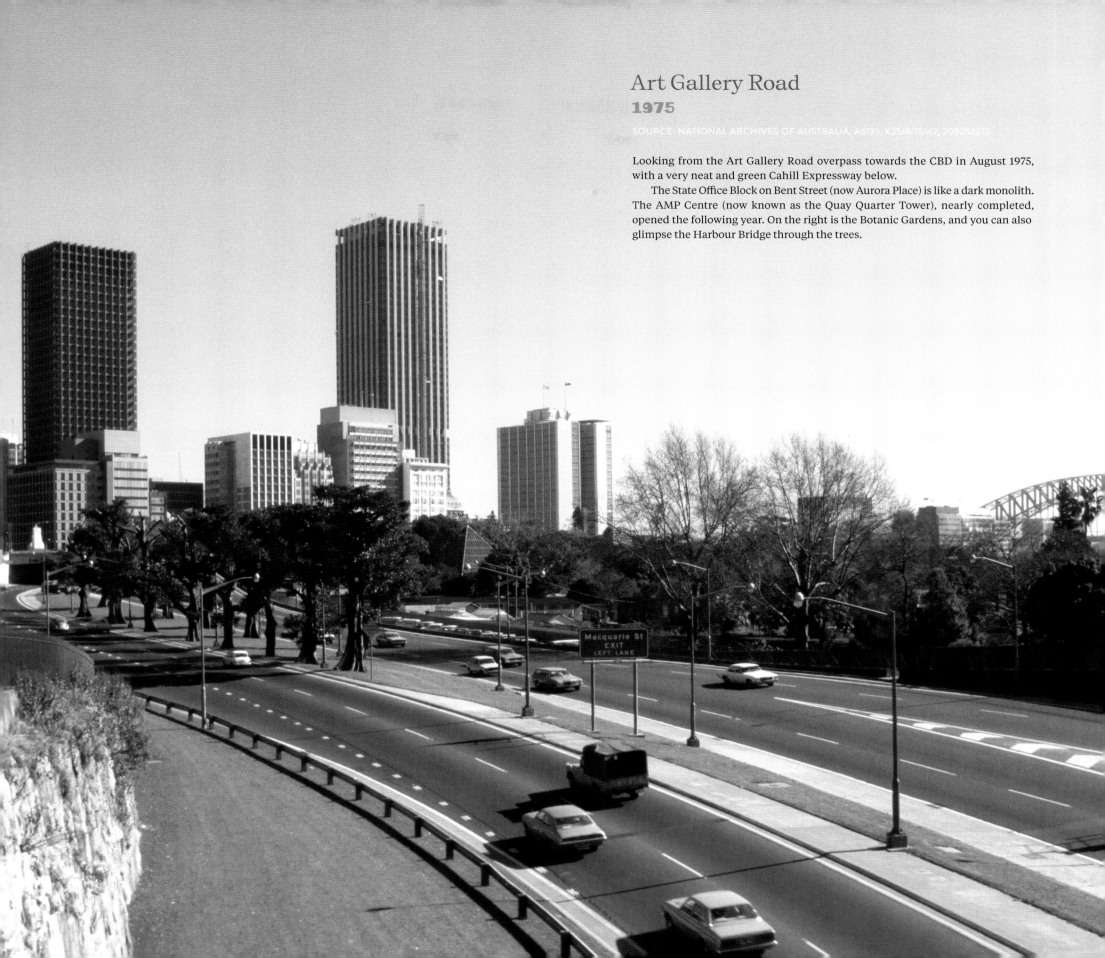

Art Gallery Road
1975

SOURCE: NATIONAL ARCHIVES OF AUSTRALIA, A6135, K25/8/75/42, 203052275

Looking from the Art Gallery Road overpass towards the CBD in August 1975, with a very neat and green Cahill Expressway below.

The State Office Block on Bent Street (now Aurora Place) is like a dark monolith. The AMP Centre (now known as the Quay Quarter Tower), nearly completed, opened the following year. On the right is the Botanic Gardens, and you can also glimpse the Harbour Bridge through the trees.

Macquarie St
EXIT
LEFT LANE

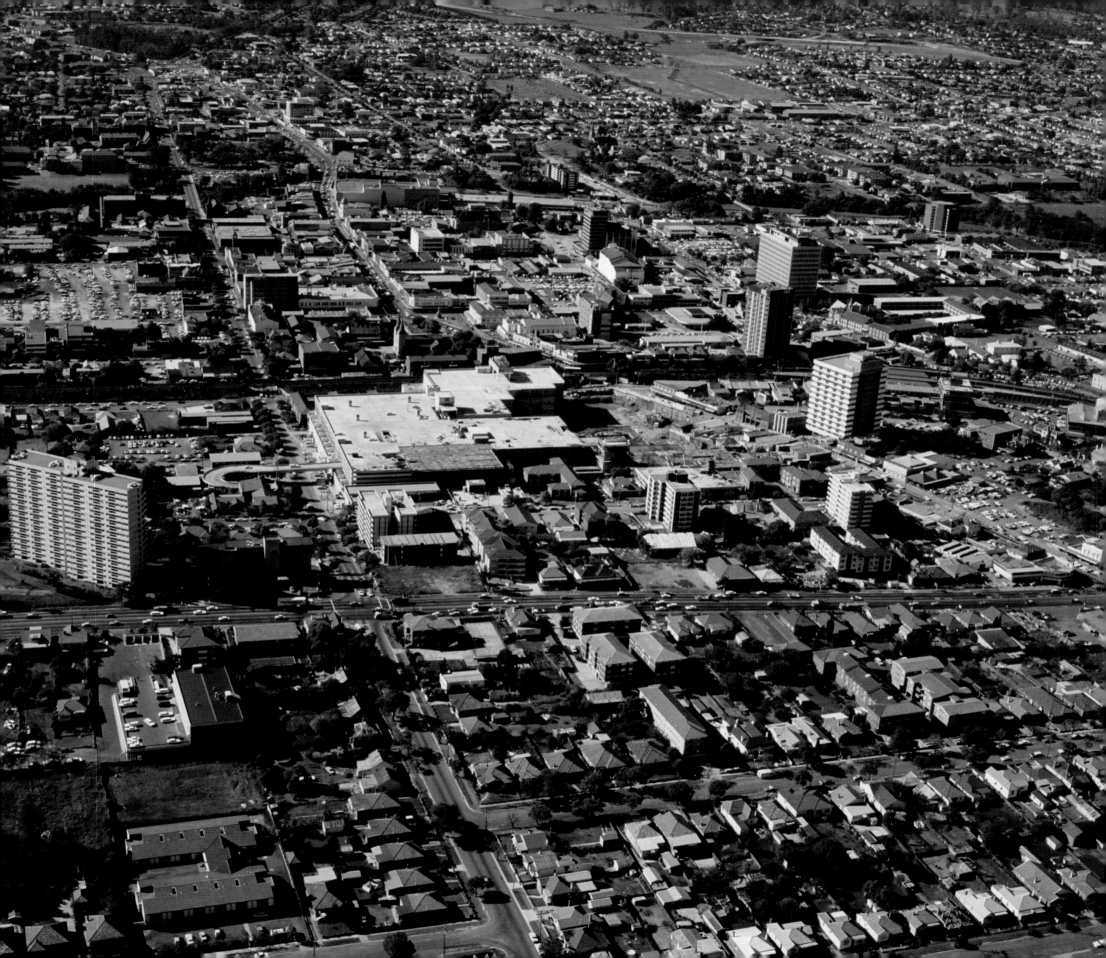

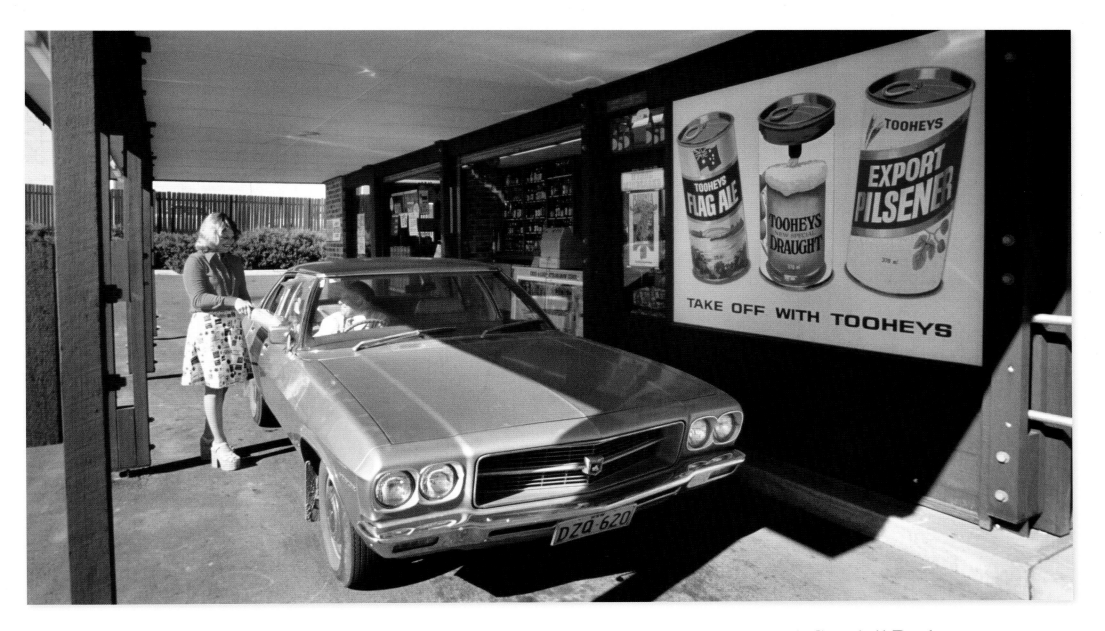

Parramatta
1975

PHOTOGRAPHERS: MAX DUPAIN AND JILL WHITE
SOURCE: MITCHELL LIBRARY, STATE LIBRARY OF NEW SOUTH WALES, V1-FL19446998

The City of Parramatta has always been a vibrant community, and has changed significantly since this aerial photograph was taken, some time between May and September 1975.

The way you can tell the date range is that stage one of the Westfield shopping centre, which opened in May 1975, is operational, whereas stage two, which opened in September that year, is still under construction. When stage two opened, it was the biggest shopping centre in Australia. Westfield Parramatta is now significantly bigger.

It's amazing to think about how Parramatta has become a bustling hub and a second CBD, with significant development occurring in the last decade, including a new campus of the University of Western Sydney, and the new Parramatta Light Rail, the first stage of which is scheduled to open in 2024.

High Flyer Hotel, Condell Park
1975

SOURCE: NATIONAL ARCHIVES OF AUSTRALIA, A6135, K3/7/75/15, 11782951

'Yeah, thanks luv, have you got any Benson and Hedges 25s?' The driver of this HQ Premier may also have been picking up a bottle of Lindeman's highly popular Ben Ean Moselle at the new Drive-Thru Bottle-o at the High Flyer Hotel in Condell Park in June 1975.

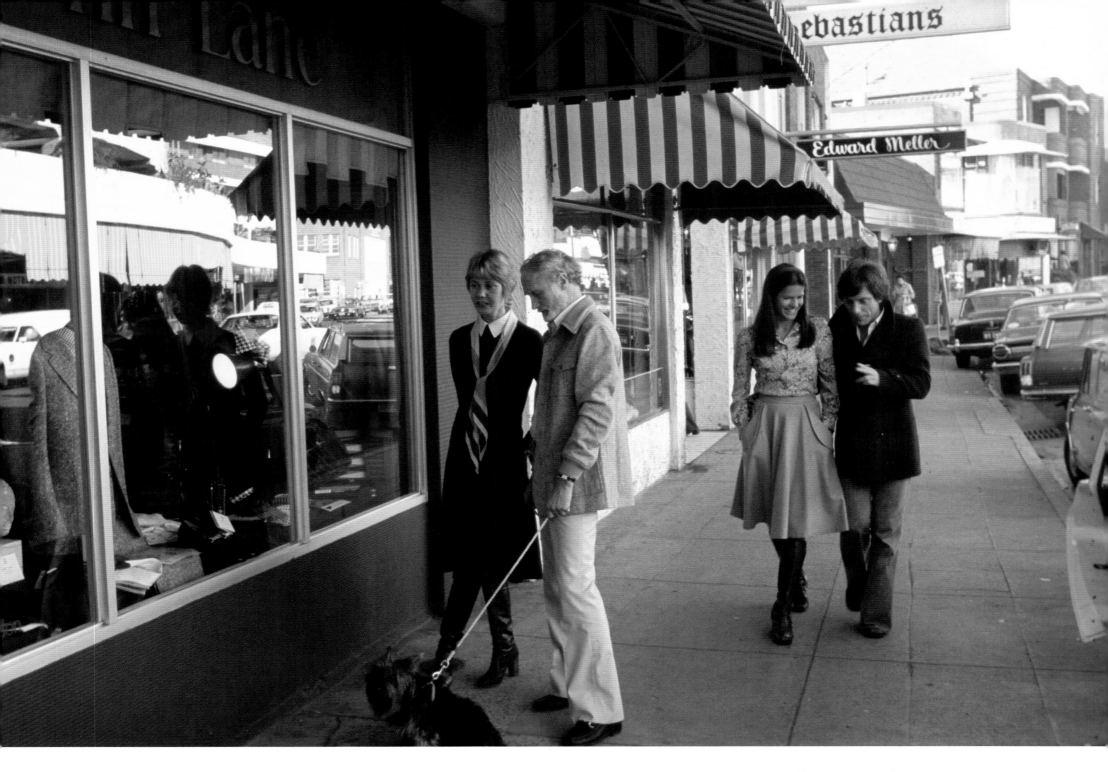

Knox Street, Double Bay
1975

SOURCE: NATIONAL ARCHIVES OF AUSTRALIA, A6135, K18/6/75/29, 11871018

Checking out the exclusive boutiques on the main drag of fashionable Double Bay in June 1975. You can also see The Cosmo in the reflection of the window on the opposite side of Knox Street.

Also notable is the fact that parking was still an acquired skill — look at the cars in this shot, particularly the Silver Shadow! Cripes!

Sydney Markets, Hay Street, Haymarket
1975

SOURCE: NATIONAL ARCHIVES OF AUSTRALIA, A6135, K24/3/75/40, 11792917

Looking east towards Harbour Street as shopkeepers and merchants load their trucks and vans with fresh produce from the original Sydney Markets at Haymarket in March 1975.

This is a fabulous photograph — and it reminds me of my grandfather. Like many people in this shot, he would head into Haymarket each morning and go around to the growers, picking up fruit and vegetables on one of those barrows. He would pack his Dodge truck by hand (there were no forklifts in those days) before heading for his shop, which was in North Narrabeen.

The building on the left housed the Sydney Entertainment Centre before it was demolished in the early 1980s. The markets slowly migrated to Flemington, near Homebush, starting in the 1970s, and were fully operational at that location by 1984. Paddy's Market, in the building on the right, is still there; it was significantly redeveloped in the mid-1990s for a new apartment and shopping centre complex (known as Market City), but maintains its original facade at street level.

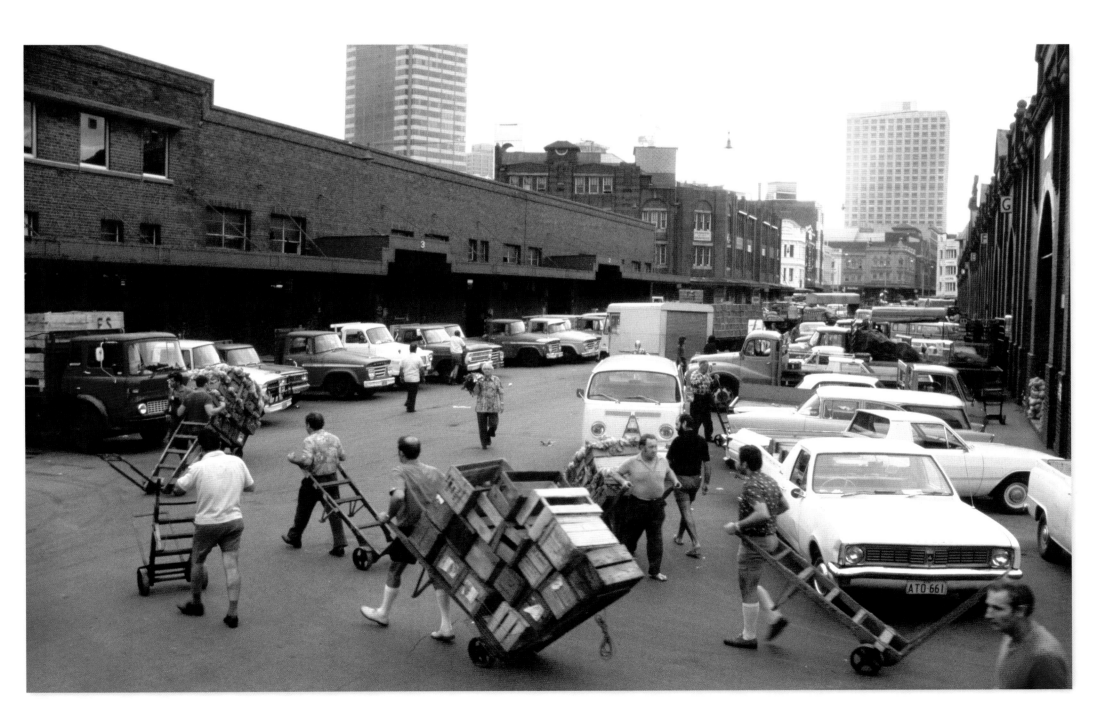

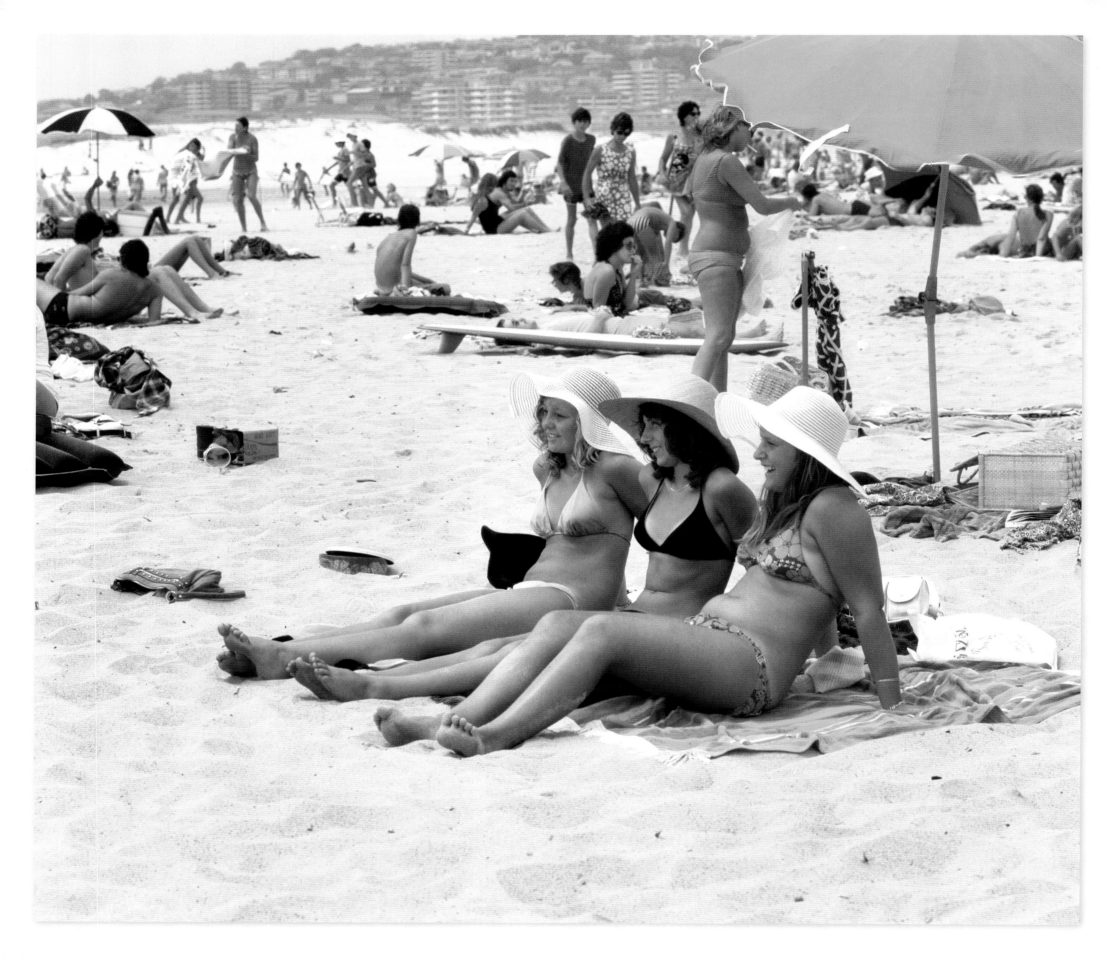

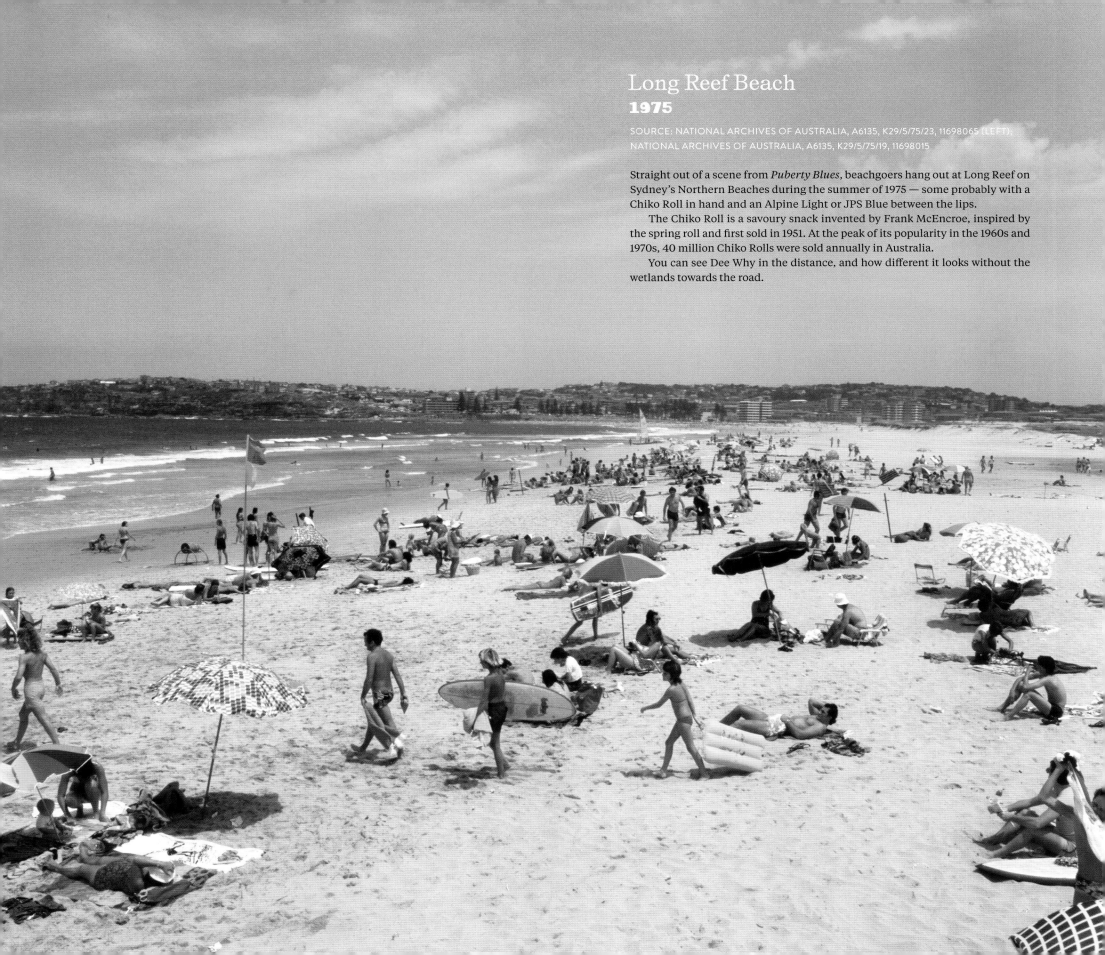

Long Reef Beach
1975

SOURCE: NATIONAL ARCHIVES OF AUSTRALIA, A6135, K29/5/75/23, 11698065 (LEFT); NATIONAL ARCHIVES OF AUSTRALIA, A6135, K29/5/75/19, 11698015

Straight out of a scene from *Puberty Blues*, beachgoers hang out at Long Reef on Sydney's Northern Beaches during the summer of 1975 — some probably with a Chiko Roll in hand and an Alpine Light or JPS Blue between the lips.

The Chiko Roll is a savoury snack invented by Frank McEncroe, inspired by the spring roll and first sold in 1951. At the peak of its popularity in the 1960s and 1970s, 40 million Chiko Rolls were sold annually in Australia.

You can see Dee Why in the distance, and how different it looks without the wetlands towards the road.

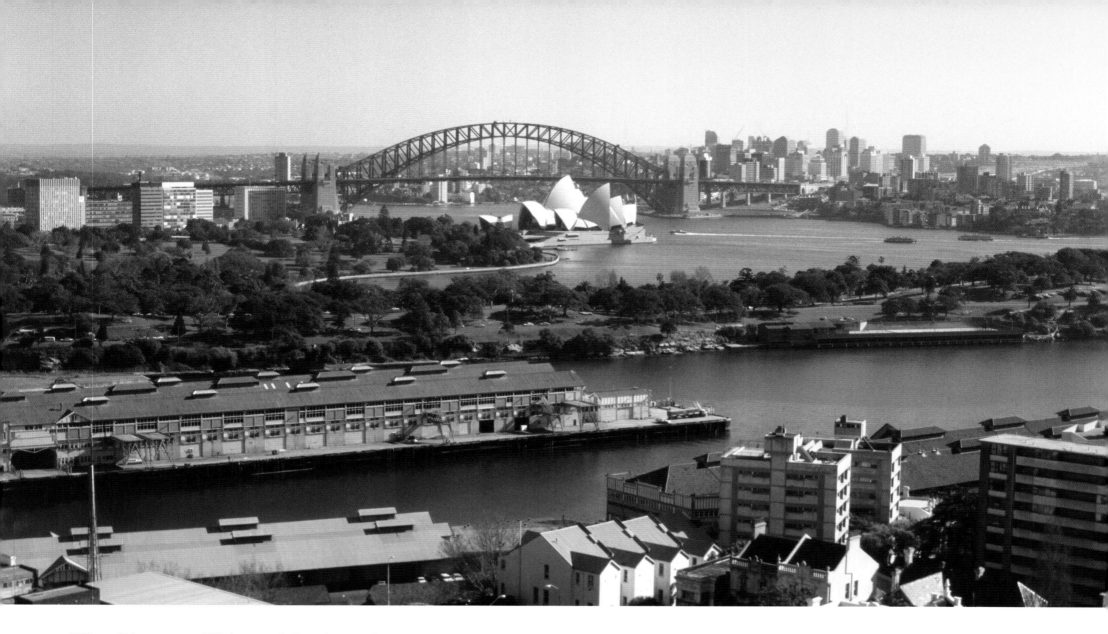

The Chevron Hilton, Macleay Street, Potts Point

1975

SOURCE: NATIONAL ARCHIVES OF AUSTRALIA, A6135, K25/8/75/25, 203052258

Looking north-west towards the harbour from The Chevron on Macleay Street in August 1975.

You can see North Sydney and Kirribilli in the distance, the iconic pair of the Harbour Bridge and the Opera House at Bennelong Point, as well as the buildings on Circular Quay West, the Botanic Gardens, Mrs Macquaries Point, the Andrew 'Boy' Charlton Pool, the finger wharf at Woolloomooloo (still a commercial wharf in 1975), and the various apartments and terraces on Potts Point below.

William Street, Darlinghurst ▶

1975

SOURCE: STATE OF NEW SOUTH WALES (TRANSPORT FOR NSW) 2016, DEPARTMENT OF MAIN ROADS, 100382-56

An XA Falcon RSL taxi travels westbound on William Street during construction work on the Kings Cross Tunnel in October 1975. The tunnel would be opened in mid-December the same year, and is now part of the Cross City Tunnel network.

To the left of the roadworks, eastbound motorists pass the Kings Cross Hotel, travelling towards the Kingsgate Hotel on Darlinghurst Road. Opened to the public in 1971, this hotel operated in various incarnations as the Kingsgate, the Hyatt Kingsgate, and the Millennium, before its conversion in 2003 to an apartment complex known as Zenith Residences.

Affixed to the base of the building is the first of many iterations of the landmark Kings Cross Coca-Cola sign, which hides a mural designed by artist Roger Foley, also known as Ellis D. Fogg.

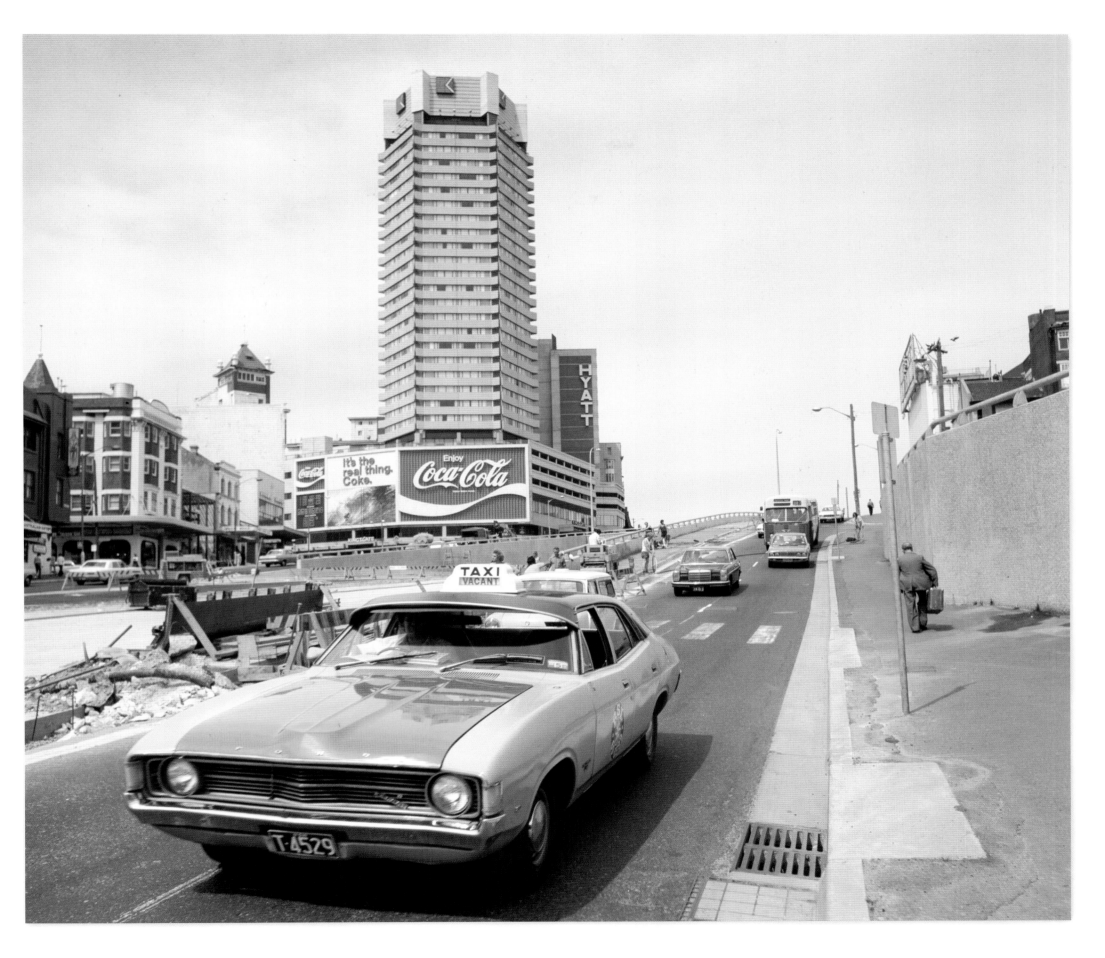

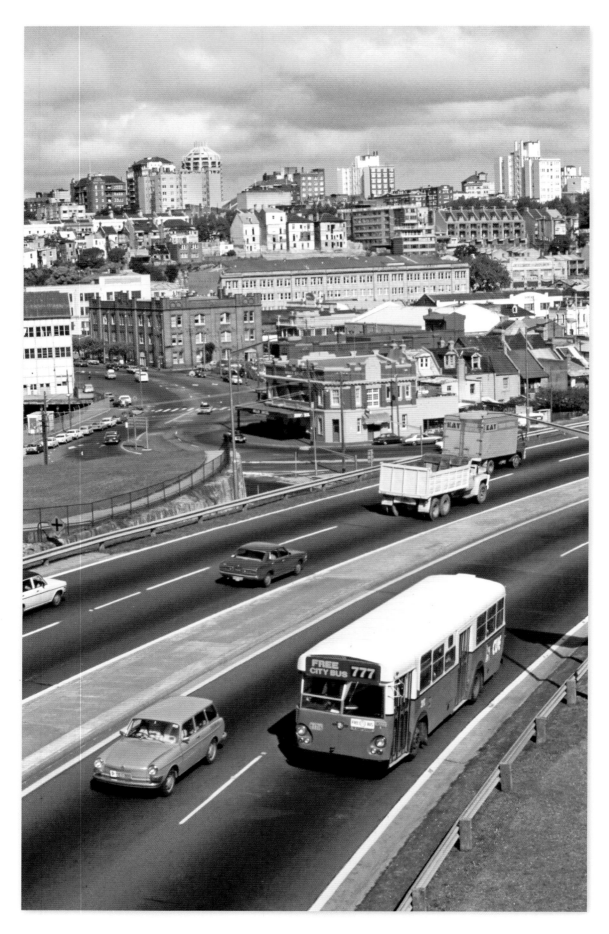

Woolloomooloo
1976

PHOTOGRAPHER: JOHN WARD
SOURCE: CITY OF SYDNEY ARCHIVES, A-01110493

Looking east from the Art Gallery Road overpass over the Cahill Expressway towards Woolloomooloo in October 1976.

Before the Eastern Distributor was completed in the late 1990s, the Cahill Expressway used to go through the Domain Tunnel and down towards Palmer Street and Sir John Young Crescent.

In the distance, you can see the escarpment running along Victoria Street, separating Potts Point and Woolloomooloo at the base, with the Gazebo, Kingsclere, and Byron Hall quite visible.

You can also see some of the original terrace houses that were part of the controversial Victoria Point development, which was subject to a number of green bans at the time.

King Street, Newtown ▶
1977

SOURCE: CITY OF SYDNEY ARCHIVES, A-00062660

We're in 'bluebags' territory, the home of the Newtown Jets. This is the busy intersection of King and Wilson streets, with the Oxford Hotel just in shot on the corner of Eliza and King streets.

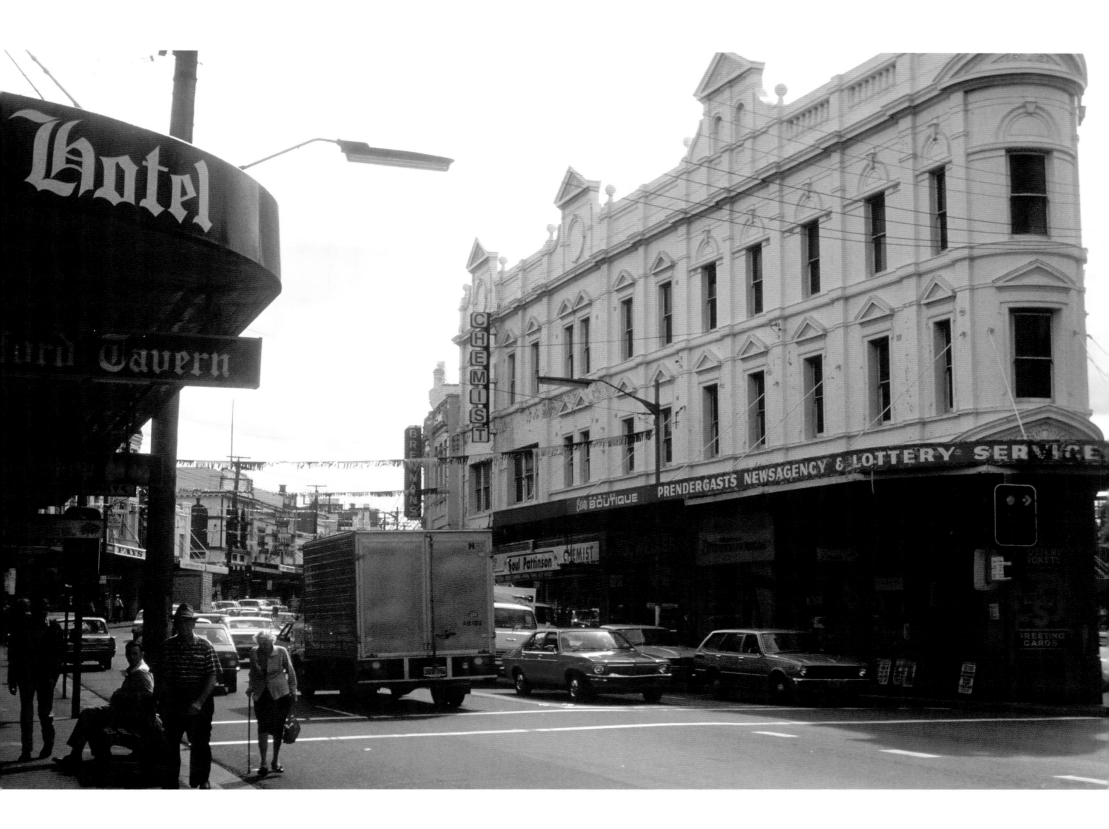

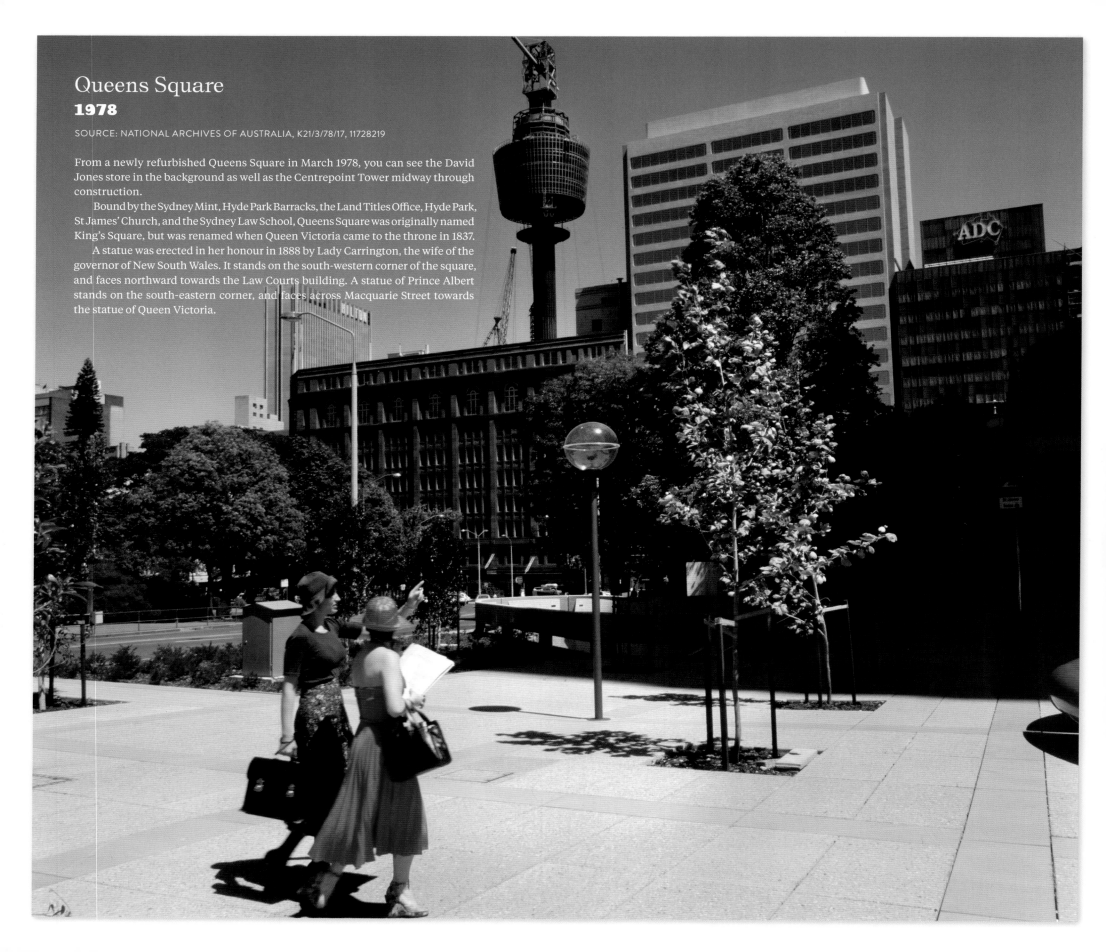

Queens Square
1978

SOURCE: NATIONAL ARCHIVES OF AUSTRALIA, K21/3/78/17, 11728219

From a newly refurbished Queens Square in March 1978, you can see the David Jones store in the background as well as the Centrepoint Tower midway through construction.

Bound by the Sydney Mint, Hyde Park Barracks, the Land Titles Office, Hyde Park, St James' Church, and the Sydney Law School, Queens Square was originally named King's Square, but was renamed when Queen Victoria came to the throne in 1837.

A statue was erected in her honour in 1888 by Lady Carrington, the wife of the governor of New South Wales. It stands on the south-western corner of the square, and faces northward towards the Law Courts building. A statue of Prince Albert stands on the south-eastern corner, and faces across Macquarie Street towards the statue of Queen Victoria.

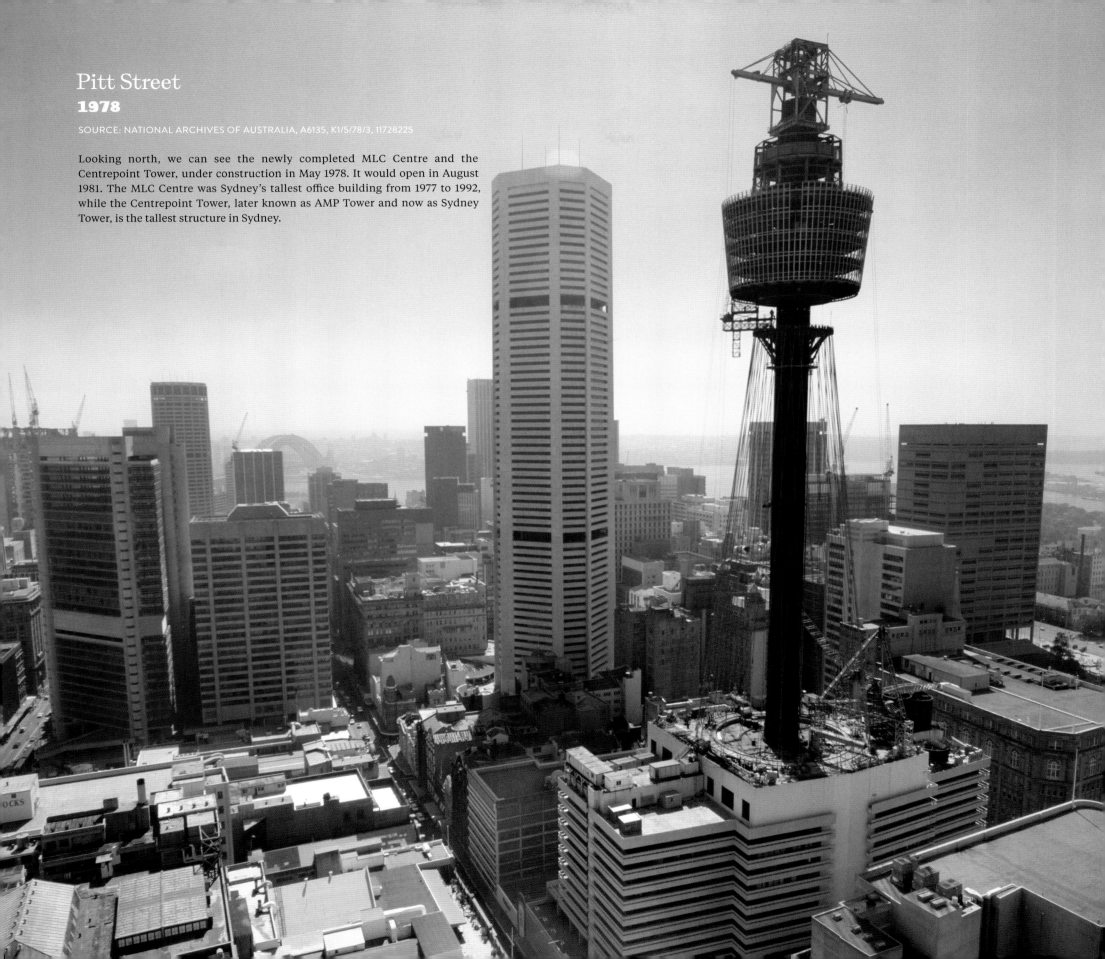

Pitt Street
1978

SOURCE: NATIONAL ARCHIVES OF AUSTRALIA, A6135, K1/5/78/3, 11728225

Looking north, we can see the newly completed MLC Centre and the Centrepoint Tower, under construction in May 1978. It would open in August 1981. The MLC Centre was Sydney's tallest office building from 1977 to 1992, while the Centrepoint Tower, later known as AMP Tower and now as Sydney Tower, is the tallest structure in Sydney.

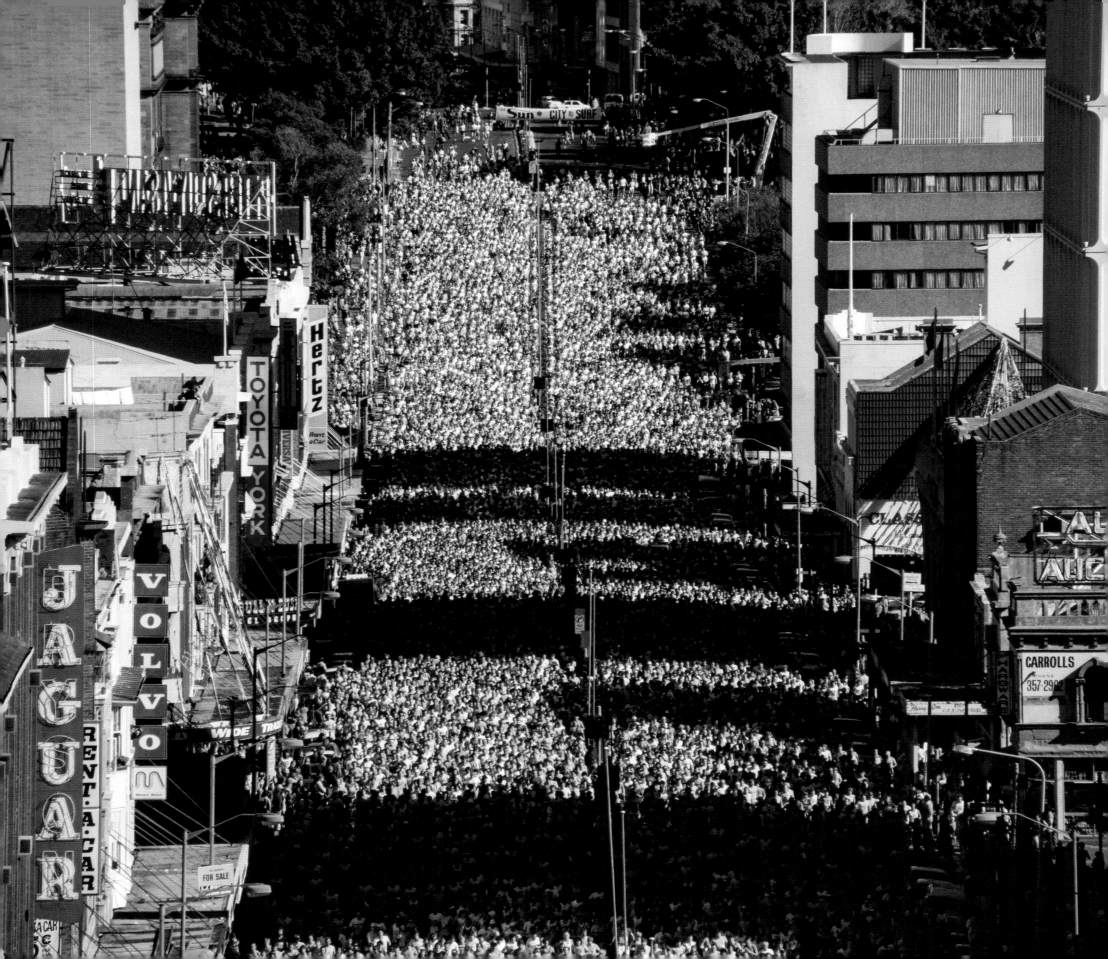

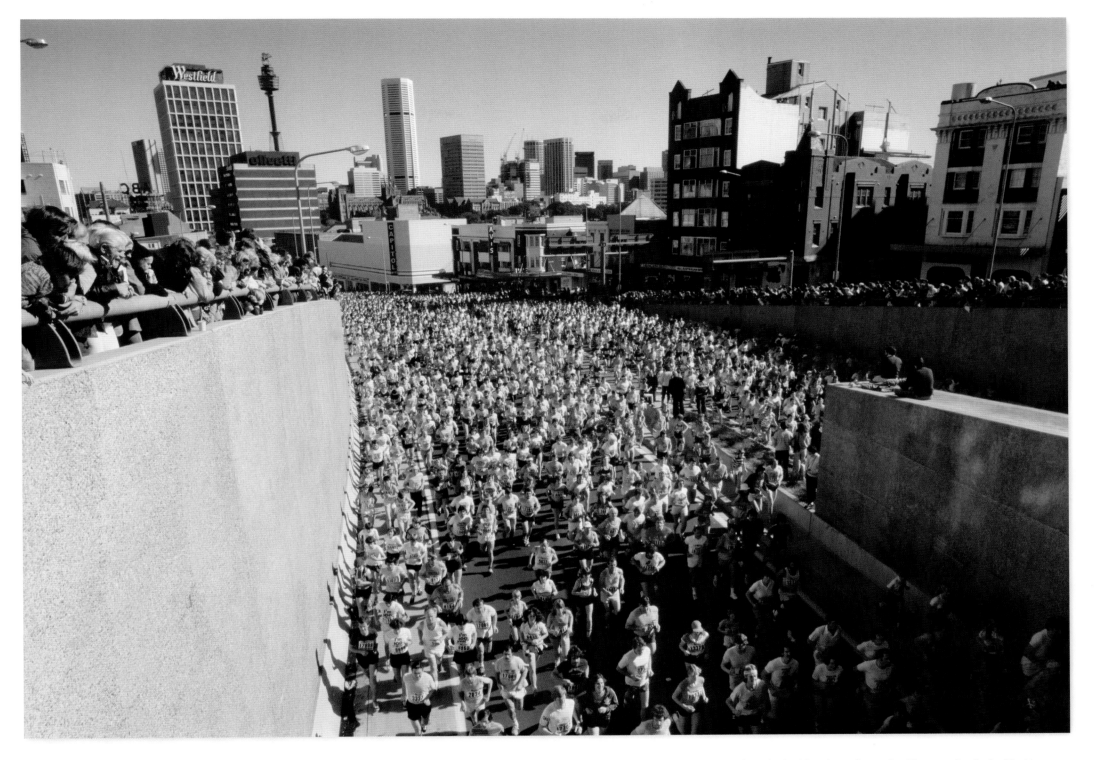

City to Surf Run, William Street

1978

SOURCE: NATIONAL ARCHIVES OF AUSTRALIA, A6135, K21/8/78/1, 11938145 (LEFT);
NATIONAL ARCHIVES OF AUSTRALIA, A6135, K21/8/78/31, 11938146 (ABOVE)

In the image on the left, we're looking down from what I'm guessing is the Hyatt Kingsgate (now the Zenith Residences) at a sea of sweatband-clad participants running up William Street as part of the 1978 City to Surf sponsored by *The Sun* newspaper.

It has been an annual event in Sydney since September 1971, when staff of *The Sun*, inspired by the Bay to Breakers event in San Francisco, conceived of the 9.4-mile (15.1-kilometre) road run — attracting 1,576 participants. The event, moved to the second Sunday in August in 1973, is now run over a distance of 14 kilometres, finishing at Bondi Beach, and attracts more than 80,000 participants.

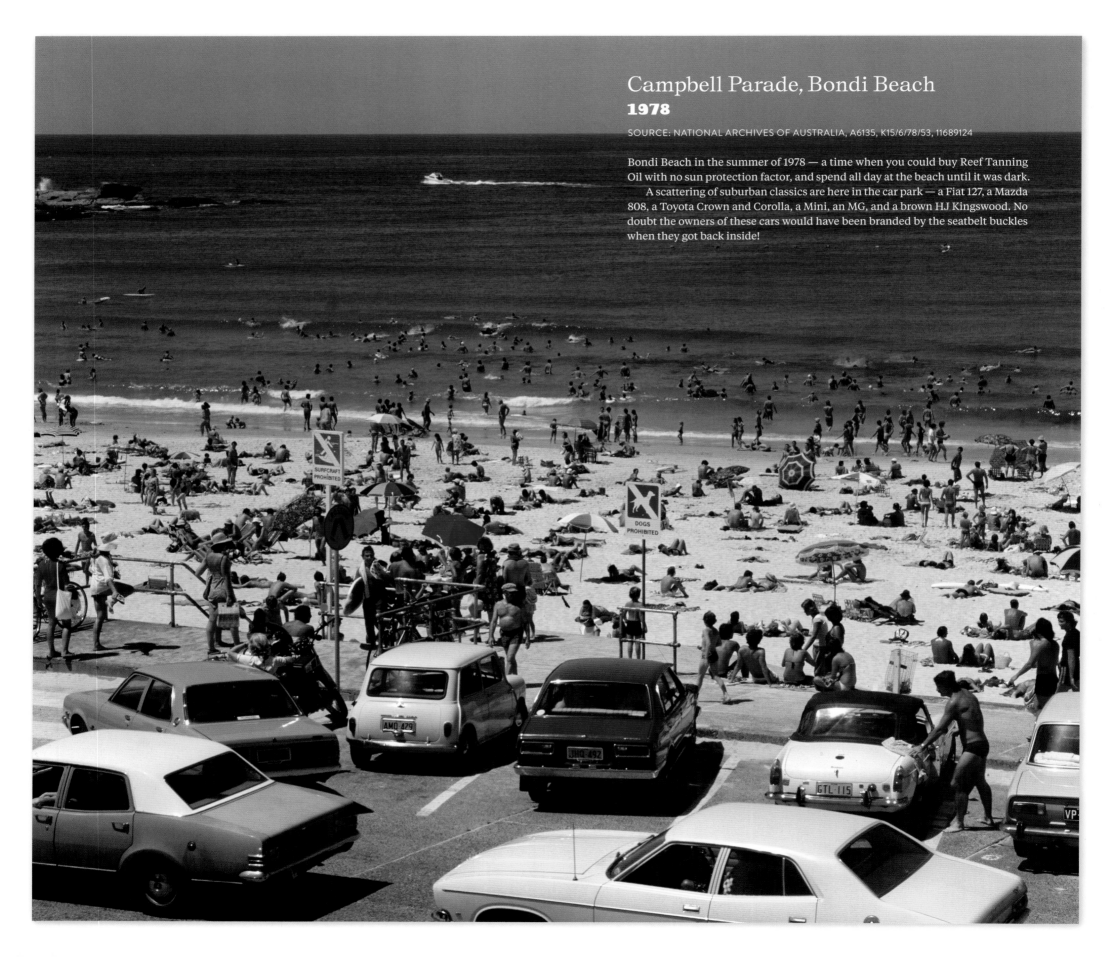

Campbell Parade, Bondi Beach
1978

SOURCE: NATIONAL ARCHIVES OF AUSTRALIA, A6135, K15/6/78/53, 11689124

Bondi Beach in the summer of 1978 — a time when you could buy Reef Tanning Oil with no sun protection factor, and spend all day at the beach until it was dark.

A scattering of suburban classics are here in the car park — a Fiat 127, a Mazda 808, a Toyota Crown and Corolla, a Mini, an MG, and a brown HJ Kingswood. No doubt the owners of these cars would have been branded by the seatbelt buckles when they got back inside!

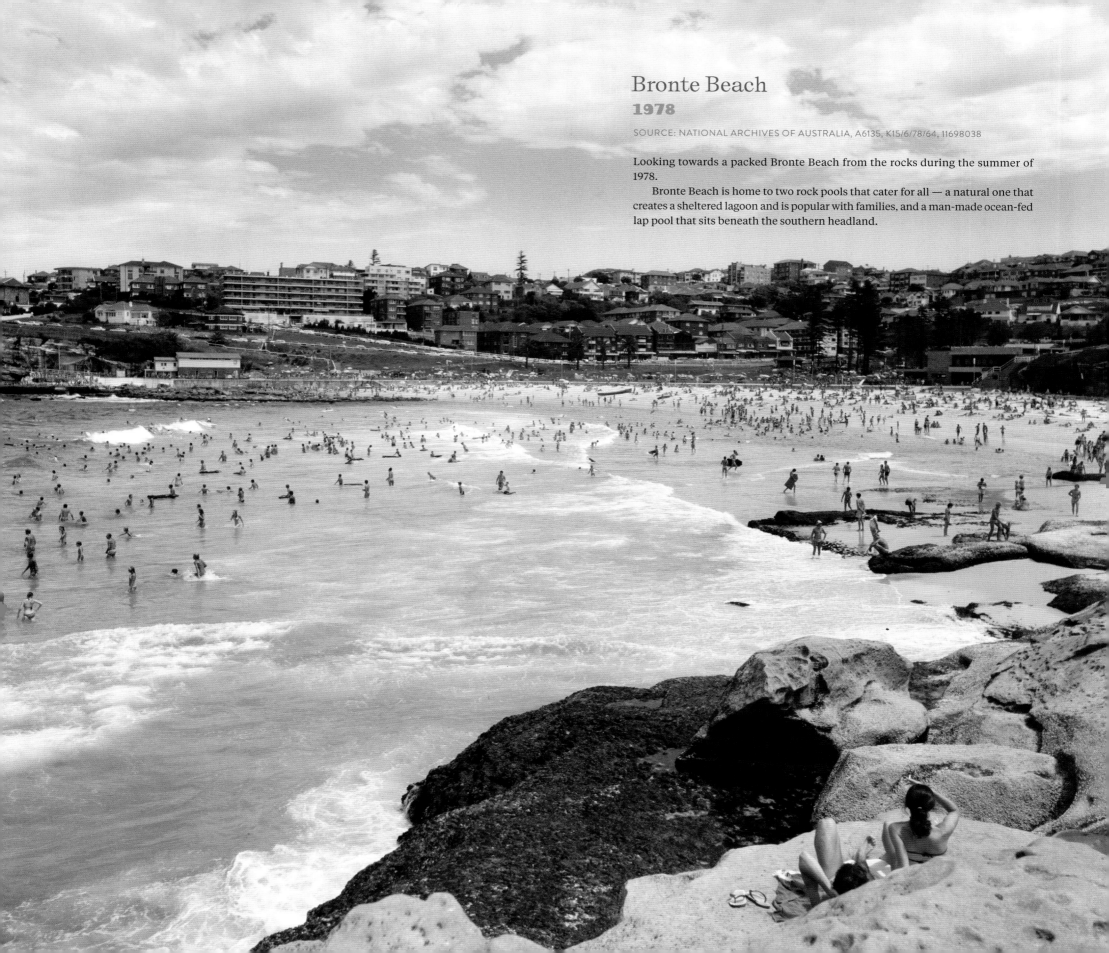

Bronte Beach
1978

SOURCE: NATIONAL ARCHIVES OF AUSTRALIA, A6135, K15/6/78/64, 11698038

Looking towards a packed Bronte Beach from the rocks during the summer of 1978.

Bronte Beach is home to two rock pools that cater for all — a natural one that creates a sheltered lagoon and is popular with families, and a man-made ocean-fed lap pool that sits beneath the southern headland.

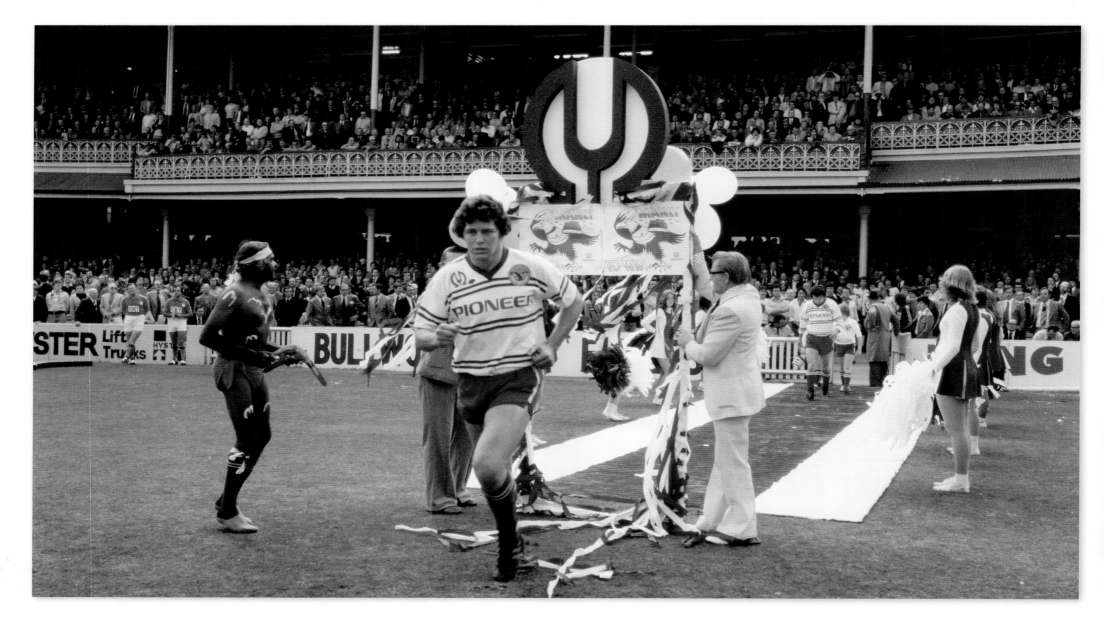

Sydney Cricket Ground, Moore Park
1978

SOURCE: NATIONAL ARCHIVES OF AUSTRALIA, A6135, K4/10/78/20, 11943667

Manly run onto the field for the Rugby League grand final on 19 September 1978 at the SCG. This particular grand final was a replay of the final that had been held three days before when Manly drew 11-all against the Cronulla Sharks — only the second time in the history of the game that this had happened.

Manly went on to take out the premiership in this game, defeating Cronulla 16-0.

Sydney Harbour ▸
1978

SOURCE: STATE OF NEW SOUTH WALES (TRANSPORT FOR NSW) 2016, DEPARTMENT OF MAIN ROADS, 101254-56

A smoggy but eventful day in Sydney Town. Looking towards the CBD from the Harbour Bridge, we can see the ocean liner *Queen Elizabeth 2* (colloquially known as the *QE2*) docking into the Overseas Passenger Terminal on the morning of 24 February 1978, with many boats and people along the fringe of the foreshore out to see the grand liner dock in Sydney Cove.

Queen Elizabeth II visited Australia 16 times during her long reign, including to open the Sydney Opera House in 1973, Parliament House in 1988, and the Melbourne Commonwealth Games in 2006. The *QE2* was operated by Cunard as both a transatlantic liner and a cruise ship from 1969 to 2008, and now operates as a floating hotel in Dubai.

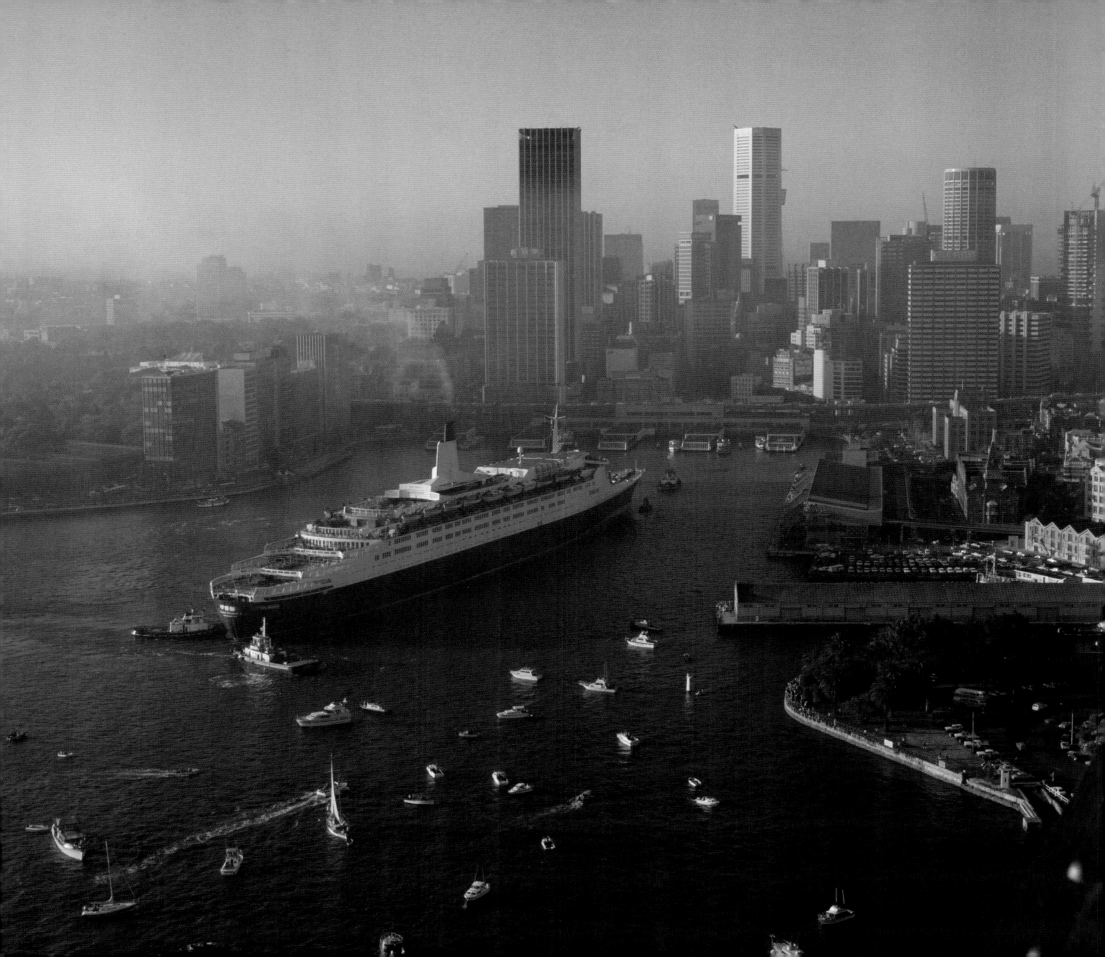

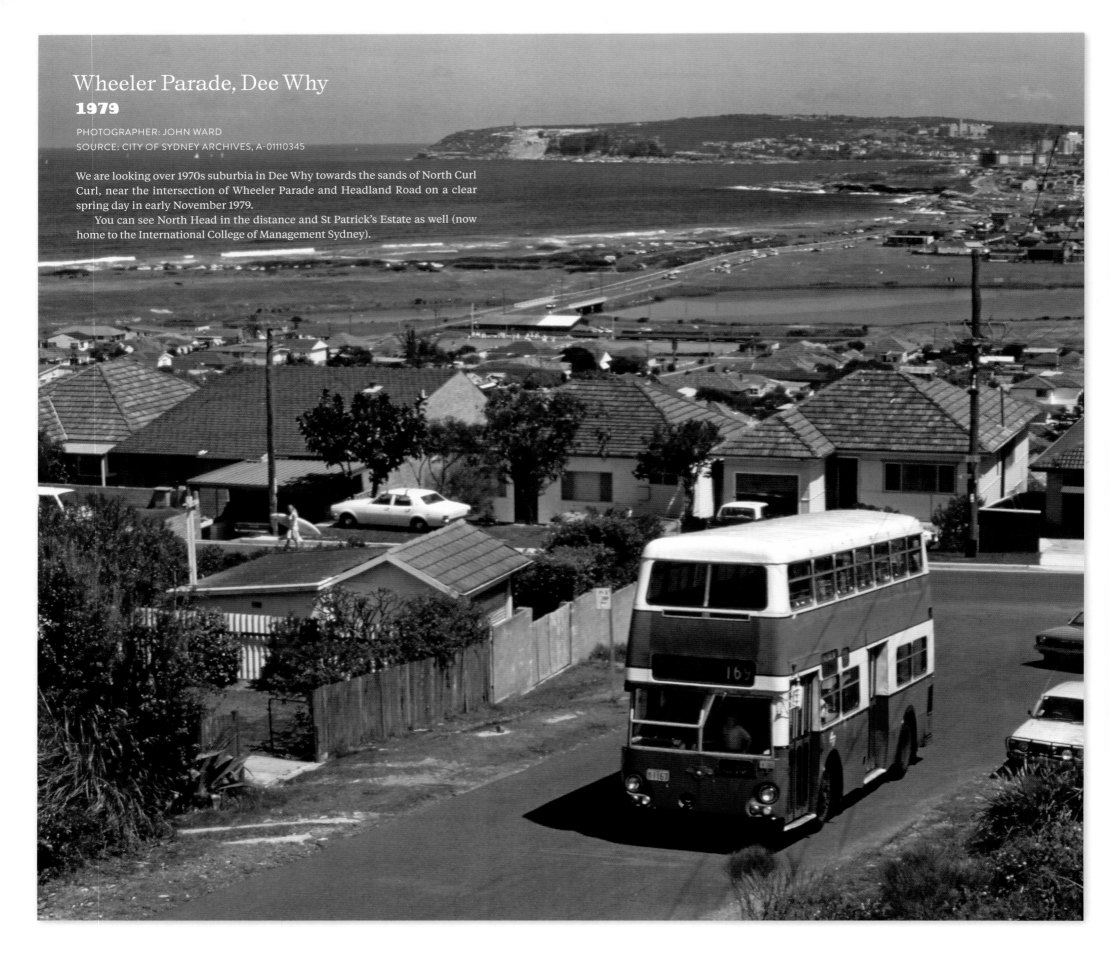

Wheeler Parade, Dee Why
1979

PHOTOGRAPHER: JOHN WARD
SOURCE: CITY OF SYDNEY ARCHIVES, A-01110345

We are looking over 1970s suburbia in Dee Why towards the sands of North Curl Curl, near the intersection of Wheeler Parade and Headland Road on a clear spring day in early November 1979.

You can see North Head in the distance and St Patrick's Estate as well (now home to the International College of Management Sydney).

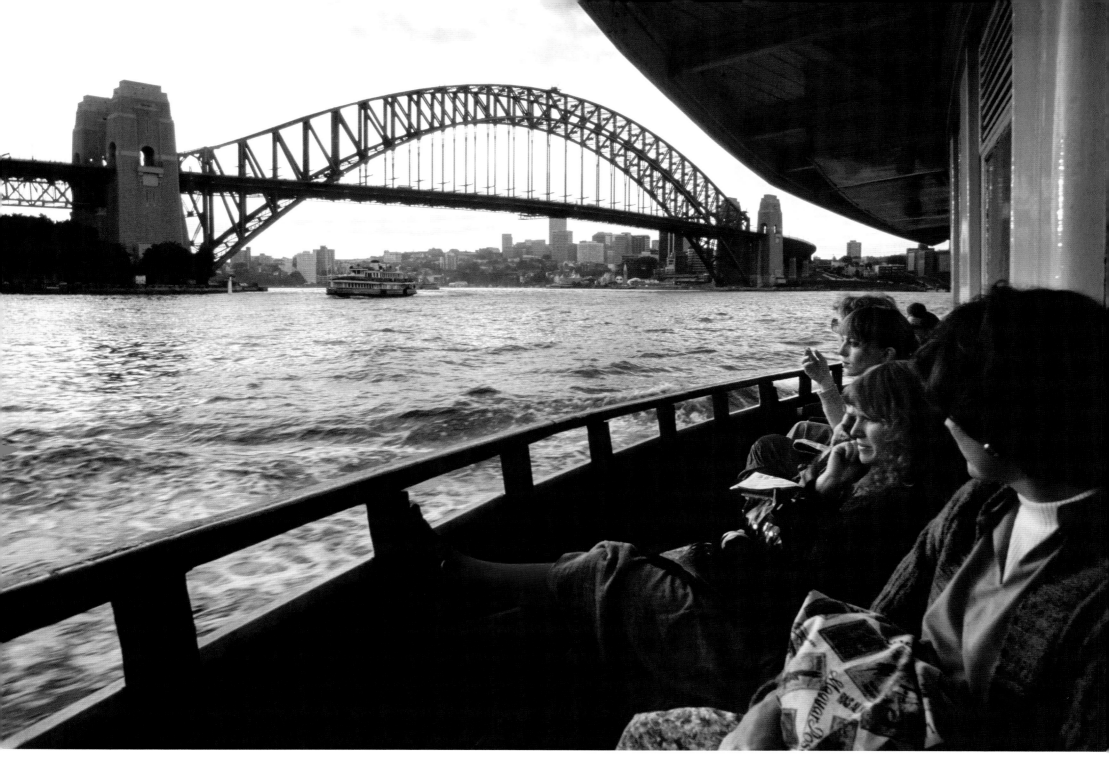

Sydney Harbour
1979

Heading home on the ferry in the early evening in July 1979.

Sydney Royal Easter Show, Showground, Moore Park

1979

Crowds enjoy the rides and stalls at the Easter Show held in April 1979, originally an agricultural show that by 1979 had turned into a show of rides, showbags, and other crazy attractions such as 'Robert and Rhonda', the Siamese Twins, and the Ghost Train.

Strand Arcade, Pitt Street
1979

SOURCE: NATIONAL ARCHIVES OF AUSTRALIA, A6135, K12/1/79/50, 11795644 (BELOW)
AND 11795548 (RIGHT)

Here are some lovely shots of shoppers in a newly refurbished Strand Arcade in January 1979, including a very stylish mother and her two daughters. Check out how groovy the older woman behind them is, with the wide collar and flares!

Located between Pitt and George streets, it's the only Victorian-style arcade left in Sydney. Opened in 1892, it had become run down by the mid-1970s. A fire broke out in May 1976. The arcade was renovated and restored between 1976 and 1978. Renovations included the installation of the tiled floor, which is still present today. The arcade was added to the New South Wales Heritage Register in December 2011.

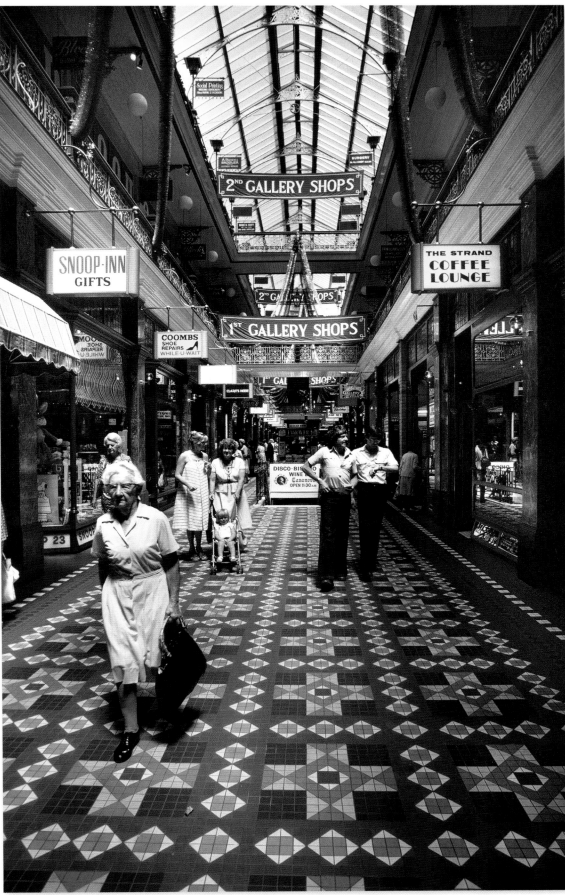

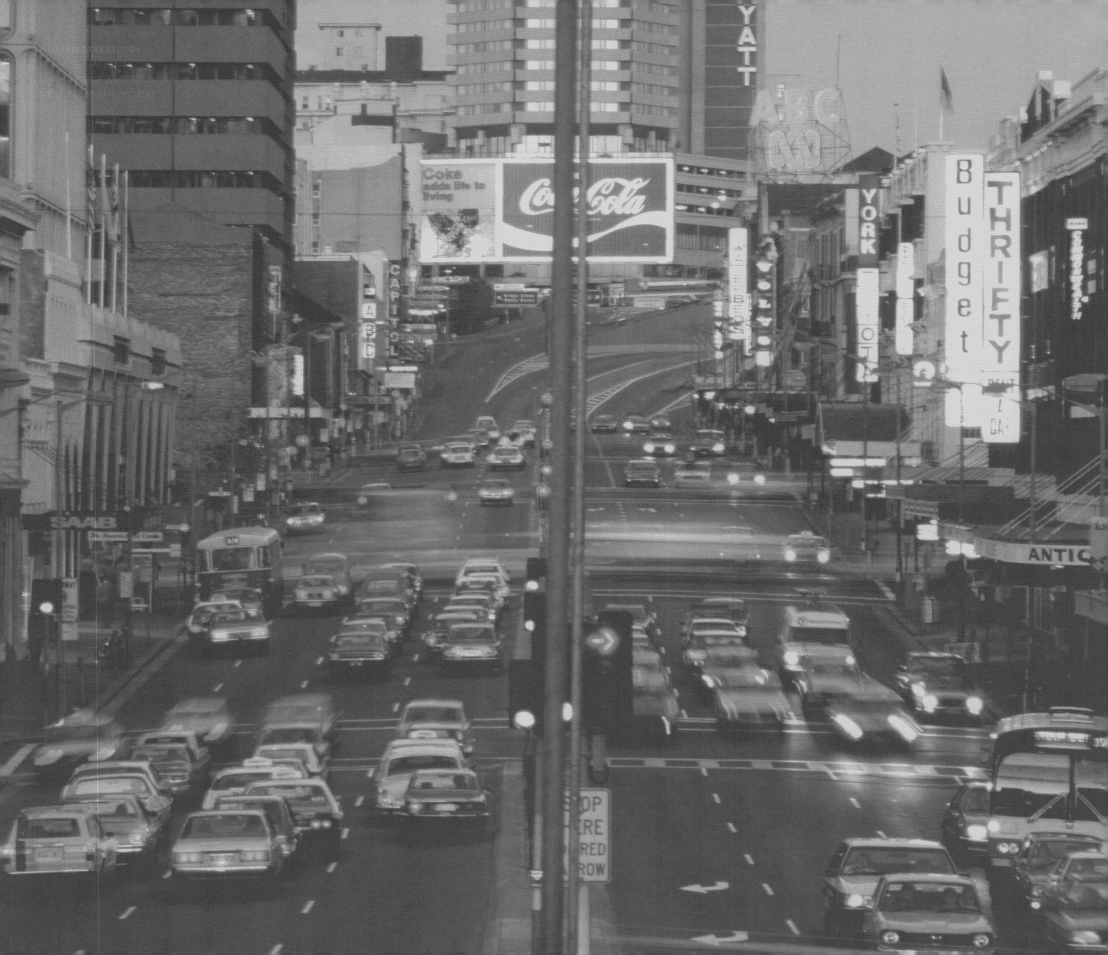

the 1980s

My favourite decade, the 1980s were exciting and colourful, and brought Sydney to the international stage — particularly for visitors from the US and the UK, after highly popular Tourism Australia campaigns presented by Paul Hogan, with his 1984 'Throw a shrimp on the barbie' catchline and featuring Sydney Harbour. Even David Bowie decided to call Sydney home between 1983 and 1992, using several locations around Sydney in film clips shot during 1983 for 'Let's Dance' and 'China Girl'.

The Sydney skyline continued to evolve — particularly with the completion of Centrepoint Tower in August 1981. There was also Qantas House (completed in 1982), the Capita Centre on Castlereagh Street (1984), the National Australia Bank Tower (1986), and Grosvenor Place (1988). By the mid-1980s, Pitt Street had been partially closed and turned into a pedestrian mall between King and Market streets, opening as the Pitt Street Mall, as we know it today, in 1987.

By the mid-1980s, a major redevelopment of much of the Darling Harbour area, west of the Sydney CBD, was underway. It would be transformed from railyards into a new entertainment precinct, including restaurants, a shopping centre, and a convention centre (prior to this, major exhibitions were held in the exhibition halls at Moore Park). Most of this new precinct, including the convention centre, would be opened in 1988. The Sydney Entertainment Centre was completed in May 1983 and would become the main venue for some of the world's best entertainers until its closure in 2015.

The way we moved around the city changed dramatically during the 1980s, as double-decker buses were out, and articulated (or bendy) buses were in — the last double-decker ran in May 1986, and they wouldn't return until 2017. There was the rolling completion of more stages of the North-West Link, or the Western Distributor as we know it these days, which saw the closure of the Pyrmont Bridge in August 1981; more sections of the M4 motorway, linking the greater western suburbs of Sydney to the inner west, were completed; and more of the F3 (now known as the M1), linking Sydney and Newcastle, was being completed, including the crucial Mooney Mooney Bridge, which opened in December 1986. July 1988 saw the opening of the controversial Sydney Monorail, linking the new Darling Harbour precinct and the CBD. By the end of the decade, construction had already started on a vital second harbour crossing to improve traffic flows on the Bradfield Highway.

The 1980s was a decade of more iconic moments for our city. The first visit of Prince Charles and Princess Diana in March 1983 brought hundreds of thousands to pack Sydney streets to see the couple on their six-week tour of Australia and New Zealand, after their marriage in July 1981. This was followed by another visit during the Bicentennial Celebrations in January 1988 — the last visit they made to Sydney and Australia before their separation in 1992.

We also celebrated the 50th anniversary of the Sydney Harbour Bridge in 1982, with thousands walking across the bridge to mark the milestone. There were also spectacular public events: Dame Joan Sutherland and Luciano Pavarotti appeared in concert at the Sydney Opera House in January 1983, in what was described as the 'concert of the century'; Elton John married Renate Blauel at St Mark's Church in Darling Point on Valentine's Day 1984; and the *Queen Elizabeth 2* passenger liner visited the city on Valentine's Day 1985, coinciding with the visit of the British Airways Concorde.

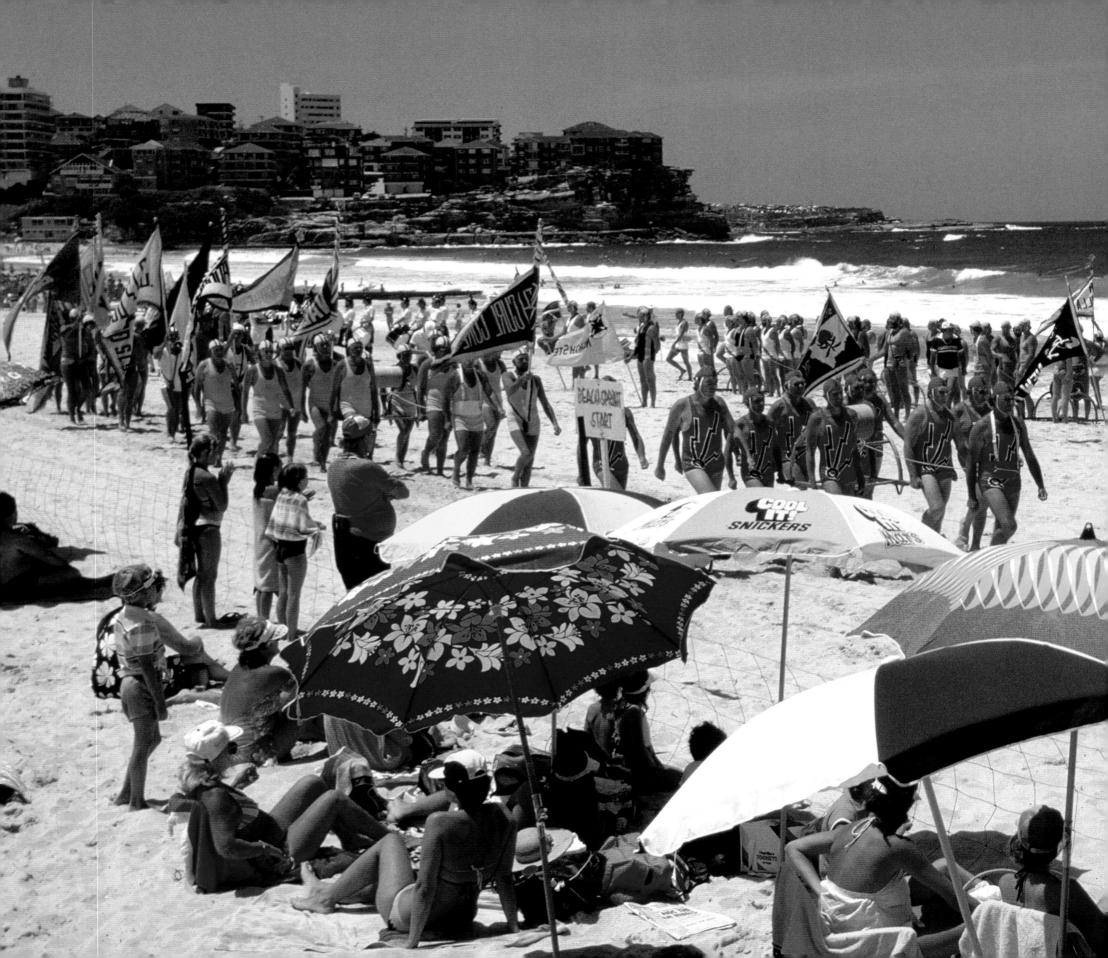

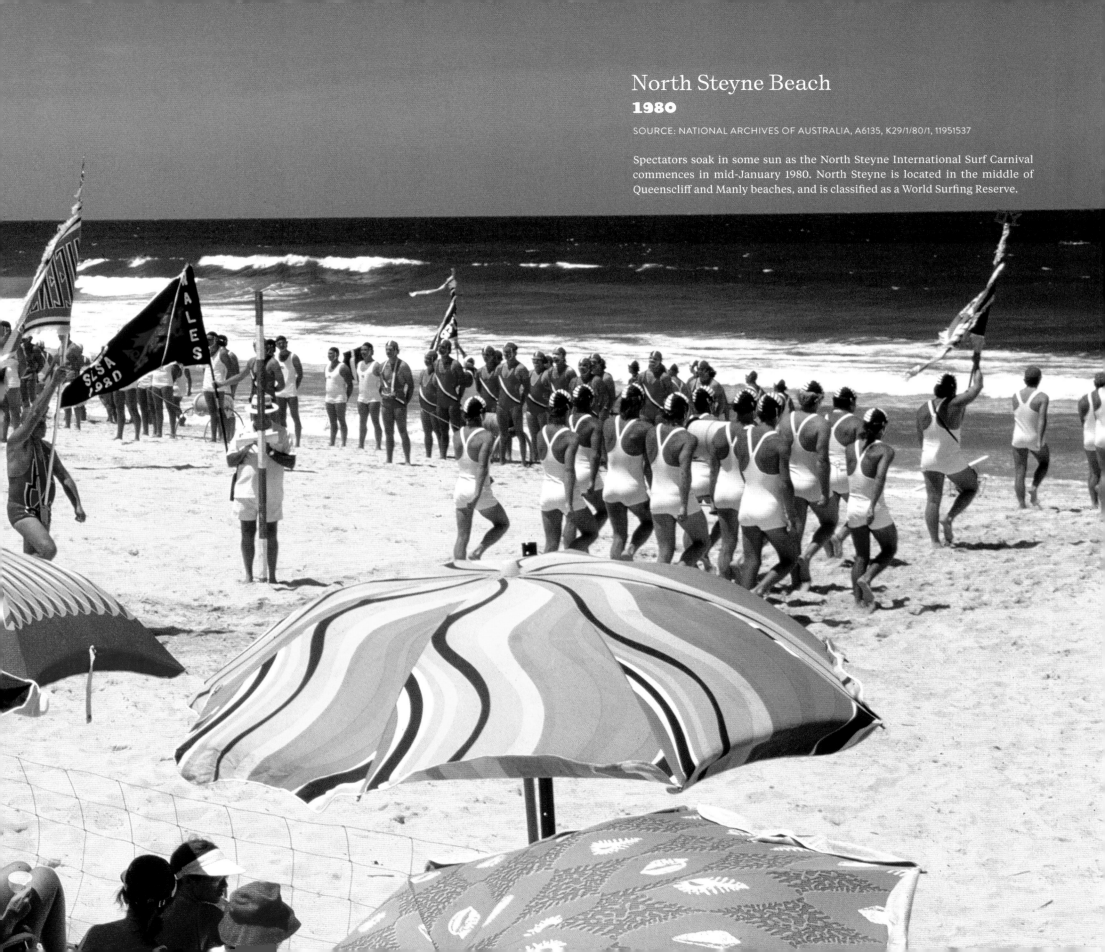

North Steyne Beach
1980

SOURCE: NATIONAL ARCHIVES OF AUSTRALIA, A6135, K29/1/80/1, 11951537

Spectators soak in some sun as the North Steyne International Surf Carnival commences in mid-January 1980. North Steyne is located in the middle of Queenscliff and Manly beaches, and is classified as a World Surfing Reserve.

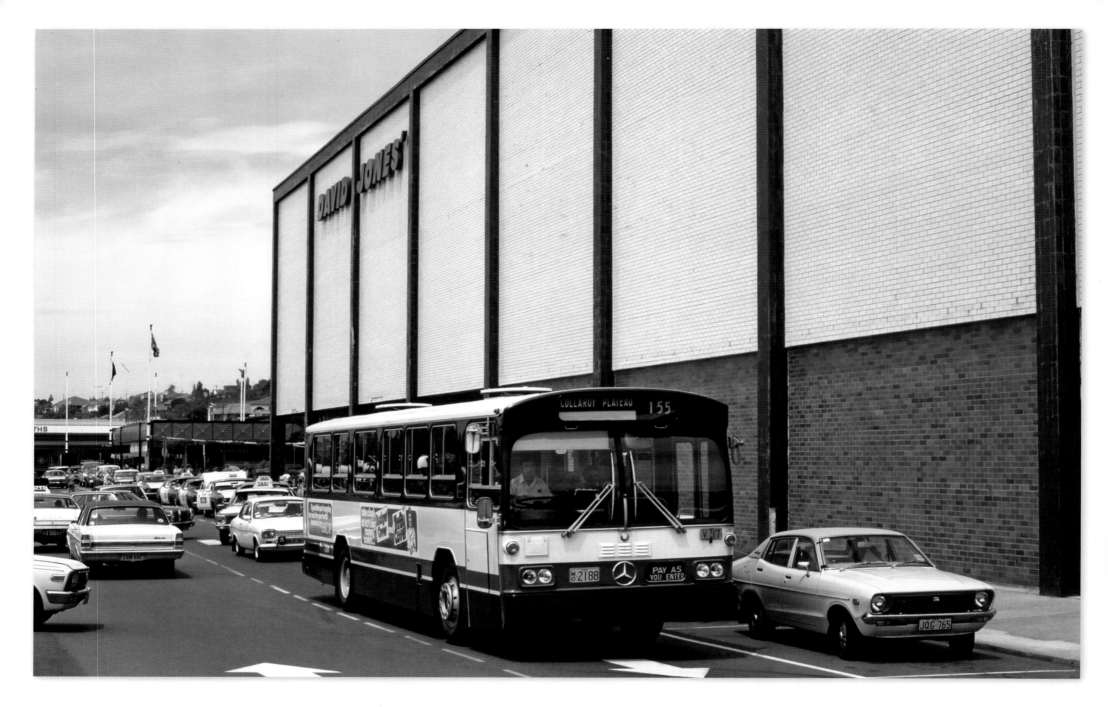

Warringah Mall, Brookvale

1980

PHOTOGRAPHER: JOHN WARD
SOURCE: CITY OF SYDNEY ARCHIVES, A-01110327

Looking towards the southern end of the original Warringah Mall in January 1980.

Opened in April 1963, it was the second-largest shopping centre in the southern hemisphere at the time (with Melbourne's Chadstone being the largest).

It would be another three years before the movie *BMX Bandits*, starring Nicole Kidman, was filmed here.

Bankstown Civic Centre ▶

1980

SOURCE: NATIONAL ARCHIVES OF AUSTRALIA, A8746, KN6/6/80/160, 11910767

Queen Elizabeth II speaks to members of the crowd upon her arrival at Bankstown Civic Centre during a visit in late May 1980, held as part of that year's royal tour. The statue behind the crowd was designed and constructed by Alan Ingham, who was commissioned in 1963 to create a memorial to Sir Joseph Banks, and is called *The Spirit of Botany*.

Later the same day, the Queen would take the train from Bankstown Station to Martin Place to inspect the newly finished precinct.

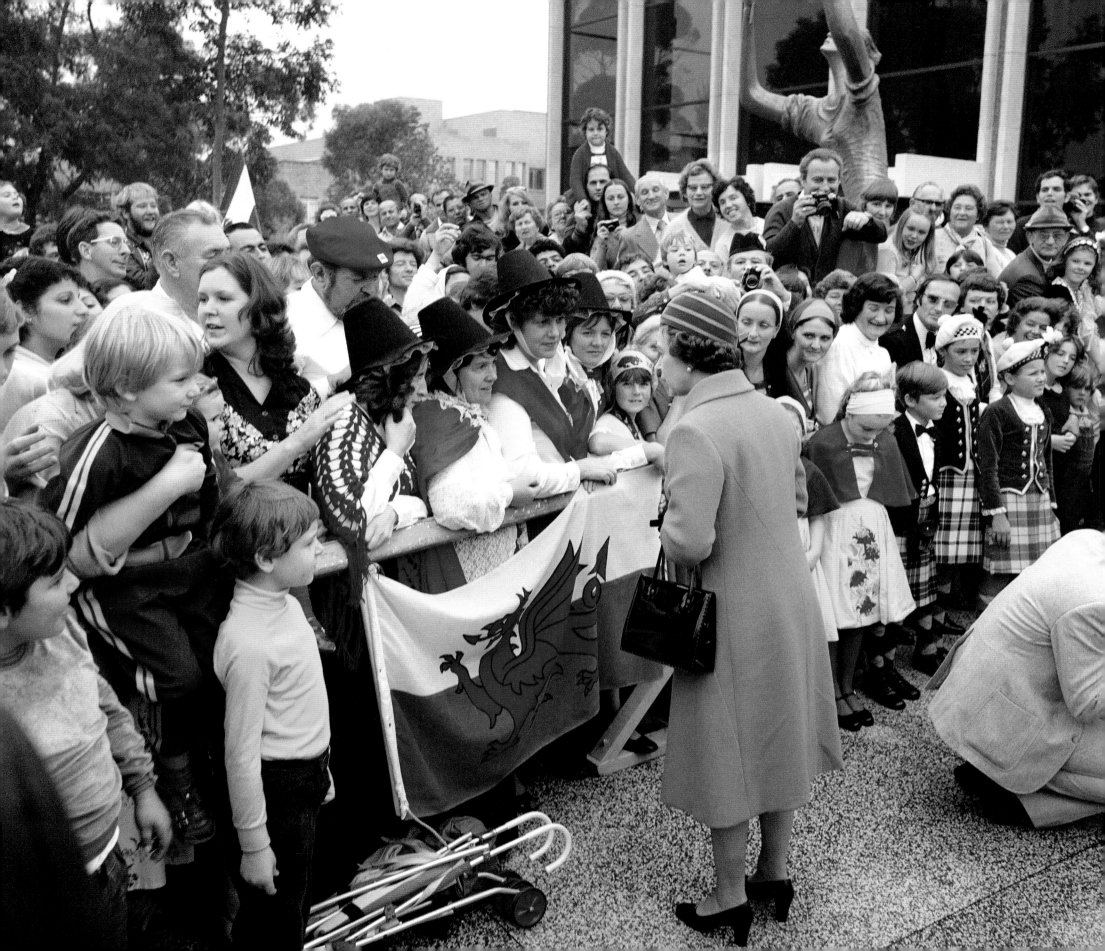

Pyrmont Bridge Road, Darling Harbour
1980

PHOTOGRAPHER: JOHN WARD
SOURCE: CITY OF SYDNEY ARCHIVES, A-01110297

Looking east over the Pyrmont Bridge towards the CBD in May 1980.

It's quite amazing to see how sparse the skyline of the CBD looks from here, with the Hilton and T&G buildings since dwarfed by many others. It would be another year before the Pyrmont Bridge would be shut for good, eventually becoming pedestrianised.

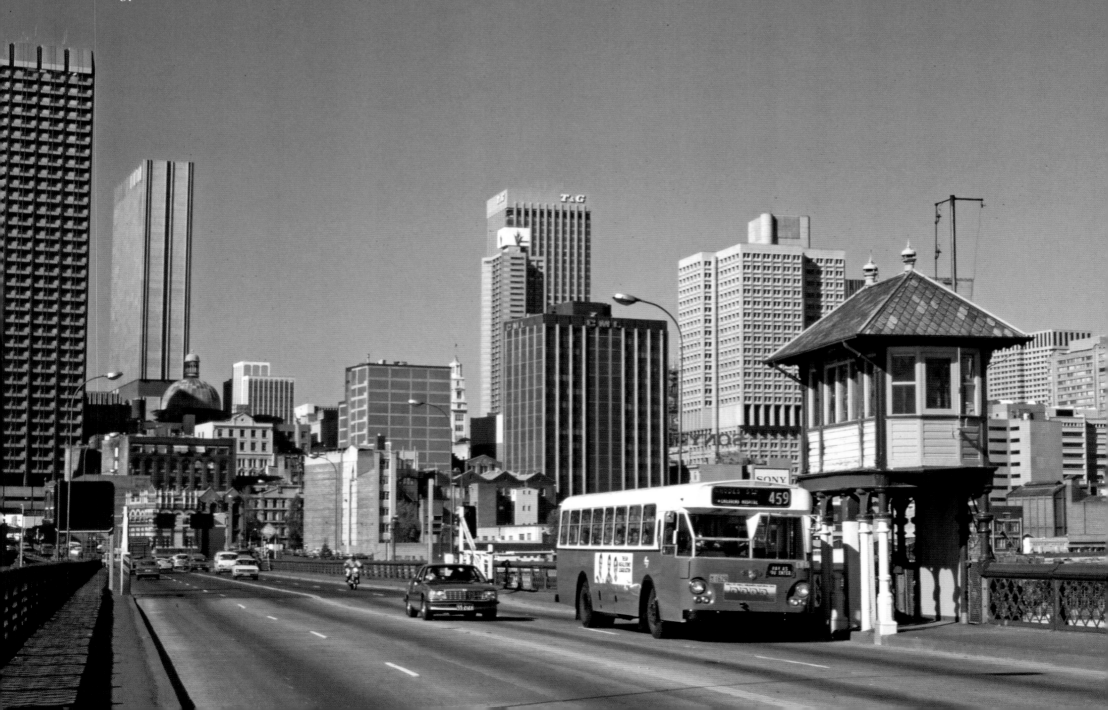

Demeter Bakery, Mitchell Street, Glebe

1981

SOURCE: NATIONAL ARCHIVES OF AUSTRALIA, A6135, K31/3/81/5, 11795582

A baker with his freshly baked loaves from the Demeter Bakery checks out the intersection of Derwent and Mitchell streets in late March 1981. The bakery was an institution for many years, following the alternative principles of Rudolf Steiner, and was one of the first fully organic bakeries of its kind in Sydney, opening around 1980. The building has been home to a bakery, flour mill, toyshop, cafe, reading room, book centre, health-food store, and, until recently, Florilegium Books.

Martin Place
1981

SOURCE: NATIONAL ARCHIVES OF AUSTRALIA, A6135, K11/2/82/35, 11754054

Looking from George Street towards the Christmas tree outside the GPO in Martin Place in the lead-up to Christmas 1981.

Many Sydneysiders have fond memories of travelling into the city to get a photograph taken in front of the tree during the festive season — it has been a mainstay in Martin Place during the Christmas period since the early 1970s.

Australian Surf Championships, Wanda Beach ▸
1981

SOURCE: NATIONAL ARCHIVES OF AUSTRALIA, A6135, K10/4/81/39

Spectators laze in the sand and try to get some shade while watching the dragon boats during the Australian Surf Championships at Wanda Beach in late March 1981.

Wanda Beach was also one of the main settings for the original film version of *Puberty Blues*, which was released in cinemas in December 1981 and based on the coming-of-age novel of the same name by Kathy Lette and Gabrielle Carey. The novel and film became synonymous with this era and the beach culture of the 1970s and 1980s in Australia, and a favourite for many teens at the time.

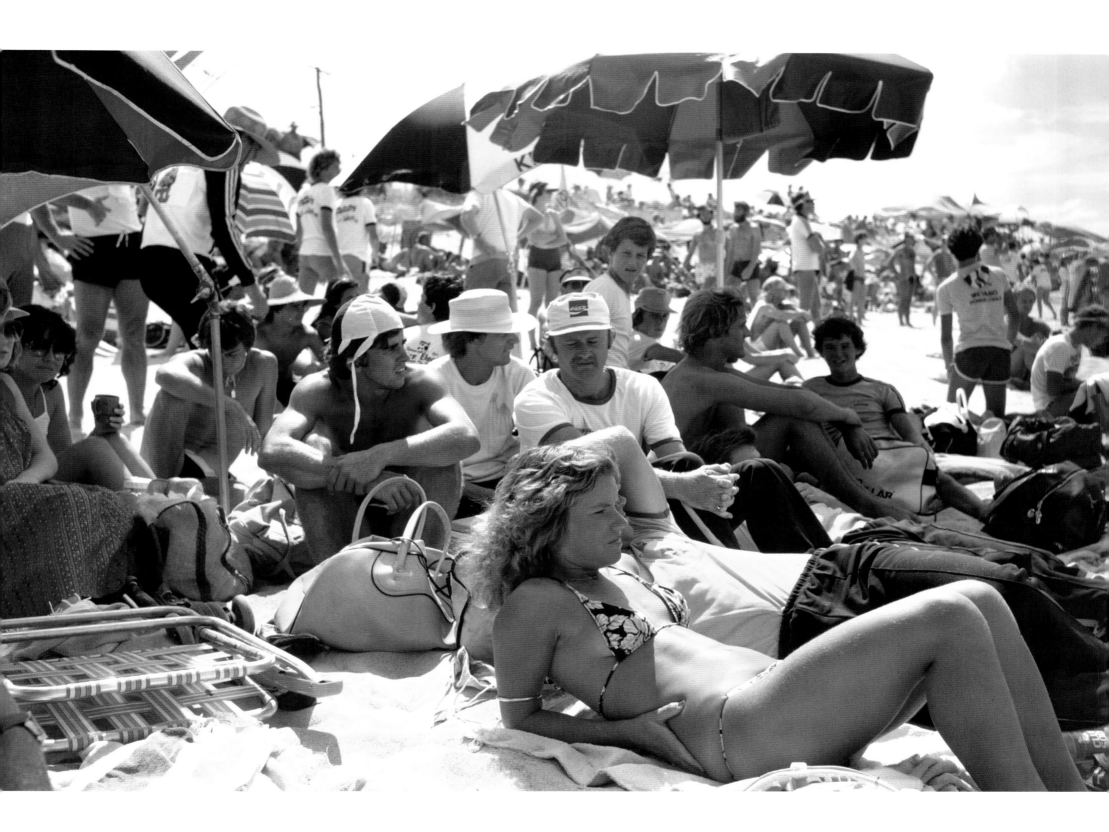

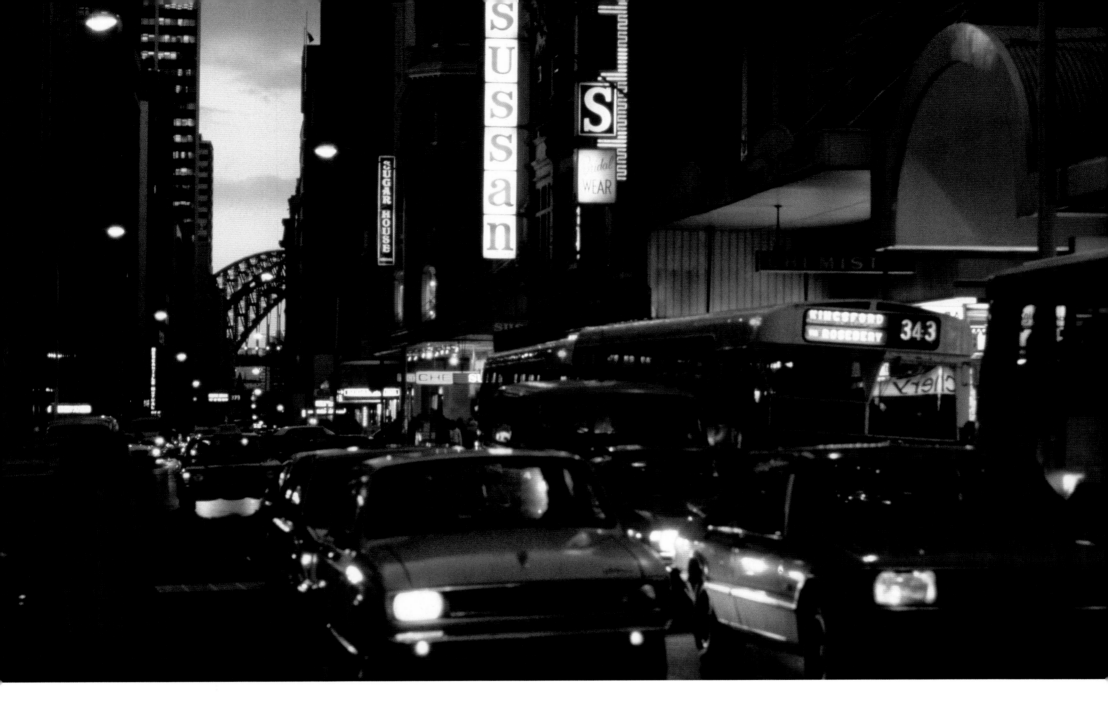

Pitt Street

1981

SOURCE: NATIONAL ARCHIVES OF AUSTRALIA, A6135, K1/9/81/68, 11728544

Looking north down Pitt Street during the evening peak at dusk in August 1981, before this section of the street between King and Market streets was converted to its current form as the Pitt Street Mall in the mid-1980s.

Sugar House was formerly the Kings Hotel, a four-storey building built in 1879 on the site of Australia's first sugar exchange.

East Esplanade, Manly ▶

1981

PHOTOGRAPHER: JOHN WARD
SOURCE: CITY OF SYDNEY ARCHIVES, A-01110251

Here is an aerial shot of Manly Wharf and Manly Fun Pier from the intersection of Belgrave Street and East Esplanade in mid-January 1981.

The Manly Wharf Bar now occupies the Fun Pier site, and the car park seen here is long gone, and has been pedestrianised.

The distinctive ten-foot-high entrance to Manly's Shark Aquarium was removed in February 1981 after greeting millions of visitors for nine years.

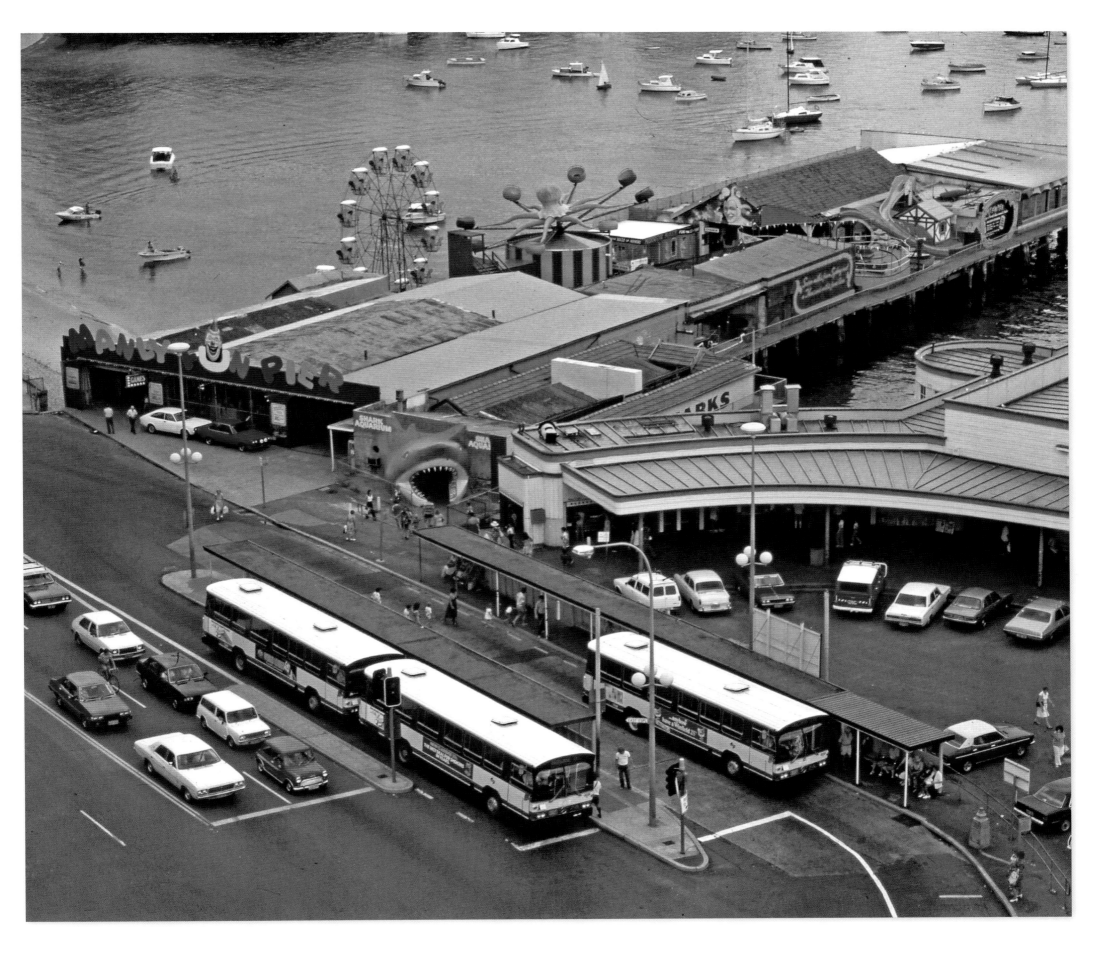

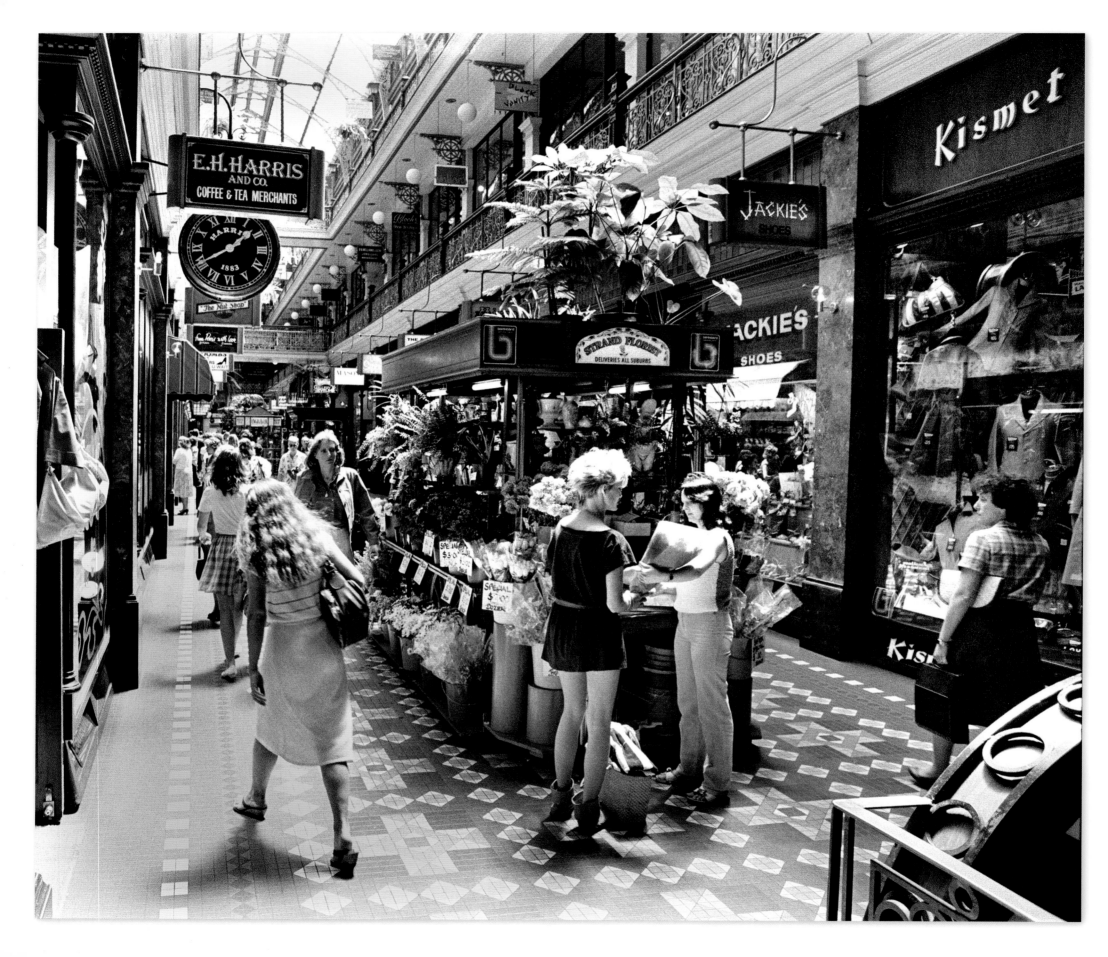

Strand Arcade, Pitt Street
1982

SOURCE: NATIONAL ARCHIVES OF AUSTRALIA, A6180, 13/12/82/18, 11795273; NATIONAL ARCHIVES OF AUSTRALIA, A6180, 13/12/82/12, 11795272

We're at the Strand Arcade in November 1982. Among the boutique shops, you could buy a hanging fern from the florist to spruce up your home, or stop in at the Harris tea house, the nut shop, or the coffee lounge for a break, while waiting to have your shoes repaired by Elie, or your dress altered by Lorraine at The Strand Bride.

After dark, the ground floor turned into the cool 'Stranded' Nightclub (which is now a JB Hi-Fi), where you could groove out to the latest New Wave mixes from Yazoo, Kim Wilde, A Flock of Seagulls, or Soft Cell.

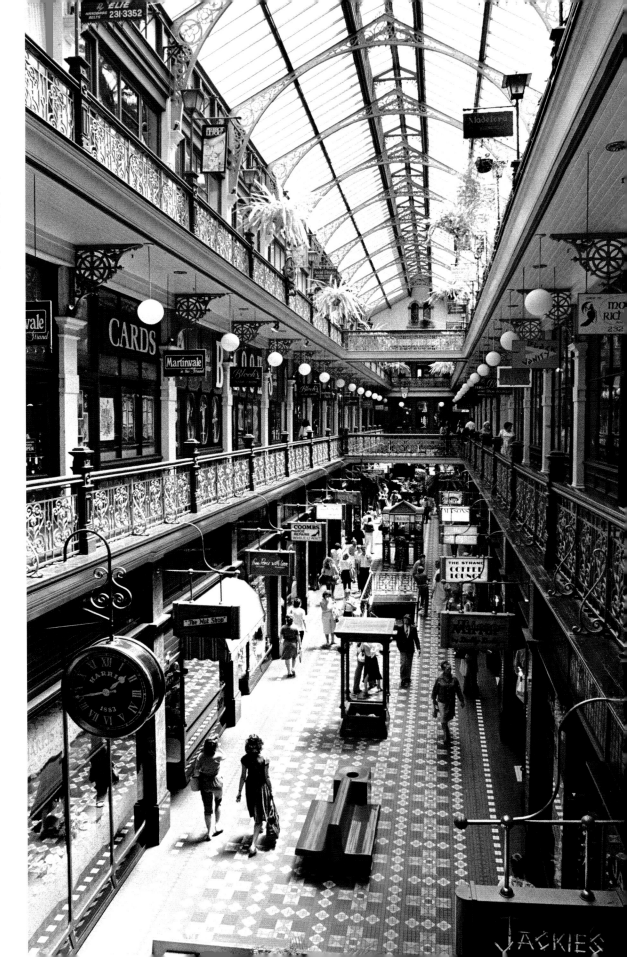

Western Distributor
1982

SOURCE: STATE OF NEW SOUTH WALES (TRANSPORT FOR NSW) 2016,
DEPARTMENT OF MAIN ROADS, 100886

We're looking at the CBD skyline from the newly built North Western Freeway (now known as the Western Distributor) near Darling Harbour in October 1982.

On the left below you can see the original buildings where Cockle Bay Wharf sits today, most of which were redeveloped during the Darling Harbour precinct redevelopment in the mid-1980s.

Also in view are some of the key CBD buildings (from left to right): Qantas, American Express, National Mutual, Radmill, and the Centrepoint Tower, which would have been just over a year old after its completion in August 1981. You can also see the Hilton Hotel behind the CML building.

Most of the view of the CBD is vastly different from this vantage point today, due to the development of office towers along Sussex Street during the late 1980s and 1990s.

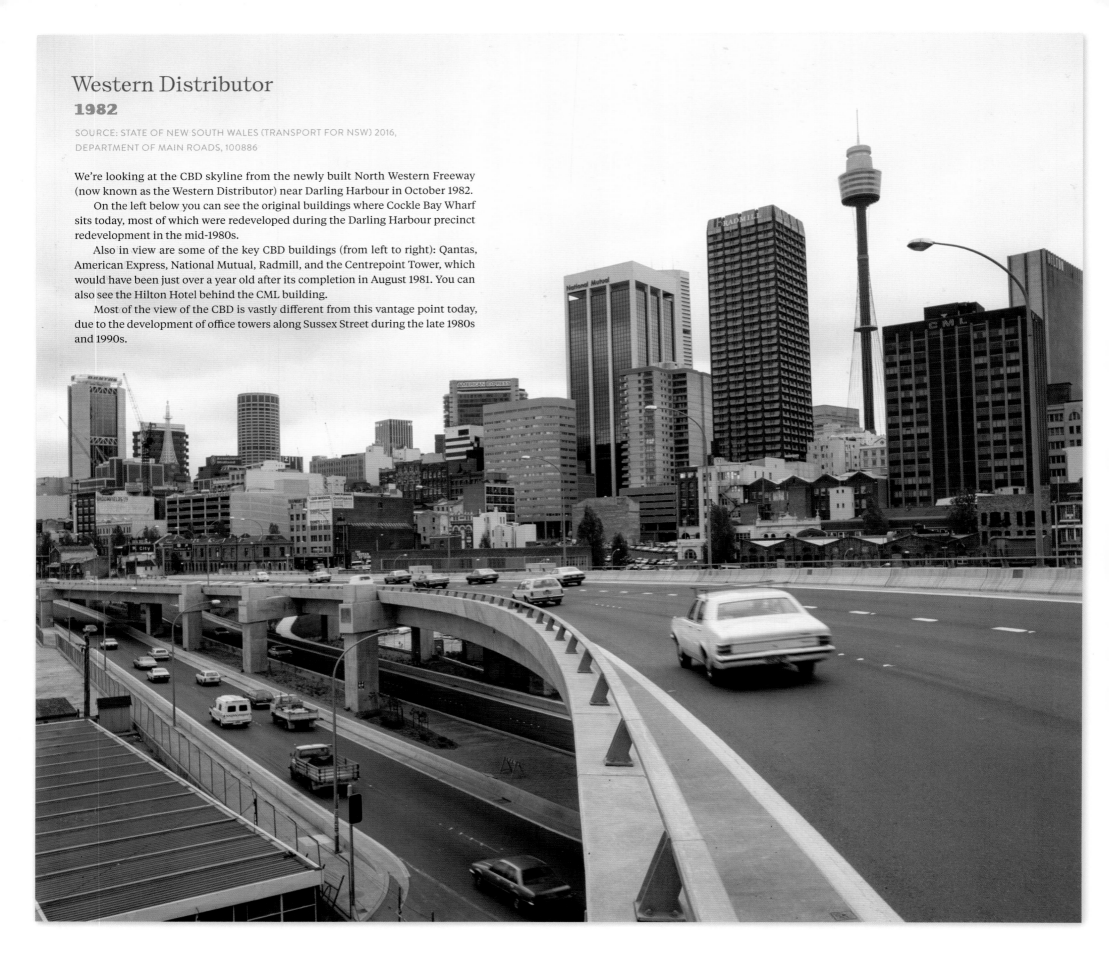

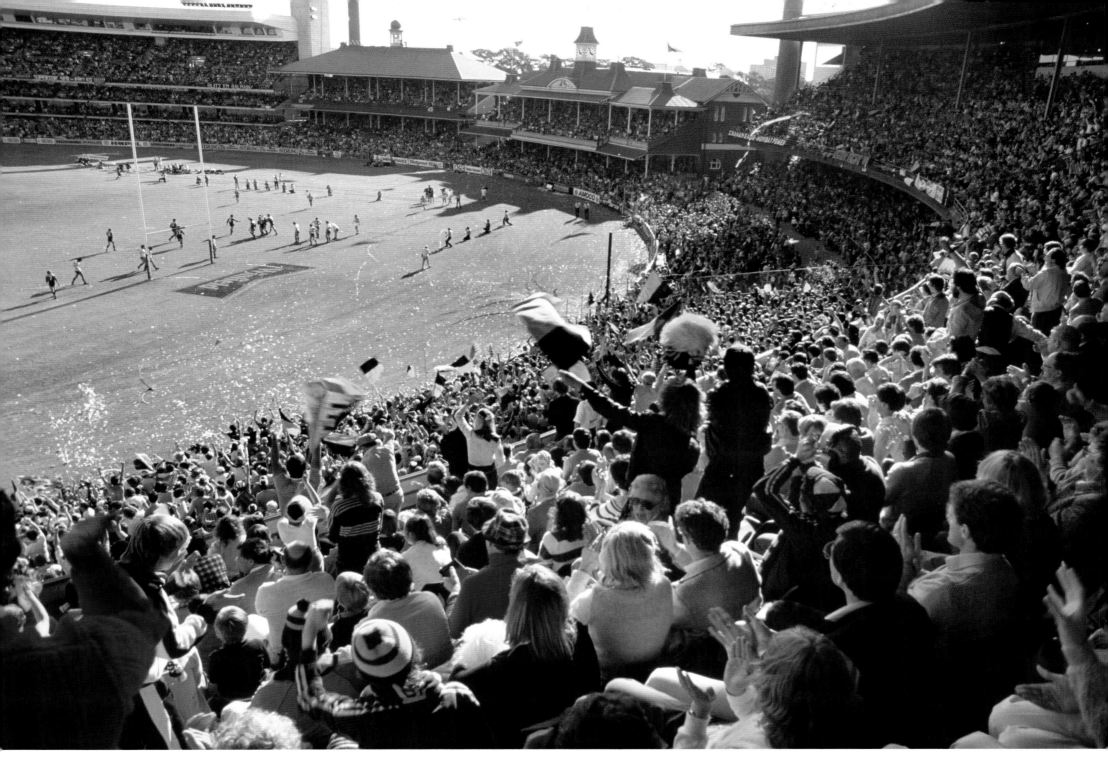

Sydney Cricket Ground, Moore Park
1982

SOURCE: NATIONAL ARCHIVES OF AUSTRALIA, A6135, K28/2/83/3, 11943709

The packed crowd in the stands cheer on their teams as the Manly Sea Eagles and the Parramatta Eels play for the 75th premiership on 26 September 1982.

Parramatta took out the title, beating Manly by 21–8. There were 52,186 people at the match.

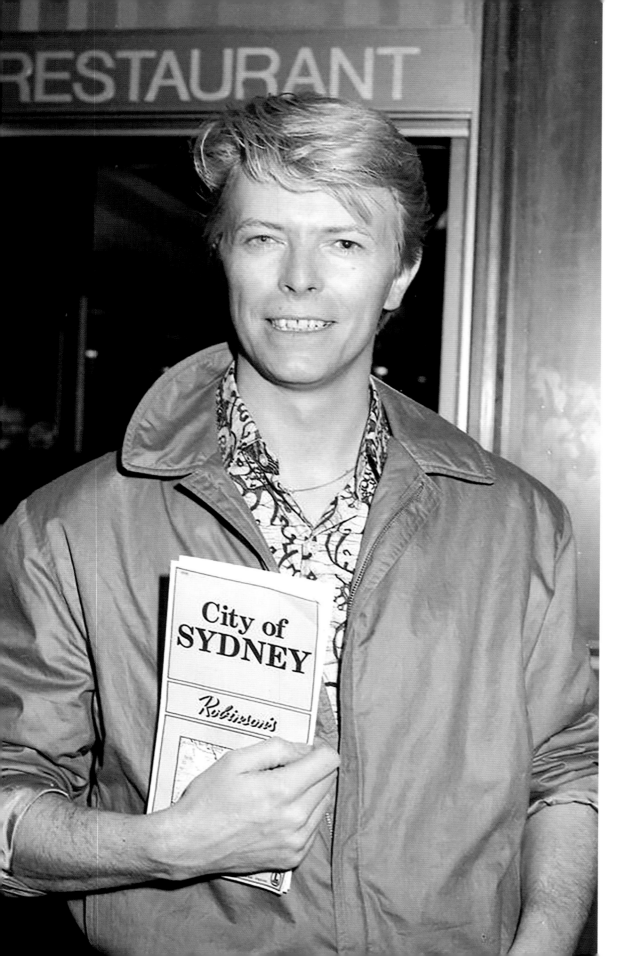

Sebel Townhouse Hotel, Elizabeth Bay Road, Elizabeth Bay
1983

PHOTOGRAPHER: JOHN O'GREADY
SOURCE: *THE SYDNEY MORNING HERALD* ARCHIVES, 2/03/1983, FXB85274

The musical icon David Bowie is photographed on arrival at the Sebel Town-house in early March 1983. Bowie was in Australia promoting his upcoming album *Let's Dance*, which was to be released the following month, with the headline single of the same name due to be released in mid-March. 'Let's Dance' would go on to become the biggest-selling single of Bowie's career.

Bowie used Sydney for the film clips of both 'Let's Dance' and another hit single on the album, 'China Girl' (a cover of the Iggy Pop song of the same name). The clips were shot during February 1983, and featured several locations around the city.

It was also during this period that Bowie bought a Sydney base — purchasing an apartment in the Kincoppal complex in Elizabeth Bay in March 1983. He owned it until early 1992, around the time he married model Iman Abdulmajid.

Grand Concourse, Central Railway Station ▸
1983

SOURCE: NATIONAL ARCHIVES OF AUSTRALIA, A6135, K30/3/83/77, 11962467

Passengers traverse the Grand Concourse and wait for trains on the rotunda seats outside the newsagency in March 1983.

You can see the new computer-screen timetables, which replaced the old indicator board in June 1982. The original indicator board was built in 1906, and now sits on display in the Powerhouse Museum.

Sydney Cricket Ground, Moore Park

1983

SOURCE: NATIONAL ARCHIVES OF AUSTRALIA, A6135, K26/1/83/47, 11954133

A packed SCG during the first day of the Australia v. England fifth and final Test in the 1982–83 Ashes series in early January 1983. England held on to force a draw, but Australia won the series and regained the Ashes.

Warriewood Beach ▸

1983

SOURCE: NATIONAL ARCHIVES OF AUSTRALIA, A6135, K23/3/83/143, 11698088

Beachgoers at Warriewood during the summer, in February 1983.

Martin Place

1983

SOURCE: NATIONAL ARCHIVES OF AUSTRALIA, A6135, K24/3/83/21, 11728626

People queue to buy a copy of the newspaper and maybe a Polly Waffle at the newspaper stand opposite the Commonwealth Bank building in Martin Place near Castlereagh Street, on an afternoon in March 1983.

You can tell it's the afternoon because they're selling *The Sun* newspaper, the sister publication of *The Sydney Morning Herald* — in the days when print media were still dominant. *The Sun* ceased publication in 1988, and morphed into what we now know as the Sunday tabloid *The Sun-Herald*.

You could also pick up the latest issue of *Cleo* magazine, the brainchild of founding editor Ita Buttrose and proprietor Kerry Packer, and also the subject of the great 2011 docudrama *Paper Giants*.

Launched in November 1972, *Cleo* was one of the great indicators of how Australia was changing, bringing to a wide readership a mix of provocative journalism and news of a rapidly changing social landscape. *Cleo* ceased publication more than three decades later, in March 2016.

Sydney Opera House, Bennelong Point ▸

1983

PHOTOGRAPHER: ANWAR HUSSEIN
SOURCE: GETTY IMAGES

This is a famous press photo taken at the steps of the Opera House as Diana, Princess of Wales, walks among the overwhelming crowds that greeted the arrival of the Prince and Princess of Wales in Sydney on 28 March 1983.

This was the royal couple's first tour together of Australia and New Zealand, and Princess Diana's first trip abroad — she was just 22 years of age. Diana is wearing a pink dress by Bellville Sassoon, one of her go-to labels, and a hat by John Boyd.

The tour would last six weeks between March and May 1983 — four weeks in Australia, and two weeks in New Zealand.

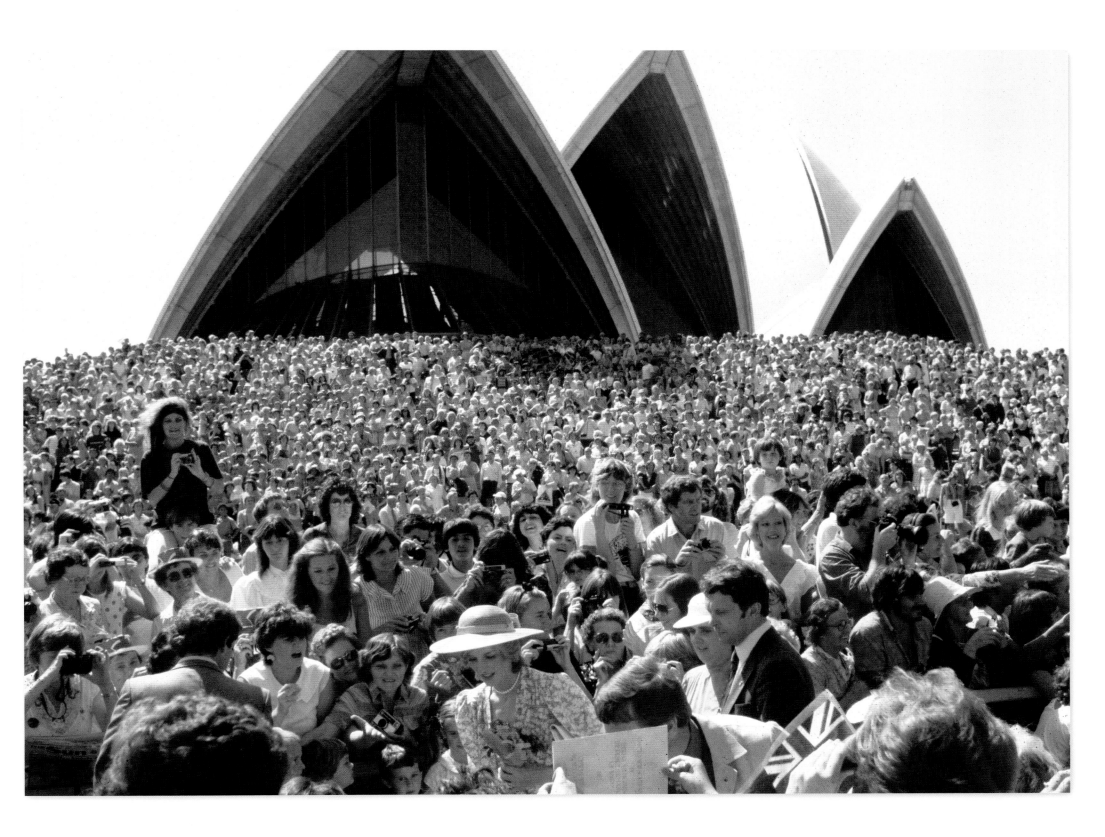

Glebe Point Road, Glebe
1983

A row of gorgeous Federation terraces line Glebe Point Road in June 1983. Many of the terrace houses, particularly around the inner-city areas, were renovated during the 1960s and 1970s in ways that removed most of their original features; but some, like this one, retained their beautiful wrought-iron work and cornices.

Sydney Harbour ▸
1984

We're looking south-west towards the CBD, Bennelong Point, Sydney Cove, and Farm Cove in early November 1984. From left to right, you can see the Royal Botanic Gardens, the Opera House at Bennelong Point, Circular Quay, the Overseas Passenger Terminal, and the historic district of The Rocks.

Also notable is the very sparse-looking western side of the CBD, which is yet to be developed along Sussex Street. Many of the medium-rise buildings at the northern end of the CBD still remain.

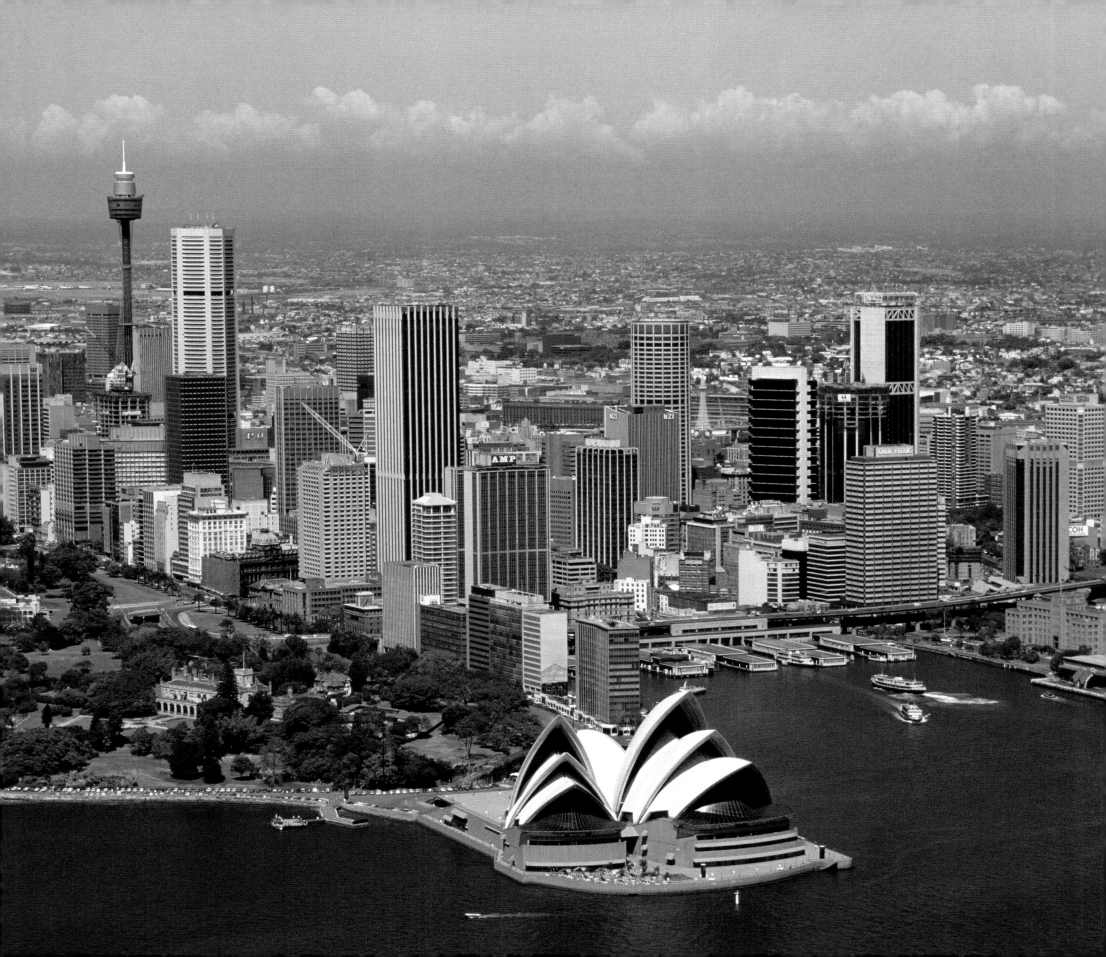

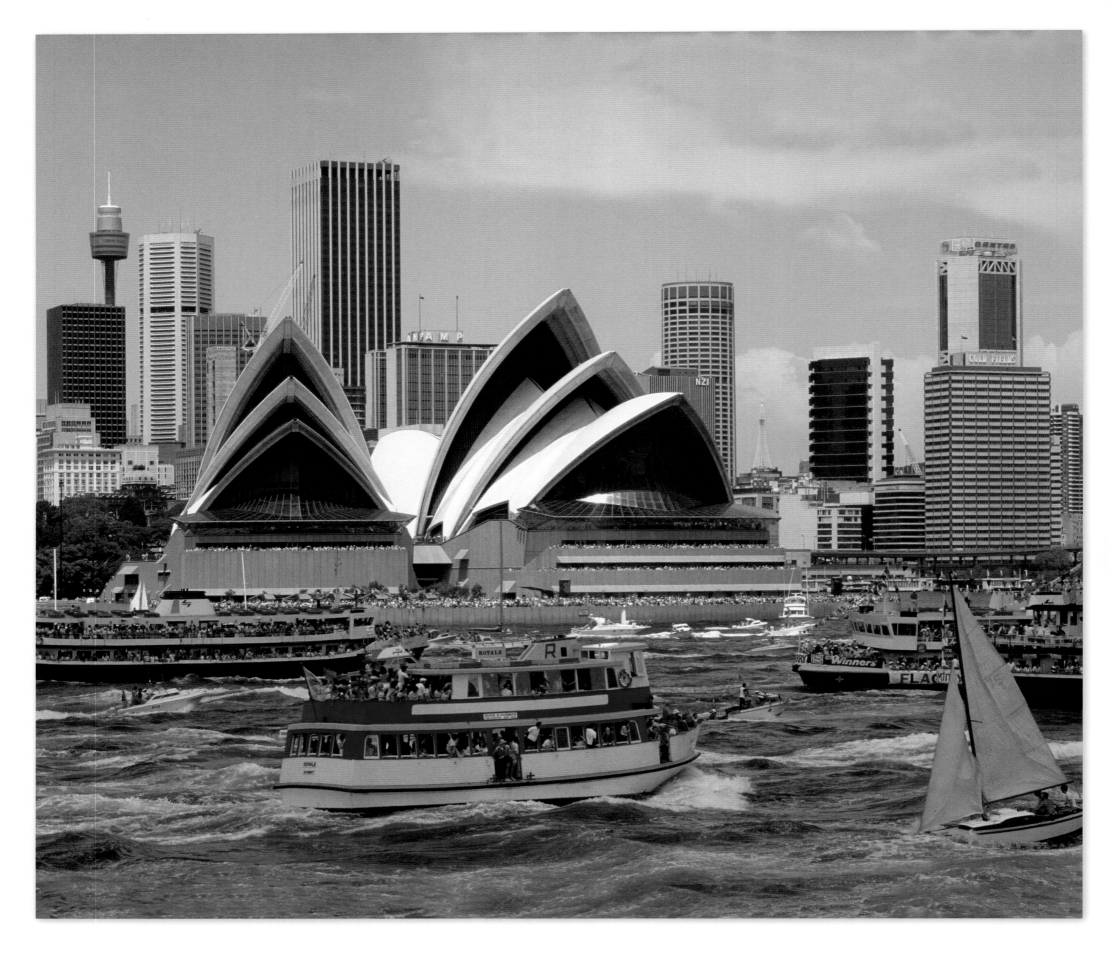

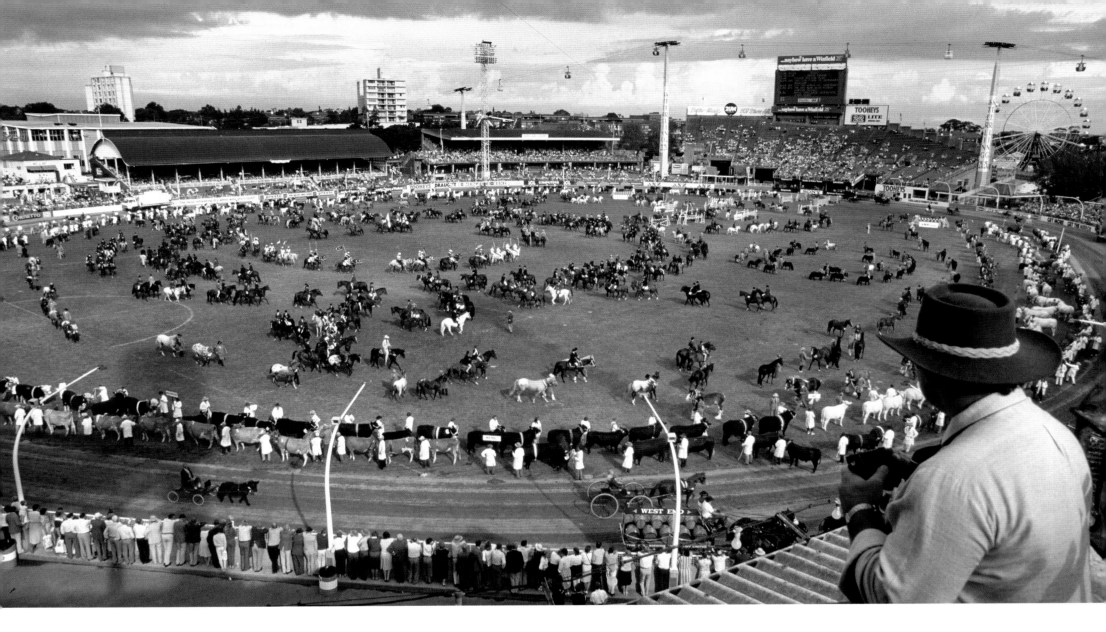

Sydney Harbour
1984

SOURCE: NATIONAL ARCHIVES OF AUSTRALIA, A6135, K6/2/84/113, 11754245

The lady-class ferries *Lady Northcott* and *Royale*, and others, speed towards the Harbour Bridge and past the Opera House during the 1984 Sydney Harbour Ferrython, as part of the Festival of Sydney celebrations in January 1984.

The 1984 race became infamous when the ferry *Karrabbee*, which finished third, sank after returning to Circular Quay. Recovery efforts took a whole week, and the ferry was subsequently taken out of service.

Lady Northcott was first put into service in September 1974, and kept operating until October 2017, when it was donated to an Aboriginal-owned cruise company.

Sydney Royal Easter Show, Showground, Moore Park
1985

SOURCE: NATIONAL ARCHIVES OF AUSTRALIA, A6135, K22/4/85/34, 11750717

Looking at the Grand Parade during the 1985 Royal Easter Show in April at the Sydney Showground.

The parade is one of the Show's main events, celebrating its rural traditions and reflecting the background of the Show's organisers, the Royal Agricultural Society of New South Wales. It brings together the country and the city, combining its agricultural competitions with live entertainment and carnival fun. The Show was held at the Sydney Showground for 116 years before moving to Sydney Olympic Park in 1998, where it is still held today.

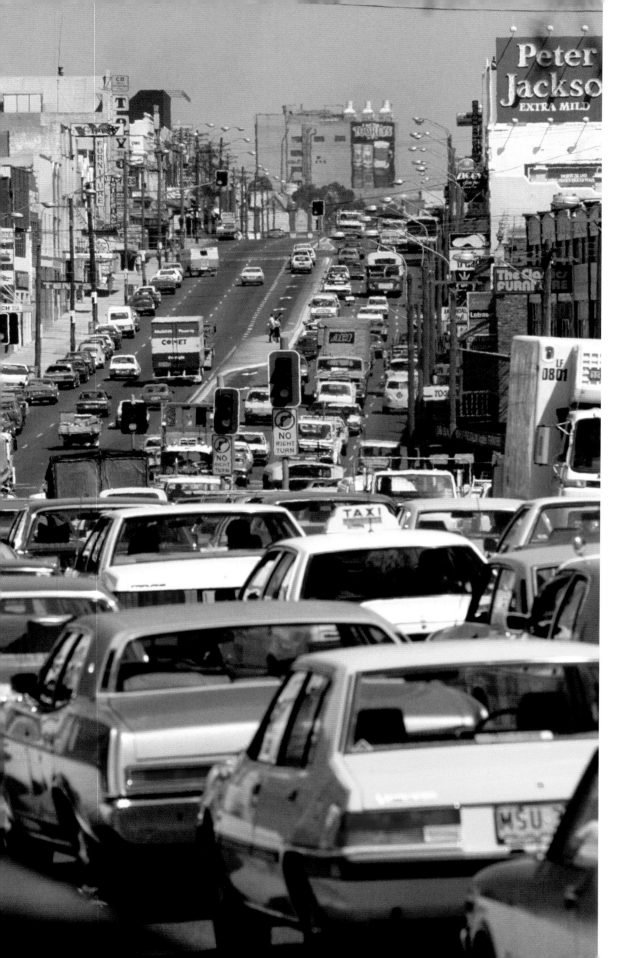

Parramatta Road, Camperdown
1985

SOURCE: NATIONAL ARCHIVES OF AUSTRALIA, A6135, K22/3/85/14, 11963323

We're looking westwards from near the intersection of Denison Street and Parramatta Road towards the Annandale shopping strip in mid-March 1985, before the clearway was put in.

The large grey building in the distance is now the Kennards Storage building on Parramatta Road, Petersham. As for the small businesses that traded along Parramatta Road seen here, they are nearly all gone.

I love the cars — you hardly see some of these anymore! Also noteworthy, as a sign of the times, is the cigarette advertising on some of the buildings.

General Holmes Drive, Mascot ▶
1985

SOURCE: STATE OF NEW SOUTH WALES (TRANSPORT FOR NSW) 2016, DEPARTMENT OF MAIN ROADS, 100854-56

Crowds gather on General Holmes Drive to watch the British Airways G-BOAE Concorde depart Sydney Airport on 15 February 1985. The Concorde only flew twice to Sydney — once in 1972, and then in 1985. It broke the previous London-to-Sydney record by 33 hours.

You can only imagine how loud it would have been from where this photo was taken. Nevertheless, a few people have scaled the barbed-wire fencing to get a shot!

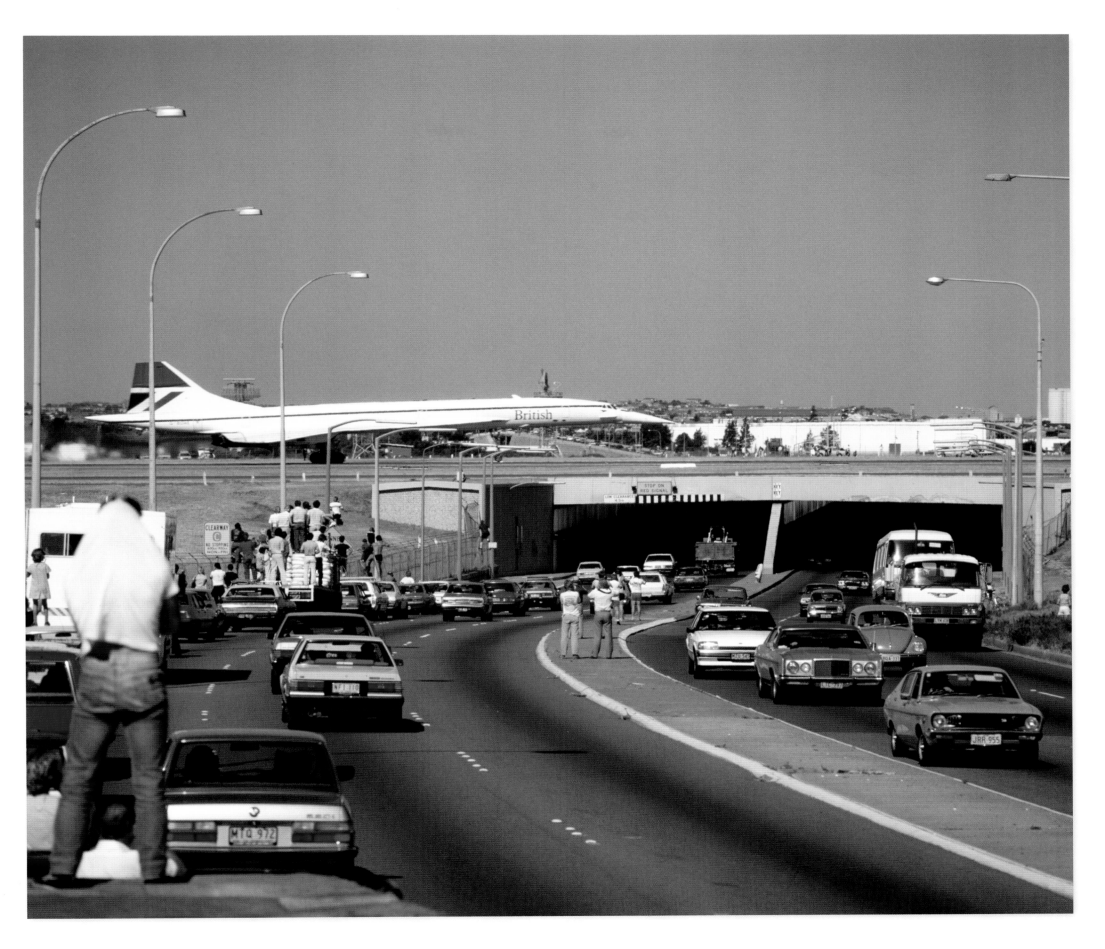

Parramatta Road, Petersham

1985

SOURCE: NATIONAL ARCHIVES OF AUSTRALIA, A6135, K22/3/85/15, 11963385

This is the view west towards the Petersham shopping strip and the intersection of Norton Street and Parramatta Road, from the intersection of Crystal Street and Parramatta Road. It wouldn't be 1985 without a Tooheys beer billboard!

It's amazing to see how many businesses used to trade along Parramatta Road, and that there was no clearway (which is probably why most of these shops are now vacant).

Another remarkable thing about this photo is the lane layout of Parramatta Road — crowded as it is, it's unchanged today.

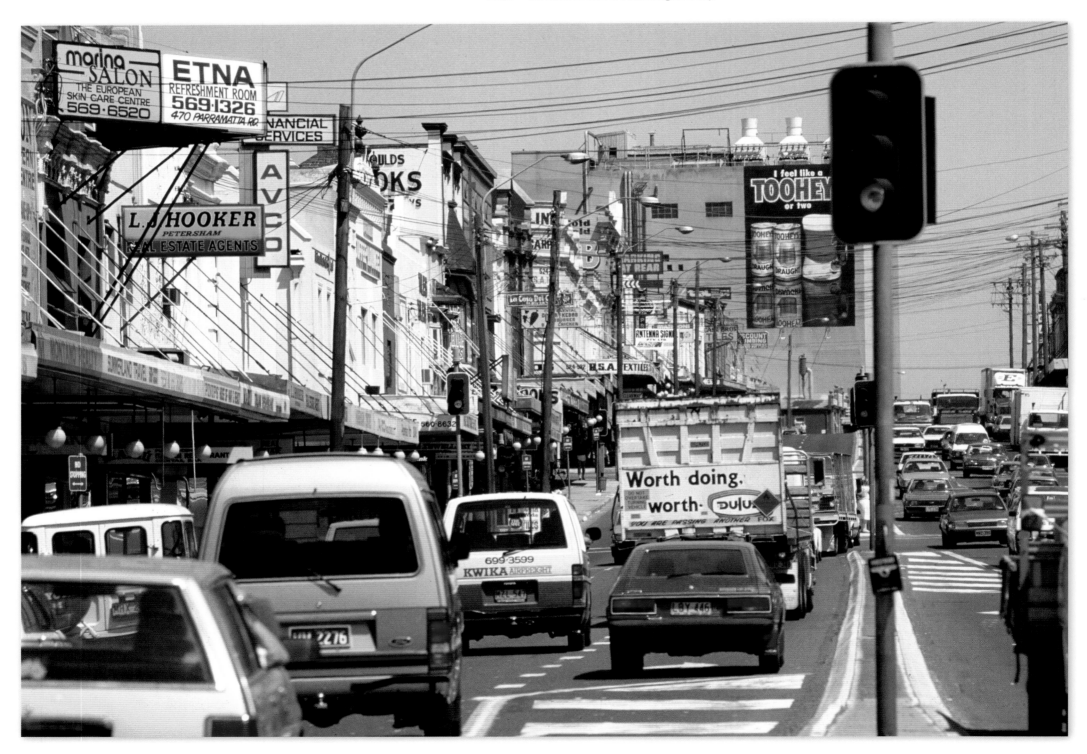

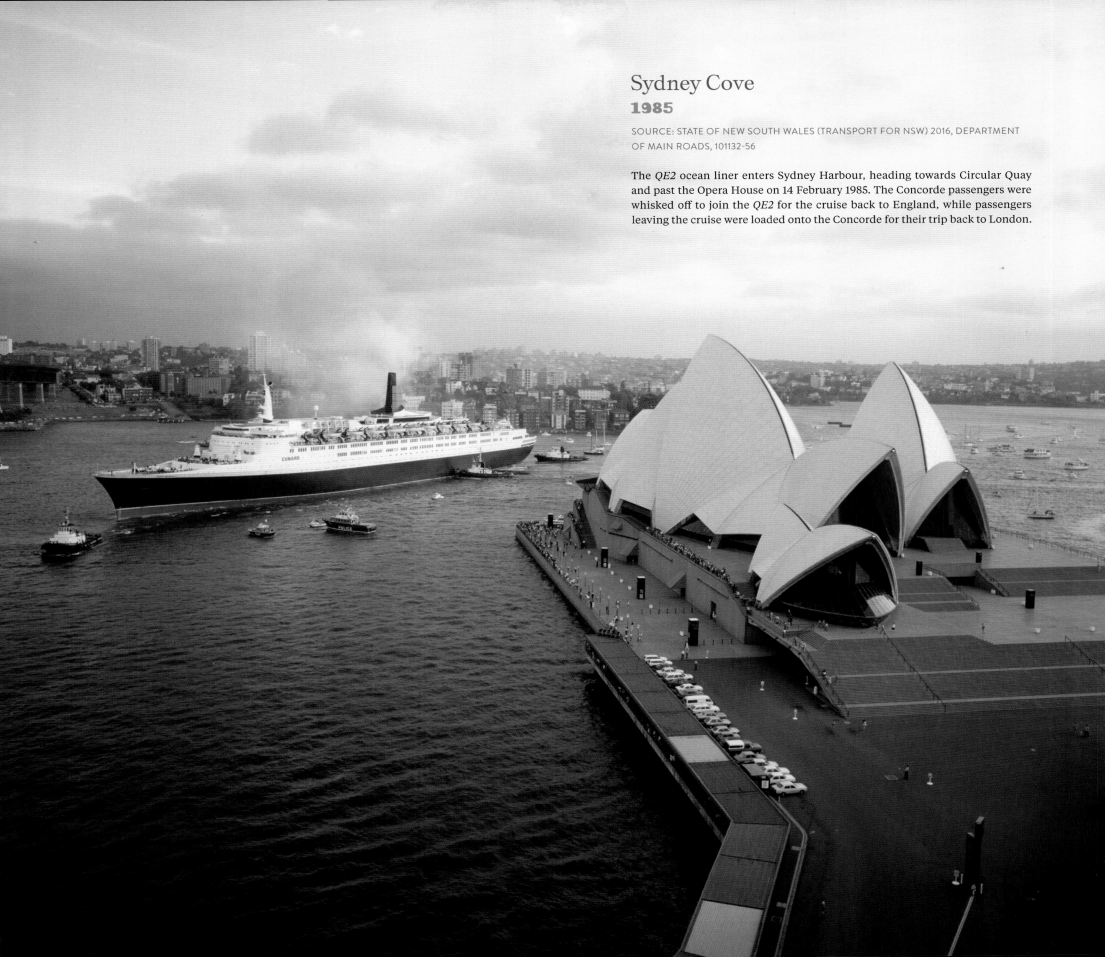

Sydney Cove
1985

SOURCE: STATE OF NEW SOUTH WALES (TRANSPORT FOR NSW) 2016, DEPARTMENT OF MAIN ROADS, 101132-56

The *QE2* ocean liner enters Sydney Harbour, heading towards Circular Quay and past the Opera House on 14 February 1985. The Concorde passengers were whisked off to join the *QE2* for the cruise back to England, while passengers leaving the cruise were loaded onto the Concorde for their trip back to London.

Pitt Street

1986

SOURCE: NATIONAL ARCHIVES OF AUSTRALIA, A6135, K18/ /86/16, 11728748

Looking north down Pitt Street from the intersection of Hunter and Pitt streets towards Circular Quay on a grey, rainy day in August 1986. You can just see the outline of the Harbour Bridge through the heavy rainfall in the background.

It seems from this photograph that this part of the city hasn't changed over the years — it doesn't look too dissimilar to how it is today. However, the building in the background featuring 'OVE' in capital letters, Phoenix House, was demolished in 1997 to make way for the Foreign Exchange building.

Martin Place

1986

SOURCE: NATIONAL ARCHIVES OF AUSTRALIA, A6135, K13/1/86/92, 11728744

Looking east up a bustling Martin Place from George Street towards Pitt Street, and at the Dobell Memorial Sculpture and Fountain in January 1986.

The sculpture was unveiled in October 1979, commemorating Sir William Dobell, one of Australia's most celebrated landscape and portrait artists. The sculpture was moved in October 1999 to its current location in Bond Street, opposite Australia Square, when the amphitheatre was moved behind the fountain in the 2000s, during an upgrade to the Martin Place precinct for the Sydney 2000 Olympic Games.

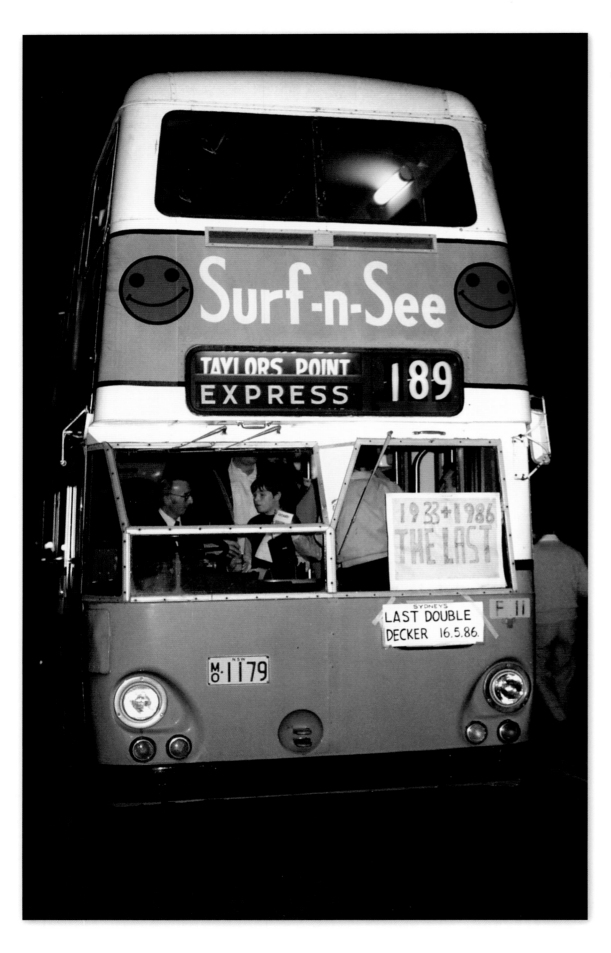

Taylors Point Wharf, Hudson Parade, Clareville
1986

PHOTOGRAPHER: JOHN WARD
SOURCE: CITY OF SYDNEY ARCHIVES, A-01108609

Passengers aboard the Urban Transit Authority's 1179 Atlantean double-decker bus at its final stop at Taylors Point Wharf on the evening of 16 May 1986. This was the last trip by the first generation of double-deckers in Sydney before they were decommissioned, more than 50 years after they were introduced.

Double-deckers were brought into service in 1933, and became an icon of Sydney, especially in their blue-and-green livery. It would be another 30 years before double-deckers returned, firstly with private bus companies, and then on government-run lines, with the B-Line bus network servicing the Northern Beaches in the mid-2010s.

Double-deckers were replaced from 1986 onwards by articulated (or bendy) buses.

George Street ▸
1987

SOURCE: NATIONAL ARCHIVES OF AUSTRALIA, A6135, K30/3/87/13, 11874306

We're looking south from near the intersection of King Street and George Street in March 1987.

You can see the Gowings building in the distance on the left, as well as the Queen Victoria Building on the right, some of the original buildings that have since been redeveloped, and also the Dymocks building at 426 George Street and the Strand Arcade at 412 George Street before it got its heritage-style awning.

You can also see, on the far left, part of the Darrell Lea chocolate shop, on the corner of King and George streets, which was opened by founder Harry Lea in the 1920s. Harry started his business in 1917, selling sweets from a cart in Manly. He made the sweets out the back of his fruit shop on The Corso.

This store would become the oldest shop in the company, where it remained until the business entered administration in September 2012 and closed. It's now the site of a Telstra shop.

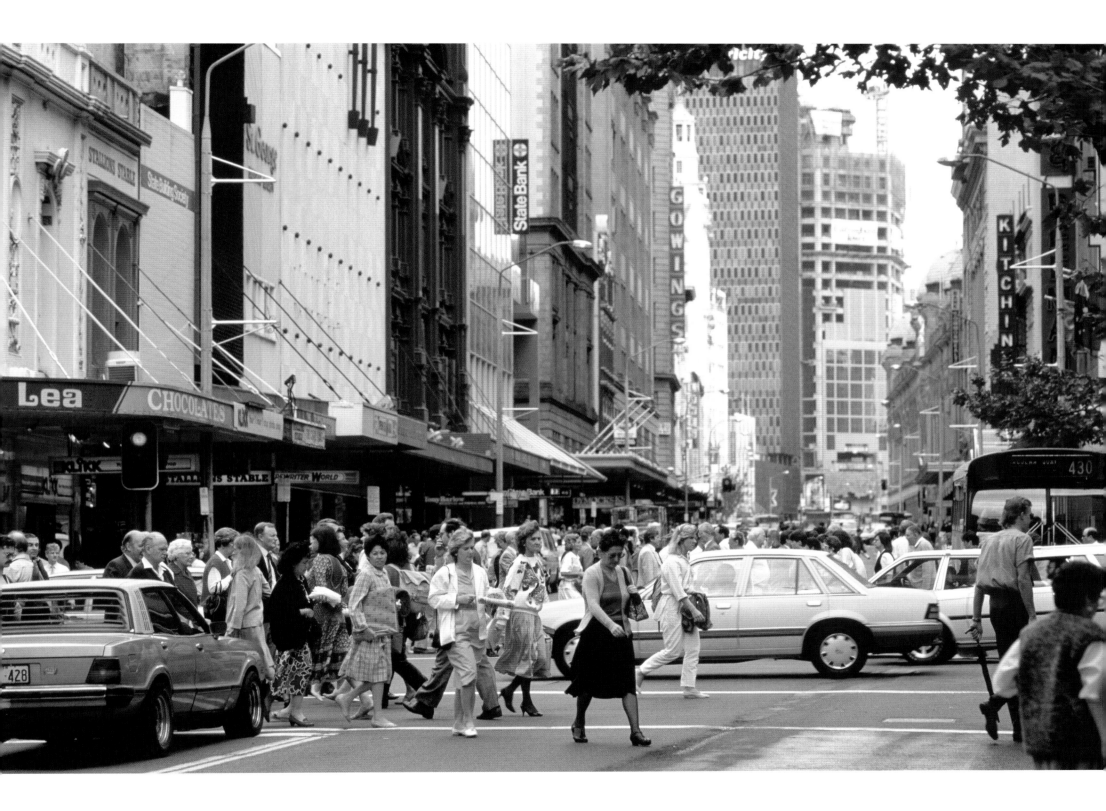

Sydney
1987

SOURCE: NATIONAL ARCHIVES OF AUSTRALIA, A6135, K30/1/87/57, 11728782

This is an iconic view of the city, the harbour, and the surrounds in January 1987.

You can see the Lower North Shore with Kirribilli on the left, and Milsons Point on the right with Luna Park. Over the water, the Opera House's restaurant section is being developed on the foreshore (where the Opera Bar is today), and there is continuing development being undertaken of Darling Harbour on the western fringe of the towering CBD.

You can also see the Grosvenor Place building under construction at 225 George Street, which was designed by Harry Seidler and would be completed in 1988.

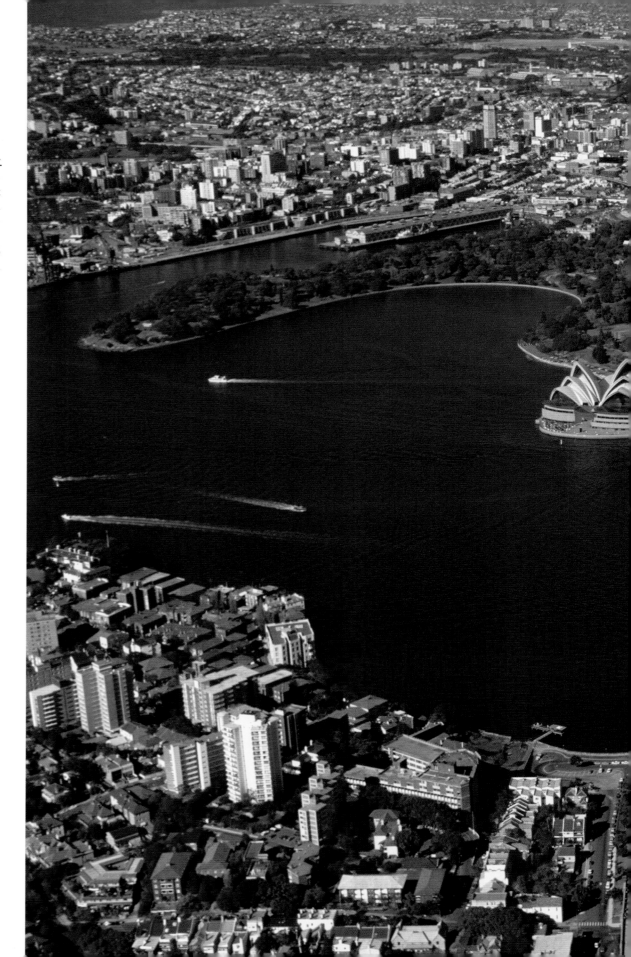

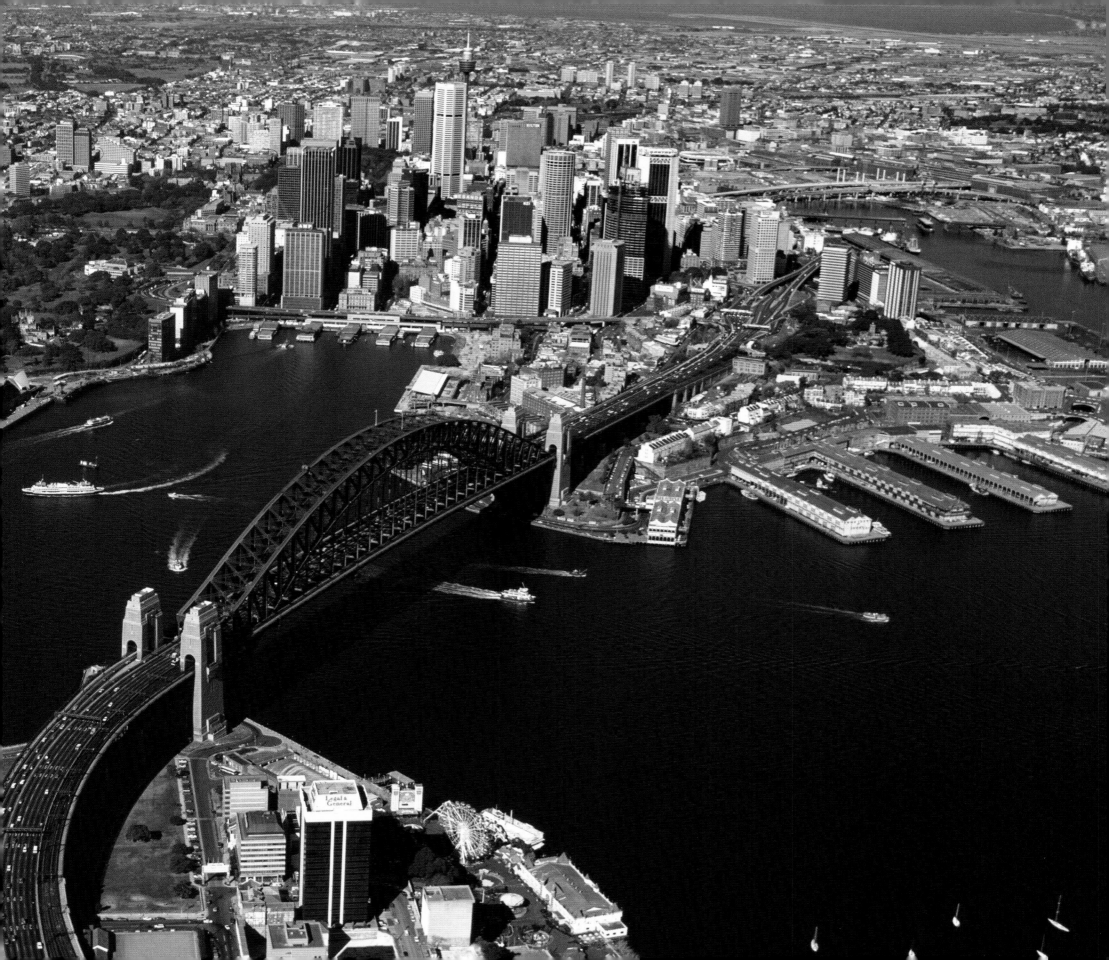

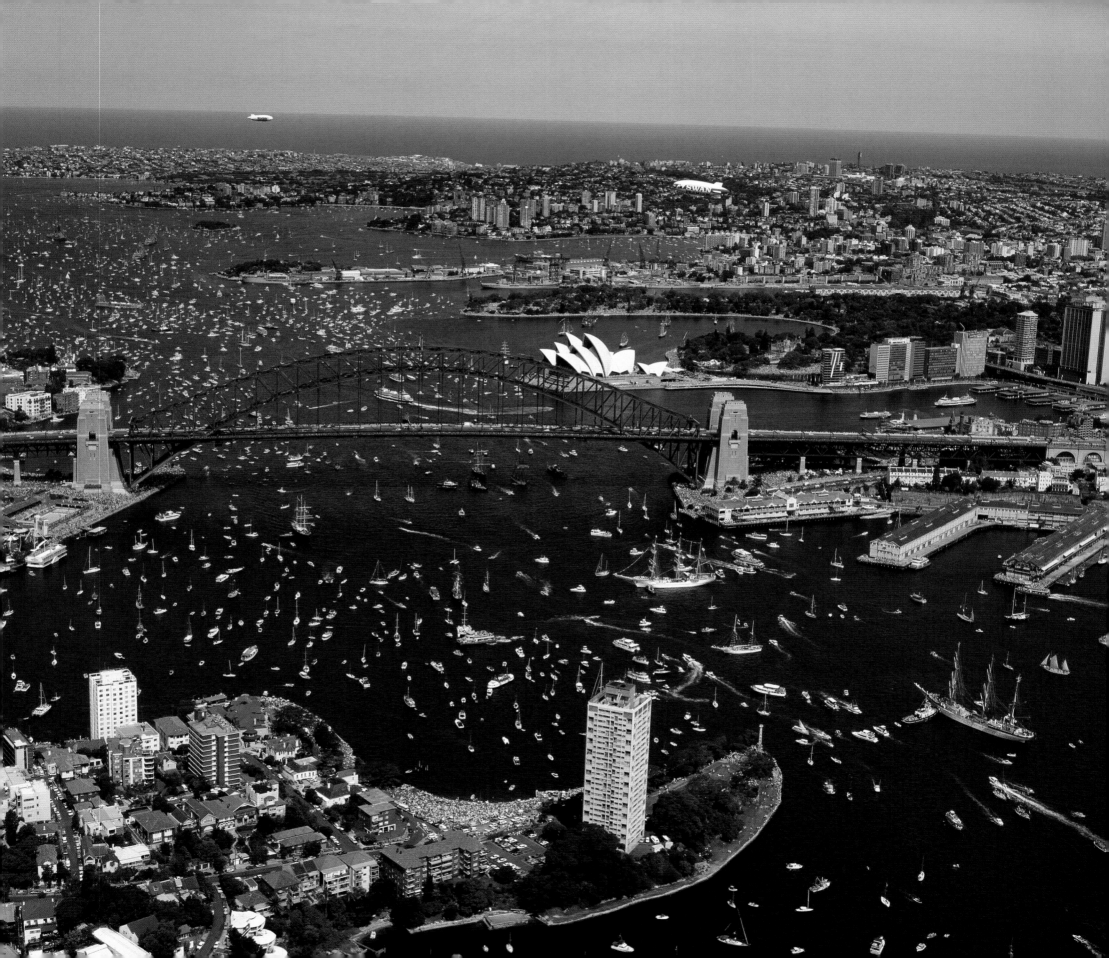

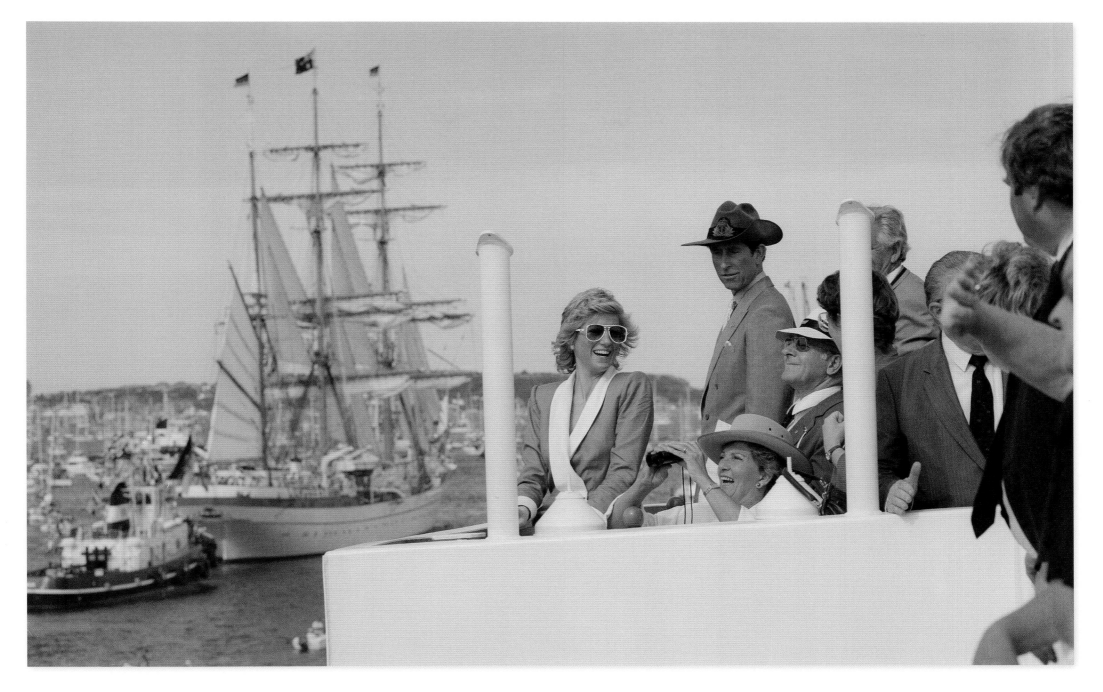

Sydney Harbour
1988

SOURCE: NATIONAL ARCHIVES OF AUSTRALIA, A6135, K15/2/88/37, 11756090'

Sydney Harbour during celebrations for the Bicentenary on 26 January 1988. There's an amazing display, featuring naval ships and hundreds of private boats, and thousands of people have turned out to watch the festivities from the shoreline and from other vantage points around the harbour.

You can also see the Kodak and Swan Premium blimps floating above the pageant.

Bennelong Point
1988

SOURCE: NATIONAL ARCHIVES OF AUSTRALIA, A8746, KN18/2/88/56, 11914007

Princess Diana and Prince Charles (wearing an Akubra), along with Prime Minister Bob Hawke and his wife, Hazel (handling binoculars), having a light-hearted moment while watching the Bicentennial festivities on 26 January 1988.

This was the couple's last visit to Australia and Sydney before their separation in December 1992 and divorce in August 1996.

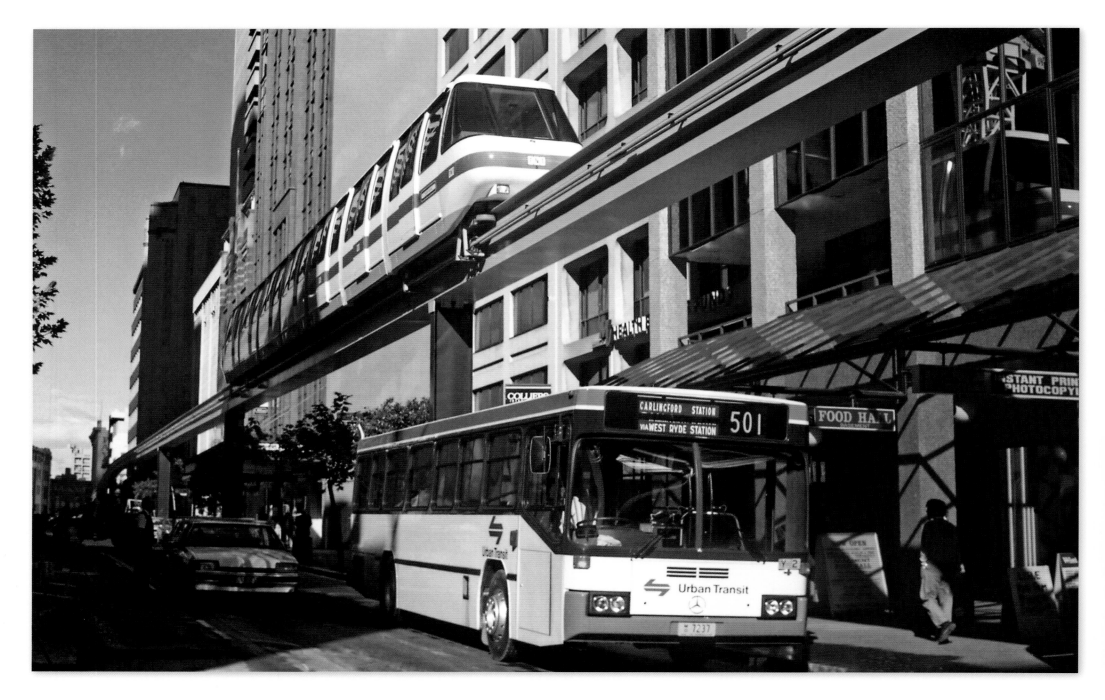

Pitt Street
1988

PHOTOGRAPHER: JOHN WARD
SOURCE: CITY OF SYDNEY ARCHIVES, A-01078981

We're looking west as the 501 bus heads to the intersection of Pitt and Park streets while, above it, the new TNT Harbourlink monorail is on a test run in late May 1988. The single-loop monorail connected the new Darling Harbour precinct, Chinatown, and the city's central business and shopping districts. It opened in July 1988 and closed in June 2013.

Darling Harbour ▸
1989

SOURCE: NATIONAL ARCHIVES OF AUSTRALIA, A6135, K2/06/89/30, 11649175

A bustling, brand-new Darling Harbour with crowds enjoying the new Harbour-side Shopping Centre and various restaurants in the new entertainment precinct, in early 1989.

The precinct was officially opened by Queen Elizabeth II in May 1988 after a major redevelopment of the area during the mid-1980s. The precinct was closed in December 2022, and is due to undergo a major redevelopment.

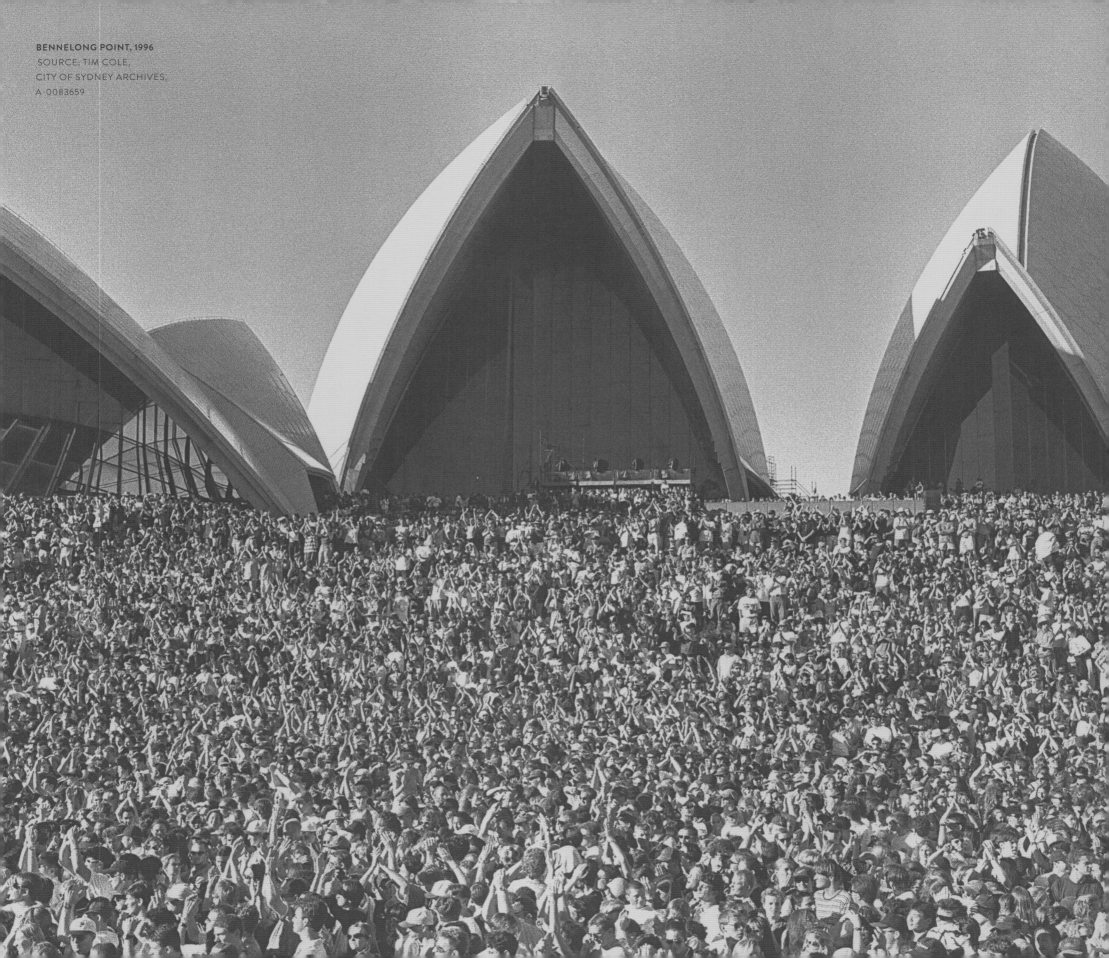

THE 1990s

We wave goodbye to the glowing neon, big hair, and bubble-gum pop of the 1980s, and welcome the decade that bought us the internet, Aerobics OzStyle, Cheez TV, grunge, parachute tracksuits, and Eurodance.

The 1990s in Sydney was a period of continued growth — more skyscrapers were built, turning the CBD into an international business hub. The addition of buildings such as the Chifley Tower (completed in 1992), the Wintergarden building on O'Connell Street (1991), and the Governor Phillip Tower (1993), and the demolition of the State Office Block to make way for Renzo Piano's Aurora Place (completed in 2000) created a sleeker, more contemporary aesthetic in the CBD, with the Chifley Tower becoming one of the most exclusive office buildings in the city. Many older buildings were demolished throughout the 1980s and 1990s, including the wonderful Anthony Hoardings building on George Street, which fell into disrepair and was demolished in the mid-1980s. For most of the 1990s, it sat as an open hole due to numerous disputes over the development that was planned for the site — the World Square.

Darling Harbour continued to become *the* entertainment district, with the opening of the IMAX theatre and SEGA World, and most of Sydney's major conventions and shows now being held at the Convention Centre.

Our 'temporary' monorail became a permanent fixture, connecting the CBD with Darling Harbour — many people like me, who grew up in the 1990s, would remember the novelty of it. We also waved goodbye to the iconic 'Red Rattler' trains in 1992 for sleeker new models that had closing doors. Sydney also got a second harbour crossing, alleviating the traffic congestion on the Harbour Bridge, in the form of the Sydney Harbour Tunnel in mid-1992.

We also celebrated one of the most special moments for our city with the securing of the 2000 Summer Olympic Games, when Juan Antonio Samaranch famously announced in the early hours of 24 September 1993: 'And the winner ... is ... Sydney!' That announcement led to the birth of the Sydney Olympic Park precinct at Homebush in central Sydney, which was constructed throughout the 1990s and gave our city world-class venues that would host sporting events until today.

Sydney was also used as the backdrop for a number of film productions in the 1990s — including *Strictly Ballroom* (1992), *Muriel's Wedding* (1994), *The Adventures of Priscilla, Queen of the Desert* (1994), *Mighty Morphin Power Rangers* (1995), *Mission Impossible 2* (1999), and *The Matrix* (1999). Not only was Sydney on the big screen, but its streets and suburbs were also the settings for many iconic television shows — namely, *Water Rats*, which was shot throughout the city as well as at Goat Island, where the so-called Operations building still stands today; and, of course, *Home and Away*, set in fictional Summer Bay (Palm Beach in reality). The latter is one of Australia's longest-running television programs and has given birth to some of Australia's biggest stars on stage and screen.

Watsons Bay
1990

SOURCE: NATIONAL ARCHIVES OF AUSTRALIA, A6135, K25/07/90/3, 11650595

From the Watsons Bay Wharf, we can see the Watsons Bay Hotel in its original livery, with the beer garden packed with patrons, along with the equally busy adjacent Sydney institution, Doyles on the Beach, in early 1990.

Doyles was established at Watsons Bay in 1885, and is Australia's oldest continously running fish-and-chip shop.

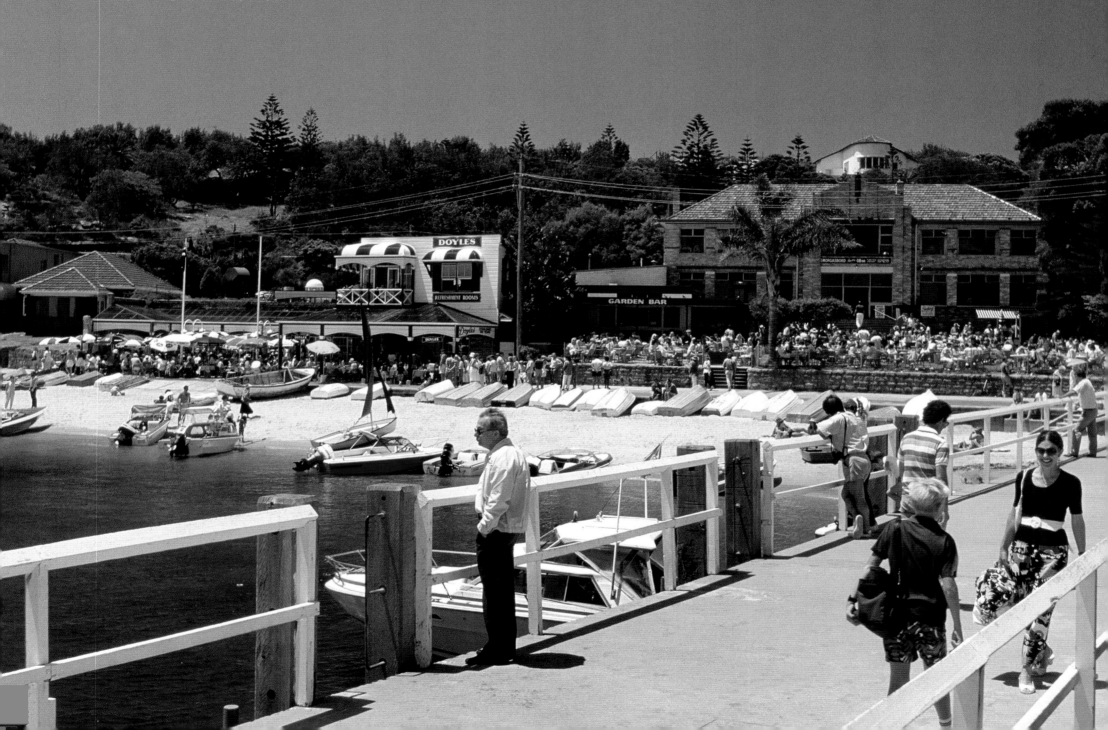

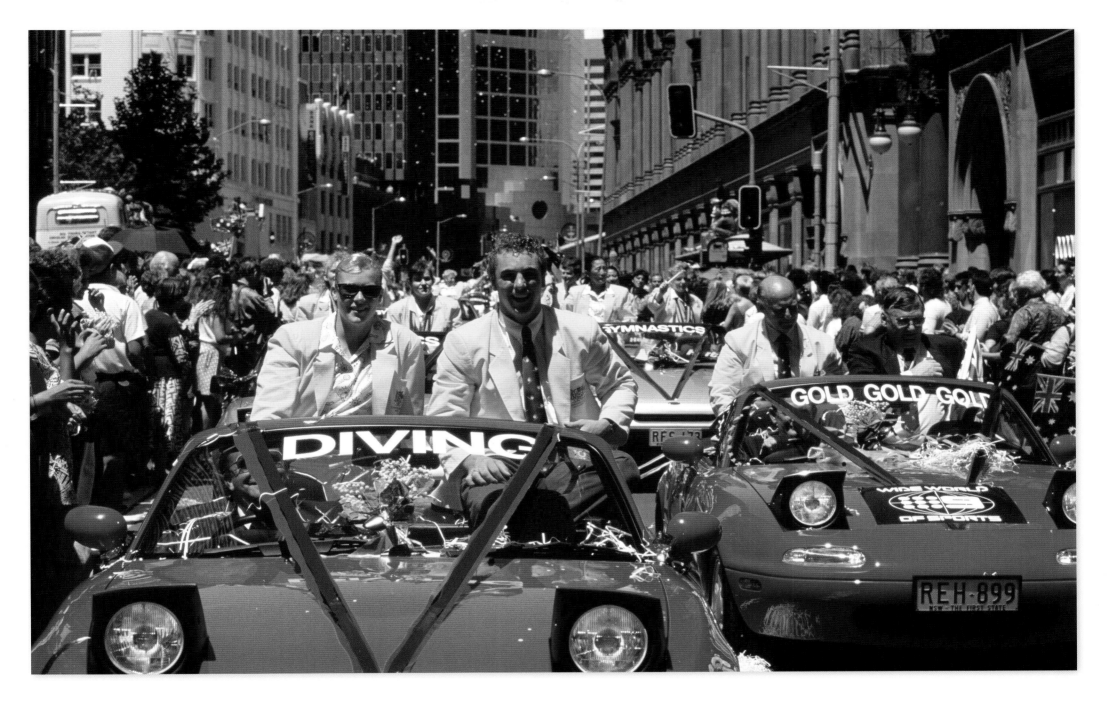

George Street

1990

SOURCE: NATIONAL ARCHIVES OF AUSTRALIA, A6135, K26/2/90/16, 11947684

Russell Butler, Craig Rogerson, and fellow medallists celebrate their victories during the ticker-tape parade aboard newly released Mazda MX-5s and Ford Capris, with crowds of well-wishers lining George Street. The Commonwealth Games were held in Auckland in January and February 1990. Australia topped the medal tally with 162 medals in total, including 52 gold.

York Street

1991

SOURCE: NATIONAL ARCHIVES OF AUSTRALIA, A6135, 25/11/91/5, 13071192

Here is a view looking south down York Street and towards the Queen Victoria Building, with the town hall in the background, near the intersection of Market and York streets in late November 1991.

The now-defunct monorail is heading towards the Cockle Bay Wharf stop, which is still there today.

Freedom Plaza,
Cabramatta ▸

1991

SOURCE: NATIONAL ARCHIVES OF AUSTRALIA, A6135, K20/3/91/36, 11728914

Here is the striking Friendship Arch in Freedom Plaza at Cabramatta in March 1991, opened by the premier, Nick Greiner, earlier that year.

Since the 1980s, Cabramatta has been the main centre for Vietnamese culture in Sydney, and is known colloquially as 'Little Saigon'. Cabramatta has the largest Vietnamese community in Australia.

止於至善

LÀ LÀNH ĐÙM LÀ RÁCH
TO REST IN THE HIGHEST EXCELLENCE

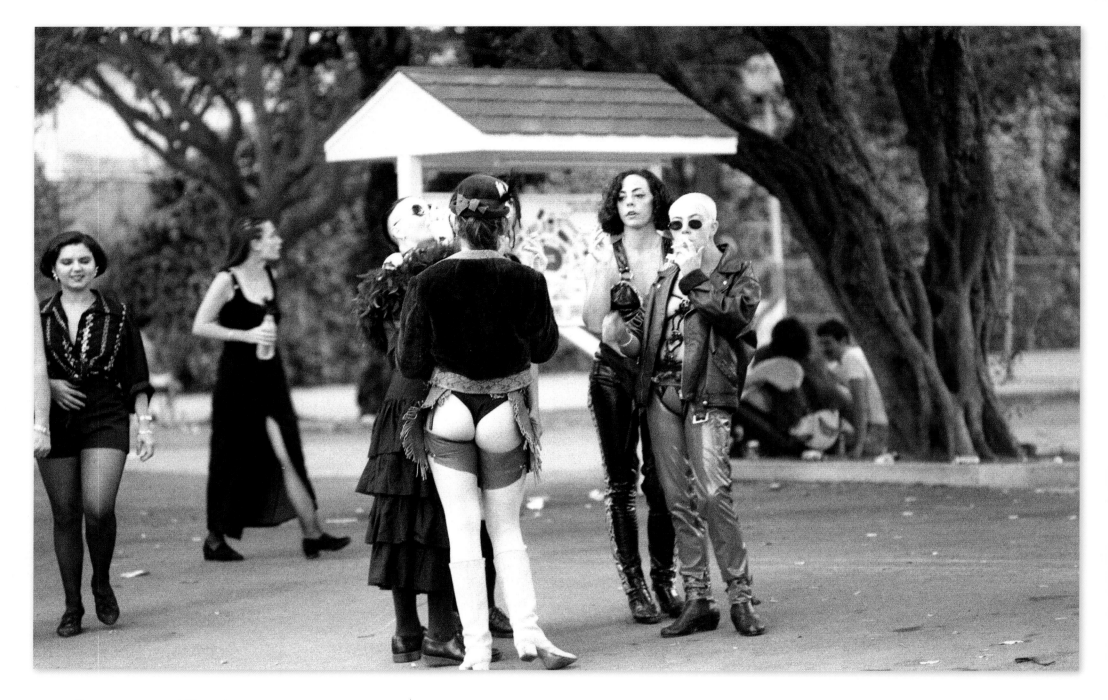

Centennial Park
1991

PHOTOGRAPHER: C. MOORE HARDY
SOURCE: CITY OF SYDNEY ARCHIVES, A-00070795

Revellers hanging out in Centennial Park the day after Mardi Gras celebrations, in March 1991. The first Sydney Mardi Gras was held on 24 June 1978 to mark the anniversary of the Stonewall riots in New York in 1969. Around 500 people attended. Sydney's Mardi Gras has now become one of the largest in the world, with over 12,500 participants in 2023.

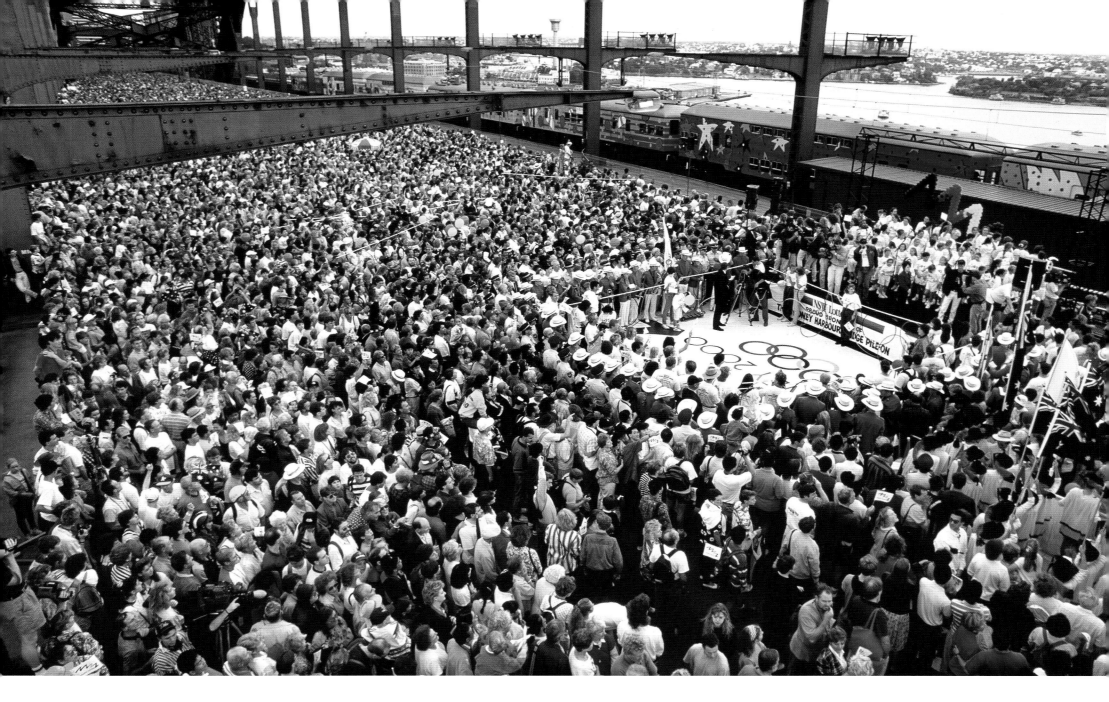

Sydney Harbour Bridge
1992

SOURCE: NATIONAL ARCHIVES OF AUSTRALIA, A6135, K16/4/92/29A, 11874371

A vast crowd gathers for the 60th anniversary of the opening of the Sydney Harbour Bridge in mid-March 1992. You can see the themed Red Rattler train on the rail line to mark the occasion — the last of the Red Rattlers were removed from service in January that year, after 66 years.

The celebrations were part of Sydney's bid to host the 2000 Olympic Games.

Sydney Cove
1993

SOURCE: NATIONAL ARCHIVES OF AUSTRALIA, A6135, K28/9/93/22, 11860158

A fireworks display above the Opera House decked out in Olympic colours in the lead-up to the final days of the Olympic campaign bid in late September 1993.

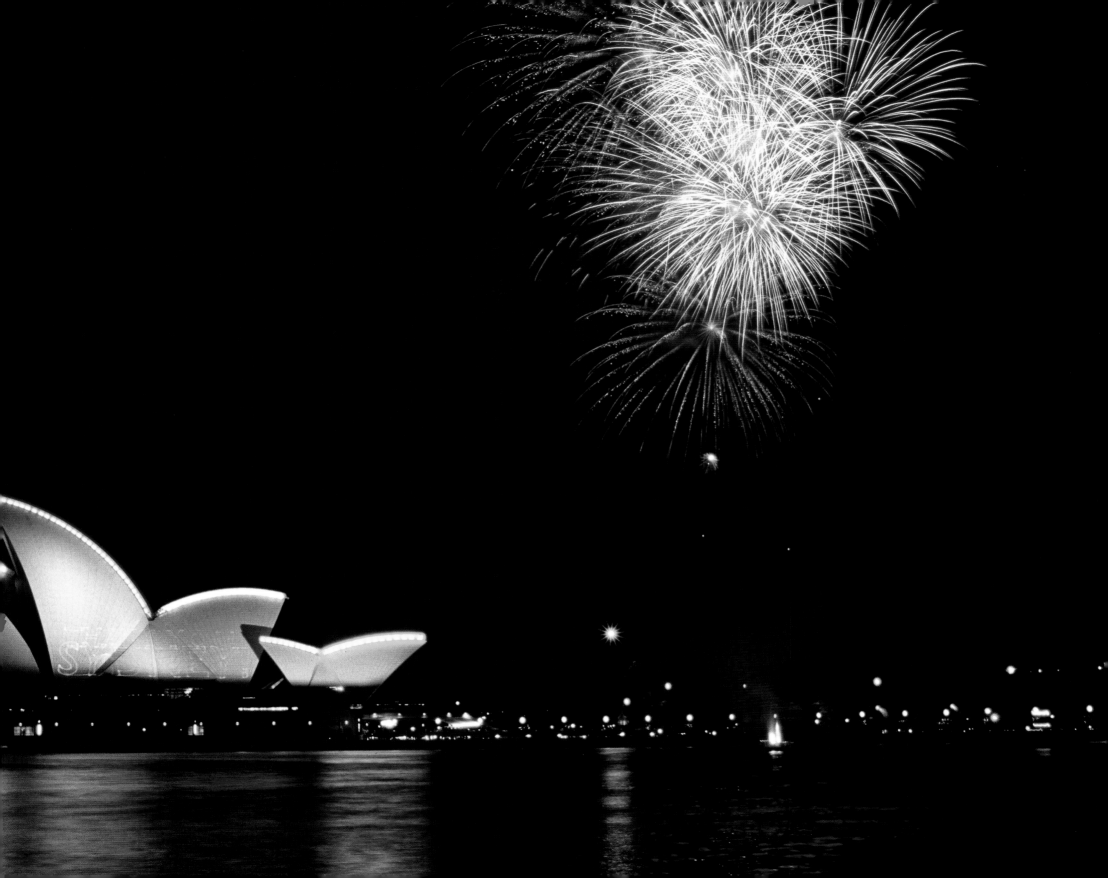

PHOTOGRAPHER: TIM COLE
SOURCE: CITY OF SYDNEY ARCHIVES, A-00083468

Revellers celebrate at Circular Quay in the small hours of 24 September 1993, with the first newspapers fresh off the press after Juan Antonio Samaranch, the president of the International Olympic Committee, announced at 4.27 am that Sydney had been successful in its bid to host the 2000 Summer Olympics.

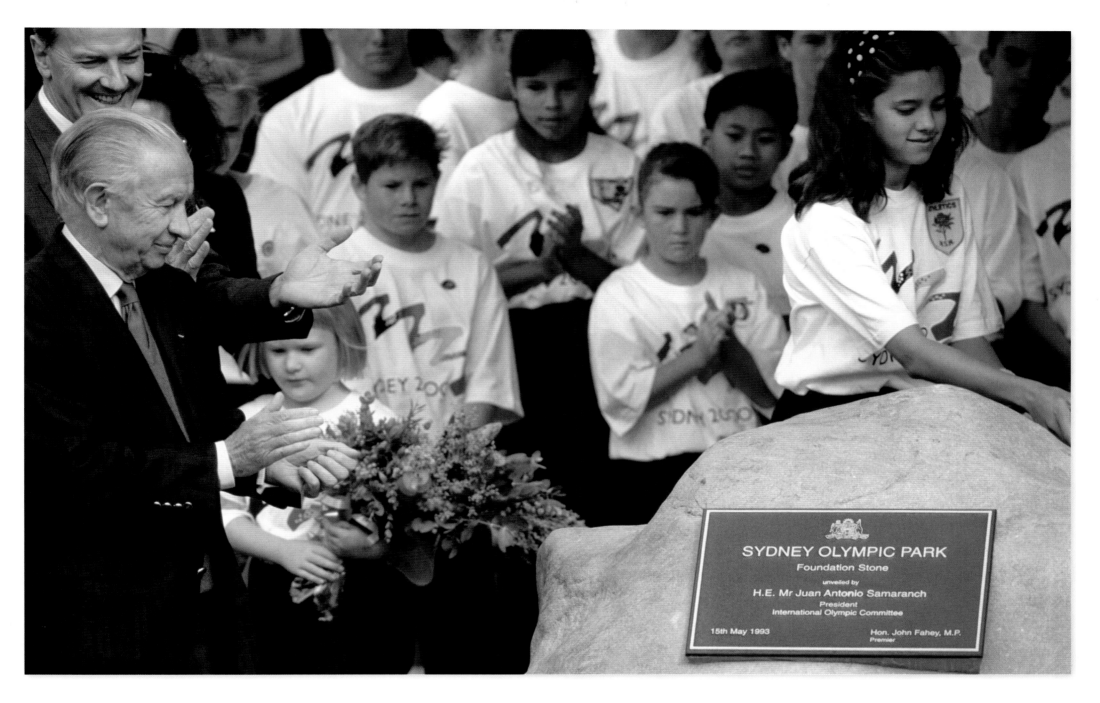

Sydney Olympic Park, Homebush Bay
1993

SOURCE: NATIONAL ARCHIVES OF AUSTRALIA, A6135, K25/5/93/131, 11860125

Juan Antonio Samaranch unveils the foundation stone for Sydney Olympic Park at Homebush in mid-May 1993.

Previously the site of an abattoir, and formally known as Lidcombe North, it was renamed Homebush Bay in 1989. Plans for its redevelopment commenced in 1992 in anticipation of Sydney's bid for the 2000 Olympics.

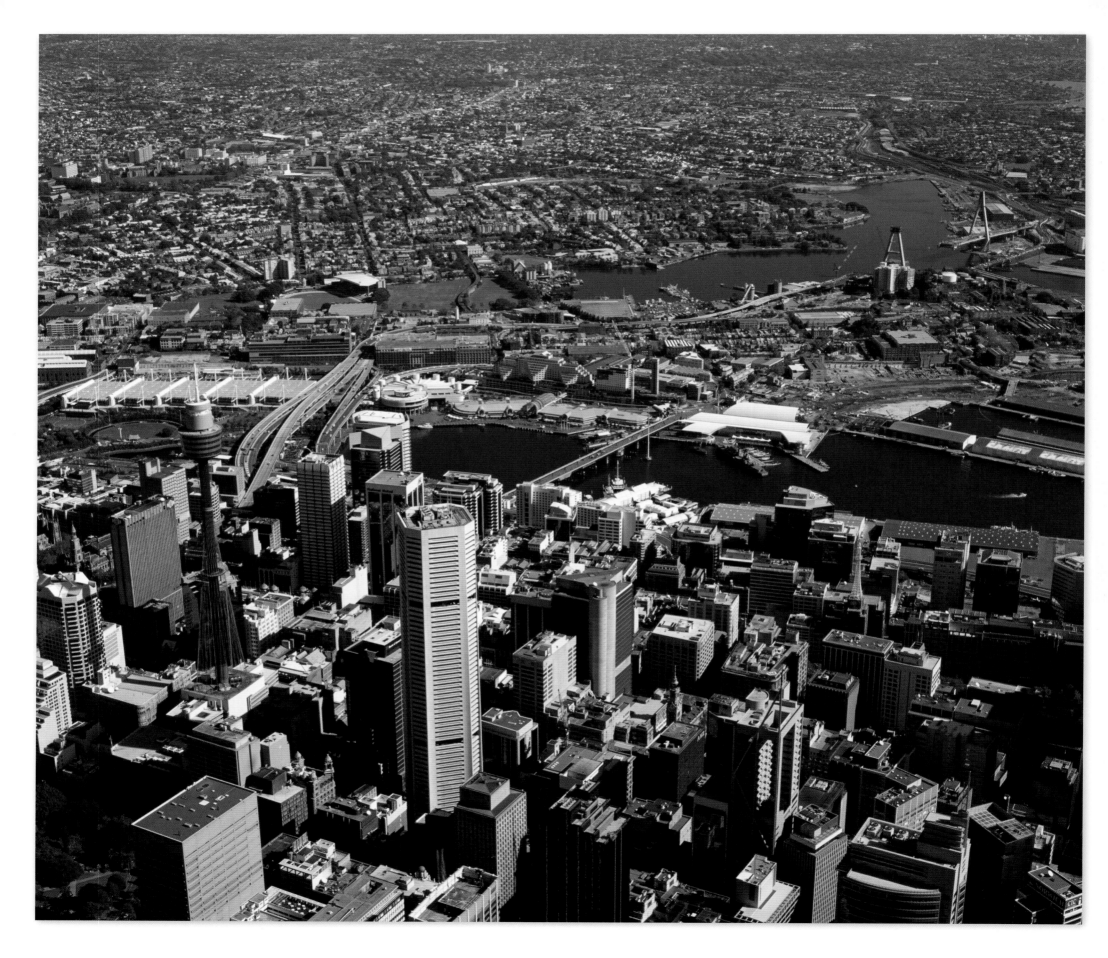

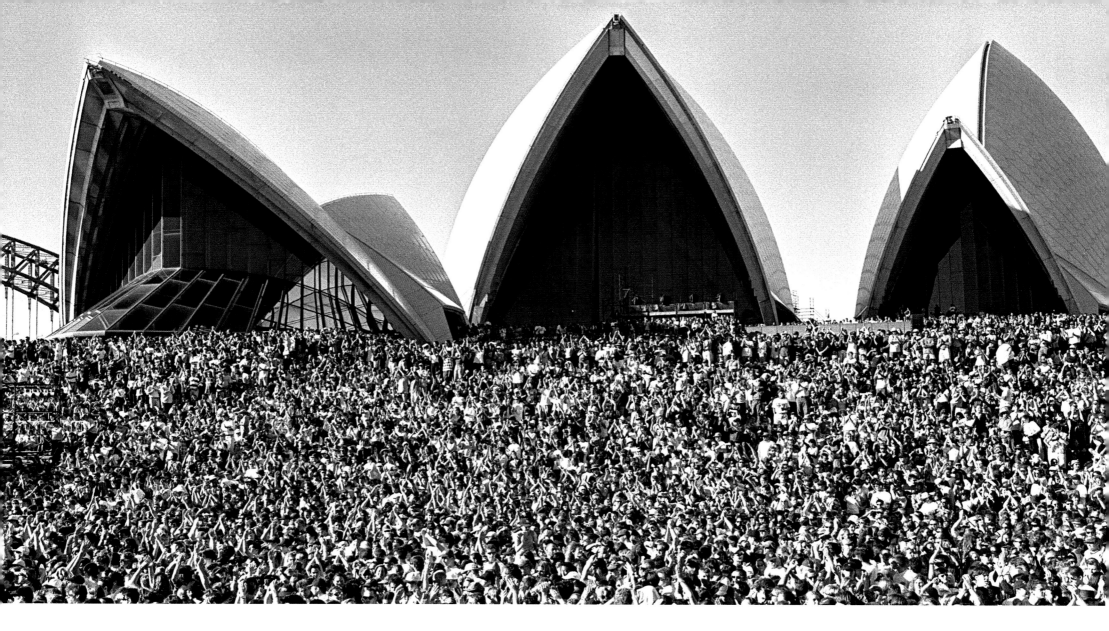

Sydney City
1994

SOURCE: STATE OF NEW SOUTH WALES (TRANSPORT FOR NSW) 2016,
ROADS AND TRAFFIC AUTHORITY, 107422-56

We're looking west over the CBD and the inner-western suburbs in May 1994.

You can see the Darling Harbour precinct in its heyday, with its recreation area and tennis courts, and towards Haymarket, the Convention Centre, and Harbour-side Shopping Centre — and the monorail link that runs over the Pyrmont Bridge.

Further to the right you can see the Anzac Bridge under construction. The Glebe Island Bridge is still open to traffic, and remained one of the main arterials into the city until December 1995, when the Anzac Bridge opened.

Sydney Opera House, Bennelong Point
1996

PHOTOGRAPHER: TIM COLE
SOURCE: CITY OF SYDNEY ARCHIVES, A-0083659

Revellers pack the Opera House steps in one of the most celebrated moments for music in Australia and during the 1990s, at the famous 'Farewell to the World' concert for Crowded House on 24 November 1996.

Originally, the concert was to be held the day before; it was delayed due to inclement weather. This was the last concert that the group played, with the proceeds being donated to the Sydney Children's Hospital.

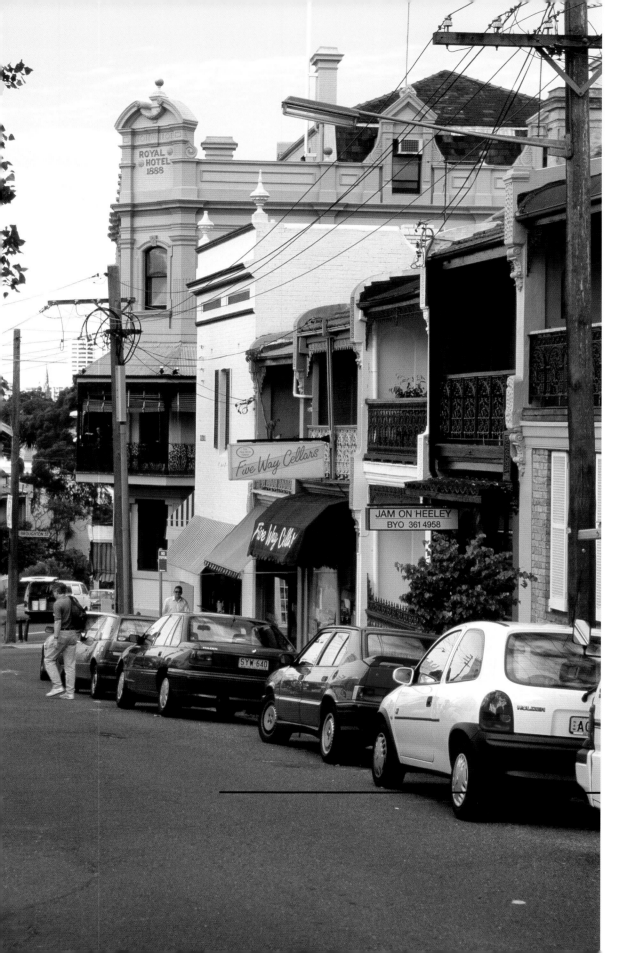

Five Ways, Paddington
1996

SOURCE: NATIONAL ARCHIVES OF AUSTRALIA, A6135, K26/2/96/2, 11729165;
NATIONAL ARCHIVES OF AUSTRALIA, A6135, K26/2/96/10, 11729171

Welcome to the mid-1990s in upmarket Paddington. It looks a bit different today, of course, but the Royal Hotel and Five Ways Cellars are still in these same spots.

Later, the dry cleaners, the laundromat, and the video shop — showing the latest-release VHS blockbusters, such as the Sandra Bullock classic *While You Were Sleeping* — that lined Glenmore Road were replaced with cafes.

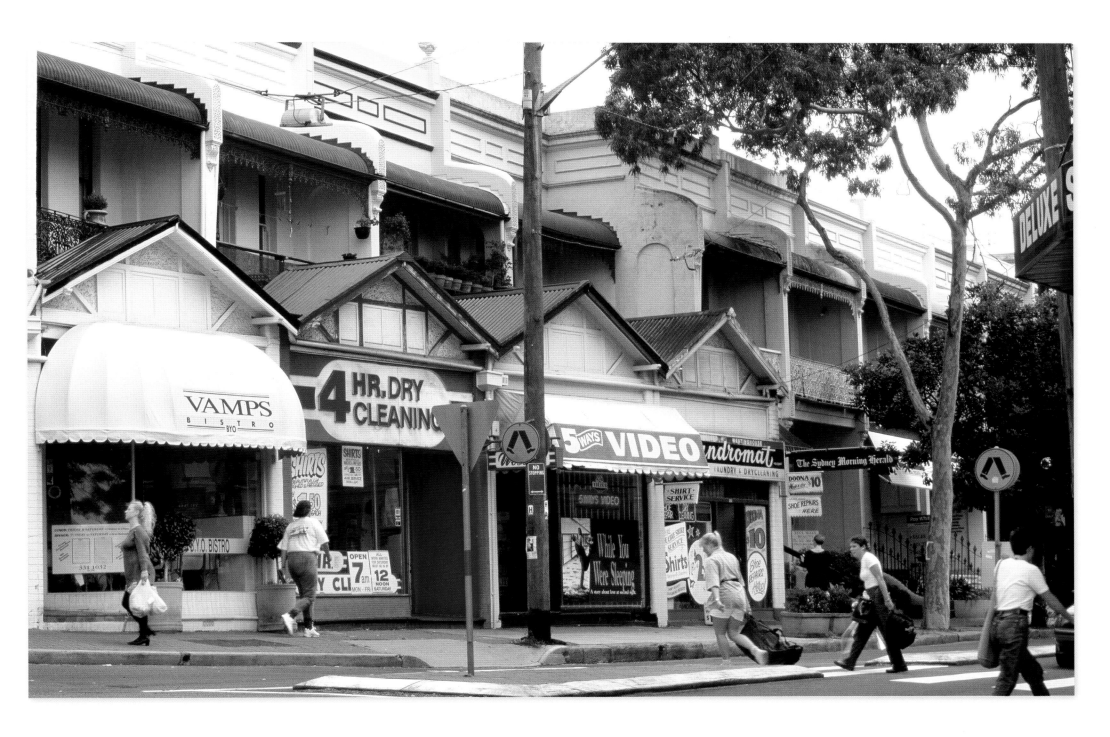

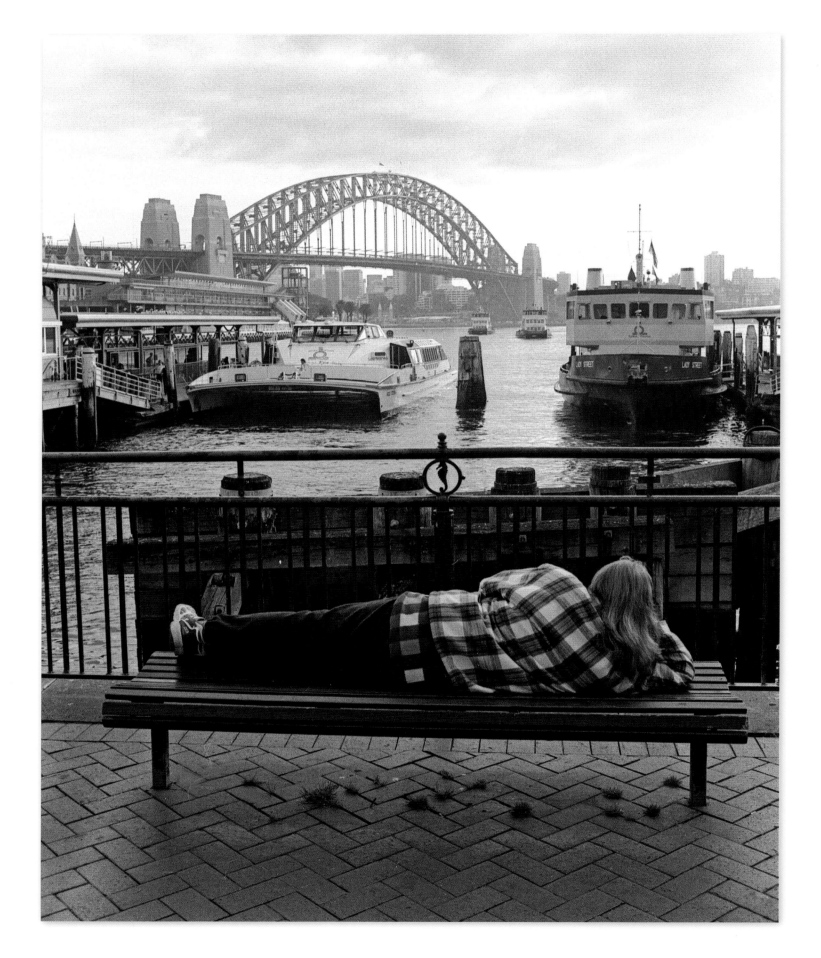

Circular Quay
1997

PHOTOGRAPHER: TIM COLE
SOURCE: CITY OF SYDNEY ARCHIVES, A-0083670

A passer-by rests to admire the view from a bench between the ferry terminals at Circular Quay, with a RiverCat catamaran and the *Lady Street* ferry in port.

Oxford Street, Darlinghurst
1997

PHOTOGRAPHER: C. MOORE HARDY
SOURCE: CITY OF SYDNEY ARCHIVES, A-00070511

A crowd heads for the annual 'Shop Yourself Stupid' HIV/AIDS fundraiser for the Bobby Goldsmith Foundation during Mardi Gras celebrations in March 1997.

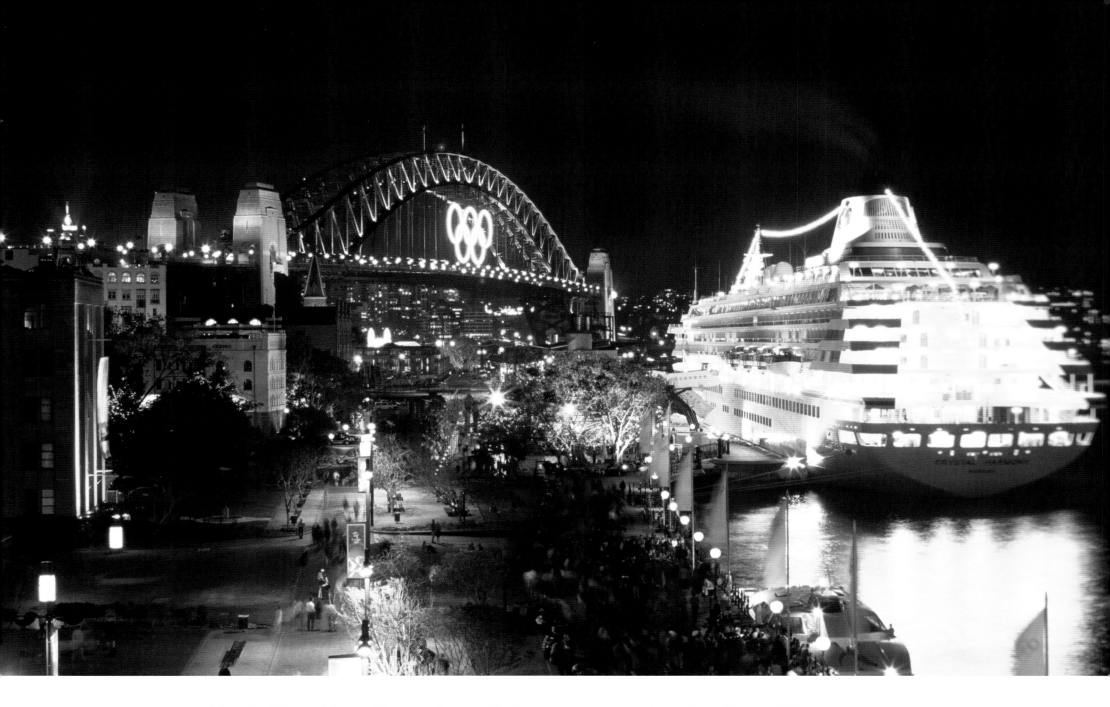

Men's Triathlon, Bennelong Point
2000
SOURCE: CITY OF SYDNEY ARCHIVES, A-00056602

Revellers and the media gather to watch the men's triathlon medalists take to the podium at the finish line outside the Opera House on 17 September 2000.

Circular Quay West
2000
SOURCE: CITY OF SYDNEY ARCHIVES, A-00056908

A view from from the Cahill Expressway looking towards Circular Quay West during the Olympic Games in late September 2000. You can see the crowds of people below at Circular Quay, with the Harbour Bridge lit up with the Olympic rings to mark the occasion.

Sydney Harbour
2000

SOURCE: CITY OF SYDNEY ARCHIVES, A-00007003

Sydney rings in the new millennium with fireworks in the small hours of 1 January 2000, with the Harbour Bridge displaying its theme for that year: 'Eternity'.

The theme was derived from the famous tag written by Arthur Stace in chalk on numerous sidewalks across the CBD over a 35-year period between 1932 and 1967.

Author's note

This book has been an interesting experience. Not many people can say they have authored a book — and I feel privileged that I've been able to do this with the help of the wonderful team at Scribe.

It is dedicated to the wonderful photographers and historians behind this collection of photographs that have survived the passage of time.

The sources of these photographs are cited in the captions throughout this book. A huge thank you to the teams at the National Archives of Australia, the State Library of New South Wales archives, Getty Images, and the City of Sydney Archives (in particular, Naomi Crago, who has been incredibly helpful). A special mention to my friend Sandy Weir, who has been incredibly helpful as well in the process of putting this book together, and Jack Shepherdson.

Also, to my family — Joe, Antoinette, Daniela, Ryan, Josh, and Laura. I would not be making this book without your support. And, of course, the many people who chucked *Retro Sydney* a follow — I would not be making this book if it wasn't for you, either.